# THE

# VISUAL

# ARTIST'S

# BUSINESS

# AND

# LEGAL GUIDE

# THE
# VISUAL
# ARTIST'S
# BUSINESS
# AND LEGAL
# GUIDE

COMPILED AND EDITED BY

GREGORY T. VICTOROFF, ESQ.

A PRESENTATION OF

THE BEVERLY HILLS BAR ASSOCIATION

COMMITTEE FOR THE ARTS

 A JEROME HEADLANDS PRESS BOOK

 PRENTICE HALL, Englewood Cliffs, NJ 07632

Library of Congress Cataloging-in-Publication Data

The Visual artist's business and legal guide/compiled and edited by Gregory T. Victoroff;
    introduction by Gregory T. Victoroff.
        p.   cm.
       "Jerome Headlands Press book."
       Rev. ed. of: The Visual artist's manual. 1984.
       Includes bibliographical references and index.
       ISBN 0-13-304593-5
        1. Artists--Legal status, laws, etc.--United States. 2. Artists--United States--Handbooks,
    manuals, etc. 3. Forms (Law)--United States.   I. Victoroff, Gregory T. (Gregory Timothy), 1954- .
    II. Visual artist's manual.
    KF390.A7V57   1994
    349.73'0247--dc20
    [347.300247]                              94-24758
                                                  CIP

Prentice-Hall, Inc.
A Division of Simon & Schuster
Englewood Cliffs, NJ 07632

Disclaimer. This book is intended to provide helpful and authoritative information. However, the publisher is not engaged in rendering legal, accounting or other professional services and hereby disclaims any guarantees or warranties of any kind as to the current accuracy of anything contained herein. Chapters are designed to identify business and legal issues, not as substitutes for qualified professional assistance. Legal or expert advice should be obtained from an experienced, competent professional in the appropriate circumstances.

Designed and produced by:
Jerome Headlands Press
Jerome, Arizona 86331

Cover and book design by Julie Sullivan, Sullivan Scully Design Group
Cover and book illustrations by Paul Nonnast
Copy editor and proofreader George Glassman
Index by Marc Savage, Savage Indexing Service

Manufactured in the United States of America

10 9 8 7 6 5 4 3 2 1

ISBN 0-13-304593-5

Prentice Hall International (UK) Limited, London
Prentice-Hall of Australia Pty. Limited, Sydney
Prentice-Hall Canada Inc., Toronto
Prentice-Hall Hispanoamericana, S.A., Mexico
Prentice-Hall of India Private Limited, New Delhi
Prentice-Hall of Japan, Inc., Tokyo
Simon & Schuster Asia Pte. Ltd., Singapore
Editora Prentice-Hall do Brasil, Ltda., Rio de Janeiro

# Table of Contents

# Contracts and Business Practices 83-156

# RESTRICTIONS ON CONTENT                    279-310

# INTRODUCTION

GREGORY T. VICTOROFF, ESQ.

*Art, like law, consists of drawing the line somewhere.*

In the early 1980s, a handful of idealistic and ambitious young lawyers, artists and arts advocates compiled the first edition of *The Visual Artist's Manual.* It was published in 1981 by the Committee for the Arts (CFTA) of the Barristers (young lawyers division) of the Beverly Hills Bar Association (BHBA). Today, CFTA has the same broad objectives: to produce an educational and informative publication relating to visual art and law, of lasting value to arts professionals and lawyers; and to assist in delivering high quality legal services and information at nominal cost.

*The Visual Artist's Business and Legal Guide,* greatly updated and expanded from the earlier version, is designed to assist artists and others in the art business to protect copyrights, understand contracts, raise funds, spot fraud and preserve art.

The CFTA, including the authors and others who contributed to this book, believe that preserving art and helping artists to be fairly compensated encourages the creation of more art, and that channeling energy into creating and appreciating art is a worthwhile and uplifting endeavor.

Art benefits everyone in our society, it helps define who we are. Yet few people appreciate how difficult it is for artists to make a living from their art. Little appreciation is given to the years of study and training, the enormous expense of materials, the problems encountered with dealers, exhibitions, grants, museums and galleries, and the difficulties of making sales.

In the United States, artists and art lovers have recently been targets of self-serving politicians who blame artists for the social problems depicted in their art. We recognize art's role as a reflection of the world around us. An important purpose of this book is to help ensure the free and uninhibited expression of political, moral and social messages as communicated by artists in their role as thinkers, dreamers and provocateurs.

Highlights of this work include chapters on new laws respecting artists' moral rights and prohibiting art destruction; gallery, publishing and licensing agreements; legal perils of appropriationist art and a discussion of censorship. Practical assistance is provided in chapters on fund raising, artists' portfolios and self-promotion, gallery representation, packing and shipping art, and insurance.

Artists today enjoy greater legal protection and benefits than at any other time in history. But new laws respecting artists' moral rights, freedom from censorship, copyright ownership and gallery consignment and disclosure requirements were not guaranteed to artists out of friendship. Artists and lawyers together organized and fought for these laws. Through an awareness of these laws, artists and art lovers can exert a degree of control over art's place in our culture.

Vincent Van Gogh, one of the greatest artists in the past 200 years, was an abject commercial failure during his lifetime. If this book helps a single struggling artist to overcome the vicissitudes visited upon Van Gogh and countless other artists, we will have accomplished our goal.

"We all know that art is not truth." Picasso said. "Art is a lie that makes us realize truth."

## Acknowledgments

The editor gives sincere thanks to:

all the authors for their magnificent contributions and cooperation through the edit stages; to the following individuals, companies and organizations who provided information and assistance, without which this book would have been a lot harder to complete: Daniel Bain, Steve Shonack, The Inn at Ventana, Bob Engle and Pasadena Art Center College of Design, Betty Brown and the Art Department of Cal. State Northridge, Jackie Sofen and the Art Dealers Association of California, Jenny Skobal, Lisa Paperno and Michael Zak, Harris Fogel and the College of the Desert Photography Department, Ardon Alger and the Chaffee College Art Department, Michael Doland, Esq., Nana Nash Duarte, Leslie Emge, the Victoroffs, California Lawyers for the Arts, Peter Karlen and Carol Ellen Rowe, OLA Word Processing, the American Society of Media Photographers (ASMP), the Graphic Artists' Guild (GAG), the Visual Artists and Galleries Association, Inc. (VAGA), Marguerite Dvorak, Kyhm Penfil, Marty Collins, Thomas Rhodes and the Santa Monica Museum of Art, Nancy Turner and the J. Paul Getty Museum, Miles Hurwitz, Slater and Jesse, Ed, Karen and Linda Buttwinick and the Brentwood Arts Center, Professor Robert Lind, Jonathan Bickart, Karen Sochar, Dean Monroe Price and the late, great Melville B. Nimmer for his vision and inspiration;

to the following BHBA volunteers: Nancy Wax, Susan Keen and Katherine Thompson;

to the following authors whose chapters were not included in this edition: Martin Bressler, Casey Hall, Edward R. Hearn, Margaret L. Kaplan, Kathleen Lane, Hope London, Michael McCann, Marie C. Malaro, Carla Messman, Suzanne Muchnic, Melvin Nefsky, Richard Nevins, Jerald Ordover, Robert L. Schuchard and Stephen Weil;

to the authors who contributed to earlier editions of this book who were not able to contribute to this edition: Robert Anthoine, Lawrence Blake, Estelle Bern, Marianne Borselle, Lorin Brennan, Allen B. Cutrow, Marc Darrow, Maureen Duris, Mark E. Halloran, Shari F. Lesnick, Leal Morgan, Susan D. Praskin, Jae Wagoner, Dorothy Weber, Martin Weber and Curtis Wilkie;

to the following people who helped with the resource appendix: Daniel Bain, Steve Shonack, the BHBA volunteers listed above and Casey Hall, Kathleen Lane, Sue Tillman and Marlene Weed;

to Jerome Headlands Press and staff (Diane Rapaport, President and Sue Tillman, editorial assistant); to Julie Sullivan, Sullivan Scully Design Group, Flagstaff, AZ for graphic design; to George Glassman, copy editor and proofreader; to Noel Fray, Connie Lacey and Victor Vas at Port Mingus Productions, Jerome, AZ for graphic production assistance, and to Paul Nonnast for cover and book illustrations.

# Legal Protection for Art and Artists

# COPYRIGHT: AN ARTIST'S TOOL

**STEPHEN F. ROHDE**

*Stephen F. Rohde is a partner of the Los Angeles
law firm of Rohde & Victoroff, which specializes in
copyright, trademark, and entertainment law. Mr. Rohde
writes and lectures frequently in these areas as well as
constitutional law. He represents writers, artists, film
and television producers and book publishers.
He is a graduate of Northwestern University
and Columbia Law School.*

**W**hat do a photograph of Oscar Wilde, a balsa wood model of the steamship *Queen Mary,* the Zapruder film of the J.F.K. assassination and a miniature reproduction of Rodin's sculpture *Hand of God* have in common?

Answer: They have each been found to be entitled to federal copyright protection. Visual artists are quite comfortable with the tools of their trade: brush, pallet, canvas, clay, knife, camera, ink, paints, etc. But all too routinely, they don't use a tool just as valuable and certainly as useful in the creation and perpetuation of their works: copyright protection.

If you retain nothing else from this brief review of United States copyright laws, learn once and for all that you can protect your artistic creations from plagiarism, infringement and unauthorized exploitation by simply taking advantage of one of the most important self-help statutes ever enacted. Without hiring a lawyer, without dealing with a bureaucratic labyrinth, without waiting months or years, and—perhaps most importantly—without paying more than $20 for each work, you can enjoy sweeping rights and remedies that protect your works for your own security and control, significantly enhance their commercial value, and lead to widespread dissemination in a variety of media, all for your financial benefit.

Forget those rumors and half-baked stories you may have heard suggesting that your painting, graphic, sculpture, design, photograph or other work of visual art is, for some esoteric reason, not entitled to copyright protection. Your work is entitled to copyright protection and you should take advantage of all of the legal protection that is rightfully yours by following the simple and inexpensive steps described below.

## THE COPYRIGHT OFFICE

The United States Copyright Office is a division of the Library of Congress. It is part of the Federal Government and, among other things, is empowered to administer the Copyright Act.

The Copyright Office is not permitted to give legal advice but will provide, free of charge, a wide variety of circulars, all of which are listed in "Publications of the Copyright Office." These materials explain all of the provisions of the Copyright Act in simple, nontechnical language. The best place to start is Circular R1 entitled "Copyright Basics," which provides a useful overview of the Copyright Law.

Although the Copyright Office is delighted to provide this information without charge, it hastens to point out that if you need information or guidance on matters such as disputes over the ownership of a copyright, suits against possible infringers, the procedure for getting a work published, or the method of obtaining royalty payments, it may be necessary to consult an attorney.

One widespread misconception is that the Copyright Office grants copyrights to particular applicants. This is inaccurate. Without ever contacting the Copyright Office, one obtains copyright protection by merely creating a work.

> **COPYRIGHT HOTLINE**
>
> The Copyright Office Publication Hotline is (202) 707–9100. Copyright Office specialists are available to answer your questions at (202) 707–3000. Copyright registration forms may be ordered by calling the 24-hour copyright form hotline: (202) 707–9100. The forms come with detailed instructions. Or write to: Register of Copyrights, Library of Congress, Washington, D.C. 20559.

Although nothing more is required to secure copyright protection, should an artist need to prove authorship, as in an infringement lawsuit, or wish to enjoy all the remedies available under the Copyright Act, the artist must file a copyright application, pay a fee of $20 and deposit one or more copies of the work. (More about these procedures later.)

The Copyright Office routinely reviews these applications to make certain that minimal statutory requirements have been met, and it issues a Certificate of Registration of Copyright. Except in rare instances, there are no hearings, no further requirements, and there is no additional expense. Indeed, obtaining a Copyright Registration is easier than obtaining a driver's license, and it doesn't have to be renewed every few years.

## THE "NEW COPYRIGHT ACT"

After years of debate and lobbying, Congress passed the Copyright Act of 1976, which became effective on January 1, 1978. This was the first general revision of the United States copyright law since 1909. For certain limited purposes, the 1909 law is still applicable but has generally been superseded by the Copyright Act of 1976. The comments in this chapter deal, for the most part, with the law as it presently exists under the Copyright Act of 1976.

## DEFINITION OF COPYRIGHT

Copyright is a form of legal protection provided under federal law to the authors of "original works of authorship," including literary, musical, dramatic and certain other intellectual works. It is not necessary for a work to be published or generally distributed to the public for it to be entitled to copyright protection.

The owner of a copyright has the exclusive right to do and to authorize others to do each of the following:

♦ To reproduce the copyrighted work.

♦ To prepare derivative works based upon the copyrighted work.

♦ To distribute copies of the copyrighted work to the public by sale or other transfer of ownership, or by rental, lease or lending.

♦ To perform the copyrighted work publicly, in the case of literary, musical, dramatic and choreographic works, pantomimes, motion pictures and other audiovisual works.

♦ To display the copyrighted work publicly in the case of literary, musical, dramatic and choreographic, or sculptural works, including the individual images of a motion picture or other audiovisual work.

It is a violation of law for anyone to exercise these rights without the permission of the copyright owner, subjecting the infringer to civil and criminal penalties (although criminal prosecutions are rare, except in the highly publicized cases of motion picture piracy).

The rights enjoyed by a copyright owner are not, however, unlimited in scope. In some cases the copyright statute provides specific exemptions from copyright liability. In addition, the Copyright Act recognizes the doctrine of "fair use," treated separately below.

One of the fundamental limitations on copyright protection is the First Amendment to the United States Constitution. Copyright protects the form of expression of an idea, but not the idea itself. No artist can claim exclusive ownership of the idea of a winter glade, a sunset or a child's smile. But an artist can surely claim copyright protection of his or her original painting, photography or sculpture depicting these public domain ideas.

## WORKS PROTECTED BY COPYRIGHT

Copyright protection exists for original works of authorship when they become fixed in a tangible form of expression. The fixation does not need to be perceptible by the human eye so long as it may be communicated with the aid of a machine or device. The Copyright Act recognizes seven different categories of copyrightable works, of which the category "pictorial, graphic and sculptural works" is most important for our purposes here.

Provided the requirements of "creativity" and "originality" are met, the following are examples of copyrightable works: two-dimensional and three-dimensional works of fine, graphic, and applied art, photographs, prints and art reproductions, maps, charts, globes, technical drawings, diagrams, models, artistic jewelry, enamel, glassware, tapestries, designs printed upon scarves and dress fabrics, dinnerware patterns, dolls, Christmas decorations, cemetery monuments, letterheads, bookends, clocks, lamps, door knockers, candlesticks, inkstands, chandeliers, piggy banks, sundials, salt and pepper shakers, fishbowls, casseroles, ashtrays, prints, lithographs, photo engravings, and labels. This list is illustrative and is not intended to exhaustively set forth the wide variety of artistic works entitled to copyright protection. Copyright protection for some forms of postmodern art, is discussed in the chapter, "Protecting Postmodern Art."

The law requires a minimal element of creativity. The courts have continuously grappled with the distinction between that which contains some creativity and that which does not. One court put forth the following definition: "A thing is a work of art if it appears to be within the historical and ordinary conception of the term art." But Justice Oliver Wendell Holmes detected the cultural bias implicit in such a definition when he wrote that "it may be more than doubted, for instance, whether the etchings of Goya or the paintings of Manet would have been sure of protection when seen for the first time." Most artists need not be troubled by the requirement of creativity so long as they contribute an ounce of creative authorship.

Separate from creativity, a copyrightable work must be original. It cannot be merely a copy of another copyrighted work or a work in the public domain. But any distinguishable variation created by the artist in an otherwise unoriginal work of art will constitute sufficient originality to support a copyright. Likewise, an original reproduction of a work of art can itself be subject to copyright protection. For example, a hand-made miniature reproduction of Rodin's sculpture *Hand of God* was found to be protected because of the "complexity and exactitude" of the miniaturization, although a mere scale reduction of the sculpture would not itself have been sufficiently original. Here again, most artists pride themselves on their originality, and so long as they avoid the slavish and exact copying of existing works, the requirements of originality will be met.

## MATERIAL NOT PROTECTED BY COPYRIGHT

Statutory copyright protection is not generally available for certain material, including the following:

♦ Titles, names, short phrases, and slogans; familiar symbols or designs that have not been originated by the author; mere variations of typographic ornamentation, lettering or coloring; mere listings of ingredients or contents.

♦ Ideas, procedures, methods, systems, processes, concepts, principles, discoveries, or devices, as distinguished from a description, explanation or illustration of such matters.

♦ Works that have not been fixed in a tangible form of expression, such as

choreographic works that have not been notated or recorded or improvisational performances or multimedia shows that have not been written or recorded.

♦ Works consisting entirely of information that is common property and contains no original authorship, such as standard calendars, height and weight charts, tape measures and rules, and lists or tables taken from public documents or other common sources.

## DIVIDING AND LICENSING COPYRIGHTS

One of the significant changes contained in the Copyright Act of 1976 is the abolition of the concept of the "indivisibility of copyright." Under the 1909 law there was a single "copyright," and the "bundle of rights" belonging to a copyright owner were "indivisible," making it impossible to "assign" anything less than all of the rights encompassed by the copyright.

The Copyright Act of 1976 explicitly recognizes the divisibility of copyright and provides that any of the exclusive rights comprised in a copyright may be transferred and owned separately. Moreover, so long as the assignment of a particular right is exclusive, it may be limited in time or territory. Thus, for example, an artist who creates a distinctive design—let's say the caricature of a famous movie star—can enter into a series of separate exclusive licenses granting the copyright in the work to someone else for the jacket of a hardcover biography; a full-size poster; sheets and pillowcases; wallpaper; school book covers; and on and on. In addition, each of these exclusive licenses can be limited to a specific number of years or to a specific geographical market.

Divisibility benefits both the artist and the licensee. The artist is able to deliberately and, hopefully, with great care and foresight, subdivide each of the separate rights he or she enjoys as copyright owner without the compulsion that previously existed under the 1909 law to assign the entire copyright to the first gallery or patron willing to pay enough to cover the overdue rent bill. Today the artist, whether well-established or unknown, can retain certain rights, certain markets and certain time periods, thereby hedging his or her bets in hopes of increased popularity and commercial success.

By the same token, one who acquires an exclusive license of some but not all of the rights in a copyright is a "copyright owner" of those particular rights and is entitled to all of the protection and remedies accorded to a copyright owner, including the right to register the copyright and sue for infringement without joining the original copyright owner of the entire work.

Given the divisibility of copyright, great care must be taken in writing agreements by which certain rights in a work of art are transferred. An artist must make certain that the agreement signed accurately describes exactly what is being disposed of, with any limitations as to time, territory or specific rights clearly expressed. In addition, if separate compensation is to be paid for each separate right (on the theory that the sum of the parts may be greater than the whole), similar care should be used in allocating the compensation, including any cash payments or royalties. The agreement should also state whether compensation for one exclusive right may be cross-collateralized against the compensation for another exclusive right. Depending upon the importance of the work and the money at stake, such negotiations and the drafting of agreements may require an attorney.

## CLAIMING COPYRIGHT

Copyright protection arises upon the moment of creation. As soon as a work of authorship is created in fixed form, the copyright in that work immediately becomes the property of the author who created it. Thus, the moment brush touches canvas or ink touches paper, a copyright comes into existence and is owned by the artist or author.

The only exception to this magnificent notion is that in the case of a work made for hire the employer and not the employee is presumptively considered the author.

Authors who have collaborated on a joint work are the co-owners of the copyright in the work, unless there is a written agreement altering this relationship.

The copyright in each separate contribution to a periodical or other collective work is distinct from the copyright in the collective work as a whole and vests initially in the author of the separate contribution.

It is particularly important for artists to understand that mere ownership through purchase, gift or other transfer of the physical painting, photograph, sculpture or other work of visual art (or for that matter any copyrightable work) does not give the purchaser or possessor the copyright to the work itself. The law provides that transfer of ownership of any material object protected by copyright does not in and of itself convey any rights in that copyright. Thus, unless the artist and purchaser have a written agreement giving the purchaser some or all of the rights in the artist's work, the purchaser is not entitled to reproduce that work, prepare derivative works, distribute copies of the work, or license others to do so. Each of the rights contained in the copyright are retained by the artist to do with as he or she sees fit, so long as the artist's use does not breach any agreement with the purchaser. Under the "First Sale Doctrine," however, the lawful owner of a copy of a work is entitled, without the authority of the copyright owner, to sell or otherwise dispose of possession of that copy.

## SECURING A COPYRIGHT

As noted at the outset, no publication or registration or other action in the Copyright Office or elsewhere is required to secure copyright under the Copyright Act of 1976, unlike the 1909 law that required either publication with copyright notice or registration in the Copyright Office. To repeat: copyright protection attaches to a work immediately upon its creation in fixed form. If a work is prepared over a period of time, the part of the work existing in fixed form on a particular date constitutes the created work as of that date, giving rise to the peculiar fact that the upper portion of a painting, if completed first, is protected by copyright even before the lower portion is finished.

## DEFINITION OF PUBLICATION

Although publication is no longer a necessary step in obtaining statutory copyright, publication remains important to copyright owners. The Copyright Act of 1976 defines publication as the distribution of copies of a work to the public by sale or other transfer of ownership or by rental, lease, or lending, and it notes that the offering

to distribute copies to a group of persons for purposes of further distribution, public performance or public display constitutes publication but a public performance or display of a work does not in and of itself constitute publication.

When a work is published, each published copy should bear a copyright notice. (This is not a legal requirement to secure copyright, but a lack of notice may limit a claim for damages.) Publication remains an important concept because of several significant legal consequences that follow from publication, including the following:

♦ Works that are published with notice of copyright in the United States are subject to mandatory deposit with the Library of Congress.

♦ Publication of work can affect the limitations on the exclusive rights of the copyright owner set forth in the Copyright Act of 1976.

♦ The year of publication is used in determining the duration of copyright protection for anonymous and pseudonymous works and for works made for hire.

♦ Deposit requirements for registration of unpublished works differ from those for registration of published works.

A recurring question is whether the public display of a work of art constitutes publication. Under the 1909 Act the answer to this question was highly disputable and the consequences were drastic for the artist. Under the old law, several courts had decided that the mere public exhibition of a work of art constituted a publication thereof and that without a proper copyright notice, the work had been injected into the public domain and all copyright protection had been lost. The United States Supreme Court softened this position by ruling that a general publication of a painting does not occur, when it is publicly exhibited if the public is admitted to view the painting on the express or implied understanding that no copying shall take place, and provided further that measures are taken to enforce this restriction.

The new Copyright Act makes clear that a display of a work of art does not in and of itself constitute publication. The only remaining quandary for the artist is presented by the principle that public display combined with public sale or public offer of sale can constitute a publication of the work. If a public exhibition is not intended to constitute a sale or offer of sale, this should be made apparent to the exhibitor, gallery and the public by public notices in the advertising, on the show program or at the exhibition.

## PROPER COPYRIGHT NOTICE

In 1989, the United States finally joined the Berne Convention, an international copyright treaty. To implement U.S. adherence to Berne, certain provisions of U.S. copyright law were modified for works first published after March 1, 1989.

Mandatory copyright notice is no longer required; failure to affix a copyright notice no longer results in loss of copyright. However, voluntary notice is still advisable. When a work is published under the authority of the copyright owner, a notice of copyright should be placed on all publicly distributed copies, whether published

inside or outside the United States. Failure to comply with the notice requirements can result in the loss of certain additional rights otherwise available to a copyright owner. For example, a lack of notice can deprive a copyright owner of greater damages available for a willful infringement. As noted, the Copyright Office is not involved in the affixation of the copyright notice and the copyright owner need not obtain prior permission from the Copyright Office.

Three elements are necessary for copyright notice:

1. The symbol © or the word "copyright" or the abbreviation "copr." It is recommended that the symbol © be used since it (and only it) complies with the Universal Copyright Convention entitling the artist to certain international protection.

2. The year of first publication of the work. In the case of compilations or derivative works incorporating previously published material, the year date of first publication of the compilation or derivative work is sufficient. Of particular importance to visual artists is the rule that the year date may be omitted where a pictorial, graphic, or sculptural work, with accompanying textual matter, if any, is reproduced in or on greeting cards, postcards, stationery, jewelry, dolls, toys, or any "useful article."

3. The name of the owner of copyright in the work, or an abbreviation by which the name can be recognized, or a generally known alternative designation of the owner. Under most circumstances, a tradename, nickname or other generally known assumed name will suffice.
Example: "© 1995 Alice Artist"

There is a special short-form of notice applicable to pictorial, graphic and sculptural works published prior to January 1, 1978, and to later publications of works first published prior to January 1, 1978. Not only does the special short-form notice dispense with the requirement of the year of the first publication, but instead of the copyright owner's name, the notice can simply contain the initials, monogram, mark or symbol of the copyright owner, accompanied by the symbol ©. In such circumstances, the name of the copyright owner must appear, if not in the notice, then on some accessible portion of the work, or in the margin, back, permanent base, or pedestal, or on the substance on which the work was mounted. This special short-form notice does not apply to works first published *after* January 1, 1978.

## PLACEMENT OF THE COPYRIGHT NOTICE

The copyright notice should be "affixed" to copies of the work in such a manner and location as to "give reasonable notice of the claim of copyright." The three elements of the notice should ordinarily appear together on each copy. Whether reasonable notice has been given is a question of fact depending upon the circumstances of each case, and the artist should make a genuine effort to give reasonable notice notwithstanding his or her artistic concern about the disfigurement of the work.

A notice need not appear in the most prominent place on the work so long as it is legible to the naked eye (except where the work itself requires magnification, such as motion pictures, microfilms or filmstrips). Courts have upheld notices placed on the back or underside of a work. But no matter how prominent or legible, the notice must be affixed to the work. Copyright notices on tags, wrappers, containers or the wall of a room in which a work is displayed have been held by the courts to not constitute proper notice. On the other hand, a copyright notice on a gummed label intended to be pasted on the work and a copyright notice on a cardboard display package with a plastic window containing a doll and used as a keeping place for the doll have been upheld as sufficiently affixed to the work.

## AFFIXING THE COPYRIGHT NOTICE

The Copyright Office has promulgated Regulations under the Copyright Act of 1976 specifying examples of acceptable methods of affixation and positions of the copyright notice for various works, including pictorial, graphic and sculptural works. Because of the importance of this issue and the uncertainties it presents for an artist genuinely interested in obtaining maximum copyright protection, the five guidelines of the Copyright Office are set forth, in full, below.

♦ Where a work is reproduced in two-dimensional copies, a notice affixed directly or by means of a label cemented, sewn, or otherwise permanently secured to the front or back of the copies, or to any backing, mounting, matting, framing, or other material to which the copies are permanently attached in which they are permanently housed, is acceptable.

♦ Where a work is reproduced in three-dimensional copies, a notice affixed, sewn, or otherwise permanently secured to any visible portion of the work, or to any base, mounting, framing, or other material on which the copies are permanently attached or in which they are permanently housed, is acceptable.

♦ Where, because of the size or physical characteristics of the material in which the copies are reproduced, it is impossible or extremely impractical to affix a notice to the copies directly or by means of a permanent label, a notice is acceptable if it appears on a tag that is of durable material and that is attached to the copy with sufficient permanency that it will remain with the copy during the entire time it is passing through the normal channels of commerce.

♦ Where a work is reproduced in copies consisting of sheet-like or strip material bearing multiple or continuous reproductions of the work, the notice may be applied: (1) to the reproduction itself; (2) to the margin, salvage, or reverse side of the copies at frequent and regular intervals; or (3) if the material contains neither a salvage nor a reverse side, to tags or labels attached to the copies, and to any spools, reels, or containers housing them in such a manner that a notice is visible during the entire time the copies are passing through their normal channels of commerce.

♦ If the work is permanently housed in a container, such as a game or puzzle box, a notice reproduced on the permanent container is acceptable.

While the Copyright Office's valiant effort at anticipating questions concerning the proper placement of the copyright notice is most laudable, it should be apparent that this issue, like so many others in the copyright law, is destined for further judicial review. Further information is available in the Copyright Office circular, "Notice on Works of Visual Art."

Finally, although a copyright notice is not required on unpublished works, it is prudent for the artist to affix a proper copyright notice to any copies that leave his or her control.

## BENEFITS OF COPYRIGHT REGISTRATION

As noted, copyright registration is not a condition of obtaining copyright protection but is instead a legal formality intended to make a public record of the basic facts relating to a particular copyrighted work. Nevertheless, the copyright law provides several attractive benefits that make registration highly recommended.

♦ Registration establishes a public record of the copyright claim and provides the copyright owner with an official document that can prove useful in keeping potential infringers from risking liability.

♦ Registration is ordinarily necessary before a copyright infringement lawsuit may be filed in court.

♦ Registration establishes prima facie evidence in court of the validity of the copyright and of the facts stated in the copyright registration certificate, if made before publication or within five years of publication.

♦ If registration is made within three months of publication or prior to an infringement of the copyrighted work, statutory damages and attorneys' fees will be available to the copyright owner in court actions, whereas otherwise only an award of actual damages and profits is available to the copyright owner.

## PROCEDURE TO REGISTER A COPYRIGHT

In order to register a work for copyright, *three* items must be sent to the Copyright Office in the same envelope or package:

**1.** A properly completed application form, called Form VA: "Published and Unpublished Works of the Visual Arts," a copy of which, together with the very useful instructions prepared by the Copyright Office, is reproduced at the end of this chapter.

**2.** A fee of $20 for each application. Artists may also register a group of works for a single $20 fee, if they can be properly considered a collective work or a series.

**3.** A deposit of the work being registered.

### Deposit Requirements

Because meeting the deposit criteria of copyright registration varies depending on circumstances, these general guidelines should be followed:

♦ If the work is unpublished, one complete copy.

♦ If the work was first published in the United States on or *after* January 1, 1978, two complete copies of the best edition.

♦ If the work was first published in the United States *before* January 1, 1978, two complete copies of the work as first published.

♦ If the work was first published outside the United States, whenever published, one complete copy of the work as first published.

♦ If the work is a contribution to a collective work (a magazine, book, etc.) published after January 1, 1978, one complete copy of the best edition of the collective work.

Given the unusual size, shape and bulk of some visual arts, the Copyright Office regulations may allow the deposit of "identifying material" instead of copies. Such material should consist of photographic prints, transparencies, Photostats, drawings or similar two-dimensional reproductions or renderings of the work, in a form visually perceptible without the aid of a machine or device.

If the work is a pictorial or graphic work, the material should reproduce the actual colors employed in the work, and in all other cases the material may be in black and white or may consist of a reproduction of the actual colors. As many pieces of identifying material should be submitted as are necessary to clearly show the entire copyrightable content of the work for which registration is being sought. Only one set of complete identifying material is required. Additional technical requirements regarding the size and dimension of the identifying material can be obtained by requesting Circular R40a from the Copyright Office.

Likewise, the Copyright Office has established detailed regulations concerning the determination of the best edition of a work. These technicalities are beyond the scope of this chapter but are clearly and concisely set forth in Circular R7b. All circulars mentioned above may be obtained free of charge from the Copyright Office.

Although a copyright registration is not required, the Copyright Act establishes a mandatory deposit requirement for works published with notice of copyright in the United States. Such a deposit must be made within three months of publication in the United States for the use of the Library of Congress. Although failure to make the deposit does not affect copyright protection, failure to do so after notice from the Register of Copyrights can lead to fines and other penalties.

## LENGTH OF COPYRIGHT PROTECTION

### Works Originally Copyrighted On or After January 1, 1978

A work that is created and fixed in tangible form for the first time on or after January 1, 1978, is automatically protected from the moment of its creation. Ordinarily it enjoys copyright protection for the duration of the life of the author plus an additional fifty years after the author's death. In the case of a joint work prepared by two or more authors who did not work for hire, the term lasts for fifty years after the last surviving author's death (resulting in the possibility of increasing collaborations with very young joint authors). For works made for hire or where the copyright owner is a corporation, and for anonymous and pseudonymous works (unless the author's identity is revealed in Copyright Office records), the duration of copyright will be seventy-five years from publication or one hundred years from creation, whichever is shorter.

Works that were created before January 1, 1978 but had been neither published nor registered for copyright by that date have been automatically brought under the new statute and are now given federal copyright protection generally computed in the same way as for new works. However, all works in this category are guaranteed at least twenty-five years of statutory protection.

### Works Copyrighted Before January 1, 1978

Under the 1909 Act, copyright was secured either on the date a work was published, or for unpublished works, on the date of registration, if any. In both cases, the copyright lasted for a first term of twenty-eight years and, if renewed, for a renewal term of twenty-eight years.

The new copyright law extended the renewal term from twenty-eight years to forty-seven years for copyrights that were valid on January 1, 1978. The complexities of renewal under the old and new copyright laws are beyond the scope of this chapter and more detailed information can be obtained by requesting circulars Nos. 1 "Copyright Basics," 15 "Renewal of Copyright" and 15a "Duration of Copyright" from the Copyright Office or by consulting a copyright attorney.

## TRANSFER OF COPYRIGHT

Given the doctrine of divisibility of copyright, any or all of the exclusive rights or any portion of the rights of a copyright owner may be transferred to a third party, but the transfer of exclusive rights is not valid unless the transfer is (a) in writing and (b) signed by the owner of the rights conveyed or his or her duly authorized agent. Licensing of a right on a nonexclusive basis need not be in writing and is not considered a transfer for copyright purposes.

A copyright may also be conveyed by operation of law and may be bequeathed by will or passed as personal property under the applicable laws of intestate succession. Copyright is a personal property right, and it is subject to the various state laws and regulations that govern the ownership, inheritance, or transfer of personal property as well as terms of contracts or conduct of business, the details of which are, of course, beyond the scope of this chapter and require consultation with an attorney.

The transfer of all or part of a copyright is usually made in a written document that may be recorded in the Copyright Office, although the Copyright Office does not provide any particular forms for such purposes. Recordation of a transfer is not required to make it valid between the parties, but it may provide certain legal advantages and does serve to put third parties on notice for a variety of purposes.

## TERMINATION OF A COPYRIGHT TRANSFER

Under the 1909 law, if artists assigned their copyrights, they reverted to the artists, if they were alive, or if not living, to other specified beneficiaries, provided a renewal claim was registered in the twenty-eighth year of the original term. If, however, the renewal rights had been expressly assigned and the author survived to the commencement of the renewal term, then the assignee was entitled to the renewal of copyright.

The new Copyright Act has eliminated the renewal feature, except for works already in their first term of statutory protection as of January 1, 1978. In place of the renewal, the new law generally permits any transfer of the copyright or any part thereof to be terminated within a five-year period commencing thirty-five years after the grant of rights under certain conditions by the service of a written notice on the transferee. Artists who wish to reacquire their rights should make a note in their calendar thirty-five years from the transfer so they won't miss this opportunity.

Of more immediate concern, for works already under statutory copyright protection under the old law, the new law provides a similar right of termination covering the nineteen additional years extending the renewal term from twenty-eight to forty-seven years.

It is worth noting that these beneficial termination provisions do not apply to works made for hire since in such cases the employer or person who commissioned the work is the author—not by reason of any transfer of copyright, but by operation of the Copyright Act itself.

Although the termination of transfers may appear to be insignificant in the short run, it is sure to be a valuable right for an author or his or her heirs, particularly where a work of art has appreciated in value beyond the artist's original expectations at the time he or she relinquished their rights.

## COPYRIGHT INFRINGEMENT

To prove copyright infringement, the copyright owner must show (a) that the defendant had access to the copyrighted work; (b) that the infringing work is substantially similar to the copyrighted work; and (c) that the copying was done without the copyright owner's permission.

Volumes have been written on copyright infringement and this is one area of copyright law that justifies consultation with an experienced copyright lawyer. If you believe your copyright has been infringed or if you have been accused of copyright infringement, don't panic and don't ignore the situation. Promptly consult a copyright lawyer.

A copyright owner or the owner of any exclusive rights in a copyright may recover "the actual damages suffered by him or her as a result of the infringement, and any

profits of the infringer that are attributable to the infringement and are not taken into account in computing the actual damages." The Copyright Act provides for injunctions, impounding and disposition of infringing articles, increased damages in lieu of actual damages and reasonable attorneys' fees and court costs, as well as (rarely enforced) criminal penalties.

Instead of actual damages and the defendant's profits, a successful plaintiff can elect to recover statutory damages. In an ordinary case, the statutory range is from $500 to $20,000. This can be reduced to $200 for an innocent infringement or increased to $100,000 for a willful infringement.

In many circumstances, a copyright infringement action can be combined with an action for unfair competition, violation of various state and federal trademark laws, and breach of express or implied contractual agreements. Federal courts have primary jurisdiction over copyright infringement cases and can exercise jurisdiction over related state law claims.

## THE "FAIR USE DOCTRINE"

Some artists and others who are not particularly conversant in copyright law often cite the doctrine of "fair use" to justify infringement of copyright. The doctrine of fair use, which was recognized by the courts under the 1909 Act and has now received specific statutory recognition in the Copyright Act of 1976, allows the limited use of a copyrighted work for certain prescribed purposes and under certain restricted circumstances.

The new law provides that for purposes "such as criticism, comment, news reporting, teaching (including multiple copies for classroom use), scholarship or research" the fair use of a copyrighted work is not an infringement of copyright. In determining whether the use made of a work in any particular case is a fair use, the factors to be considered, as identified in the statute, shall include: the purpose and character of the use, including whether such use is of a commercial nature or is for nonprofit educational purposes; the nature of the copyrighted work; the amount and substantiality of the portion used in relation to the copyrighted work as a whole; the effect of the use upon the potential market for or value of the copyrighted work.

While these factors are relatively self-explanatory, it is immediately apparent that each case depends upon its own particular facts. In order to avoid a controversy over whether a particular use is fair or not, it is prudent to seek permission for the use of a copyrighted work or any portion thereof. Handy rules gratuitously offered by friends and colleagues, suggesting that an artist can always make fair use of a certain amount of a copyrighted work without fear of infringement usually lead one astray.

# ⊘Filling Out Application Form VA

*Detach and read these instructions before completing this form.*
*Make sure all applicable spaces have been filled in before you return this form.*

## BASIC INFORMATION

**When to Use This Form:** Use Form VA for copyright registration of published or unpublished works of the visual arts. This category consists of "pictorial, graphic, or sculptural works," including two-dimensional and three-dimensional works of fine, graphic, and applied art, photographs, prints and art reproductions, maps, globes, charts, technical drawings, diagrams, and models.

**What Does Copyright Protect?** Copyright in a work of the visual arts protects those pictorial, graphic, or sculptural elements that, either alone or in combination, represent an "original work of authorship." The statute declares: "In no case does copyright protection for an original work of authorship extend to any idea, procedure, process, system, method of operation, concept, principle, or discovery, regardless of the form in which it is described, explained, illustrated, or embodied in such work."

**Works of Artistic Craftsmanship and Designs:** "Works of artistic craftsmanship" are registrable on Form VA, but the statute makes clear that protection extends to "their form" and not to "their mechanical or utilitarian aspects." The "design of a useful article" is considered copyrightable "only if, and only to the extent that, such design incorporates pictorial, graphic, or sculptural features that can be identified separately from, and are capable of existing independently of, the utilitarian aspects of the article."

**Labels and Advertisements:** Works prepared for use in connection with the sale or advertisement of goods and services are registrable if they contain "original work of authorship." Use Form VA if the copyrightable material in the work you are registering is mainly pictorial or graphic; use Form TX if it consists mainly of text. **NOTE:** Words and short phrases such as names, titles, and slogans cannot be protected by copyright, and the same is true of standard symbols, emblems, and other commonly used graphic designs that are in the public domain. When used commercially, material of that sort can sometimes be protected under state laws of unfair competition or under the Federal trademark laws. For information about trademark registration, write to the Commissioner of Patents and Trademarks, Washington, D.C. 20231.

**Architectural Works:** Copyright protection extends to the design of buildings created for the use of human beings. Architectural works created on or after December 1, 1990, or that on December 1, 1990, were unconstructed and embodied only in unpublished plans or drawings are eligible. Request Circular 41 for more information.

**Deposit to Accompany Application:** An application for copyright registration must be accompanied by a deposit consisting of copies representing the entire work for which registration is to be made.

**Unpublished Work:** Deposit one complete copy.

**Published Work:** Deposit two complete copies of the best edition.

**Work First Published Outside the United States:** Deposit one complete copy of the first foreign edition.

**Contribution to a Collective Work:** Deposit one complete copy of the best edition of the collective work.

**The Copyright Notice:** For works first published on or after March 1, 1989, the law provides that a copyright notice in a specified form "may be placed on all publicly distributed copies from which the work can be visually perceived." Use of the copyright notice is the responsibility of the copyright owner and does not require advance permission from the Copyright Office. The required form of the notice for copies generally consists of three elements: (1) the symbol "©", or the word "Copyright," or the abbreviation "Copr."; (2) the year of first publication; and (3) the name of the owner of copyright. For example: "© 1991 Jane Cole." The notice is to be affixed to the copies "in such manner and location as to give reasonable notice of the claim of copyright." Works first published prior to March 1, 1989, **must** carry the notice or risk loss of copyright protection.

For information about notice requirements for works published before March 1, 1989, or other copyright information, write: Information Section, LM-401, Copyright Office, Library of Congress, Washington, D.C. 20559-6000.

## LINE-BY-LINE INSTRUCTIONS

*Please type or print using black ink.*

### 1 SPACE 1: Title

**Title of This Work:** Every work submitted for copyright registration must be given a title to identify that particular work. If the copies of the work bear a title (or an identifying phrase that could serve as a title), transcribe that wording *completely* and *exactly* on the application. Indexing of the registration and future identification of the work will depend on the information you give here. For an architectural work that has been constructed, add the date of construction after the title; if unconstructed at this time, add "not yet constructed."

**Previous or Alternative Titles:** Complete this space if there are any additional titles for the work under which someone searching for the registration might be likely to look, or under which a document pertaining to the work might be recorded.

**Publication as a Contribution:** If the work being registered is a contribution to a periodical, serial, or collection, give the title of the contribution in the "Title of This Work" space. Then, in the line headed "Publication as a Contribution," give information about the collective work in which the contribution appeared.

**Nature of This Work:** Briefly describe the general nature or character of the pictorial, graphic, or sculptural work being registered for copyright. Examples: "Oil Painting"; "Charcoal Drawing"; "Etching"; "Sculpture"; "Map"; "Photograph"; "Scale Model"; "Lithographic Print"; "Jewelry Design"; "Fabric Design."

### 2 SPACE 2: Author(s)

**General Instruction:** After reading these instructions, decide who are the "authors" of this work for copyright purposes. Then, unless the work is a "collective work," give the requested information about every "author" who contributed any appreciable amount of copyrightable matter to this version of the work. If you need further space, request Continuation Sheets. In the case of a collective work, such as a catalog of paintings or collection of cartoons by various authors, give information about the author of the collective work as a whole.

**Name of Author:** The fullest form of the author's name should be given. Unless the work was "made for hire," the individual who actually created the work is its "author." In the case of a work made for hire, the statute provides that "the employer or other person for whom the work was prepared is considered the author."

**What is a "Work Made for Hire"?** A "work made for hire" is defined as: (1) "a work prepared by an employee within the scope of his or her employment"; or (2) " a work specially ordered or commissioned for use as a contribution to a collective work, as a part of a motion picture or other audiovisual work, as a translation, as a supplementary work, as a compilation, as an instructional text, as a test, as answer material for a test, or as an atlas, if the parties expressly agree in a written instrument signed by them that the work shall be considered a work made for hire." If you have checked "Yes" to indicate that the work was "made for hire," you must give the full legal name of the employer (or other person for whom the work was prepared). You may also include the name of the employee along with the name of the employer (for example: "Elster Publishing Co., employer for hire of John Ferguson").

**"Anonymous" or "Pseudonymous" Work:** An author's contribution to a work is "anonymous" if that author is not identified on the copies or phonorecords of the work. An author's contribution to a work is "pseudonymous" if that author is identified on the copies or phonorecords under a fictitious name. If the work is "anonymous" you may: (1) leave the line blank; or (2) state "anonymous" on the line; or (3) reveal the author's identity. If the work is "pseudonymous" you may: (1) leave the line blank; or (2) give the pseudonym and identify it as such (for example: "Huntley Haverstock, pseudonym"); or (3) reveal the author's name, making clear which is the real name and which is the pseudonym (for example: "Henry Leek, whose pseudonym is Priam Farrel"). However, the citizenship or domicile of the author **must** be given in all cases.

**Dates of Birth and Death:** If the author is dead, the statute requires that the year of death be included in the application unless the work is anonymous or pseudonymous. The author's birth date is optional but is useful as a form of identification. Leave this space blank if the author's contribution was a "work made for hire."

**Author's Nationality or Domicile:** Give the country of which the author is a citizen or the country in which the author is domiciled. Nationality or domicile **must** be given in all cases.

**Nature of Authorship:** Categories of pictorial, graphic, and sculptural authorship are listed below. Check the box(es) that best describe(s) each author's contribution to the work.

**3-Dimensional sculptures:** fine art sculptures, toys, dolls, scale models, and sculptural designs applied to useful articles.

**2-Dimensional artwork:** watercolor and oil paintings; pen and ink drawings; logo illustrations; greeting cards; collages; stencils; patterns; computer graphics; graphics appearing in screen displays; artwork appearing on posters, calendars, games, commercial prints and labels, and packaging, as well as 2-dimensional artwork applied to useful articles.

**Reproductions of works of art:** reproductions of preexisting artwork made by, for example, lithography, photoengraving, or etching.

**Maps:** cartographic representations of an area such as state and county maps, atlases, marine charts, relief maps, and globes.

**Photographs:** pictorial photographic prints and slides and holograms.

**Jewelry designs:** 3-dimensional designs applied to rings, pendants, earrings, necklaces, and the like.

**Designs on sheetlike materials:** designs reproduced on textiles, lace, and other fabrics; wallpaper; carpeting; floor tile; wrapping paper; and clothing.

**Technical drawings:** diagrams illustrating scientific or technical information in linear form such as architectural blueprints or mechanical drawings.

**Text:** textual material that accompanies pictorial, graphic, or sculptural works such as comic strips, greeting cards, games rules, commercial prints or labels, and maps.

**Architectural works:** designs of buildings, including the overall form as well as the arrangement and composition of spaces and elements of the design. NOTE: Any registration for the underlying architectural plans must be applied for on a separate Form VA, checking the box "Technical drawing."

# 3 SPACE 3: Creation and Publication

**General Instructions:** Do not confuse "creation" with "publication." Every application for copyright registration must state "the year in which creation of the work was completed." Give the date and nation of first publication only if the work has been published.

**Creation:** Under the statute, a work is "created" when it is fixed in a copy or phonorecord for the first time. Where a work has been prepared over a period of time, the part of the work existing in fixed form on a particular date constitutes the created work on that date. The date you give here should be the year in which the author completed the particular version for which registration is now being sought, even if other versions exist or if further changes or additions are planned.

**Publication:** The statute defines "publication" as "the distribution of copies or phonorecords of a work to the public by sale or other transfer of ownership, or by rental, lease, or lending"; a work is also "published" if there has been an "offering to distribute copies or phonorecords to a group of persons for purposes of further distribution, public performance, or public display." Give the full date (month, day, year) when, and the country where, publication first occurred. If first publication took place simultaneously in the United States and other countries, it is sufficient to state "U.S.A."

# 4 SPACE 4: Claimant(s)

**Name(s) and Address(es) of Copyright Claimant(s):** Give the name(s) and address(es) of the copyright claimant(s) in this work even if the claimant is the same as the author. Copyright in a work belongs initially to the author of the work (including, in the case of a work made for hire, the employer or other person for whom the work was prepared). The copyright claimant is either the author of the work or a person or organization to whom the copyright initially belonging to the author has been transferred.

**Transfer:** The statute provides that, if the copyright claimant is not the author, the application for registration must contain "a brief statement of how the claimant obtained ownership of the copyright." If any copyright claimant named in space 4 is not an author named in space 2, give a brief statement explaining how the claimant(s) obtained ownership of the copyright. Examples: "By written contract"; "Transfer of all rights by author"; "Assignment"; "By will." Do not attach transfer documents or other attachments or riders.

# 5 SPACE 5: Previous Registration

**General Instructions:** The questions in space 5 are intended to find out whether an earlier registration has been made for this work and, if so, whether there is any basis for a new registration. As a rule, only one basic copyright registration can be made for the same version of a particular work.

**Same Version:** If this version is substantially the same as the work covered by a previous registration, a second registration is not generally possible unless: (1) the work has been registered in unpublished form and a second registration is now being sought to cover this first published edition; or (2) someone other than the author is identified as a copyright claimant in the earlier registration, and the author is now seeking registration in his or her own name. If either of these two exceptions apply, check the appropriate box and give the earlier registration number and date. Otherwise, do not submit Form VA; instead, write the Copyright Office for information about supplementary registration or recordation of transfers of copyright ownership.

**Changed Version:** If the work has been changed and you are now seeking registration to cover the additions or revisions, check the last box in space 5, give the earlier registration number and date, and complete both parts of space 6 in accordance with the instruction below.

**Previous Registration Number and Date:** If more than one previous registration has been made for the work, give the number and date of the latest registration.

# 6 SPACE 6: Derivative Work or Compilation

**General Instructions:** Complete space 6 if this work is a "changed version," "compilation," or "derivative work," and if it incorporates one or more earlier works that have already been published or registered for copyright, or that have fallen into the public domain. A "compilation" is defined as "a work formed by the collection and assembling of preexisting materials or of data that are selected, coordinated, or arranged in such a way that the resulting work as a whole constitutes an original work of authorship." A "derivative work" is "a work based on one or more preexisting works." Examples of derivative works include reproductions of works of art, sculptures based on drawings, lithographs based on paintings, maps based on previously published sources, or "any other form in which a work may be recast, transformed, or adapted." Derivative works also include works "consisting of editorial revisions, annotations, or other modifications" if these changes, as a whole, represent an original work of authorship.

**Preexisting Material (space 6a):** Complete this space and space 6b for derivative works. In this space identify the preexisting work that has been recast, transformed, or adapted. Examples of preexisting material might be "Grunewald Altarpiece" or "19th century quilt design." Do not complete this space for compilations.

**Material Added to This Work (space 6b):** Give a brief, general statement of the **additional** new material covered by the copyright claim for which registration is sought. In the case of a derivative work, identify this new material. Examples: "Adaptation of design and additional artistic work"; "Reproduction of painting by photolithography"; "Additional cartographic material"; "Compilation of photographs." If the work is a compilation, give a brief, general statement describing both the material that has been compiled **and** the compilation itself. Example: "Compilation of 19th century political cartoons."

# 7,8,9 SPACE 7,8,9: Fee, Correspondence, Certification, Return Address

**Fee:** The Copyright Office has the authority to adjust fees at 5-year intervals, based on changes in the Consumer Price Index. The next adjustment is due in 1996. Please contact the Copyright Office after July 1995 to determine the actual fee schedule.

**Deposit Account:** If you maintain a Deposit Account in the Copyright Office, identify it in space 7. Otherwise leave the space blank and send the fee of $20 with your application and deposit.

**Correspondence (space 7):** This space should contain the name, address, area code, and telephone number of the person to be consulted if correspondence about this application becomes necessary.

**Certification (space 8):** The application cannot be accepted unless it bears the date and the **handwritten signature** of the author or other copyright claimant, or of the owner of exclusive right(s), or of the duly authorized agent of the author, claimant, or owner of exclusive right(s).

**Address for Return of Certificate (space 9):** The address box must be completed legibly since the certificate will be returned in a window envelope.

# FORM VA
**For a Work of the Visual Arts**
UNITED STATES COPYRIGHT OFFICE

REGISTRATION NUMBER

_____

VA        VAU

EFFECTIVE DATE OF REGISTRATION

Month      Day      Year

**DO NOT WRITE ABOVE THIS LINE. IF YOU NEED MORE SPACE, USE A SEPARATE CONTINUATION SHEET.**

## 1

**TITLE OF THIS WORK ▼**

**NATURE OF THIS WORK ▼** See instructions

**PREVIOUS OR ALTERNATIVE TITLES ▼**

**PUBLICATION AS A CONTRIBUTION** If this work was published as a contribution to a periodical, serial, or collection, give information about the collective work in which the contribution appeared.     **Title of Collective Work ▼**

If published in a periodical or serial give:   **Volume ▼**     **Number ▼**     **Issue Date ▼**     **On Pages ▼**

## 2

### a

**NAME OF AUTHOR ▼**

**DATES OF BIRTH AND DEATH**
Year Born ▼      Year Died ▼

Was this contribution to the work a "work made for hire"?
☐ Yes
☐ No

**AUTHOR'S NATIONALITY OR DOMICILE**
Name of Country
OR { Citizen of ▶ _____
Domiciled in ▶ _____

**WAS THIS AUTHOR'S CONTRIBUTION TO THE WORK**
Anonymous?  ☐ Yes  ☐ No
Pseudonymous?  ☐ Yes  ☐ No

If the answer to either of these questions is "Yes," see detailed instructions.

**NATURE OF AUTHORSHIP**  Check appropriate box(es). **See instructions**
☐ 3-Dimensional sculpture    ☐ Map    ☐ Technical drawing
☐ 2-Dimensional artwork    ☐ Photograph    ☐ Text
☐ Reproduction of work of art    ☐ Jewelry design    ☐ Architectural work
☐ Design on sheetlike material

### NOTE

Under the law, the "author" of a "work made for hire" is generally the employer, not the employee (see instructions). For any part of this work that was "made for hire" check "Yes" in the space provided, give the employer (or other person for whom the work was prepared) as "Author" of that part, and leave the space for dates of birth and death blank.

### b

**NAME OF AUTHOR ▼**

**DATES OF BIRTH AND DEATH**
Year Born ▼      Year Died ▼

Was this contribution to the work a "work made for hire"?
☐ Yes
☐ No

**AUTHOR'S NATIONALITY OR DOMICILE**
Name of Country
OR { Citizen of ▶ _____
Domiciled in ▶ _____

**WAS THIS AUTHOR'S CONTRIBUTION TO THE WORK**
Anonymous?  ☐ Yes  ☐ No
Pseudonymous?  ☐ Yes  ☐ No

If the answer to either of these questions is "Yes," see detailed instructions.

**NATURE OF AUTHORSHIP**  Check appropriate box(es). **See instructions**
☐ 3-Dimensional sculpture    ☐ Map    ☐ Technical drawing
☐ 2-Dimensional artwork    ☐ Photograph    ☐ Text
☐ Reproduction of work of art    ☐ Jewelry design    ☐ Architectural work
☐ Design on sheetlike material

## 3

### a

**YEAR IN WHICH CREATION OF THIS WORK WAS COMPLETED**  This information must be given in all cases.
◀ Year

### b

**DATE AND NATION OF FIRST PUBLICATION OF THIS PARTICULAR WORK**
Complete this information ONLY if this work has been published.
Month ▶ _____ Day ▶ _____ Year ▶ _____
◀ Nation

## 4

See instructions before completing this space.

**COPYRIGHT CLAIMANT(S)** Name and address must be given even if the claimant is the same as the author given in space 2. ▼

**TRANSFER** If the claimant(s) named here in space 4 is (are) different from the author(s) named in space 2, give a brief statement of how the claimant(s) obtained ownership of the copyright. ▼

DO NOT WRITE HERE
OFFICE USE ONLY

APPLICATION RECEIVED

ONE DEPOSIT RECEIVED

TWO DEPOSITS RECEIVED

FUNDS RECEIVED

**MORE ON BACK ▶**   • Complete all applicable spaces (numbers 5-9) on the reverse side of this page.
    • See detailed instructions.     • Sign the form at line 8.

DO NOT WRITE HERE

Page 1 of _____ pages

**DO NOT WRITE ABOVE THIS LINE. IF YOU NEED MORE SPACE, USE A SEPARATE CONTINUATION SHEET.**

**PREVIOUS REGISTRATION** Has registration for this work, or for an earlier version of this work, already been made in the Copyright Office?

☐ Yes  ☐ No  If your answer is "Yes," why is another registration being sought? (Check appropriate box) ▼

**a.** ☐ This is the first published edition of a work previously registered in unpublished form.

**b.** ☐ This is the first application submitted by this author as copyright claimant.

**c.** ☐ This is a changed version of the work, as shown by space 6 on this application.

If your answer is "Yes," give: **Previous Registration Number** ▼          **Year of Registration** ▼

**5**

**DERIVATIVE WORK OR COMPILATION**  Complete both space 6a and 6b for a derivative work; complete only 6b for a compilation.

**a. Preexisting Material**  Identify any preexisting work or works that this work is based on or incorporates. ▼

**b. Material Added to This Work**  Give a brief, general statement of the material that has been added to this work and in which copyright is claimed. ▼

**6**

See instructions
before completing
this space.

**DEPOSIT ACCOUNT**  If the registration fee is to be charged to a Deposit Account established in the Copyright Office, give name and number of Account.

**Name** ▼          **Account Number** ▼

**7**

**CORRESPONDENCE**  Give name and address to which correspondence about this application should be sent.    Name/Address/Apt/City/State/ZIP ▼

Area Code and Telephone Number ▶

Be sure to
give your
daytime phone
◀ number

**CERTIFICATION\***  I, the undersigned, hereby certify that I am the

check only one ▼

☐ author

☐ other copyright claimant

☐ owner of exclusive right(s)

☐ authorized agent of _____

          Name of author or other copyright claimant, or owner of exclusive right(s) ▲

**8**

of the work identified in this application and that the statements made
by me in this application are correct to the best of my knowledge.

**Typed or printed name and date** ▼ If this application gives a date of publication in space 3, do not sign and submit it before that date.

_____ **Date** ▶ _____

☞          **Handwritten signature (X)** ▼

\*17 U.S.C. § 506(e): Any person who knowingly makes a false representation of a material fact in the application for copyright registration provided for by section 409, or in any written statement filed in connection with the application, shall be fined not more than $2,500.

July 1993—300,000     ♻ PRINTED ON RECYCLED PAPER          ☆U.S. GOVERNMENT PRINTING OFFICE: 1993-342-582/80,021

# PROTECTING POSTMODERN ART

**STEVEN SHONACK**

*Steven Shonack received his A.B. degree in 1990 from the
University of California, Berkeley and his J.D. degree in
1994 from Loyola Law School, Los Angeles.*

T he Copyright Act of 1976 protects eight
types of expression, including photographs, paintings, sculpture, and conventional
forms of theater. Broadened protection was given to visual works, more specifically
"pictorial, graphic, and sculptural works," which the Copyright Act defines as includ-
ing "applied art, photographs, prints and reproductions" in either two or three
dimensions.

Although many forms of postmodern expression are protectable under this defini-
tion, artists may have difficulty obtaining copyrights for works that use appropriations.
Further, any postmodern artist who utilizes found objects or appropriates the work of
others without a use license need be concerned about the potential for copyright
infringement.[1]

## A LANDMARK INFRINGEMENT DECISION

In 1980, photographer Art Rogers snapped a portrait of a friend's litter of eight
German Shepherd puppies. The resulting photograph, *Puppies,* which included the
owners of the puppies seated on a bench, was published in a local newspaper and was
exhibited for a short time at the San Francisco Museum of Modern Art. Reproduc-
tion rights for *Puppies* were licensed to a company that produces notecards and
postcards. Rogers, though, reserved his right to use *Puppies,* which he exercised by
later including it in an anthology of canine photography.

Sometime in early 1988, sculptor Jeff Koons purchased at least one *Puppies* note-
card. The cards contained a notice of copyright in Rogers' name, but Koons removed
the notice and sent the notecards to an Italian studio. Koons commissioned the studio
to create a sculpture out of the photograph, with explicit instructions for the work to
copy the photo. Four sculptures were eventually created for Koons, and after making
corrections to conform them more closely to the photograph, Koons christened them
*String of Puppies.* The Sonnabend Gallery in New York, which has long been Koons'
agent, sold three of the sculptures to collectors for a combined $367,000.

---

1 This chapter was adapted by Mr. Shonack from an article he wrote called "Postmodern Piracy: How Copyright Law Constrains
Contemporary Art," 14 Loyola *L.A. Entertainment Law Journal* at 281 (1994).

Rogers learned of the existence of Koons' sculptures when he saw *String of Puppies* pictured in the *Los Angeles Times*. Rogers sued Koons for copyright infringement.

In 1990, an injunction was granted that prevented Koons from exploiting his own sculptures.[2] The Court of Appeals for the Second Circuit affirmed,[3] and the United States Supreme Court denied Koons' appeal.[4]

Arguably a descendant of the postmodern aesthetic developed by Marcel Duchamp, Koons finds the practice of appropriating other works to be artistically valid. Although Jeff Koons is a significant figure in the art world and his works are representative of a prominent form of artistic expression, under copyright law Koons is an infringer.

Sherrie Levine has built a career out of rephotographing famous photographs and redrawing Matisse drawings. She may also be exposed to liability for infringement for her entire oeuvre, since virtually every work she has created is a derivative work under the *Rogers* definition.[5] For owners of preexisting works, *Rogers* is a powerful piece of ammunition in protecting their rights. As long as his copyright endures, the arrangement of the subject matter of *Puppies* is the exclusive property of Art Rogers.

## EFFECTS OF INFRINGEMENT REMEDIES ON POSTMODERN ART

Once infringement has been established in a case involving postmodern art, the issue of damages can be especially crucial. The Copyright Act allows the copyright owner to elect to recover statutory damages, in lieu of the infringer's actual profits. In cases where a less commercially successful artist infringes, statutory damages permits a greater award than would probably be calculated from actual damages. Where infringement occurs by appropriation, statutory damages will be the likely method of recovery.

The Copyright Act also empowers courts to fashion equitable relief as necessary, up to and including the destruction of the infringing works. This type of relief has potentially serious effects on the postmodern artist, who, despite an infringement, has made a purposeful commentary about the appropriated work. In other words, the remedy can result in the destruction of this type of art. In *Rogers*, the district court ordered Koons to ship his copy of *String of Puppies* to Rogers.

Given the wide latitude available to the trial court in such cases, artists who infringe run the risk of losing their works as part of the judgment. It would have been within the discretion of the district court to have ordered Koons to destroy *String of Puppies.* Although exercise of these equitable powers is rare when works of art are at issue, the legal effect of the Copyright Act is to permit destruction of art to protect generalized economic interests. The chilling effect of such a remedy is considerable if artists are not willing to run the risk of losing their art. Thus, the impact of the *Rogers* line may be to severely restrict the growth of one of the most prominent

---

2 *Rogers v. Koons,* 751 F. Supp. 474, 475-76 (S.D.N.Y. 1990).
3 *Rogers v. Koons,* 960 F.2d 301 (2d Cir. 1992).
4 113 S. Ct. 365 (1992).
5 Artists such as Levine must still be concerned about copyrights for deceased artists, since copyrights are transferred, along with other property rights, according to laws of succession. Since works created before Matisse's death in 1954 can claim copyright protection for up to 75 years, there may still be a valid copyright on any Matisse work created after 1919.

artistic movements of the twentieth century.

Artists should consider the extent of their liability in terms of statutory damages; it is not sufficient to dismiss potential infringements because the resulting work is not commercially viable. This provision may seriously undercut the ability of artists to produce works for fear that it may have severe financial consequences.

## POSTMODERN ART AFTER ROGERS V. KOONS

The decisions in the *Rogers* line will adversely impact the practice of postmodern art. A solid precedent has now been established for future plaintiffs to bring infringement claims against artists who appropriate the copyrighted art of others.

For Jeff Koons in particular, the *Rogers* decisions may spell the end of his career as a practitioner of found art. In two separate cases, both relating to works Koons created for the same show that featured *String of Puppies,* Koons was found to have infringed underlying works. In *Campbell v. Koons,*[6] Koons once again commissioned a sculpture to be made from a photograph. In this instance, Koons purchased a notecard of Barbara Campbell's *Boys with Pig* and sent it to the same Italian studio that created *String of Puppies.* The district court, noting the overwhelming similarity to *Rogers,* held for Campbell as a matter of law: "This case needs little discussion, for it is substantially identical to *Rogers v. Koons*." The court rejected Koons' fair use defenses just as quickly: "The Second Circuit's decision in *Rogers v. Koons* also forecloses, as a matter of law, Koons' asserted affirmative defenses of Fair Use and Parody." Koons was ordered to send all copies of the infringing sculpture to Campbell, as well as any photographs or representations of his work.

In *United Feature Syndicate, Inc. v. Koons,*[7] Jeff Koons commissioned four sculptures entitled *Wild Boy and Puppy.* The puppy in each sculpture was a representation of "Odie," a character in the syndicated comic strip "Garfield." Koons freely admitted that he directly copied "Odie" into his sculptures. Unlike in *Campbell,* the district court did not find this case to be on all fours with *Rogers,* although the Second Circuit's opinion served as a helpful framework. Following a standard infringement analysis, summary judgment was granted for plaintiff United Feature Syndicate. *Rogers* was cited extensively by the court in its rejection of Koons' fair use and parody defenses. The court concluded by holding that "[i]n sum, drawing all reasonable inferences in defendant's favor, there is no evidence which would allow a reasonable fact finder to rule for the defendant on the issue of copyright liability in the instant case."[8]

More ominously, though, the *Rogers* decisions may have a chilling effect that extends well beyond the courtroom. Many contemporary artists regularly practice forms of appropriation and utilize found objects. It is now inadvisable for postmodern artists to create works while remaining oblivious to copyright laws. Art Rogers, in asserting his rights under the law to protect his financial interest in his expression, has broken down the barrier that separated the economic justifications of copyright from the aesthetic traditions of postmodern art.

6 1993 U.S. Dist. Lexis 3957 (S.D.N.Y. 1993).
7 817 F. Supp. 370 (S.D.N.Y. 1993).
8 Id at 385.

## CONCLUSION

The *Rogers* cases were the first to confront the tension that exists between contemporary art and copyright law. Under a traditional copyright analysis, it would be difficult to disagree with the verdict against Jeff Koons. Koons admittedly appropriated Art Rogers' copyrighted photograph and sold the resulting work for $375,000. By any infringement standard, Koons infringed on Rogers' copyright. Furthermore, the fair use defense does not apply because of Koons' commercial motivation and his artistic stance, which equates the aesthetic value of art with its financial value.

Unfortunately for postmodern artists, these decisions have created a dangerous precedent that may erode artistic freedom. While it is laudable that Jeff Koons will no longer reap the rewards of other artists' talent, many other artists may be forced to subjugate artistic inspiration to fear of infringement.

Thus, the *Rogers* cases present a serious obstacle to all practitioners of postmodernism. If given the opportunity, a court may be sympathetic to postmodern ideology and reinterpret copyright law to allow some leeway for use of found objects and other postmodern techniques. In *Rogers*, however, the Second Circuit refused to look past Jeff Koons' financial motives and his disregard for copyright law. In suing Jeff Koons, Art Rogers has successfully asserted his copyright, but the basis for that decision may severely impair the development of appropriationist art.

# REGISTRATION OF COPYRIGHTS IN TEXTILE DESIGNS

**LOUISE NEMSCHOFF**

*Louise Nemschoff, Esq. practices law in Beverly Hills,
with an emphasis on copyright, trademark, intellectual
property and entertainment law. She is a graduate of
Harvard College and Yale Law School.*

The recognition of copyrights in textile and fabric designs is a fairly recent development. It was only in 1954 that it became clear as the result of a Supreme Court decision,[1] that copyright protection was available for such designs. This may explain, at least in part, why relatively little has been written on the subject, why few cases have been decided dealing with such copyrights and why textile designers and needlework artists have been relatively slow in availing themselves of the protection of the copyright laws.

As with other types of works, some degree of originality is necessary for a textile design to be copyrightable.[2] Although the required level of originality can be minimal, it must go beyond an obvious and common arrangement of colors and shapes. For example, it is unlikely that the mere alternation of red and white stripes of equal width across a fabric would qualify for copyright protection. Copyright Office regulations incorporate this requirement by providing that a pictorial, graphic or sculptural work "must embody some creative authorship in its delineation or form" to be acceptable for registration.

Ordinarily, Form VA should be used to register textile design copyrights. The form itself is quite straightforward, but the nature of the required deposit may pose some problems for the registrant.

If the work is a limited edition piece of textile art, it may satisfy the requirements of the Copyright Office regulations permitting the deposit of identifying material (i.e., photographs) in lieu of actual copies of a pictorial or graphic work of art. For a published work to come under these provisions, the owner of the copyright must be an individual author and the work must be published in a limited edition of no more than three hundred numbered copies or there must be less than five copies of the work published.

Large works such as tapestries and rugs may come under provisions pertaining to oversize deposits. This regulation requires that identifying material be submitted in lieu of actual copies for any work that exceeds ninety-six inches in any dimension.

An actual swatch must be deposited for any work fixed or published only in the form of a two-dimensional reproduction on sheet-like material, such as fabric, textile or carpeting.

1 *Mazer v. Stein*, 347 U.S. 201 (1954).
2 *Feist Publications, Inc. v. Rural Telephone Service Co.*, 111 S. Ct. 1282 (1991).

This requirement also applies to wallpaper, floor tiles, wrapping paper and the like. Only one swatch must be deposited, since the archival needs of the Library of Congress do not require the deposit of a second copy. For this reason, such works are also exempted from the Copyright Act's provisions requiring a deposit within three months after publication of a work.

If, however, the fabric or design has been published only in the form of a "three-dimensional manufactured article," such as a piece of clothing or furniture, then identifying material must be deposited in lieu of a copy. The design of the clothing or article itself, as opposed to the fabric design, is generally not copyrightable.

Where the fabric, carpeting or the like contains a repeated design, the swatch deposited must include at least one complete depiction of the design and at least part of one repetition of the design. Copyright examiners do scrutinize these swatches before registration to determine whether or not a design is repetitive.

Since the United States joined in the international copyright treaty known as the Berne Convention, copyright notice is no longer required for copyright protection. However, it is still advisable to include the notice on works to give notice of the copyright and defeat the claims of innocent infringement in copyright enforcement litigation. Therefore, it is likewise advisable for materials deposited on registration to show the copyright notice affixed to the work, whether actual copies or identifying material is used for deposit. Where appropriate, the copyright notice may be applied as with any other pictorial, graphic or sculptural work. For works reproduced on fabrics, carpeting or other sheet-like material, Copyright Office regulations provide that the notice may be placed (a) on each reproduction of the design, (b) on the margin, selvage or reverse side of the material at frequent and regular intervals, or (c) if there is no selvage or reverse side (as with certain knitted or woven designs, for example), on tags or containers housing them in a manner that renders the notice visible while copies of the work pass through normal channels of commerce.

The regulations do not specify the frequency with which the notice should be repeated on rolls of fabric, carpeting, wallpaper and the like. Clearly, the notice need not appear once for each repetition of the design, at least where the design as a whole depends not only on the repetition of a smaller design unit (e.g., a flower), but also on how that unit is arranged or placed on the material. Beyond this, the adequacy of the notice may depend on a number of factors, including the size of the design, the size of the roller used to print the design and the size of the smallest commercial unit by which the product is sold. Moreover, the frequency with which the notice is repeated on the deposit copy of the work may set the standard or at least an outside limit for judging the adequacy of the notice on other published copies of the work.

The Visual Artists' Rights Act of 1990 applies to some, but not all works of textile art, providing its creators with the right to claim (or disclaim) authorship of the work and the right to prevent intentional mutilation, distortion or modification of the work. These "moral rights" are available to the creator of a painting, drawing, print or sculpture

(defined to include all two-dimensional and three-dimensional works of fine, graphic and applied art) existing in a single copy or in a signed and numbered limited edition of two hundred copies or less. However, works of "applied art" are specifically excluded from protection under the Act. Thus, the rights of attribution and integrity that are assured under the Act would not appear to be available for most textile designs.

The owners of rights to designs reflected in or on utilitarian articles such as fabric or carpeting are sometimes advised to protect their works under design patents. While such protection may be more extensive than the protection afforded under copyright law, it is also more difficult and costly to obtain.

It is clear that a single work may be eligible for either copyright or patent protection, but there is still some dispute as to whether or not a work is entitled to both forms of protection simultaneously. Copyright Office regulations provide that copyright registration will be denied once a design patent has issued, although registration will not be refused solely because a design patent application is pending. This provision applies to scientific or technical drawings as well as pictorial, graphic and sculptural works. While it is not clear that this regulation would withstand careful scrutiny by the courts, it does suggest the advisability of early copyright registration for fabric or carpet designs. It seems clear that copyright registration will not bar the subsequent issuance of a design patent for the same work.

# The Visual Artists' Rights Act

**KATHERINE M. THOMPSON**

*Katherine M. Thompson has her law practice in West Los Angeles, California and specializes in areas of art and copyright. She is a graduate of Pepperdine University, 1991.*

On December 1, 1990, President Bush signed H.R. Bill 5316, the Visual Artists' Rights Act (VARA). The VARA amends the Copyright Act of 1976 to provide for moral rights for visual artists.

It creates a uniform national standard that helps safeguard the rights of artists. Moral rights, or droit moral, have their origin in Europe; they were first enacted in France in the earlier part of this century. The foundation for these rights is the recognition of the artist's reputation and the cultural legacy he or she has created rather than the pecuniary interest in the work. The European droit moral is a bundle of rights that includes the right of disclosure, the right of paternity, the right of integrity, and the right of withdrawal.

> As Senator Kennedy, the major proponent of the Visual Artists' Rights Act, eloquently stated before the Senate:
>
> "In our country, as in every other country and civilization, artists are the recorders, and preservers of the national spirit. The creative arts are an expression of the character of the Nation–they mirror its accomplishments, warn of its failings, and anticipate its future."

The Berne Convention of 1886 provides artists with moral rights in their work. This international treaty requires all members to adhere to a minimum standard of moral rights for their artists. When the United States became a signatory, however, it sought to change the Copyright Act only where necessary to comply. The VARA amends the Copyright Act to provide a definition of art; to grant artists additional rights, such as the right of attribution and the right of integrity. Only the author or artist of the work of visual art as defined in the VARA is given these rights, regardless of whether or not he or she is the copyright owner. These rights are separate from the economic rights set forth in the Copyright Act and are analogous to the protections set forth in the Berne Convention.

## SUMMARY OF THE VARA

The VARA was passed in an effort to grant visual artists certain moral rights. These moral rights create an important link between artists and their work and signal the recognition of art and the need to preserve it. The VARA creates a uniform

national standard that provides predictability and certainty to artists, dealers, and collectors as to what their duties and rights are in relation to a work of visual art.

Under prior U.S. copyright laws, artists had authority to control the reproduction of their work only if they did not sell the original. This first sale doctrine prevented visual artists from controlling the secondary market for their work. With the passage of the VARA, artists now retain certain moral rights in their work that are not revoked at subsequent sale.

## Definition of Work of Visual Art

The VARA amends the Copyright Act to create a definition for a "work of visual art." According to Section 602, the definition includes:

♦ A painting, drawing, sculpture, print or still photographic image produced for exhibition purposes only, existing in single copy.

♦ A print in a limited edition of two hundred or fewer, all signed and consecutively numbered by the artist.

♦ A sculpture in a multiple cast, carved or fabricated sculptures of two hundred or fewer, all consecutively numbered by the artist and bearing his or her signature or identifying mark.

♦ A still photographic image produced for exhibition purposes only in a limited edition of two hundred or fewer, all signed and consecutively numbered by the artist.

Neither works made for hire nor uncopyrightable material, such as utilitarian items, come under the purview of the new definition of a work of visual art. Also excluded are items that are not considered unique and singular, such as those that generally exist in multiple copies and are collaborative in nature. These include any part or portion of any poster, map, globe, chart, technical drawing, diagram, model, applied art, motion picture or other audiovisual work, book, magazine, newspaper, periodical, data base, electronic publication or similar publication, or any merchandising item or advertising, promotional, descriptive, covering or packaging material or container.

The VARA's definition creates a fundamental legal distinction between what is a work of visual art and what is not that does not necessarily jibe with traditional definitions of art. A discussion of problems associated with art definitions imposed by various laws are to be found in the chapter, "Defining Art: A Legal Perspective."

## The Right of Attribution and the Right of Integrity

The "Right of Attribution" grants the artist of a work of visual art, as defined under the VARA, the right to claim or disclaim authorship of that work. The artist may disclaim authorship of any work either because he or she did not create it or because the work has been distorted, mutilated, or otherwise modified in such a manner that it would harm their honor or reputation.

The "Right of Integrity" guarantees to the artist that his or her artistic vision and intention will be preserved. The artist has the right to prevent the intentional destruction, mutilation or other modification of his or her work of visual art that would be harmful to their reputation or honor. Further, the artist has the right to prevent the

intentional or grossly negligent destruction of a work of recognized stature.

Only the artist of the visual work of art as defined by the VARA has the power to enforce the right of attribution and integrity, regardless of whether he or she is the copyright owner. The copyright owner, as such, has no moral rights.

Important exceptions to the right if integrity are provided in the VARA. Any damage or modification of a work of visual art due to the passage of time or due to the inherent nature of the materials used is not a violation of the artist's right of integrity. In addition, any damage or modification of a work of visual art due to the conservation and exhibition (including lighting or placement) is not a violation of the artist's moral rights unless it was a result of gross negligence.

A more complete discussion of art destruction issues are to be found in the chapter, "Art Destruction: An Overview."

## Duration of Rights

The rights of attribution and integrity shall endure for the life of the artist. In a joint work, the rights endure until the death of the last surviving author.

Works of visual art created before the effective date June 1, 1991, may be governed by the VARA or state statute. If the work was made before June 1, 1991, but the artist has not transferred title of the work before June 1, 1991, the work falls under the purview of the VARA and the moral rights last the life of the artist. If, however, the work was transferred before that date, the VARA will not grant the artist any moral rights to that particular work of visual art. The artist instead must look to the applicable state statute to receive protection. States with moral rights provisions include California, Connecticut, Georgia, Louisiana, Maine, Montana, Massachusetts, Nevada, New Jersey, New York, Pennsylvania, Rhode Island, and Utah.

## Transfer and Waiver

The rights of attribution and integrity may not be transferred by the artist; however, the artist may waive his or her rights. To make the waiver valid and effective, the artist must expressly agree to waive his or her moral rights in a writing signed by the artist. The writing must specifically identify the work and explain the uses of the work to which the waiver applies. The waiver will only apply to those identified works of visual art. In the case of joint artists, one artist may waive the rights of attribution and integrity for all of the artists who participated in the creation of the work of visual art.

## Remedies

The VARA expressly excludes the violation of moral rights from any criminal penalties. No new or amended civil remedy provision was enacted by the VARA. All the civil remedies available under the Copyright Act, such as injunctions, damages, and attorney fees are available for any artist whose moral rights are threatened or violated.

## CRITICISM OF THE VARA

This Act and other previous visual artists' rights bills have been criticized on the grounds that they may violate U.S. property rights, the First Amendment to the U.S. Constitution, and various civil liberties.

## Property Rights in Art

Art may be considered either a chattel or a unique object rather than a commodity. Although many people buy art for the aesthetic pleasure it brings them, art is increasingly considered a form of investment. The investment status of art makes it appear to have become somewhat of a property interest. According to critics of the VARA, the imposition of moral rights is a type of artist's lien on the work of visual art and dictates what one is allowed to do with their own property.

This is a false assumption. The VARA limits property rights no more than real estate, historic preservation and zoning regulations have done in the past. Furthermore, fewer owners of art will wish to alter their works of visual art than will owners of real property. The artist's right of integrity, in essence, also protects each subsequent owner of the work, by assuring that the art remains true to its original state and accurately portrays the intention of the artist.

## First Amendment

The First Amendment serves to protect freedom of expression. It serves the public by maintaining an open marketplace of ideas. In this regard, it protects the artist's right to express himself or herself through their artwork as well. The VARA's moral rights provisions aim to prevent this artistic expression from being damaged or destroyed.

Critics claim that the legislature has gone too far to protect the artist's freedom of expression and claim that the right of integrity granted by the VARA may actually impede the freedom of expression of others.

"There is a sensitive question here of making art into religious objects, into sacred objects that cannot be touched… one must recognize that the destruction of the statues of Lenin and Stalin are creative, important political acts."[1]

Furthermore, critics of the VARA compare the flag desecration statute to the right of integrity granted by the VARA. One is allowed to destroy or mutilate the American flag as a vehicle of expression, but the VARA prevents the same treatment for works of visual art.

There is no doubt that these are important political acts but a work of visual art is part of our cultural legacy and is irreplaceable. It is this rationale that separates the destruction of the flag from the destruction of art, not that one is more respected or sacred than the other.

The VARA is not the first such curtailment of the First Amendment. The Copyright Act provides that no one may make a copy or prepare a derivative work by changing the original without first obtaining the express permission of the copyright owner. The right of integrity gives the artist similar power. Artwork and other intellectual endeavors have previously been recognized worthy of protection and special consideration by the copyright clause; the VARA simply extends this special consideration to the artist as well. A long held principle of defamation and privacy is that freedom of expression does not give one the right to distort, alter or fabricate another's expression. This would defame the artist and subject him or her to indignity, since he or she maintains reputation through public opinion of his or her work.

1 "New Law Gives Rights to Artists After Work is Sold," *Washington Times*, Nov. 28, 1990, Part E, at 1 (quoting Mr. Monroe Price, advocate for the arts).

### Civil Liberties

Finally, the question of an individual's civil liberties has been brought to the forefront by the VARA grant of the right of integrity. It is said that the right of integrity forces people to preserve art they may find offensive or immoral, prohibiting "the owners from destroying [art]... who, either by gift or inheritance, find themselves in possession of art of recognized stature that they consider offensive or immoral (e.g., pornographic or sacrilegious art)."[2] If this is the case, the unwilling owner has many alternatives short of destruction. They can sell or donate the art. If they do not wish to part with it but do not want to see it, rather than altering it they can simply store it out of sight and sensibilities. The VARA's grant of the right of integrity cannot compel an owner of art to display it, view it or even like it.

## PREEMPTION OF THE VARA OVER STATE STATUTES

The VARA preempts all state moral rights statutes that are not as far reaching as the federal act. However, some causes of action, such as misattribution of a reproduction of an artwork, which are unavailable under the federal scheme but available under state laws are not preempted. When language is absent from an existing statute, judges will deal with preemption on a case by case basis and the principal of stare decisis (legal precedence) will play an important role.

The VARA explicitly enumerates the circumstances in which state law and common law will not be preempted: "Any cause of action from undertakings commenced before the effective date...; activities violating legal or equitable rights that are not equivalent to any of the rights conferred by s. 106A with respect to works of visual art; or activities violating legal or equitable rights which extend beyond the life of the author."[3] Furthermore, state laws that provide greater protections of rights than the VARA will not be preempted; for example, the California Art Preservation Act that extends artists' protection fifty years after their death would not be preempted.[4] The House Report states that state causes of action regarding works not covered by the VARA, for example, the Connecticut statute that protects photographs not taken for exhibition purposes only, are not preempted. However, since the VARA is unclear on this point, it is questionable whether courts will follow this same preemption scheme.[5]

## RESALE ROYALTY RIGHT

The resale royalty right, or droit de suite, has been a part of European moral rights for many years: France (1920), Belgium (1921), Czechoslovakia (1926), Poland (1935), Tunisia (1937), Sweden (1937), Uruguay (1937), Italy (41), Yugoslavia (1957), West Germany (1965), Morocco (1970), Luxembourg (1972).[6] The resale royalty allows

2 "Artistic License Takes on a New Meaning," *Legal Times,* Dec. 17, 1990, at 23.
3 The Visual Artists' Rights Act s. 605 2(A), (B), (C).
4 Similar such provisions exist for Connecticut (50 years after death), Massachusetts (50 years after death), Pennsylvania (50 years after death), Georgia (50 years after death). See GA. CODE ANN. s. 8–5–7(b) (1989); CONN. GEN. STAT. s. 42–116t(d) (Supp. 1990); MASS. GEN. L. ch. 231, s. 85S(g) (Supp. 1990); PA. STAT. ANN. tit. 73, ss. 2107(1) (Supp. 1990).
5 Most states have broader definitions of work of visual art than does the VARA. The New York definition includes "any visual or graphic art of any medium." N.Y. ARTS & CULT. AFF. s. 14.01(1) (McKinney 1984).
6 ROWE, K., Visual Artists and the First Amendment Moral Rights and Resale Royalties, PRACTICING LAW INSTITUTE, 297 PLI/Pat 499, July 12, 1990.

artists to receive a royalty payment each time their work is resold at an appreciated value. Therefore, artists can profit from the increased value of their work.

For example, France and Germany provide for a 3% royalty on the resale of a work even if there has been no increase in price. In Italy, the royalty right applies only if there has been a price increase in the work.[7] The French rationale to grant artists a resale royalty right is that the increase in the value of the art is due to the continuing effort of the artist to improve their artistic talent and reputation. The German rationale, on the other hand, centers on the theory that the true value of the work is always inherent in it. At first sale, the public did not fully appreciate the work either due to lack of understanding or lagging taste. Later, the public catches up in appreciation to the true value of the work.[8]

The VARA directs the Register of Copyrights along with the Chair of the National Endowment for the Arts to conduct a study on the feasibility of granting a federal resale royalty right to be submitted no later than eighteen months after the enactment of the VARA. The study will be "conducted in consultation with other appropriate departments and agencies of the United States, foreign governments, and groups involved in the creation, exhibition, dissemination, and preservation of works of art, including artists, art dealers, collectors of fine art, and curators of art museums." Unfortunately, since 1976, when California enacted the first (and only) resale royalty provision,[9] an imbroglio has surrounded the resale royalty right issue; supporters are as fervent as those who oppose it. The result is stalled federal legislation.

Proponents of a resale royalty provision argue that visual artists should be put on equal status with writers, dramatists, and composers who do receive royalties. Visual art often has a latent value that increases over time and the artist who continues to produce new work adds to that latent value. Artists, therefore, should be entitled to share in the increased value of the work they created. Furthermore, artists rarely have the requisite bargaining power to sell their first works for any substantial sum and more frequently sell their work cheaply in an effort to obtain exposure.

On the other hand, opponents argue that the resale royalty notion is elitist and that the unknown artist will suffer. They also fear that dealers and collectors will not want to do business with artists. When a resale royalty provision was proposed for the VARA, forty artists including Willem de Kooning, Sam Francis, Robert Motherwell, Frank Stella, and Roy Lichtenstein opposed it claiming it would make it more difficult for unknown artists to attract collectors.[10]

Opponents claim that artists who currently sell their work cheaply will receive even less at first sale under the assumption that they will get a royalty later. They claim the resale royalty will create a decline in the art market because people will buy in a market where the royalty does not apply. France suffered such a decline when the resale royalty right was implemented there.

In California, where the law has been in effect since 1976, no link has been established between the decline of art sales and the enactment of the right, with one exception. When the Resale Royalty Act was passed, Sotheby's auction house pulled out of the state.[11]

7 LELAND, C., Copyright for the Representation of Artists, Collectors, and Dealers, PRACTICING LAW INSTITUTE, 297 PLI/Pat 263, July 12, 1990.
8 Goetzl, "In Support of the Resale Royalty," 7 *Cardozo Arts & Ent. L.J.* 249, 256 n.190 (1989).
9 CAL. CIV. CODE s. 986 (West Supp. 1991). Under the California provision, the artist is entitled to 5% of the resale price and this right only applies if the resale price is higher than the purchase price. Id.
10 Comment, "Moral Rights: The Long and Winding Road Toward Recognition," 14 *Nova L.R.* 435, 436 (1990).
11 Duboff, "Introduction to Artists Rights Symposium," 7 *Cardozo Arts & Ent. L.J.* 227, 228 (1989).

Most importantly, opponents maintain that the administration of such a law is unworkable, inviting noncompliance, evasion and fraud.

Due to artists' weak bargaining power, private contracts providing for resale royalties are usually not adequate even when they are created.

Despite these valid concerns, the potential benefits of a federal resale royalty right are great. Not only will a nationwide resale royalty right provide a pecuniary interest for artists that extends beyond the first sale, but it will elevate the status of the artist. A direct link between the artist's past work and current endeavors will be established. When the artist's work increases in value due to his or her perseverance, they will be allowed to share in that increase. In addition, a nationwide resale royalty right will have less of a negative effect on the art market as will varying state statutes. It will be easier for collectors to avoid purchasing art in certain states rather than avoiding the whole U.S. art market. In conclusion, the resale royalty right may not benefit each artist equally, but it will certainly benefit artists as a group.

# DEFINING ART: A LEGAL PERSPECTIVE

**PETER H. KARLEN**

*Peter H. Karlen practices art, publishing, and intellectual property law (including copyright, trademark, and moral rights law) in La Jolla, California.*

**M**any artists, dealers, and collectors don't fully realize the implications of legally categorizing and defining art. For instance, an artist can create a work without considering whether that kind of work is protected under copyright, customs, moral rights, and resale royalties laws. Not every work is protected under the various laws benefiting the arts.

As an example, an artist created a mosaic that was installed in a building. When the building owner threatened to tear down the building, mosaic and all, the artist had to rely on an art preservation statute that protected only *paintings, drawings, sculptures,* and *works of art in glass.* Unfortunately for the artist, the mosaic was not created with tiles of *glass* but rather with ceramic tiles, and though the artist had created a pictorial work by arranging the colored tiles, the individual tiles were not hand-*painted.* Perhaps from a distance, the work might have even looked like a painting. But it wasn't considered one, and the artist could do nothing to prevent its destruction.

The purpose of this chapter is to demonstrate the importance of understanding and devising legal definitions of art; illustrate the problems involved in legal definitions; and set forth some of the most important legal definitions.

## PROBLEMS IN LEGAL DEFINITIONS

Art-related legal definitions are important for artists because they establish the boundaries for protecting the artist's works and reputation. For example, when legally protected fine art is defined only in terms of paintings, drawings, and sculptures, the artist creating a weaving, mosaic, or collage, may be without protection.

One concern for artists is that the legal definition for any art-related term can be different depending on which state's law is being used. For instance, there are at least ten states that have moral rights statutes that protect artists' crediting rights, reputations, and works. To be protected, however, a work must qualify as fine art, and many of the statutes have their own unique definition of fine art.

Moreover, traveling from one area of law to another may yield different definitions for the same term. In one area of law that favors artists' rights, the definition of an art-related work such as a painting is given broader scope than in another area of law that pays little attention to artists. Painting is more likely to be broadly defined under a

moral rights statute than under a customs law that allows customs duties exemptions for the importation of paintings.

Moreover, legal definitions under the same statute can change over time. Under the customs laws, it was not until the 1920s that nonrepresentational art was clearly considered fine art.

Even when artists and attorneys think they know how to legally categorize a work, they are surprised by court decisions. In a California moral rights case, the trial judge ruled that a mural was *not* a painting under the California Art Preservation Act, meaning that the mural could be destroyed with impunity.[1] Of course, a mural is a painting on a wall, by definition, and the judge was overruled on appeal. In another case under the California Art Preservation Act, the first moral rights statute in the U.S., a court ruled that architectural drawings were not drawings within the meaning of the statute.[2] Clearly, such drawings were drawings by definition, but the court reached a good decision in not giving legal protection to a kind of creation probably not contemplated by the legislature in enacting the law.

A further concern is that legal definitions for art often clash with art world definitions. For instance, many artists doing large public projects in urban areas, particularly projects that have architectural components, may believe they are creating sculptures because they perceive the works as such and because these works are often reviewed in sculpture publications. But the law may categorize them as architectural or landscape works.

With all these problems in mind, let's look at some of the most important legal definitions in the visual arts, which every artist should be familiar with. We start with the broadest and most important definitions first.

## PICTORIAL, GRAPHIC AND SCULPTURAL WORKS

Perhaps the broadest definition comes under copyright law. It is "pictorial, graphic, and sculptural works" that are subject to copyright protection. Section 101 of the Copyright Act reads, in part, as follows:

*Pictorial, graphic, and sculptural works include two-dimensional and three-dimensional works of fine, graphic, and applied art, photographs, prints and art reproductions, maps, globes, charts, diagrams, models, and technical drawings, including architectural plans. Such works shall include works of artistic craftsmanship insofar as their form but not their mechanical or utilitarian aspects are concerned; the design of a useful article, as defined in this section, shall be considered a pictorial, graphic, or sculptural work only if, and only to the extent that, such design incorporates pictorial, graphic, or sculptural features that can be identified separately from, and are capable of existing independently of, the utilitarian aspects of the article.*

The listing of works in the definition is not exhaustive, and there are more works within each category of pictorial, graphic, and sculptural.

Pictorial works include works such as paintings, photographs, prints, art reproductions, and maps. Graphic works include drawings, charts, and diagrams. And sculptural works include sculptures, three-dimensional models, wall reliefs, and jewelry.

1 *Botello v. Shell Oil Company*, 229 Cal. App. 3d 1139 (1991).
2 *Robert H. Jacobs, Inc. v. Westoaks Realtors, Inc*, 159 Cal App. 3d 637 (1984).

As made clear by statute, works of artistic craftsmanship will qualify insofar as their form but not their mechanical or utilitarian aspects are concerned. Designs of useful articles also qualify, but only if and only to the extent that the design incorporates pictorial, graphic, or sculptural features that are separately identifiable or exist independently of the utilitarian aspects of the article. For instance, the leg of a chair, especially a modern chair, no matter how aesthetically done, is usually not copyrightable. But if you carve cherubs on that chair leg, you have created a copyrightable work. Similarly, a lamp base in the shape of a mermaid will be protected, but the usual abstract lamp base, no matter how nicely done, will not. Such designs, not covered by copyright law, can sometimes be protected under the law of design patents.

The good aspect of this broad definition is that it includes almost every kind of work in the visual arts that one can imagine, but only works fixed in a tangible medium of expression. The definition does not include conceptual works. As an example, a visual artist created a conceptual work consisting of sand and soil that the artist collected throughout the country at different sites and separately packed and labeled in various containers. Though the work was an impressive piece, it would be difficult to claim any copyright protection for it. Certainly it was not a pictorial or graphic work, and the artist never attempted to protect the shapes of the containers as a sculptural work.

## WORK OF VISUAL ART

The next most important definition is for work of visual art under the Visual Artists' Rights Act of 1990 (VARA). Section 101 of the Copyright Act in defining this term reads as follows:

*A "work of visual art" is—*

*(1) a painting, drawing, print, or sculpture, existing in a single copy, in a limited edition of two hundred copies or fewer that are signed and consecutively numbered by the author, or, in the case of a sculpture, in multiple case, carved, or fabricated sculptures of two hundred or fewer that are consecutively numbered by the author and bear the signature or other identifying mark of the author; or*

*(2) a still photographic image produced for exhibition purposes only, existing in a single copy that is signed by the author, or in a limited edition of two hundred copies or fewer that are signed and consecutively numbered by the author.*

Unlike the copyright act definition of pictorial, graphic, and sculptural works, which is a very broad definition allowing for inclusion of traditional, nontraditional, and multimedia works, the VARA definition of work of visual art is relatively restricted. It is confined to the most prominent traditional art forms, paintings, drawings, sculptures, prints, and photographs, and qualifying limited editions thereof.

Specifically excluded are:

*Any poster, map, globe, chart, technical drawing, diagram, model, applied art, motion picture or other audiovisual work, book, magazine, newspaper, periodical, data base, electronic information service, electronic publication, or similar publication.*

Also excluded are merchandising items or advertising, promotional, descriptive, covering, or packaging material or container; a work made for hire; and any work not subject to copyright protection.

You can see from the exclusions that Congress intended to let the public know

that this definition would be restricted. Exclusions of items such as globes, charts, motion pictures, magazines, newspapers, databases, electronic information services, etc., were to placate user groups who were concerned that moral rights would extend to these kinds of items. But these exclusions were somewhat overkill since items like databases, electronic information services, and books are clearly not paintings, drawings, prints, sculptures, or photographs. Or can they be?

There is a plan afoot to make artworks available on screen-like devices in people's homes, so perhaps certain electronic information services or electronic publications could be subject to claims that they are presenting paintings or drawings. With the advent of CD–ROM and multimedia technologies, the realism brought to the electronic depiction of art may force a change in legal definitions.

## WORK OF FINE ART

The California Art Preservation Act, the grandfather of all moral rights statutes in the U.S., defines protected fine art in terms of "an original painting, sculpture, or drawing, or an original work of art in glass of recognized quality, but shall not include work prepared under contract for commercial use by its purchaser." Prints, photographs, and limited editions are not protected, unlike under the VARA.

Massachusetts, Pennsylvania, New Mexico, and Connecticut adopted moral rights statutes modeled after the California law. However, their definitions of fine art were much broader. The Massachusetts statute, which followed shortly after enactment of the California law, defines fine art as:

*Any original work of visual or graphic art of any media which shall include, but is not limited to, any painting, print, drawing, sculpture, craft object, photograph, audio or video tape, film, hologram, or any combination thereof of recognized quality.*

The second moral rights statute enacted in the U.S., the New York statute, also protects fine art. Under the New York statute, fine art means:

*A painting, sculpture, drawing, or work of art, and print, but not multiples.*

The New York statute was followed by other moral rights statutes in New Jersey, Louisiana, Maine, Rhode Island, Nevada, but their definitions of fine art were different. For example, the Louisiana statute defines a work of fine art as:

*Any original work of visual or graphic art of recognized quality in any medium which includes, but is not limited to, painting, drawing, print, photographic print, or sculpture of limited edition of no more than three hundred copies; however "work of fine art" shall not include sequential imagery such as motion pictures.*

Not only do artists have to worry about having their fine art protected in one state but unprotected in another; they must also note that statutory definitions of fine art can be different under the various statutes of their own state.

The California moral rights statute defines fine art in relation to paintings, sculptures, drawings, and works of art in glass of recognized quality and not created for commercial use, but the California Artist–Dealer Relations Act, which protects artists who consign their works to art dealers, defines fine art in relation to:

*A painting, sculpture, drawing, work of graphic art (including an etching, lithograph, offset print, silkscreen, or a work of graphic art of like nature), a work of calligraphy, or a work of mixed media (including a collage, assemblage, or any combination of the foregoing art media).*

The California resale royalties legislation, unique to California, even has a different definition than the California moral rights definition. Under the resale royalty statute, fine art is also confined to paintings, sculptures, drawings, or original works of art in glass, but there is no further requirement that the work be of recognized quality or that the work not have been created for commercial use. The California Revenue and Taxation Code, which grants a tax exemption for artworks displayed in an art gallery or museum, mentions, the "free fine arts" in terms of various media including:

> *Applied paper and other materials, manufactured or otherwise, such as are used on collages, artists' proof etchings unbound, and engravings and wood cuts unbound, lithographs, or prints made by other hand transfer processes unbound, original sculptures or statuary.*

## WORK OF ART

Artist–dealer relations statutes that govern consignments will often use the term "work of art"; so do statutes that govern the conveyance of physical art objects.

As an example, the New Hampshire statute governing consignments says that a work of art includes any of the following:

> *(a) a visual rendition including, but not limited to, a painting, sculpture, mosaic, or photograph;*
>
> *(b) a work of calligraphy;*
>
> *(c) a work of graphic art, including, but not limited to, an etching, lithograph, offset print, silkscreen, or other work of similar materials;*
>
> *(d) a craft work in materials including, but not limited to, clay, textile, fiber, wood, metal, plastic, glass, or similar materials;*
>
> *(e) a work in mixed media, including, but not limited to, a collage or a work consisting of any combination of items listed in subparagraphs (a) through (d) of this paragraph.*

As is usually the case, definitions for the same term under the same kinds of statutes will be different. So an artist's work placed on consignment in a gallery in one state will be protected against loss, damage or theft by a ruthless dealer, while a similar work placed on consignment in another state will be in peril.

## PAINTING

We must now consider that even definitions of the component works, that make up the broader definitions for "work of visual art," "work of fine art," and "work of art," are subject to change.

As mentioned above, in *Botello v. Shell Oil Company*, the trial court ruled that a mural is not a painting, a silly result because a mural is by definition a painting on a wall. The judgment had to be appealed before common sense prevailed. A mural is a kind of painting in the same way that a painting is a particular kind of pictorial work. Clearly, not every pictorial work is a painting, and not every painting is a mural.

The question always confronting the courts deciding what a painting is usually concerns not the painting materials themselves but the surface upon which the paint or other coloring agent is applied.

For instance, in *United States v. Perry,*[3] the U.S. Supreme Court held that stained glass windows containing effigies of saints and other representations of biblical entities were not paintings exempt from customs duties.

However, in *Tiffany v. United States,*[4] the court held that silk and bone fans on which artists had executed watercolor paintings would be customs-exempt paintings and not merely silk manufactures.

In *Petry Co. v. United States,*[5] the court said that mosaic pictures should be classified as manufactured of marble and were not customs-free paintings. What would happen if the mosaic tiles were hand-painted rather than mechanically precolored?

Perhaps a good definition of painting is: "A work of art created by applying colors in a viscous medium to a relatively flat surface."

But even such a definition would fail because many contemporary paintings are not done on flat surfaces, though one would not want to call every painted sculpture a painting.

## DRAWING

A drawing is a particular kind of graphic work and perhaps even pictorial work, depending on the kind of drawing. Arguably, a highly detailed representational drawing might be considered a pictorial work, whereas technical drawings might be considered graphic works.

In the case of *Robert H. Jacobs, Inc., v. Westoaks Realtors, Inc.,* cited previously, a California Appeals Court said that for purposes of moral rights protection, architectural drawings were not "drawings." One would expect a similar ruling under any statutory scheme where the purpose was to protect fine art and not utilitarian drawings.

A different result was reached in *Vonnegut and Bohn v. United States,*[6] in which an architect's drawings were held a work of art for customs purposes.

The most common problem in defining drawing in relation to an art statute is differentiating utilitarian drawings from artistic ones.

## SCULPTURE

The individual art term most likely to create problems is sculpture.

A sculpture is a particular kind of sculptural work. It is created by construction, molding, carving, or other shaping. What differentiates sculpture from other sculptural works is its artistic content and its usual lack of utility.

Often, it is hard to draw the line between sculpture, and landscape and architectural works. The mountain being carved in South Dakota in the shape of Chief Crazy Horse may be considered a sculpture notwithstanding its enormous size. The same is true of Mount Rushmore. But an abstract outdoor work making use of trees, soil, and other natural land features, is more apt to be called a landscape work and not a sculpture. Also, a work having the shape of a gazebo, pergola, or pavilion or comprising

3 146 U.S. 71 (1892).
4 66 F. 736 (C.C.S.D.N.Y. 1895).
5 11 Ct Cust App. 525 (1923).
6 T.D. 25104, G.A. 5609 (1904), affirmed sub nom. *Young v. Bohn*, 141 F. 471 (C.C.D.Ind. 1905).

benches, walkways, stairs, fences, and other features designed for human use may be an architectural work rather than a sculpture.

For instance, in the recent case of *City of Carlsbad v. Blum,*[7] brought under the VARA and the California Art Preservation Act, the structure comprised, amongst other things, concrete walls, benches, walkways, steel bars, pools of water, soil, plants, and a pergola-like structure in the center. Carlsbad, who we represented, contended that the work was a landscape or architectural work. The artist argued that the work was a sculpture. Though this case was settled and no court ruling decided the issue, it is a harbinger of more to come.

The early customs cases also illustrate difficulties in defining sculpture.

In *Morris European and American Express Co. v. United States,*[8] the court was willing to accept that an artistically created church altar could qualify for a customs exemption.

However, in *United States v. Olivotti & Co.,*[9] a marble font and two marble seats didn't qualify as sculptures because they were nonrepresentational. As the court said:

> *Sculpture as an art is that branch of the free fine arts which chisels or carves out of stone or other solid material or models in clay or other plastic substance for subsequent reproduction by carving or casting imitations of natural objects, chiefly of the human form, and represents some such objects in their true proportions of length, breadth, and thickness or of length and breadth only.*

In *Brancusi v. United States,*[10] the court took the opposite view. The abstract three-dimensional work *Bird in Flight* was held a sculpture because it was the work of a professional sculptor and because of its aesthetic content. But, later, in *United States v. Ehrich,*[11] vases created by a French sculptor, the result of shaping molten glass with a spatula, were treated as decorative or ornamental glassware and not as customs-free sculptures.

## LIMITED EDITION MULTIPLES

Numerous states have adopted laws regulating the sale and advertising of limited editions. These laws exist in California, Georgia, Hawaii, Illinois, Maryland, Michigan, Minnesota, New York, North Carolina, Oregon, and South Carolina. Originally the focus was on prints, but the laws now regulate limited editions in other media, including sculpture castings and photographic prints. The New York law, upon which others were modeled, gives interesting definitions for the key terms. Under the New York Arts and Cultural Affairs Law, the following definitions appear.

> *Prints in addition to meaning a multiple produced by, but not limited to, such processes as engraving, etching, wood carving, lithography, and serigraphy, also means multiples produced or developed from photographic negatives or any combination thereof.*

The term "proofs" means:

> *Multiples which are produced from the same masters as the multiples in a limited edition, but which, whether so designated or not, are set aside from and are in addition to the limited edition to which they relate.*

7 Civ. 93–430 S(M) (D.C.S.D.Cal. 1993).
8 85 F. 864 (C.C.S.D.N.Y. 1898).
9 7 Ct. Cust. App. 46 (1916).
10 54 Treas. Dec. 428 (Cust. Ct. 1928).
11 22 C.C.P.A. 1 (1934).

The definition of "master" under the New York statute reads:

*Master when used alone is used in lieu of and means the same as such things as printing plate, stone, block, screen, photographic negative or other light material which contains an image used to produce visual art objects and multiples.*

"Limited edition" means:

*Works of art produced from a master, all of which are the same image and bear numbers or other markings to denote the limited production thereof to a stated maximum number of multiples, or otherwise held out to a maximum number of multiples.*

Very similar or identical definitions are found in most of the other statutes.

## CONCLUSION

Artists trying to find out whether their work is protected by statute are entering a legal minefield. Definitions of the same term vary from jurisdiction to jurisdiction and even within one jurisdiction itself. Moreover, the very same definition under a single statute may change from time to time either by legislative enactment or court decision. A sculpture one day may become an architectural work the next, and vice versa.

Because many artists work in nontraditional or lesser-used media, e.g., collages and assemblages, or on their own unique creations, their works are often unprotected. The

usual bias is to protect traditional kinds of work. The only way for artists' groups to change this is to lobby for new and amended laws so that a more complete range of pictorial, graphic, and sculptural works are protected under a variety of statutes that benefit artists.

Confining protection to paintings, drawings, sculptures, prints, and photographs, as one sees under many statutes, puts a restraint on artistic development. Over a long period of time, restricted statutory protection is bound to have an impact by encouraging only limited creations by artists and preserving only those that fit into the legal straight jacket.

We must remember that there are judges who are not willing to accept that a mural or mosaic is a painting or that a wall relief is a sculpture, so we should make these kinds of decisions unnecessary by changing the laws.

Perhaps the best way to broaden artists' rights by changing the law is to act through one's professional organization. Artists' Equity, and the American Society of Media Photographers (ASMP) (formerly the American Society of Magazine Photographers), have been instrumental in broadening statutory protections for artists, photographers, and other creative people. Sometimes even a lone voice may be heard. A detailed and persuasive letter to a state legislator or local congressman can sometimes prompt new legislation. If your professional guild is not interested, then you

might want to contact one or more of the Lawyers for the Arts organizations established throughout the United States, which provide legal education and referral services for artists.

Infrequently, even a more casual contact may suffice. For example, at a cocktail party for a glass art organization, I met the husband of one of the officers of the organization, who happened to be a legislative aide in the California State Legislature. While talking about legal protection for glass art, I mentioned that some of California's artists' rights statutes did not protect glass works within the category of fine art and that the laws should be amended. The next thing I knew, these laws were changed to protect works of art in glass because the legislative aide had persuaded his state senator to introduce such legislation.

When you have any new ideas for broadening artists' rights by changing legal definitions, consider making them known to a professional organization and/or your government representatives. Remember, not even an army can stop an idea whose time has come.

# REGULATION OF FINE ART MULTIPLES

KATHERINE M. THOMPSON

*Katherine M. Thompson has her law practice in
West Los Angeles, California and specializes in areas
of art and copyright. She is a graduate of
Pepperdine University, 1991.*

Purchasing and collecting art is becoming more common with the middle class as well as with corporate entities and institutions. Because prints are more easily attainable and more numerous than paintings, sculptures, and other fine art, the print market has grown more rapidly in recent years than any other type of art. However, photomechanical technology, which has made prints and multiples affordable and within reach to the mass population has also made this type of art more open to forgery.

Prices have risen tremendously and the print business has become lucrative.

The increased growth of the print market has presented considerable opportunity for impropriety. Art forgers and counterfeiters are willing to assume the risk of civil and criminal prosecution since large sums of money can be made in defrauding customers.

Many states have enacted legislation to specifically combat this dilemma. The statutes commonly require specific disclosures to be made by the sellers of fine art prints and/or multiples. Further, they create remedies for the misled purchaser. Whether or not these statutes solve the fraudulent conduct in the art market more than the traditional breach of contract and breach of express and implied warranties actions will be discussed in this article.

## CALIFORNIA LAWS

California has one of the most comprehensive and detailed disclosure laws pertaining to the sale of multiples. Unfortunately, along with the detail comes considerable complexity and confusion.

According to legislative history, the purpose of the California Sale of Fine Prints Act was to restore confidence and integrity to the California print market. The California legislature had the peripheral goal of encouraging art dealers to increase sales of California art, due to their ability to verify details about the work.[1]

---

1 "California Joint Legislative Committee of Arts Reveals the 'Bite' of the Farr Act." Art Dealers' Association of California (*ADAC Newsletter*), Vol. 1, No. 3, 1989, at 3 (interview with Paul Minicucci, Principal Consultant for California Joint Legislative Committee for the Arts, Sacramento).

## Scope

The California Sale of Fine Prints Act applies to "multiples," defined as fine prints, photographs, sculpture casts, collage and "similar art objects produced in more than one copy."[2] It is inapplicable to multiples sold for under $100 each.

California is the first and only state to require that a certificate of authenticity accompany a multiple when sold, exchanged or consigned. The enactment of such legislation represents a change in the usual dealings of art merchants. It was often thought that inquiry into ownership led collectors and dealers to believe that they would become victims of theft due to the public knowledge of their ownership.[3]

The seller, defined as anyone who holds himself out as having knowledge particular to the works, or to whom the knowledge may be attributed, must then attest to the validity of all statements made about the multiple and all items disclosed. According to this definition, an art dealer is not the only one who can be considered a seller under this Act. Private individuals, interior decorators, art consultants, etc., anyone with knowledge or who holds themselves out as having knowledge can be considered seller and subject to this Act. The following clause is to be added to the certificate of authenticity: "[T]his is to certify that all information and the statements contained herein are true and correct." This statement almost rises to the equivalent of a sworn statement.

The Act therefore holds sellers liable for any omissions or incorrectly stated information in the certificate of authenticity. It should be noted, however, if the artist sells or consigns his own work to a collector, the artist is not liable for any similar such mistake, omission, or erroneous information for which the dealer would be liable.

Furthermore, charitable organizations have certain exemptions, but if they use an art dealer to carry out any sale or consignment, the art dealer becomes liable and must provide the certificate of authenticity. It seems that the seller, most commonly the art dealer, is the only one liable for violations of the Act. While the artist can consign his own work as easily as an art dealer can, the artist is not then subject to the same liability as the dealer under this law. Both dealer and artist must disclose certain information; however, the dealer is liable if the information is omitted or incorrect, the artist is not. This does not make any sense because the living artist is the best authority on his work and should be required to disclose the information correctly.

## Disclosure

Disclosures must be made in connection with all sales and consignments of multiples. Each prospectus, offering, publication and catalog selling or offering multiples for sale must contain the specific disclosure notification as stated verbatim in the Act itself. Furthermore, each place of business engaged in the sale of multiples shall post a notice, specifically dictated in the Act, appraising potential buyers of their rights under the statute.

The Act provides a detailed list of items to be disclosed, including: name of the

2 CAL. CIV. CODE §1740.
3 Comment, "Title Disputes in the Art Market: An Emerging Duty of Care for Art Merchants," 51 *Geo. Wash. L. Rev.* 449, n.45 (1983).

artist, whether the name is on the multiple, signature, medium, posthumous status, limited edition size and specifications, fate of the plate, etc. Each section varies the information to be disclosed according to what type of multiple is involved. Not all of the information listed need be disclosed for each multiple; a date line delineates what information belongs in the certificate (i.e., after 1983, from 1950 to effective date, after 1949, prior to 1950, between 1900 and 1949, and prior to 1900). Due to the complexity of the disclosure requirements in the Act and the form in which they are presented, compliance is difficult. Compliance is possible only if the Certificate of Authenticity is made with the Act open to the disclosure requirement so that you can cross reference the type of multiple with the date it was produced to see exactly what must be disclosed.

The Act does not abandon the idea of warranties that traditionally accompany the sale of goods, including fine art multiples. The section of the Act that addresses warranties again makes the distinction by medium and date for the specific warranty to accompany the multiple. Additional conflict occurs when comparing the disclosure section with the warranties section. The name of the artist, for example, must be disclosed and attested to for multiples produced prior to 1949, but the name of the artist need not be expressly warranted. Under the pre–1900 subcategory, the source of the artist's name need not be disclosed but must be expressly warranted. If a warranty is akin to a guarantee, how can you guarantee information that you cannot attest to its truth, or, conversely, how can you attest to the truth of the information but not have to guarantee it? This is a source of great inconsistency. As such, it is important to keep in mind that the seller must be familiar with both what is to be disclosed on the Certificate of Authenticity as well as what is under express warranty. They are not always the same items.

## Remedies and Penalties

The Act offers civil remedies such as rescission, interest, costs of suit, reasonable attorneys' fees, expert witness fees, treble damages for willful noncompliance, civil penalties of $1,000 per violation with a possible civil penalty surcharge of $1,000 and injunctive relief. The buyer enforces the Act against the seller; but, the multiple in question must be returned to the seller before any of these remedies can be sought.

Only one case, *Charlene Grogan–Beall v. Ferdinand Roten Galleries, Inc.,* has been reported under the Act.[4] The case involved faulty certification, an untimely delivery of the certificate of authenticity, and the sale of an artist's proof in a series not disclosed in the catalog. Originally the case was brought as a class action, but the court decertified the class. Because of the decertification and reduced liability of the defendant, *Grogan–Beall* is said to have judicially "emasculated… the California statute."[5] Since 1982 no other case has been reported under the California Sale of Fine Prints Act. Clearly, this does not mean that there has been no violation since 1982, but rather that the Act is difficult and ineffective.

The civil remedies are not extensive and there are no criminal fines or imprisonment. As a result, forgers ignore the risk of detection because the penalties are not severe. Forgers generally operate on a large scale and as such, the damage they can expect if one individual sues under the Act is so small that it cannot concern them. Furthermore, according to a Los Angeles Deputy District Attorney, the judicial system

4 133 Cal. App. 3d 969, 184 Cal. Rptr. 411 (1982).
5 Id at 540.

is not ready to hear these cases under the civil statute. In order for the court to address these art fraud cases, the prosecutor must fit the violations of the forgers into the criminal violations of fraud, grand theft, larceny, or forgery.

## NEW YORK LAWS

More than any other two states, California and New York have extremely similar legislation with respect to multiple and print sale regulation.[6] The California Sale of Fine Prints Act was originally enacted in 1970, and became operative July 1, 1971. It was the first of its kind in the nation. The New York statute was enacted in 1982. Both have been amended since that time, New York's statute most recently in 1990 specifically adding sculpture to its title and provisions. The New York Sale of Visual Art Objects and Sculptures Produced in Multiples Act was promulgated to protect purchasers of visual art objects produced in multiples. Multiples sold for $100 or less are exempt from the statute.

### Scope

The New York statute applies to multiples and has been recently amended specifically to include sculpture. The requisite disclosure described in the statute must be made on a "written instrument" rather than in a certificate of authenticity, a difference from California law.

Unlike the California statute, New York law does not impose strict liability on the merchant/dealer. The end seller is not ultimately liable for any previous violation. In New York, if the artist sells or consigns a multiple of his own creation, he will be considered a merchant and will thus incur the same liability for his misrepresentation, error, and omission. Furthermore, if the selling art merchant can establish that he relied on incorrect information provided by another consignor, artist or merchant to him in writing, he, along with the purchaser, may look to the selling merchant for remedies. Thus, there is an incentive for each merchant down the line of sales to provide accurate information to avoid liability in future sales.

With this improvement in dealer liability also comes a regression. An additional standard is applied on the New York merchant with respect to express warranty; if the art merchant makes disclaimers as to information required to be disclosed, he will not be liable only if he made reasonable inquiries, according to the custom of the art business, or if the information could not have been determined even if he had made such inquiry. The requirement of reasonable inquiry is new.

The bottom line is, if you do not know, you must make reasonable inquiry.

### Disclosure

Disclosures must be made in connection with all sales and consignments of multiples pursuant to the statute. Furthermore, each prospectus, offering, publication and catalog selling or offering multiples for sale must state a specific disclosure notification paragraph as dictated in the statute itself. Furthermore, each place of business engaged

---

6 N.Y. ARTS & CULT. AFF. LAW §§15.01–15.19 (McKinney Supp. 1991). See generally Comment, Regulation of the New York Art Market: Has the Legislature Painted Dealers Into A Corner?, 46 FORDHAM L. REV. 939 (1978); Comment, A Giant Step Forward – New York Legislation on Sales of Fine Art Multiples, 7 COLUM. J.L. & ARTS 261 (1982).

in the sale of multiples shall post a notice, specifically dictated in the code, apprising potential buyers of their rights under the statute.

The information required to be disclosed includes, among other items, the artist's name, signature, the medium or process, if artist is deceased, use of master (plate, mold, or cast), date, limited edition size and specifications, etc.

The list does not depart greatly from that required in California, and similarly it is divided by date of production: on or after January 1, 1982, 1950 – January 1, 1982, 1949–1900, and pre–1900. Interestingly, each state whose legislation applies to multiples, rather than merely to prints, also delineates information required to be disclosed by date of production of the multiple.

The cross referencing of date and multiple type for compliant disclosure is simplified in New York. Separate sections dealing with each time period category facilitate the determination of what information is required to be disclosed for a specific work. This improvement in form will make compliance much easier for the New York art merchant.

A recent amendment brought a new section that is completely unique to New York, addressing sculpture produced, fabricated or carved after January 1, 1991. It defines the information to be disclosed for sculptures and more specifically for "copies of sculpture not made from the master." This section was enacted to combat the unauthorized copying of sculptures done from molds of existing casts, a problem specifically cited in regards to Rodin and Remington works.

### Remedies and Penalties

The New York law offers only civil remedies such as rescission with interest, costs of suit, reasonable attorneys' fees, expert witness fees, treble damages for willful noncompliance, and potential civil penalties of $500. The multiple in question must be returned in similar condition to which it was sold to the seller before any of these remedies can be sought. Injunctive relief is also available, however, it is a remedy reserved for the attorney general only. As in California, there are no serious penalties for violation.

## MICHIGAN LAWS

Michigan is the only other state to address multiples in its legislation and to emulate the California and New York statutes. The Michigan Art Multiples Sales Act was enacted in 1987.[7] As in California and New York, multiples sold for $100 or less are exempt from the disclosure statute.

### Scope

The Michigan law applies to multiples and defines multiples in a manner similar to California and New York including prints, photos and other graphics, but does not specifically include sculpture. Therefore sculpture is exempt from the disclosure statute. The term multiple in this statute refers to graphics and photos and echoes the scope of the other state statutes that apply to prints exclusively.

The information must be disclosed in a written instrument as defined in the statute to include a bill of sale, invoice, certificate of authenticity, catalog, or other memorandum.

---

7 MICH. COMP. LAWS ANN. §§442.351 – 442.367 (West 1989).

Michigan specifically addresses artist liability in a separate section for emphasis. "An artist who is not otherwise an art merchant, who sells or consigns a multiple of the artist's own creation, shall for the purposes of that sale or consignment incur the obligations prescribed by this act for an art merchant."[8] Michigan, like New York, specifically legislated to impose liability on the artist, whereas, in California and Illinois, the artist is specifically exempt. The other states are silent on the matter.

### Disclosure

Disclosures must be made in connection with all sales and consignments of multiples pursuant to the statute. Furthermore, each prospectus, offering, publication and catalog selling or offering for sale multiples must state a specific disclosure notification paragraph as dictated in the statute itself. Furthermore, each place of business engaged in the sale of multiples shall post a notice, specifically dictated in the code, apprising potential buyers of their rights under the statute.

In this respect, Michigan mirrors both California and New York.

The information to be disclosed includes: the artist's name, signature, medium, process, posthumous status, reproductive status, limited edition size and specifications, and date. Although the statute applies only to prints and photographs in its text, despite its title reference to multiples, it too distinguishes disclosure requirements by date of production of the work (December 1949 to December 31, 1987; December 31, 1899 to January 1, 1950; and, before January 1, 1900). In the date disclosure guideline, Michigan has learned from New York's clearer divisions and has created separate sections for each time period.

Michigan specifically creates express warranties in its statute, in addition to any common law and Uniform Commercial Code warranties that may be created in the sale of the print or photograph.

### Remedies and Penalties

The Michigan statute offers the civil remedies of rescission, interest, costs of action and reasonable attorney's fees upon tender of the multiple to the seller. Michigan provides for neither civil penalty nor injunctive relief and is the only state not to offer treble damages for willful violation.

## ARKANSAS, HAWAII, ILLINOIS, MARYLAND, MINNESOTA AND OREGON LAWS

These states' print disclosure laws are more cursory than those of California and New York. The Arkansas Sales of Fine Prints Act was enacted in 1983,[9] Hawaii's Sale of Fine Prints Act in 1978,[10] and Illinois' Prints Disclosure Act in 1972 and renamed in 1991,[11] Maryland's Fine Prints Act in 1975,[12] Minnesota's Sale of Fine Prints Act in 1984,[13] and Oregon's Fine Print Disclosure Statements in 1981.[14] The print

8 Id. at §442.361.
9 ARK. STAT. ANN. §§4.73.301–4.73.305 (1987).
10 HAW. REV. STAT. §481 F (Supp. 1987).
11 The "Fine Print and Disclosure In Sale" of 1972, was renamed the "Prints Disclosure Act" in 1991. Furthermore, its statutory cite changed to 815 ILCS 345/0/01 et seq. from ILL. ANN. STAT. ch. 121 1/2. para. 361–369 (Smith Hurd Supp. 1989).
12 MD. CO. LAW CODE ANN. §§14–501 – 14–505 (1983).
13 MINN. STAT. ANN. §§324.06 – 324.10.
14 OR. REV. STAT. §§359.300 – 359.315 (1987).

disclosure laws in these states are virtually identical and will be discussed together, Oregon's being the shortest and least inclusive.

Hawaii is an example of a state where the print legislation has been utilized to punish violations and forgeries. Most of the concern with the multiple/print market was precipitated by Center Art Gallery sales of fraudulent Dali prints in Hawaii. In *Vazquez v. Center Art Gallery*, the buyer of the fraudulent art sued for a violation of the print law. On the other hand, in Illinois, a fraudulent lithograph case involving Picasso, Dali, Chagall, and Miro made no mention of the print legislation that specifically applied to the case (*Federal Trade Commission v. Austin Galleries of Illinois, Inc.*).

### Scope

The statutes apply only to fine prints, such as engravings, etchings, woodcuts, lithographs, monoprints, or serigraphs. The statutes generally contain a date at which the statute becomes effective: printed after July 4, 1983 in Arkansas; printed after June 1, 1983 in Hawaii; printed after July 1, 1972 in Illinois; printed after July 2, 1974 in Maryland; and printed after January 1, 1984 in Minnesota. Oregon statutes contain no such date restriction. The information to be disclosed must be done in a certificate, written invoice or receipt. Some states also maintain monetary thresholds at which the statute is applicable. The statute is inapplicable in Illinois when a print is sold for $50 or less unframed and $60 or less framed; in Maryland $25 or less unframed or $40 or less framed; in Minnesota less than $250; and Oregon has no such restriction.

Liability falls on "a person who offers or sells a fine print" signifying possible equal liability on artists and dealers, with the exception of Illinois where the artists is specifically excluded from compliance and liability.

### Disclosure

Items to be disclosed include name of artist, year of printing, size and specifications of limited edition, demise of plate, posthumous works, and name of workshop where edition was printed. This disclosure need not be made if the print is an unsigned and unnumbered reproduction not part of a limited edition. Oregon simply states that no disclosure need be made when the print is represented as a reproduction.

Hawaii, Maryland and Minnesota follow California and New York's mandate that the disclosures be made in each catalog, prospectus and circular offering prints for sale. Minnesota, however, refers only to catalog publications.

### Remedies and Penalties

Civil remedies available include rescission and treble damages for willful noncompliance, upon tender of the print. Arkansas, Illinois, Maryland and Oregon further offer interest from date of purchase while Hawaii and Illinois impose further fines of $1,000. Oregon requires no tender of the print and Minnesota includes sales tax specifically as an item for recovery.

## CRITICISM

Despite the promulgation of disclosure laws in these states, art fraud is still rampant. There are many reasons for this, including noncompliance by the art world, absence of any real enforcement mechanisms, and nonuse in legal avenues. The art world is either

unaware of the disclosure laws, or it does not know how to comply with their provisions.

The statutes create a private right of action and thus enforcement relies on the private individual, the buyer. An obstacle to civil enforcement, however, is the reluctance of the defrauded buyer to file suit. Many buyers do not realize that they may have purchased a forgery or that a certificate or written instrument must be supplied with a specific statutorily required disclosure. Even if the buyer is aware, he or she may be embarrassed to bring suit because they do not want to admit ignorance. In addition, the buyer may not want to publicize that the purchase was worthless if he or she plans to resell it or deduct it from their taxes.

The more pragmatic buyer, however, forgoes enforcement of criminal sanctions (or in this case civil suit) to preserve the supposed value of the forged object for resale or tax purposes. Consequently, private parties are not the only victims of art forgery. The United States Treasury suffers loss of tax revenue by virtue of deductible gifts of improperly authenticated art to charitable institutions and the duty free importation of ostensibly original works of art.[15]

Furthermore, a forged art work may be the basis of a fraudulent insurance claim.

These factors may discourage the buyer from bringing suit and, as a result, the forger remains unpunished.

The California and New York statutes, however, provide for injunctive relief by the state and its designates in California and the attorney general in New York. This provision allows the state to take action when the private individual will not, but to date it has not been used.

Since the promulgation of these statutes, no significant cases have been brought to enforce their provisions. California and Hawaii each have only one case referring to the legislation. However, California and Illinois have both had criminal cases dealing with art fraud, brought by the Federal Trade Commission or a state agency, without corresponding cases under their respective civil code sections.

## CONCLUSION

Art fraud is an ever-increasing dilemma that the disclosure statutes have unsuccessfully attempted to remedy. In order for the law to be effective, many changes and clarifications must be made. The disclosure procedure must be simplified and made practical. Perhaps a nation-wide disclosure document should be implemented. If disclosure should differ according to the date of production and the type of multiple, each such category should have a model certificate. Until compliance is made fully clear and accessible to the art dealer/merchant, the disclosure statutes shall remain ignored and shunned by the art world.

Additionally, the burden of liability should be distributed fairly between the artist and the art dealer. Artists are always the best source for information on their own work. If they share liability for erroneous disclosure, they will have to become an active participant in the disclosure process and this can increase acceptance and integrity. Moreover, adding integrity to the disclosure process will benefit artists by reducing skepticism about their work, thereby promoting doubt-free patronage.

---

15 Comment, Current Practices and Problems in Combatting Illegality in the Art Market, 12 SETON HALL 506, 506 (1982) (footnotes omitted).

# ART DESTRUCTION: AN OVERVIEW

**PETER H. KARLEN**
*Peter H. Karlen practices art, publishing, and intellectual
property law (including copyright, trademark, and moral
rights law) in La Jolla, California.*

Artists are usually very concerned about physical injury to their works, whether through mutilation, alteration, or destruction. Today they have many legal remedies for these injuries, particularly new moral rights laws, the most prominent of which is the Visual Artists' Rights Act of 1990 (VARA) conferring nationwide moral rights under federal law.

However, until recently, U.S. artists who sold or gave away their works could not readily oppose mutilation or destruction nor public display of altered or mutilated versions of their works. This was because *droit moral* (moral right) had not been recognized in the United States. The moral rights doctrine, so well developed in other countries, particularly France, allows the artist to prevent and remedy physical injuries to their work of art due to mutilation, defacement, alteration, or destruction. It also confers on artists the rights to claim and disclaim credit for works of art. Without moral rights protection, artists who had parted with their works but wanted to protect them had to rely on defamation, privacy, publicity, and unfair competition laws, as explained below.

In 1979 California became the first state in the U.S. to recognize artists' moral rights, in the form of the California Art Preservation Act. New York became the second State in 1983 with the adoption of the New York Artists Authorship Rights Act. Later, Massachusetts, Pennsylvania, New Mexico and Connecticut adopted legislation similar to the California law, and New Jersey, Maine, Louisiana, Rhode Island and Nevada enacted laws that followed the New York model.

Nationwide federal legislation did not come until 1990 with the enactment of the VARA. The VARA was largely motivated by U.S. accession to the Berne Convention for the Protection of Literary and Artistic Works, an international copyright convention to which the U.S. became a party in 1989 and which requires signatories to provide moral rights protection within their jurisdictions.

The purpose of this chapter is to provide an overview of what physical injuries to works concern artists, what legal rights artists have to prevent and remedy these injuries, and how artists can protect their works from injury. This *overview* chapter is a summary of many art preservation laws, particularly moral rights laws. You won't learn enough here to handle art destruction problems without getting advice from an attorney. Nonetheless, you will gain a general understanding of the rights and remedies available to artists and the important concerns in art destruction cases.

## KINDS OF INJURIES

State and federal moral rights laws, which allow artists to protect the physical integrity of their works and confer rights to claim and disclaim credit, mention most of the injuries that face artists. The physical injuries to works of art include mutilation, defacement, alteration/modification, distortion, destruction, deterioration, removal, and disappearance.

A work is often considered "defaced" when part of it, small or large, is covered over. A typical defacement occurs when a vandal spray-paints a mural. In one case we handled, an art dealer who felt that a sculpture was evil performed an exorcism ceremony on the sculpture by carving crosses on it, and therefore defaced the sculpture. The term defacement is mentioned in state moral rights statutes, particularly those modeled after the California statute, but is not used in the VARA.

Semantically, "mutilation," provided for in all state and federal moral rights statutes, is a somewhat more serious injury than defacement. For example, we had a case where the artist's large painting was cut by an art dealer into many small pieces which were framed and sold separately. Mutilation usually connotes a more extreme disfigurement or physical change than defacement.

State moral rights statutes modeled after the California law talk about alteration of a work; the federal law (VARA) and those modeled after the New York law talk about modifications. For all intents and purposes, alteration is equivalent to modification. However, alteration/modification is different from mutilation and defacement. An alteration or modification is typically made to improve the work or its usefulness to the owner or other person who has a reason for making the change; and the culprit may not intend to damage the work. For instance, we handled a case involving a painting that showed buildings reflected in water. The buyer thought it was illogical for the reflections of buildings not to be the same size as the buildings themselves and had the reflections repainted by another artist so they would be the same size as the buildings.

"Distortion," an unusual form of alteration, is mentioned in the VARA. A pure distortion does not require mutilation or defacement nor the typical kind of alteration. For instance, a painting on canvas, normally displayed flat, is wound around a kiosk, or a metal sculpture is cast into an oven, softened, and then bent out of shape. True distortions are probably the least common form of physical injury.

Destruction is remedied under federal law but is only covered under state moral rights statutes modeled after the California law. Destruction differs from alteration/modification and mutilation/defacement because it constitutes a more profound physical change. However, who can say where mutilation and defacement end and destruction begins? If one cuts to pieces two-thirds of a work while leaving the final third intact, is this mutilation or defacement, or is it destruction? Or if two-thirds of a mural is painted over, is this defacement or destruction? It's a matter of semantics. Even if the work is not salvageable, one cannot definitely say that the work has been destroyed; one can consider it badly mutilated. The typical destruction cases we have confronted involve a sculpture that has been demolished or a mural or other painting that has been completely covered over and ruined by paint, wallpaper, or other materials.

Deterioration, whether total or partial, differs from mutilation, defacement, alteration/modification, and destruction insofar as the injury is usually not deliberate. Deterioration can be caused by many factors such as moisture, light, pollution, and

chemicals applied to the work. For instance, in one case, the artist applied a preservation product to his outdoor murals to protect them against vandals and the elements. However, the preservation product itself was harmful because it dried very fast, much faster than the underlying painted substrate, thus causing the paint to crack, chip, flake, and fall off. Mark Rothko once installed a suite of large paintings in a well-lighted indoor display that resulted in the paintings completely fading.

The last kinds of injury are "removal" and "disappearance." Removal, if resulting in destruction, is merely considered destruction. But many removals do not result in physical destruction. Nonetheless, when the buyer or other person removes a site-specific piece, even without destroying the physical structure, the artist may suffer an injury almost equivalent to destruction since the piece taken from its site often loses its artistic and aesthetic value.

Disappearance differs from removal insofar as the work that disappears may have been removed intact, demolished, or even covered over. In one case, the artist had installed a large painting on the wall at a well-known hotel. Years later, the work disappeared, and only in the midst of litigation was it discovered that the piece had been covered over with wallpaper. In another case, a large outdoor steel sculpture disappeared, and only after litigating the matter did the artist learn that the work had been cut into pieces and removed.

## MORAL AND OTHER RIGHTS

What rights does the artist have to prevent and remedy art destruction, and where do these rights come from?

Moral rights laws, state and federal, are the predominant source; other state statutes and common-law doctrines also allow protection.

### The VARA

Federal moral rights legislation offers the most important protection. After all, by its own terms, the VARA preempts all state laws covering the same rights granted by the VARA that affect the subject matter covered by the act.

The VARA's subject matter is somewhat limited; it protects only works of visual art. For a discussion of legal definitions, see the chapter "Defining Art: A Legal Perspective."

Most of the battles under the VARA will concern those works of art that are covered under the act, simply because it does not clearly apply to multimedia, nontraditional, or other works that are not mainstream art. For instance, will landscape works be considered sculptures? Can a mosaic ever be a painting? What is the borderline between a print and a poster? Will a mural always be deemed a painting? We and other attorneys have confronted cases on these issues.[1]

If the artist creates their work within the scope of their employment, they probably cannot claim moral rights in the work under the VARA. Also, if the artist is an independent contractor in relation to a specially ordered or commissioned work, the

---

1 See, e.g., *City of Carlsbad v. Blum*, Civ. 93–430 S(M) (D.C.S.D.Cal. 1993) where the plaintiff City argued that large outdoor landscaped work was not a protected "sculpture"; *Botello v. Shell Oil Co.*, 299 Cal. App. 3d 1139 (1991) where the Court of Appeals ruled that a "mural" was a protected "painting," overruling trial court's contrary decision; *Robert H. Jacobs, Inc., v Westoaks Realtors, Inc.*, 159 Cal. App. 3d 637 (1984) where the court ruled that architectural drawings were not considered fine art "drawings" under moral rights statute.

work otherwise qualifies for work made for hire status, and the artist has signed a work made for hire agreement, then there may be no VARA protection. This exclusion applies to the artist either as *employee,* or as *employer* of an apprentice who creates the work for hire.

There are many reasons why a work might not be subject to copyright protection and is therefore not protected by the VARA. For example, the work might be created by an artist who is a citizen of a country having no copyright treaty relations with the United States, e.g., Iran, Yemen, and Albania. The term of copyright protection may have expired or the artist may have abandoned the copyright.

When an artist has a qualifying work, the VARA offers two kinds of rights in relation to the work. These are "integrity" rights that allow the artist to prevent and remedy attacks on the physical integrity of the work and crediting or "attribution" rights by which an artist may claim or disclaim credit for the work.

Specifically, the artist has the right to prevent any intentional distortion, mutilation, or other modification of the work that would be prejudicial to his or her honor or reputation, and the artist has a remedy against anyone who intentionally distorts, mutilates, or modifies the work. The artist also has the right to prevent the destruction of a work of recognized stature and has a remedy against someone who intentionally or grossly negligently destroys such a work.

The requirement of intentional injury under the VARA and under state statutes presents problems with proof. Take the following cases. The artist's piece, consisting of steel ramps installed in a ravine, was decimated by bulldozer operators who had no idea that the steel ramps were part of a work of art. They intentionally bulldozed the steel ramps, but did they intentionally destroy a work of art? While removing his works from an art gallery against the wishes of the gallery owner, an artist had a tug of war. He grabbed one end of the piece, the owner held the other. The piece was torn in half. Could we say that the dealer intended to destroy the painting rather than merely retain it? Or what about the people who stored an artist's work in an outhouse, and should have known that the work would be destroyed as a result of moisture, pests, and other hazards?

With regard to attribution, artists have the basic right to claim authorship of their work. They also have the right to prevent the use of their name as the author of any work they didn't create, and the right to prevent the use of their name as the author in the event of a distortion, mutilation, or other modification of the work that would be prejudicial to their honor or reputation. As discussed below, this right to disclaim credit is narrower than the right under some state moral rights statutes that allow disclaimer for any just and valid reason. Not every modification is prejudicial to the artist's honor or reputation, but the artist should still have the right to disclaim credit.

There are notable exceptions to these rights. For example, the modification of a work resulting from the passage of time or the inherent nature of the materials may not be a violation. Similarly, the modification of a work that results from conservation or public presentation (including lighting and presentation), may not be a violation, unless the modification is caused by gross negligence.

Moreover, the VARA does not apply to certain reproductions, depictions, portrayals, or other uses of the work in connection with various articles of commerce that are not works of visual art. For instance, when a work is reproduced on a map, poster, or packaging materials, in a distorted fashion, even though the artist's reputation may be injured, there can be no action under the VARA.

The artist's rights under the VARA persist during the artist's life for works created on or after June 1, 1991, the VARA's effective date. For works created before that date, title to which, as of that date, has not been transferred from the artist, the rights persist for the duration of the copyright, which may be as long as the artist's life plus fifty years.

With joint works, the rights last for the life of the last surviving co-author.

Because the rights under the VARA are not property rights but rather personal rights, they may not be transferred; but artists can waive their rights in a written instrument that specifically identifies the work and the uses of the work to which the waiver applies. Fortunately, any ambiguity in the written waiver will usually be interpreted in the artist's favor. For instance, we had a case under state law in which the court held that a transfer and waiver of all rights did not amount to a waiver of moral rights.[2]

Unfortunately, with a joint work prepared by two or more authors, any author can waive the rights for *all* the authors, a bad rule. This means that the artist making a smaller contribution to the work can waive the rights of the principal contributor.

The VARA has some rather complicated rules for works installed in buildings. For nonremovable works, i.e., works which have been incorporated into or made part of a building so that removing the work from the building will cause the work's destruction, distortion, mutilation, or other modification, the following rules apply. If the author consented to the installation in the building before the VARA's effective date, June 1, 1991, it is not protected. Also, if the artist consented to installation on or after the effective date, and did so in a written instrument signed by the artist and building owner, which specifies that installation of the work may subject it to destruction, distortion, mutilation, or other modification by reason of its removal, then the VARA does not apply.

This means that for nonremovable works installed on or after the effective date, building owners must procure written signed consents from the artist for installation or they may be stuck with these works. This rule is very favorable to artists but probably unfair to building owners, many of whom are not aware that their real estate can be encumbered unless they procure written consents.

For removable works (essentially, works that can be removed without damage or destruction), the rights apply *unless* the owner has made a diligent, good-faith attempt, without success, to notify the artist of the owner's intended action to remove the work *or* the owner did provide the notice in writing and the artist failed within ninety days after receiving the notice either to remove the work or pay for its removal.

An owner is presumed to have made a diligent, good-faith effort to send the notice if the notice was sent by registered mail to the artist at the artist's most recent address recorded with the Register of Copyrights. For this reason, as explained below, artists are encouraged to record with the Copyright Office information about works that have been installed in buildings.

Please note that the borderline between removable and nonremovable works changes as removal techniques improve. We handled a case involving murals painted on a cement wall, where the artist proved that the works were removable by a technique developed in Venice, Italy for scraping murals off walls intact.

---

2 *Burton v. Ernest W. Hahn, Inc.*, San Diego Super. Ct. No. 551,961 (1985).

One of the most important qualities of the VARA is that it preempts all state laws covering the same subject matter (works of visual art) and conferring the same integrity and attribution rights. Other federal laws, including copyright laws, are not preempted.

One purpose of preemption is to provide a uniform, national law covering the rights conferred by the VARA rather than a patchwork of local laws that overlap it.

Naturally, state laws still have considerable application. Some provide protection for the artist's life plus fifty years, with the heirs enjoying the rights after the artist's death. When the VARA's protection stops at the artist's death, state law may apply once again. Also, if the injury is to a mosaic, collage, video work, limited edition of more than two hundred, or other work that is not be covered by the VARA, state law may apply.

## The VARA's Remedies

Under the VARA, the artist usually has all the remedies available for copyright infringement. This is because the VARA is embodied in Title 17, United States Code, which embodies the copyright laws of the United States. These copyright remedies include injunctions, impoundments, awards of actual damages and profits, statutory damages, attorneys' fees, and court costs.

An "injunction" prevents the violator from initially or further injuring the work. The "impoundment" remedy allows the court to seize the mutilated work in order to prevent further injury to the artist.

The "actual damages" remedy compensates the artist for his losses. There is presently no case law to tell us precisely what these actual damages really are, but we surmise that they include compensation for injury to reputation, lost sales, and lost good will. For example, every time a mutilated work is publicly exhibited, especially in connection with the artist's name, the artist may suffer injury to reputation; the artist may also suffer lost sales and good will because the mutilated version of the work becomes associated with them.

Actual damages probably should not be measured by the cost to the artist of creating the work or by the cost of replacing it. When the artist no longer owns the physical art object, the compensation is not for injury to the work itself but rather for injury to the artist's reputation. Naturally, if the artist still owns the art object, they can ask for money damages to compensate for the damaged or destroyed property, but this is different than a moral rights recovery.

The award of the violator's profits is to deter the violation in the first place. If the violator has gained any proceeds as a result of misusing the protected work, the artist can be awarded those proceeds. If the artist prevails in the lawsuit, then the court has the right to award the artist attorneys' fees spent in pursuing the action. Court costs will also be awarded.

"Statutory damages" are a measure of damages, awardable in the court's discretion, in lieu of actual damages and profits. When the court is ready to rule in the artist's favor, the artist must elect whether to take judgment for actual damages and profits *or* the discretionary amount of statutory damages; the artist cannot take both. Statutory damages will run between $500 and $20,000 in the usual case. Where the violation has been willful, the court has the discretion to award up to $100,000 in statutory damages. The artist usually elects to recover statutory damages when it is difficult to establish actual damages and the violator's profits.

My own experience with numerous settlements and verdicts is that recoveries in art destruction cases brought under moral rights statutes usually range from seven to ten times the original purchase price paid to the artist. There's no reason not to expect a similar pattern under the VARA, especially because it provides remedies at least equivalent to or better than those under any state statute.

## The California Statute and Other Moral Rights Laws

The California statute, in some areas, is more limited in scope than the VARA. It protects only works of fine art. A work of fine art is defined as "an original painting, sculpture, or drawing, or an original work of art in glass, of recognized quality, but shall not include work prepared under contract for commercial use by its purchaser." The California law probably does not protect limited editions and does not cover photographs and prints. Also, the recognized quality requirement imposes an extra burden on artists that does not exist under the VARA except in relation to the right to prevent destruction of works of recognized stature only.

The California statute recognizes "attribution" rights by giving the artist the rights to claim credit and disclaim credit for a just and valid reason, which is a broader disclaimer right than under the VARA. The VARA allows disclaimer only for works not created by the artist or for works that have been modified, mutilated, or distorted so as to prejudice the artist's honor or reputation.

With regard to the integrity right, the California statute provides remedies for intentional defacement, mutilation, alteration, or destruction. Moreover, it provides remedies against framers, conservers, and restorers who deface, mutilate, alter, or destroy the work as a result of gross negligence. Gross negligence is said to be "the exercise of so slight a degree of care as to justify the belief that there was an indifference to the particular work of fine art." Direct actions against those who frame, conserve, and restore, give artists a powerful remedy, since the artist need only prove gross negligence rather than intentional injury. Museums and other cultural institutions that maintain collections are vulnerable because they frame, conserve, and restore works of art.

California's "works-in-buildings" rules differ from those under the VARA. The rules for removable works are similar insofar as notices or attempted notice from the building owner to the artist are required. But with nonremovable works, under the California law, it is up to the artist to *reserve* moral rights in a written instrument signed by the building owner and properly recorded (presumably with the appropriate county recorder or other land registry). Failure to get the building owner's signature or to record the document results in waiver of rights.

Under the California legislation, the rights last for the artist's life plus fifty years, and after death may be enforced by personal representatives, heirs, or beneficiaries.

As with the VARA, artists may waive their rights but only in a signed written instrument.

Under the California moral rights statute and some of the state statutes modeled after it, the artist is entitled to recover actual damages, attorneys' fees, court costs, expert witness fees, and obtain an injunction. No provision is made for statutory damages or impoundment. Thus, an artist will usually be pleased to proceed under the VARA rather than under a moral rights statute based on the California model.

Punitive damages are also available under the California statute, but the award is paid to a nonprofit arts organization.

## The New York and Other State Statutes

New York, in 1983, was the second state to enact a moral rights statute, but the New York statute has a different focus than the California one. The California law is primarily devoted to protecting the work of art, whereas the New York law is focused more on the artist's reputation.

The New York statute protects original works of fine art, limited editions comprising not more than three hundred copies, and reproductions of original fine art and original editions. A work of fine art is a "painting, sculpture, drawing, or work of graphic art and a print but not multiples." A reproduction is "a copy, in any medium, of a work of fine art, that is displayed or published under circumstances that, reasonably construed, express an intent that it be taken as a representation of a work of fine art as created by the artist."

There is no requirement of recognized quality, and the statute clearly covers multiples and reproductions.

The attribution rights are identical to those under the California statute, namely the rights to claim and to disclaim authorship for just and valid reason.

However, the New York law does not directly protect the physical integrity of works of art. It merely prohibits the knowing display in a place open to the public, or the publication or reproduction, of a protected work or a reproduction in an altered, defaced, mutilated, or modified form, *if* the work is displayed, published, or reproduced as being the work of the artist or under circumstances under which it would reasonably be regarded as the work of the artist and damage to the artist's reputation is reasonably likely to result.

As with the VARA, alteration, defacement, mutilation, or modification caused by the passage of time or the inherent nature of the work is not covered unless the injury results from gross negligence in maintaining or protecting the work. The conservation of art does not constitute a prohibited injury unless the work of conservation is performed negligently.

Though there is no definitive statutory provision, it appears that the artist's rights under the New York statute last only for their lifetime. Also, the New York law does not indicate whether the artist may waive their rights.

Under the New York statute and some of the state laws modeled after it, remedies include only actual damages and injunctions. The restricted rights and remedies of the New York law reflect the power of a strong art lobby comprised of art dealers, museums, art administrators, and other arts institutions, that was able to prevent passage of stronger moral rights legislation.

The New York statute was followed by legislation in Louisiana, Maine, New

Jersey, Nevada, and Rhode Island. Generally speaking, these statutes more closely mimic the New York statute than those of Massachusetts, Connecticut, New Mexico, and Pennsylvania that follow the California model. Again, there are some differences.

## Other Rights

There are numerous other laws that provide artists' rights to remedy physical injuries to their works. For example, privacy law that covers, among other things, the individual's right to object to the commercial use of their name and the right to object to being placed in a false light in the public eye, may apply where the work is mutilated, defaced, or modified and yet still commercially exploited in connection with the artist's name. The artist objects because the unauthorized commercial exploitation of their name and the attribution of authorship violate these privacy rights.

Even defamation law can be applied. When the artist's name is wrongfully associated with a mutilated version of their work, the artist's reputation suffers and the false attribution is arguably equivalent to outright defamation.

Unfair competition law also has a role to play. Under federal unfair competition law, which is embodied at Section 43(a) of the Lanham Trademark Act (18 U.S.C. Section 1125[a]), any person injured as a result of a false designation of origin or a false description of goods circulated in commerce has standing to complain. Again, where a mutilated work is commercially exploited in connection with the artist's name, then the use of the artist's name is a false designation of origin as well as a false description, and the artist has a right to take action for unfair competition. State unfair competition laws may also provide similar protection.

Moreover, publicity rights laws may apply. Under publicity rights laws, individuals have the right to prevent other persons from commercially exploiting their names, likenesses, voices, signatures, and photographs in connection with the sale or other exploitation of goods and services. Again, when the mutilated work is exploited in connection with the artist's name, the artist may contend that their publicity rights have been violated.

And, of course, the most obvious protection for any artist is the rights granted to any property owner to remedy an injury to their property. In most art destruction cases involving moral rights, the artist no longer owns the physical art object and is taking action against the new owner or some other third person. But where the artist still owns the art object, they can take legal action as the owner of tangible personal property. For instance, in a case involving a defective art preservation product, the artist, who still owned his murals, brought an action against the manufacturer for "products liability." The artist needed only to prove that the product was defective, and therefore the cause of action was properly brought against the manufacturer and the distributor, even without proof of fault.

Another cause of action for cases involving defective products that causes injury to the work is one for "breach of warranty." If the manufacturer or distributor has expressly warranted that the product is safe and useful for works of art, or the product is otherwise unmerchantable or does not fit the specific purposes for which it was sold and purchased, then the artist may have an action for breach of express or implied warranty.

These alternative legal remedies are useful, especially when moral rights do not apply. Of course the VARA will preempt the alternate remedies found in state law that provide relief equivalent to that provided under the VARA.

## PREVENTATIVE MEASURES TAKEN BY ARTISTS

In many ways, artists can protect their works in advance, especially via contractual arrangements, registrations with government agencies, and documentation.

### Contracts

Moral rights laws have numerous loopholes. One big hole is coverage itself. Because protection often extends to only traditional art forms, an artist creating a multimedia or nontraditional work may have no protection. The VARA protects paintings, drawings, prints, sculptures, photographs, and limited editions thereof. So what happens to the artist who creates a mosaic, collage, assemblage, or hologram? Such an artist will often need contractual protection.

By contract, artists can protect the physical integrity of their work so that, where moral rights protection fails, contractual protection persists. An artist can sign a contract with a buyer to protect and preserve the purchased work.

These contracts should be in writing. Although such oral contracts can sometimes be enforceable, they are difficult to prove. The written contract should clearly describe, among other things, the parties, the subject matter of the agreement (the work), the duration of protection, and the rights being protected. A good preservation agreement should give the artist at least similar protection to that provided under the VARA and the California-model moral rights statutes; e.g., it should protect the work against mutilation, distortion, modification, defacement, and destruction, and also prevent the work from being displayed in such a way that it will quickly deteriorate. In fact, the contract can go even further and require the buyer or other person in possession to actively preserve the work and protect it from injury.

Another special contract provision is to permit the artist to control and supervise installation of the work. Additionally, the artist can insist on retaining the right to enter the owner's premises and make repairs on the work. Finally, if the work is difficult to remove from the installation site, or the owner doesn't want to keep the piece after its removal, the artist can be allowed to control removal of the piece and even reclaim it if the owner wants to discard it.

The weak point of contractual protection, however, is that it only binds the parties to the contract. Though the initial buyer who signs the contract is bound, all subsequent purchasers are usually not, unless they too, subscribe to the agreement.

### Registration

Under the California statute, and some state statutes modeled after it, nonremovable works installed in buildings are *not* protected, unless the artist procures a written reservation of moral rights from the building owner, and that written instrument is recorded with the local land registry. Wherever such rule prevails, artists installing nonremovable works in buildings should procure and record these written instruments, though, as a practical matter, few building owners will ever sign them. In fact, I know of no instance in which a building owner signed a written reservation of moral rights.

Though registration is not usually an absolute prerequisite for moral rights protection, artists should consider copyright registration for their works. It helps protect the copyright and tends to preserve moral rights. Under 17 U.S.C. Section 106, one of the rights comprised within the copyright is the artist's exclusive right to "prepare

derivative works based on the original work." A "derivative work" is a new work that constitutes a recasting or transformation of the original work, in the same or other medium. Some commentators have argued that the modification of a work constitutes the preparation of a derivative work so that when the modification is made without the consent of the copyright owner (usually the artist), the copyright has been infringed. For example, when part of a painting has been repainted without the artist's consent, and the artist remains the copyright owner, some commentators believe that the artist has an action for copyright infringement. Therefore, if copyright infringement is an available remedy, the artist who has registered the copyright will be in better position; after all, for U.S. citizens, copyright registration is a prerequisite for bringing a copyright infringement lawsuit. Also, at the time of writing this chapter, early copyright registration confers additional remedies (i.e., attorneys' fees and statutory damages) on the vigilant artist that are not available to the artist who waits until damage occurs and then registers the copyright.

The VARA also has a registration system but only for works installed in buildings. Any artist whose work has been installed in a building can, but does not have to, register his name, address, the title of the work, a description of the work, photographs thereof, the location of the installation, and the name and address of the building owner with the U.S. Copyright Office. The purpose of this registration is to provide the means by which an artist can receive written notice from the building owner of their intention to remove the work from the building. Artists who fail to register may find that their works are being removed from buildings without receiving any such notice. Unfortunately, last time I contacted the Copyright Office in 1993 about VARA registrations, only one artist had registered.

## Documentation

Documentation of one's work and the materials used to create the work may not necessarily prevent art destruction but often helps remedy an injury.

When artists do not document their works, they may have difficulty proving injury. For instance, the artist who has not saved photographs of their work, taken at the time of creation or installation, may have difficulty proving the degree to which the work has deteriorated or has been mutilated or defaced. Sometimes the artist may find it difficult to prove any injury at all. Sometimes owners argue that the work has not been changed or has suffered no injury, and how is the artist to prove otherwise without documentation?

Documentation in most cases will consist of high-quality photographs. If duplicate photographs are sent in as deposits for copyright registrations or registrations under the VARA, then the artist has created a public record establishing the original shape, configuration, and appearance of the work.

Videotapes can prove useful with sculptures and other three-dimensional works. Still photographs do not always capture the essence of a large sculpture, landscape work, or kinetic work.

One case we handled shows the need to keep documentation. The artist had created a large painted outdoor sculpture. Over the years, the colors faded and the municipal owner repainted the sculpture, using different colors than those originally applied by the artist. Fortunately, the artist had photographs to show the original colors. If the artist had not maintained the photographs and if no other images were otherwise available, the artist would have had a very difficult time establishing that any

changes had been made *or* establishing the degree to which the changes injured her reputation.

Documentation of materials is also important, especially in cases involving long-term deterioration or damage. Artists should maintain records of all the materials used in creating each work of art. These records are especially useful where the materials themselves prove defective and cause the work to deteriorate.

For instance, we handled a case in which a coating applied to murals caused them to peel off the walls. The artist kept all the purchase receipts for the material, and a labeled can of the original liquid substance, which showed the name and address of the manufacturer and the ingredients. The artist's art destruction claim was sustained in court because the artist was able to prove conclusively that the product was defective. Without the purchase receipts and the can itself, the artist may not have had any case.

Another reason for keeping documentation of materials is to counter arguments by the owner of the work that defective materials, not the owner's conduct, caused the piece to be damaged or destroyed. The artist who can show that the materials were not at fault can therefore demonstrate the owner's guilt.

## CONCLUSION

Despite all the legislation, protecting art isn't easy. To prevent or remedy injury the artist must overcome many legal obstacles. Under the VARA, for example, the work must fall into one of the few protected categories; be subject to copyright protection and not be a work made for hire; be of recognized stature if destruction is to be avoided; not be subject to a waiver signed by any co-author; and injury must prejudice the artist's honor or reputation if mutilation, alteration, or distortion is to be remedied.

In short, the freestanding traditional work of fine art, created by a well-known artist *not* commissioned to create the work, is usually protected, whereas the nontraditional or multimedia site-specific work created by a less-established artist under commission is very hard to preserve.

In usual cases, artists should have no hesitation enforcing moral rights against those who would otherwise mutilate or destroy freestanding works. After all, there is no reason why the owner can't contact the artist if they want to repair or discard the piece. But artists must think twice about enforcing moral rights in connection with publicly-commissioned, nonremovable, site-specific pieces. In one case we handled, the artist wished to preserve a large, beach front, outdoor work that served many of the purposes of a pocket park because it had benches, walkways, pools of water, and landscaping. But the artist's desire was contrary to the wishes of much of the community. These cases involving large public works are becoming more commonplace throughout the country. The question is, should artists use moral rights to thwart the wishes of entire communities? Are artists' rights more important than democratic values?

Artists should look upon art preservation laws, particularly moral rights laws, as a privilege conferred on them in their capacities as spokespeople, seers, and savants of the nation. But if artists are not judicious in choosing how and when to enforce moral rights, and if they push moral rights too far, this privilege may be taken away or limited.

# PHOTOGRAPHY AND LAW

**GREGORY T. VICTOROFF**

*Gregory T. Victoroff is a partner in the Los Angeles
law firm of Rohde & Victoroff, handling contracts and
litigation involving photography, copyrights and celebrities'
rights. He is on the Board of Directors of Through
Children's Eyes, Inc., a gifted children's photography
program and frequently lectures at art schools and
universities on photography and law issues.*

Photographers' legal problems usually arise
in combinations of contract, copyright, insurance, privacy and defamation, possibly all
involved in a single case. Because photographers' legal rights are encountered in so
many different contexts, this chapter views the subject with a "wide angle lens,"
examining several major topics.

## COPYRIGHT: A BUNDLE OF RIGHTS

One of the most important legal issues confronting photographers is copyright.
Briefly, copyright is the exclusive right, under federal law to "use" a creative "work,"
such as displaying, copying, distributing, and incorporating or transforming the photo
into other works ("derivative works").

Copyright is actually several rights, i.e., the right to copy, distribute, display, etc.

As a photographer, when you own the copyright in your photo, you have the
exclusive right to decide what use is made of your photo. You profit from your copy-
right by permitting others to use certain rights for a limited period of time (such as
allowing a magazine to print your photo twice during a year). This permission is actu-
ally a license of the copyright. The chapter "Licensing Rights to Use a Work of Visual
Art" offers a more comprehensive discussion on licensing.

You may also sell your copyright in a photo, giving up all rights forever, called a
copyright assignment, or "buy-out" in the photographers' vernacular. As a basic rule,
remember that you generally earn more money by licensing limited rights, for a limit-
ed time, again and again throughout the copyright term, than you make by selling the
entire bundle of rights all at once and forever.

Market forces and special circumstances will dictate the best use to make of your
photos and at what price. The important thing is to know what you are selling, and to
make deals by choice, not by accident or mistake.

## Creating Copyright

Under the Copyright Act of 1976, a copyright automatically comes into existence at the moment the image of a photograph is "sufficiently permanent or stable to permit it to be perceived…" that is, "fixed in a tangible medium of expression." For all practical purposes, your copyright is created, automatically and instantly, when you develop negatives, prints or transparencies of the image. Legal scholars are in disagreement regarding whether copyrights can exist in unprocessed photographic film.

Don't confuse the creation of copyright with copyright notice or copyright registration.

## Copyright Notice

Since the United States joined the Berne International Copyright Convention, photos created or published in the U.S. after March 1, 1989 need not display a copyright notice. For photos created or published before March 1, 1989, copyright notice is mandatory. However, even for photos published after March 1, 1989, it is still advisable to give fair warning of your copyright ownership to anyone who sees copies of your photos by affixing a "copyright notice," to the photo.

The notice consists of three simple parts:

**1.** The symbol © ("c" in a circle) OR the abbreviation "Copr." OR the word "copyright."

**2.** The year of first publication, or fixation if unpublished.

**3.** The name of the copyright owner.

**A proper copyright notice looks like this:**

**© 1995 Jane Photobug**
or
**Copyright 1995 Joe Photobug**
or
**Copr. 1995 Joe Photobug**

That's all that is required.

A few details: note the emphasis on the word "OR" in part 1 above—the symbol © OR the abbreviation "Copr." OR the word "copyright" is required, NOT the combination: "© Copyright," often used. Also note part 3 requires the name of the copyright owner, not always the photographer, especially if the photo is a "commissioned work" or "work made for hire," discussed below. Part 2 refers to the year of "publication." This is a legal concept, meaning distribution of copies to the general public. If copies of the photo have not been offered to the public, the photo is "unpublished" and the year the photo was processed or taken should be on the notice.

The copyright notice should be "affixed" to all copies of the photo where it can be easily seen. For prints, copyright notice on the back is sufficient. Since affixing the notice directly onto film stock may damage transparencies or negatives, copyright notice may also be attached to slide mountings. However, Copyright Office Regulations state that a copyright notice affixed to plastic film sleeves used temporarily to house or wrap transparencies and negatives, is not sufficiently permanent to satisfy the pre–1989 requirement that copyright notice be affixed.

For photographs published between January 1, 1978 and February 28, 1989, if you accidentally forgot to affix copyright notice to copies of your photos, don't despair.

Efforts should be promptly made to add the missing notice to all copies, but a few copies that are accidentally distributed without notices will generally not destroy your copyright if you promptly take remedial measures. Remember also that your photo credit (i.e., "photo by Jane Photobug") is not a substitute for copyright notice, which should accompany the photo credit.

## Copyright Registration

Maximum copyright protection is achieved by "registration." This is the procedure of filling out Form VA and sending it with $20 and one copy of an unpublished photo, two copies of the best edition of a published photo, to the Copyright Office in Washington, D.C. To reduce the cost of registration, several photos can be registered as a "collection" on a single copyright registration application Form VA, requiring only one $20 registration fee. The title of the work called for in the application should be the title of the collection, for example, "Sierra Landscapes, 1996," or "Presidential Press Conference, 5/21/97."

Contrary to popular belief, registration is not a prerequisite to owning a valid copyright. Registration is a good practice, however, especially within three months of first publication. Registration when a work is published is the best way of establishing the date of your copyright and the required Library of Congress deposit is a good way to guarantee safekeeping of a sample photo.

More importantly, in case of an infringement, registration within three months permits you to claim reasonable attorneys' fees and statutory damages. In many infringement situations, being able to recover your attorneys' fees may substantially mitigate the economic burden of a copyright infringement lawsuit, making legal protection more affordable. In fact, if someone infringes your copyright, you must register your copyright before filing a lawsuit even if you hadn't registered it earlier. Registration is your "ticket to the courthouse."

## Copyright Ownership

Who "owns" the copyright in your photo? Usually, you do; you are the "author" or "creator" of the photo. From the moment of fixation through the duration of the copyright "term" (see below), your copyright is personal property, like a hat. During the term you can license others to use it for a limited time and purpose; you can use it yourself; you can sell it or leave it to your grandchildren in your will. Federal law generally requires all copyright assignments or sales to be in writing. This strict requirement helps protect valuable copyright ownership rights and is a good and highly recommended business practice. A common exception to this protection, however, is the work made for hire.

## Works Made for Hire

Photographers who sign work made for hire contracts generally lose their copyright forever, unless they can afford, and have legal grounds, to sue in court to have the contract invalidated.

A copyright may become the property of your employer automatically, without requirement of a writing, or notice to you, when the photo is taken in the ordinary course of your employment. This area of copyright law was intended to apply to staff photographers who are regular salaried employees. Most photographers, however, are not regular employees, they are independent contractors, working free lance. It was not

the intent of the Copyright Act of 1976 for such photographers to lose their copyrights as a result of a proliferation of work made for hire clauses being written into one-time employment contracts. Notwithstanding, it is an increasing practice for one-time buyers to present photographers who are independent contractors with so-called work made for hire agreements, attempting to acquire the photographer's copyrights.

It is very important to remember however, that contracts for work made for hire photographs, both for regular salaried employees as well as for photos which are "specially ordered or commissioned" (including contributions to "collective works"—such as magazines, newspapers, encyclopedias, etc., or as part of an "audiovisual work"—motion pictures or video or television programs), must be signed by you before the photograph is taken. If a would-be work made for hire employer asks you to sign a work made for hire contract *after* the photograph has already been developed and printed, the contract may be invalid. The copyright in a photograph cannot become the exclusive property of an employer, or of a party specially ordering or commissioning your work, by a work made for hire contract executed after the fact.[1]

A summary of California's exemplary effort to limit the routine and improper use of work made for hire contracts is to be found in the chapter, "Contracts for Employment." To date, California is the only state to do so.

### Copyright Term

For photos published or developed after January 1, 1978, the copyright's duration is the life of the author plus fifty years. If the photo is a work made for hire the copyright lasts seventy-five years, or one hundred years if unpublished. For older photos, the term is twenty-eight years plus a renewal term of twenty-eight additional years and nineteen more years in certain cases, for a total of seventy-five years. After expiration of the copyright term, the copyright ends and the photo falls into the public domain.

### Derivative Works · Merchandising

Using a photo on album covers, posters, T-shirts, etc. is creating what copyright law calls a derivative work. For a photographer, this is one of the most valuable rights in the bundle of copyrights, because a photo can be licensed for a wide variety of derivative work uses. Each separate license can earn the photographer additional income, through payment of license fees, royalties and periodic renewal payments. The chapter, "Licensing Rights to Use a Work of Visual Art" covers use rights and licensing in more detail.

## FEDERAL MORAL RIGHTS AND PHOTOGRAPHY

In addition to owning copyrights in photos (basically the right to control copying), under certain circumstances, photographers own an additional bundle of rights called "moral rights." Under newly-enacted moral rights legislation, federal law gives selected photographers rights to: claim "authorship" of their photos; prevent use of their names on photos they didn't take; prevent use of their names if their photos are distorted, mutilated or suffer "other modification prejudicial to the photographer's honor or reputation"; prevent any intentional distortion, mutilation or prejudicial modification

---

1 *Schiller & Schmidt, Inc. v. Nordisco Corp.*, 969 F.2d 410 (7th Cir. 1992).

to their photos; and prevent the destruction of photos of "recognized stature."

The following is a brief summary of federal moral rights law as it pertains to photographers. Detailed discussions about the Visual Artists' Rights Act of 1990 (VARA) and its provisions are provided in other chapters.

The VARA gives photographers all of the aforementioned rights to still photos under rather limited conditions.

First, although the photographic image can be either a positive or a negative, it must have been produced for exhibition purposes, or produced in multiple images of two hundred or fewer, signed and numbered by the photographer.

Second, the VARA only applies to photos: (1) created after June 1, 1991; or (2) created before June 1, 1991, but only if they were never sold or licensed exclusively (i.e., transferred) before that time.

Most importantly, the VARA does not apply to photos used in connection with posters, maps, globes, charts, movies, videos, books, magazines, newspapers, periodicals, or computer software.

If your photos qualify under all of the foregoing criteria, you may be entitled to moral rights protection under the VARA, including having the right to sue for money damages if your photos are damaged or prejudicially modified, either intentionally or, in some cases, through gross negligence. But there are still a few more rules: you must not have taken the photo as a work made for hire; you must not have signed away your moral rights (they may be waived in writing), but waiving moral rights to one numbered print in a limited edition does not waive rights to any other print; and the mutilation, destruction, false or unauthorized attribution or prejudicial modification must not have occurred more than three years prior to filing suit.

Moral rights registrations generally last for the same length of time as copyrights: your lifetime, plus fifty years. Remarkably, you keep your moral rights even if you've sold the photo; even if you've sold the copyright to the photo as well! Finally, to make things a little easier, copyright registration is not a prerequisite to filing a lawsuit for violation of your moral rights.

## PRIVACY

An individual's "right of privacy" is another valuable right protected by federal and state statutes. To avoid violating privacy rights, and safeguard their ability to sell their photographs, photographers should secure written permission, called a "release," from individuals who can be identified in their photos, including paid models. Even depicting certain property such as landmarks and private homes, may violate the property owner's right of privacy if permission from the owner is not obtained. Here are four ways a photographer can violate the right of privacy.

### (Mis)Appropriation/Right of Publicity

Using an individual's likeness for advertising or promotional purposes without the person's written consent falls into the privacy category called "appropriation" or

"right of publicity."

A person's "likeness," their face, silhouette or other recognizable image, is like a copyright, personal property, that can be licensed and used by others. For example, a model's face on the cover of a magazine is a use of the model's likeness to sell magazines.

## Intrusion

Photographs that "intrude on the seclusion" of an individual violate privacy rights. An example of this is an unauthorized photograph of a person sitting in their bathtub. Such an intrusion into a person's private life is unreasonable and actionable. Photographers should be sensitive to this privacy right, particularly when photographing on private property. In public places, a subject's reasonable expectation of privacy and seclusion is less, and the photographer is not as likely to intrude.

There is generally no liability for taking a person's photograph in a public place. This general rule was discussed in a well-known case entitled *Gill vs. Hearst Publishing Co.*[2] involving a photograph taken at Los Angeles' Farmer's Market. A photo taken in a courtroom was ruled permissible in *Berg vs. Minneapolis.*[3] Even when photographed in public places, however, a subject may still have enforceable privacy rights against unreasonable intrusions. For instance, in the case of *Daily Times Democrat Co. vs. Graham,*[4] a girl in a "funhouse" was photographed with her dress blown up over her head. The court said the photo invaded the girl's right of privacy. Similarly, when photographers hovered in helicopters, hang glided and parachuted into the celebrity weddings of Madonna and Elizabeth Taylor, rights of privacy were probably violated. In contrast, using a telephoto lens on a tugboat located far offshore to capture photos of Microsoft's Bill Gates' wedding, would probably be viewed by courts as somewhat less of an intrusion.

## False Light

This area of privacy law protects individuals from being depicted in misleading situations that may embarrass or damage the subject's reputation by creating a false impression in the viewer's mind. For example, a photo showing a subject in front of a jail or criminal court, especially in combination with a misleading caption, may show the subject in a "false light," creating the false impression that the subject had been imprisoned or had been charged with a crime. Photographers should be sure photos and their captions do not create a false or misleading impression that could be embarrassing or damaging to the subject. Photographers have been held liable in some cases involving misleading captions.

## Disclosure

Photos that make public disclosure of private facts can also be grounds for suit. Privacy law protects private facts, such as the contents of an individual's private letters or diary, from being disclosed to the public. Unauthorized photos of a private individual receiving medical treatment, or a tattoo on an individual's buttocks, might violate this category of privacy rights.

Four considerations should be used in determining whether a particular photo violates the right of privacy: the subject of the photo; the place where the photo is taken; the newsworthiness of the circumstances; and the particular use made of the

2 *Gill vs. Hearst Publishing* Co. (1953), 40 Cal.2d 224.
3 *Berg vs. Minneapolis, etc., et al.,* 79 F.Supp. 957.
4 *Daily Times Democratic Co. vs. Graham* (1964), 276 Ala. 380, 162 So.2d 474.

photo (i.e., whether in connection with news reporting, or for commercial profit).

**Subjects.** Certain subjects, such as paid models, expect that their likeness will be published and used commercially. The model licenses his or her right of privacy by signing a photo release in exchange for compensation.

Public figures such a movie stars, politicians and civic leaders have less of an expectation of privacy. The law presumes that they have consented to having their photo published more readily than private citizens.

**Place.** Where a photo is taken is another major factor affecting whether it violates privacy rights. An individual's expectation of privacy is less on public property, the public street or sidewalk, than when he or she is sitting at home in their bathtub. This distinction becomes hazy however, on public-private property (shopping malls, theaters, etc.). Many places, such as concert halls, although open to the public, are actually private property. A performer on the stage in an auditorium does not automatically consent to publication of photos taken of him or her while on stage. In fact, many artists' managers and concert promoters avoid misunderstandings by posting warnings at box offices, in concert halls and in concert programs. For concert and news photographers, even photo press passes may restrict the photographer to house photos only, no backstage or dressing room shots. Often rock and roll bands restrict photographers to shoot only during the first one or two songs, so the band is not photographed with runny mascara or disheveled hair. It is a good practice to clarify this issue when shooting on private property. Unlike copyright, privacy rights may be given (licensed) orally, without a writing. But oral releases are hard to prove years later in court. Therefore, always try to get a written release from individuals identifiable in your photos. Sample adult, minor, and property releases are reproduced at the end of this chapter.

**Newsworthiness.** Private citizens can become public figures—thrust into the public eye—by news events—accidents, crimes or natural disasters, which occasionally intrude, uninvited, into their lives. When this occurs, the public's "right to know" guaranteed by the First Amendment of the United States Constitution, for a time, outweighs the individual's privacy right, and individuals temporarily give up their protected privacy status as private citizens. In such cases, an exception to the right of privacy, called "newsworthiness," arises. How long this public figure status lasts is a disputed issue. The examples of the famous Kent State shooting photo, and photos of victorious Olympic athletes are often raised: after the passage of months or years, at some point in time, depending on the nature of the use, the publication of a private individual's likeness may cease to be newsworthy and become an invasion of privacy.

Photographers should also be aware of privacy rights involved in photographing certain property. Copyright, trademark, unfair competition and privacy rights all converge in cases of photos of objects owned by others, and such photos may violate valuable rights. For example, photos of a person's home may be so closely identified with the individual that selling such photos may violate privacy rights. In certain National Parks and National Forests, photographers must obtain permits to photograph park land or famous landmarks. In practice, these and other requirements (including insurance policies, reservations, etc.), are more strictly enforced with professional photographers using conspicuous amounts of equipment, or monopolizing a significant amount of space.

*Use.* Of particular significance is the specific use made of a photo depicting a person's likeness. Examples at opposite ends of the spectrum are snapshots displayed to a few family members and friends, contrasted with posters, baseball cards or magazines distributed worldwide. In between these extremes fall a variety of uses, some benign, such as photos in the photographer's portfolio. Other uses may be considered unfair or exploitative, such as selling merchandise bearing an individual's likeness. Special care should be taken whenever you know a photo will be used commercially, particularly in the merchandising area. If you are granting rights to use a photo, reread all model releases carefully to be sure you have the model's written consent to the use you are licensing. As profits increase on merchandise such as T-shirts, posters, key chains, etc., so too increases the measure of damages that may be assessed for the unauthorized use of an individual's likeness.

### Harassment

The previous discussion covered uses of a photo violating an individual's privacy rights. Under certain circumstances, however, merely taking a photo, that is, pointing the camera and snapping the shutter, may violate privacy rights. A famous case involved a lawsuit between Jackie Onassis and Ronald E. Galella, a photographer who continually followed Mrs. Onassis, effectively making a career out of photographing her for several years. Even though many of the photos were taken in public places, the court found the photographer's continuing presence to be harassment and surveillance and an invasion of Mrs. Onassis' privacy.[5]

Determining exactly what conduct constitutes harassment varies from case to case. Further, in different cultures, different standards apply. For example, in Amish, Hebrew and Native American cultures, the mere taking of a photograph can violate personal religious beliefs and be greatly offensive, causing emotional distress. In other cases, taking an individual's photograph may be interpreted as creating an implied contract to pay the subject. An innocent breach of this implied contract to pay can be considered stealing a personal attribute of value. When photographing an individual for any purpose (news, commercial or personal), courtesy and good manners help avoid many problems.

## DEFAMATION

Photographs are a form of nonverbal communication, and, like spoken or printed words, may be defamatory. Defamatory communications that damage a person's reputation give rise to lawsuits for "slander" if the words are spoken, or "libel" if the words are printed or broadcast. Defamation means either libel or slander.

### Libel

Photographs that constitute an untrue statement (in words or pictures) about a living person, understood by a third person, where the untrue statement subjects the person referred to in the statement, to contempt, embarrassment, obloquy, ridicule or hatred, are considered libelous. Libel is more permanent and lasting in form, and is therefore considered more serious and harmful than slander.

---

5 *Galella v. Onassis,* (2d Cir. 1973) 487 F.2d 986.

**In one famous case, a jockey was photographed for a cigarette magazine ad holding his saddle in front of him. The stirrup of the saddle hung between the jockey's legs and accidents of shadow and light created an image in the photo that appeared to give the jockey a striking horse-like physical attribute. The court there found that publishing the photo, with the caption "Smoking Camel cigarettes restores me after a crowded business day," subjected the jockey to embarrassment, humiliation and ridicule, and was defamatory.[6]**

Certain types of defamatory statements are considered so offensive they entitle the offended person to file suit without needing to prove any actual monetary damages, such as lost profits. These types of statements are called "libel per se." In many states, all libel, including photographs, is considered libel per se, the most serious form of defamation. In other states, statutes classify four kinds of statements about a person as libel per se: (1) that the person is dishonest or incompetent in their trade or business, (2) that the person is guilty of committing a crime, (3) that the person has a dreaded or contagious disease, or (4) that the person is unchaste or lacks chastity, particularly about a woman. Photographers should take great care when publishing or distributing photos that portray, or appear to portray, any of the aforementioned attributes.

### False Light

Photographs are defamatory if they portray a person in a false light, that is, a photo that communicates to third persons a false statement that subjects the person photographed to hatred, scorn, ridicule, contempt, embarrassment, humiliation, etc.

### Captions

Captions pose a special hazard even when combined with innocent photographs. A photo of John Doe with the caption "Mr. Doe walking away from a murder" if untrue, is libel per se. Photographers who submit or approve captions should take the precaution to fact check for accuracy, and obtain an indemnification from the publisher against any expense or claim arising out of material added to their photos, including captions, editorials and advertising.

### Defenses

Truth is a complete defense to defamation. In the example above, if John Doe truly is walking away from a murder, the photo and caption are not defamatory. Statements of opinion and humor (particularly political satire), that are understood by a reasonable person as such, are also not defamatory.

## OBSCENITY/CENSORSHIP

Selling or distributing "obscene" material, including photographs, is a crime resulting in serious penalties. One reason obscenity laws pose a risk to law-abiding photographers, is the difficulty that police, courts and ordinary citizens have in defining what is obscene and criminal. The late Professor Melville B. Nimmer's famous explanation that, "one man's profanity is another man's poetry," reflects the ephemeral nature of the obscenity standard. Passionate kissing and condoms, considered obscene forty years ago, are now routinely included even in films approved for child audiences.

6 *Burton vs. Crowell Publishing Company*, (2 Cir. 1936) 82 F.2d 154.

The inherent uncertainty of the obscenity standard is made even more unpredictable by politically-motivated enforcement of antipornography laws by state and federal authorities and changes in the composition of the United States Supreme Court.

### Obscenity, Harmful Matters and Minors

Photographers should be aware of the risks of criminal prosecution under federal and state child abuse laws now being used against filmmakers and artists. In two cases, one involving the actress Tracy Lords and another involving a poster of a famous painting by Academy Award winning artist H.R. Giger, individuals involved in the distribution of the works were criminally charged. Film producers, who were allegedly misled by misrepresentations by the actress/model Tracy Lords as to her age, were prosecuted under federal laws against using minors in adult films. This prosecution illustrates the high standard of care imposed on photographers regarding obtaining valid model releases. In many states, photographers must also obtain special work permits when using minors as models.

In San Francisco, California, photographer Jock Sturges was subjected to a search by local police and federal agents and seizure of his cameras, processing equipment, personal artwork, address books and other items. Despite the fact that Sturges' photos of nude families appear in the permanent collections of the Metropolitan Museum of Art and the Museum of Modern Art in New York, a federal judge issued the search warrant, claiming that Sturges' photos may violate child pornography laws. Even though he was never convicted of any crime, much of Sturges' photographic equipment was not returned for nearly a year.

### Censorship

Governmental censorship of still photos ebbs and flows with different administrations, countries and ideologies. Some recent examples in the United States are noteworthy.

The April 7, 1990 indictment of the Cincinnati Contemporary Arts Center and its Director, Dennis Berry, on charges of obscenity, in connection with photographer Robert Mapplethorpe's photo exhibition entitled "The Perfect Moment," resulted in a verdict of not guilty, but the trial cost the museum over $325,000 in legal fees. (More on the Mapplethorpe case can be found in the chapter "Art, Sex and Protest: Censorship and Freedom of Artistic Expression.")

Also, in late April, 1987, the U.S. Supreme Court disallowed the importation, into the United States, of Canadian documentary films about acid rain and nuclear proliferation, finding the films to be illegal foreign propaganda. This overbroad definition of propaganda, and the prevalent practice of jailing and deporting journalists and photographers by totalitarian governments all over the world, are vivid and timely illustrations of modern day government censorship stifling the free flow of photographs, information and ideas.

## CONTRACTS AND BUSINESS PRACTICES

Attending to business matters in photography, while not as exciting as taking pictures, can be just as rewarding in many respects.

## Record Keeping

Keeping careful, organized records of photos sold or licensed, and files of professional expenses and correspondence, is well worth the minor inconvenience. Job purchase orders, invoices and receipts generate income from clients and savings on tax returns. Losing track of documents and contracts can mean losing income, and incurring additional taxes and expenses.

## Contracts for Sale of Photos

Read every contract presented to you. Ideally, every contract is negotiable and should reflect promises by both sides. In many situations, a handwritten purchase order may be the only contract involved in a transaction. Beware of printed forms in which you forfeit your copyrights by a work made for hire clause. Remember that a work made for hire contract is invalid if signed after the photos have already been taken.

In preparing or reviewing a contract for sale of photos, specify the photos, the parties (photographer and buyer), the media in which the photos may be used, and the price. A good practice to protect your copyrights is to spell out the use for which the photos are sold in plain English: i.e., "two 35mm color transparencies and negatives of (subject) to be used in 1998 annual report only"; or "two 35mm color negatives of (subject) for U.S. publication only in 1998 magazine ad campaign"; or "for 1998 brochure only," or "for (1) magazine cover use and (2) inside uses for one year," or "for any use for one year excluding publication or merchandising." It is good practice to include a statement regarding copyright ownership by using the phrase: "all photos © 1998 (your name)" on any purchase order or invoice, although this is not a prerequisite to retaining ownership in your copyrights. (See previous copyright section regarding necessity and proper manner of affixing copyright notice.) Requiring a photo credit, "Photo by (your name)," whenever the photo is published, provides valuable publicity and prestige. Some photographers include a penalty clause in their contracts, charging an additional fee if an agreed on photo credit is omitted.

## Licensing Agents, Representatives and Distributors

Photographers should take great care in entering into agreements with licensing agents, stock houses or other photo distribution representatives who are given authority to distribute, sell or license the photographer's images.

Under such agreements, the photographer delivers copies of his or her best work to a trusted individual or company, sometimes called a "distribution syndicate," "licensing representative" or "licensing agent."

To facilitate the agent's or representative's ability to license rights in the photos, the photographer often gives the agent authority to grant copyright licenses to third parties, either in the agent's own name or on behalf of the photographer. The agreement further provides for payment to the photographer of royalties or a percentage of any license fee collected by the agent or representative.

But a recent court decision turned this common business arrangement into a photographer's nightmare.[7] When a photo distribution syndicate failed to pay a photographer his share of license fees, yet continued to license and distribute the photographer's photos even after the photographer declared the representation agreement terminated, the photographer sued the distribution house for infringement of

7 *Rano v. Sipa Press, Inc.,* 987 F.2d 580 (9th Cir. 1993).

copyrights. Unbelievably, the court refused to permit the photographer to terminate the agreement! The court based its decision on the following facts: even though the photographer had only given the distribution representative nonexclusive oral permission to distribute the photos, because the oral agreement was later confirmed in letters between the parties, the court deemed the permission given to the distributor to be a "transfer of copyright" under U.S. copyright law. Since the agreement did not specify a definite time limit or duration, the court considered the permission to be perpetual, lasting forever. Further, because the agreement dealt with copyrights, the court found that state laws that would normally have given the photographer the right to terminate an "at-will" contract at any time, were preempted, or superseded by federal copyright law. Finally, the court declared that even though the distributor failed to pay the photographer what was owed, such failure was not a "material" breach of the agreement, and so the photographer was prevented from "rescinding" or canceling the agreement.

The only good news for the photographer was that U.S. copyright law permits "termination of transfers," so that the distributor's agreement (or even an outright sale of copyrights) can be canceled or terminated for no reason at no cost. The bad news however, if that termination of transfers cannot be made until thirty-five years after the contract begins!

Important lessons can be learned from this case: First, always be sure to limit any licensing agency agreements to a specified term of years. The agreement can always be extended or renewed if the relationship is working out. Second, always provide that a failure to make royalty or other payments on time and in full, will constitute a material breach, permitting termination. Finally, avoid ambiguities that can be interpreted against you in court by always using written rather than oral contracts.

### Risk of Loss

Photographers are particularly at risk sending undeveloped exposed film through the mail, or surrendering film or transparencies to a photo stockhouse, laboratory, or client. Whenever practical, proof sheets or duplicate transparencies should be used when you have to relinquish physical control or possession of photos. By operation of written disclaimers usually printed on photo processing receipts, photo labs will generally be liable for only the value of unexposed film, lost or damaged in processing, not the fair market value of your "once-in-a-lifetime" photos.

In some circumstances you can reduce or shift some of the risk of loss of photos by using a form such as the American Society of Media Photographers (ASMP) Delivery Memo reproduced at the end of this article, or other contracts that specify an agreed value for each negative or transparency. This sum is stipulated in the contract as "liquidated damages" in the event of loss or damage. In this way, the value of lost photos is less speculative and more likely recoverable in a lawsuit for damages or through an insurance claim. (See later section on Insurance.)

Courts have also considered the following in fixing damages for lost transparencies: technical excellence, the photographer's prestige, earning level, and "selective eye," uniqueness of the subject matter, established sales or use prices and other factors.[8]

### Assignments and Licenses

A major responsibility in the photography business is keeping track of copyrights

---

8 *Rattner v. GEO Magazine, New York Law Journal,* p. 39, Ccl.2 (N.Y. CNTY, March 16, 1987).

you own and license and copyrights you sell outright. Every copyright assignment (sale) and license should be in writing. A simple invoice stating the permitted use of a photo (see Sale of Photo section above), is a form of copyright license. (For a more detailed discussion of use licenses, see chapter "Licensing Rights to Use a Work of Visual Art.") A copyright assignment or buy-out contract should, at a minimum, identify the specific work being purchased (i.e., the subject of the photo), the names of the copyright owner (seller) and buyer, the price, and that the copyright is assigned by the owner to the buyer. A verbal or oral promise to sell a copyright does not comply with U.S. copyright law requirements.

Calling the sale a copyright assignment in a contract is preferable to transferring copyright ownership by including work made for hire language in a contract. A photo deemed a work made for hire is instantly and forever the property of the employer/buyer. A copyright assigned to the buyer, however, is subject to termination of transfers provisions in the U.S. copyright law. Copyright ownership in photos so assigned can be reclaimed by the seller/photographer during a five year period commencing thirty-five years after the transfer or assignment. A complete copyright buy-out or work made for hire provision may be required by some buyers. In this event, the purchase price should be greater, to reflect this comprehensive transfer of rights. Remember, even a contract containing a work made for hire clause does not preclude payment of royalties, or a reversion of copyrights to the photographer after a certain number of years, or other provisions beneficial to the photographer, if such terms are included in the agreement. When negotiating contracts, remember: "if you don't ask, you don't get."

## Releases

Previously discussed in the Privacy section of this chapter, the right to appropriate or use a person's likeness in a photograph should be set forth in a written agreement between the subject and the photographer that releases or relinquishes the privacy rights of the subject, and permits, authorizes or licenses the use of the likeness.

Obtain a signed release whenever possible. Some photographers carry several short form releases typed on index cards in their camera cases at all times. An executed release from an individual who later achieves fame or celebrity can be very valuable. A minor's release, signed by a parent or guardian, is required when photographing children or a subject below the legal age. Because the legal age of consent varies from state to state, it is good practice to obtain a parent's or guardian's signature whenever there is any question of whether a subject is under twenty-one years of age. Property releases, signed by the owner of property photographed, safeguard you against possible unfair competition claims and privacy, copyright and trademark infringement suits.

## Collections

Probably the most frequent business problem confronting photographers involves collecting money owed to you on unpaid accounts. Of necessity, the photography process requires spending large amounts of money on equipment rental, transportation, film and processing, usually before receiving full payment. Receiving slow or late payment after you have incurred substantial expenses is an enormous drain on cash flow for a small business.

Fortunately, a few simple business practices can avoid or mitigate many collection problems.

**C.O.D.** A cash on delivery practice, while not the usual custom between merchants, is a first line of defense against late payments. One-half payment in advance of delivery is even better and neither unfair nor uncommon. You lose a lot of bargaining strength once you have delivered prints, negatives and transparencies and are asked to wait sixty to ninety days for payment.

**Purchase Order, Invoice, Delivery Memo, Checks.** Using a written contract (purchase order, invoice or delivery memo) for each job, specifying cash on delivery or one-half payment in advance, is suggested. It is also essential that you keep a record of the name, phone number and an actual address (not post office box) of the buyer. The contract is a good place to write this. If the buyer does not pay, or gives you a bad check, you must have the actual address where the buyer is located to effect personal service of a small claims court lawsuit. Also, it is an excellent practice to photocopy checks given to you by a buyer before you deposit them. A photocopy of the face of a check discloses vital information including the name and address of both the buyer and the bank, and, more importantly, the buyer's bank account number. This information is invaluable and must be included on instructions to the sheriff or marshal when collecting small claims judgments (see below).

**Small Claims Court.** In most cities and towns, small claims courts are available to consumers and small businesses alike, to quickly and inexpensively settle disputes involving small amounts, generally up to about $5000. Unpaid accounts jeopardize your business and dissipate creative energy. Small claims courts work well in helping to resolve late payment problems quickly and fairly.

## INSURANCE

Another aspect of any business is trying to anticipate everything that might go wrong. A little time spent anticipating unexpected yet common problems, such as auto accidents, illness, fire or theft, can make the difference between a minor inconvenience and a major disaster.

In the photography business, insurance is indispensable. In fact, insurance policies covering locations and rented camera equipment are required as part of many rental agreements. Auto insurance is required by law in many states, and if you hire an assistant or other staff you may be legally required to obtain workers compensation and disability insurance for them. If you are self-employed, and want medical insurance, you may have to obtain it without the benefit of large group plan discounts. Premiums for many kinds of insurance are costly and can become unaffordable if they are not budgeted into the cost of doing business, or when coverage is needed for extraordinary or unusual risks. A listing of artists' insurance organizations appears in the resource appendix.

### Auto, Health

Risks covered by medical and auto insurance have little to do with photography but the unexpected weekend bicycle accident that turns out to be serious, or your teenage assistant hitting a pedestrian while rushing to a shoot, can be catastrophic if you are uninsured or underinsured.

### Homeowners, Renters, Studio, Cameras, Film

Hurricanes, earthquakes, floods and crime are unpleasant realities. Homeowners, renters or studio contents insurance, cover a multitude of accidents and losses that may occur in the studio, home or apartment. Special coverages, called "floater" policies can be purchased to insure camera and studio equipment, which should be itemized and listed in detail on the policy. Photographs of camera equipment are invaluable in proving exactly what was lost and the condition of the lost or stolen property. It is very important to specify "replacement value" coverage rather than "fair market value" coverage, as the latter will only reimburse you for the depreciated value of your lost equipment. The additional cost of replacement value coverage is often well justified. Separate photographic equipment policies can be obtained to cover equipment outside your home or studio. Policies for camera malfunction or loss, or film loss or damage during processing are available and recommended for major jobs. These policies cover the costs of reshooting or replacing lost film and are your best protection when turning film over to an outside processing lab.

### General Liability/Locations

Insurance covering accidents or injuries to others occurring in your home, apartment, studio or on location, should be included as part of your homeowner's or renter's policies. It is also a standard practice at many locations to require photographers to show proof of insurance as a prerequisite to using the location. It is also a good business practice when shooting away from your studio to have this kind of insurance, because, on location, you cannot control many factors that can give rise to an accident or loss. Locations requiring $1,000,000 in coverage are not uncommon. A $1,000,000 policy covering location shooting for twelve months, costs about $500.

## ASSAULT AND BATTERY

If you are threatened, hit or even touched in an offensive manner, the person doing the offensive touching can be liable for damages in a civil lawsuit for assault or battery or both and may face criminal prosecution. This discussion is included in response to a disturbing trend by overzealous bodyguards, who assault and batter photographers. To make things worse, some celebrities enhance their notoriety by open hostility to photographers, who become even more determined as the value of the celebrity's photo increases. Such attacks are usually actionable, either as criminal violations or civil torts.

In civil law, an assault occurs if an individual puts you in reasonable fear of imminent bodily harm, such as raising a fist in a menacing manner, giving the immediate impression of impending attack. Battery occurs when you are actually touched in any offensive way. Although more than a rude bump is required (something that might occur in a crowded elevator), the force of the touching is not as important an issue as the malicious or evil intentions of the person doing the touching. Roughing up unwelcome photojournalists is not generally tolerated in modern American society. In such cases, civil courts and insurance companies often provide the best revenge. In foreign countries, however, where police, military personnel and civilians are not constrained by U.S. civil laws, the best advice is to duck.

## ADULT RELEASE

In consideration of my engagement as a model, and for other good and valuable consideration herein acknowledged as received, I hereby grant to _____ ("Photographer"), his/her heirs, legal representatives and assigns, those for whom Photographer is acting, and those acting with his/her authority and permission, the irrevocable and unrestricted right and permission to copyright, in his/her own name or otherwise, and use, re-use, publish, and re-publish photographic portraits or pictures of me or in which I may be included, in whole or in part, or composite or distorted in character or form, without restriction as to changes or alterations, in conjunction with my own or a fictitious name, or reproductions thereof in color or otherwise, made through any medium at his/her studios or elsewhere, and in any all media now or hereafter known for illustration, promotion, art, editorial, advertising, trade or any other purpose whatsoever. I also consent to the use of any printed matter in conjunction therewith.

I hereby waive any right that I may have to inspect or approve the finished product or products and the advertising copy or other matter that may be used in connection therewith or the use to which it may be applied.

I hereby release, discharge and agree to save harmless Photographer, his/her heirs, legal representatives and assigns, and all persons acting under his/her permission or authority or those for whom he/she is acting, from any liability by virtue of any blurring, distortion, alteration, optical illusion, or use in composite form, whether intentional or otherwise, that may occur or be produced in the taking of said picture or in any subsequent processing thereof, as well as any publication thereof, including without limitation any claims for libel or invasion of privacy.

I hereby warrant that I am of full age and have the right to contract in my own name. I have read the above authorization, release, and agreement, prior to its execution, and I am fully familiar with the contents thereof. This release shall be binding upon me and my heirs, legal representatives, and assigns.

NAME _____

ADDRESS _____ CITY/STATE/ZIP _____

WITNESS _____ DATE _____

## SIMPLIFIED ADULT RELEASE

For valuable consideration received, I hereby grant to_____ ("Photographer") the absolute and irrevocable right and unrestricted permission in respect of photographic portraits or pictures that he/she had taken of me or in which I may be included with others, to copyright the same, in his/her own name or otherwise; to use, re-use, publish, and re-publish the same in whole or in part, individually or in conjunction with other photographs, and in conjunction with any printed matter, in any and all media now or hereafter known, and for any purpose whatsoever for illustration, promotion, art, editorial, advertising and trade, or any other purpose whatsoever without restriction as to alteration; and to use my name in connection therewith if he/she so chooses.

I hereby release and discharge Photographer from any and all claims and demands arising out of or in connection with the use of the photographs, including without limitation any and all claims for libel or invasion of privacy.

This authorization and release shall also inure to the benefit of the heirs, legal representatives, licensees, and assigns of Photographer, as well as the person(s) for whom he/she took the photographs.

I am of full age and have the right to contract in my own name. I have read the foregoing and fully understand the contents thereof. This release shall be binding upon me and my heirs, legal representatives, and assigns.

NAME _____

ADDRESS _____ CITY/STATE/ZIP _____

WITNESS _____ DATE _____

*(Both forms reprinted with permission by the ASMP.)*

## MINOR RELEASE

In consideration of the engagement as a model of the minor named below, and for other good and valuable consideration herein acknowledged as received, upon the terms hereinafter stated, I hereby grant to _____ ("Photographer"), his/her heirs, legal representatives and assigns, those for whom Photographer is acting, and those acting with his/her authority and permission, the absolute right and permission to copyright and use, re-use, publish, and re-publish photographic portraits or pictures of the minor or in which the minor may be included, in whole or in part, or composite or distorted in character or form, without restriction as to changes or alterations from time to time, in conjunction with the minor's own or a fictitious name, or reproductions thereof in color or otherwise, made through any medium at his/her studios or elsewhere, and in any and all media now or hereafter known for art, advertising, trade or any other purpose whatsoever. I also consent to the use of any printed matter in conjunction therewith.

I hereby waive any right that I or the minor may have to inspect or approve the finished product or products or the advertising copy or printed matter that may be used in connection therewith or the use to which it may be applied.

I hereby release, discharge and agree to save harmless Photographer, his/her legal representatives or assigns, and all persons acting under his/her permission or authority or those for whom he/she is acting, from any liability by virtue of any blurring, distortion, alteration, optical illusion, or use in composite form, whether intentional or otherwise, that may occur or be produced in the taking of said picture or in any subsequent processing thereof, as well as any publication thereof, including without limitation any claims for libel or invasion of privacy.

I hereby warrant that I am of full age and have every right to contract for the minor in the above regard. I state further that I have read the above authorization, release, and agreement, prior to its execution, and that I am fully familiar with the contents thereof. This release shall be binding upon me and my heirs, legal representatives, and assigns.

_____
MINOR'S NAME

_____
MINOR'S ADDRESS           CITY/STATE/ZIP

_____
FATHER/MOTHER OR GUARDIAN

_____
ADDRESS           CITY/STATE/ZIP

_____
WITNESS           DATE

*(Reprinted with permission by the ASMP.)*

## PROPERTY RELEASE

For good and valuable consideration herein acknowledged as received, the undersigned, being the legal owner of, or having the right to permit the taking and use of photographs of, certain property designated as_____, does grant to_____ ("Photographer"), his/her heirs, legal representatives, agents, and assigns the full rights to use such photographs and copyright same, in advertising, trade, or for any purpose.

The undersigned also consents to the use of any printed matter in conjunction therewith.

The undersigned hereby waives any right that he/she/it may have to inspect or approve the finished product or products, or the advertising copy or printed matter that may be used in connection therewith, or the use to which it may be applied.

The undersigned hereby releases, discharges, and agrees to save harmless Photographer, his/her heirs, legal representatives, and assigns, and all persons acting under his/her permission or authority, or those for whom he/she is acting, from any liability by virtue of any blurring, distortion, alteration, optical illusion, or use in composite form, whether intentional or otherwise, that may occur or be produced in the taking of said picture or in any subsequent processing thereof, as well as any publication thereof, even though it may subject me to ridicule, scandal, reproach, scorn, and indignity.

The undersigned hereby warrants that he/she is of full age and has every right to contract in his/her own name in the above regard. The undersigned states further that he/she has read the above authorization, release, and agreement, prior to its execution, and that he/she is fully familiar with the contents thereof. If the undersigned is signing as an agent or employee of a firm or corporation, the undersigned warrants that he/she is fully authorized to do so. This release shall be binding upon the undersigned and his/her/its heirs, legal representatives, successors, and assigns.

_____
NAME                                                    DATE

_____
ADDRESS                                                 CITY/STATE/ZIP

_____
WITNESS

*(Reprinted with permission by the ASMP.)*

### AMERICAN SOCIETY OF MEDIA PHOTOGRAPHERS (ASMP)

ASMP, a trade association for photographers whose work is produced for publication, was established in 1944 to promote high professional and artistic standards in photography. The organization works to further the professional interests of its more than five thousands members by disseminating information on a wide range of subjects and concerns.

14 Washington Road
Suite 502
Princeton Junction,
New Jersey 08550-1033
Telephone (609) 799-8300
Fax (609) 799-2233

# STOCK PHOTOGRAPHY DELIVERY MEMO

TO:

DATE:
SHIPMENT NO.:

PHONE NO.:

PROJECT:
OUR JOB NO.:

ORDERED BY:
CLIENT:

YOUR P.O. NO.:
YOUR JOB NO.:

PHOTOGRAPHS TO BE RETURNED BY:

| QTY. | ORIG. (O) DUPL. (D) | FORMAT | PHOTOGRAPH SUBJECT/ID NO.: | VALUE (IF OTHER THAN $1500/ITEM) IN EVENT OF LOSS/DAMAGE |
|------|---------------------|--------|----------------------------|---------------------------------------------------------|
|      |                     |        |                            |                                                         |

TOTAL COLOR _____     TOTAL B&W

Check count and acknowledge by signing and returning one copy. Count shall be considered accurate and quality deemed satisfactory for reproduction if said copy is not immediately received by return mail with all exceptions duly noted. Photographs must be returned by registered mail, air courier or other bonded messenger which provides proof of return.

SUBJECT TO ALL TERMS AND CONDITIONS ABOVE AND ON REVERSE SIDE

ACKNOWLEDGED AND ACCEPTED:_____   _____

PLEASE SIGN HERE                                    DATE

## TERMS AND CONDITIONS

1.  "Photograph(s)" means all photographic material furnished by Photographer hereunder, whether transparencies, negatives, prints or otherwise.

2.  After 14 days, the following holding fees are charged until return: Five Dollars ($5.00) per week per color transparency and One Dollar ($1.00) per week per print.

3.  Submission is for examination only. Photographs may not be reproduced, copied, projected, or used in any way without (a) express written permission on Photographer's invoice stating the rights granted and the terms thereof and (b) payment of said invoice. The reasonable and stipulated fee for any other use shall be three times Photographer's normal fee for such usage.

4.  Client assumes insurer's liability (a) to indemnify Photographer for loss, damage, or misuse of any photographs and (b) to return all photographs prepaid, fully insured, safe and undamaged, by bonded messenger, air freight, or registered mail. Client assumes full liability for its principals, employees, agents, affiliates, successors and assigns (including without limitation messengers and freelance researchers) for any loss, damage, or misuse of the photographs.

5.  Reimbursement by Client for loss or damage of each original transparency shall be in the amount of One Thousand Five Hundred Dollars ($1,500), or such other amount set forth next to said item on the front hereof. Reimbursement by Client for loss or damage of each other item shall be in the amount set forth next to said item on the front hereof. Photographer and Client agree that said amount represents the fair and reasonable value of each item, and that Photographer would not sell all rights to such item for less than said amount.

6.  Photographer's copyright notice "© [YEAR OF FIRST PUBLICATION] [PHOTOGRAPHER'S NAME]" must accompany each use as an adjacent credit line. Invoice amount will be tripled if said credit is not provided.

7.  Client may not assign or transfer this agreement, or any rights granted hereunder. This agreement binds and inures to the benefit of Photographer, Client, Client's principals, employees, agents and affiliates and their respective heirs, legal representatives, successors and assigns. Client and its principals, employees, agents and affiliates are jointly and severally liable for the performance of all payment and other obligations hereunder. No amendment or waiver of any terms is binding unless set forth in writing and signed by the parties. This agreement incorporates by reference Article 2 of the Uniform Commercial Code, and the Copyright Act of 1976, as amended.

8.  Except as provided in [9] below any dispute regarding this agreement shall be arbitrated in [PHOTOGRAPHER'S CITY AND STATE] under rules of the American Arbitration Association and the laws of [STATE OF ARBITRATION]. Any dispute involving $_____ [LIMIT OF LOCAL SMALL CLAIMS COURT] or less may be submitted without arbitration to any court having jurisdiction thereof. Client shall pay all arbitration and court costs, reasonable legal fees, and expenses, and legal interest on any award or judgment in favor of Photographer.

9.  Client hereby expressly consents to the jurisdiction of the federal courts with respect to claims by photographer under the Copyright Act of 1976, as amended.

10. Client will not make or permit any alterations, additions, or subtractions in respect of the photographs, including without limitation any digitalization or synthesization of the photographs, alone or with any other material, by use of computer or other electronic means or any other method or means now or hereafter known.

11. Client will indemnify and defend Photographer against all claims, liability, damages, costs, and expenses, including reasonable legal fees and expenses, arising out of any use of any photographs for which no release was furnished by Photographer, or any photographs which are altered by Client. Unless so furnished, no release exists.

# Contracts and Business Practices

# CONTRACTS: GET THEM IN WRITING

**SUSAN A. GRODE AND DEBRA L. FINK**
*Susan A. Grode, Esq. is a partner in the law firm of
Kaye, Scholer, Fierman, Hays and Handler and
specializes in matters relating to creators and their creations
in the fields of entertainment, publishing and the
visual arts. Ms. Grode is counsel to many artists' groups
and foundations and has lectured to members of the bar
as well as artists at UCLA and USC. She is a
graduate of Cornell University and the
University of Southern California Law School.*

*Debra L. Fink, Esq. is an attorney in Los Angeles.
She received her A.B. degree, magna cum laude, in
Communications from the University of Miami
and her J.D. degree from Loyola Law School.*

Apublisher makes an offer to do a print
edition and prints and sells certain pieces that the artist insists are off register and are
of inferior quality. A company art director asks for a slide presentation of designs that
an artist submits at a cost of $50 for slides, binders and postage. The slides are never
returned and the artist later discovers her modified designs decorating the company's
most popular products. A patron commissions a portrait/sculpture or photographic
study. The sculptor or photographer submits his maquette or proofs for approval and
discovers that the patron has lost interest and refuses to pay. A painter executes a mas-
sive mural for an office building and later discovers that the mural is to be demolished
along with the building.

Visual artists who put their work into the stream of commerce must know how to
deal with the business and professional relationships surrounding that work well before
the creative process begins. Traditionally, artists have relied on verbal agreements with
galleries, museums, art directors, publishers, purchasers, managers, agents and repre-
sentatives. But oral understandings generally lack sufficient detail to constitute a
binding contract. Artists, often unknowingly, relinquish important rights and fail to
take precautions against injury to themselves, their artwork and their reputations
because they have neglected the security of a written agreement.

The graphic artist could have requested written aesthetic and technical approval
of the print edition as a condition of the publisher being able to sell it. The designer
could have placed copyright notices on all slides and required a delivery invoice,
signed by the company (noting the copyright and a prohibition against reproduction)

requiring payment for each slide not returned within a specific time period. The sculptor/photographer could have insisted that the patron sign an agreement detailing approvals and payments at each stage of the work. The painter could have prepared a written agreement providing that in the event of alteration (painting, redecorating) or destruction of the building, the owner could not paint over or mutilate the mural and that the painter would have the right and ample time to remove the mural itself.

Negotiations can take place sporadically, over long periods of time, among many participants, with numerous changes in the general and specific terms of commitment. It is unlikely then, that all parties to an agreement will, at any time, have the same recollection and understanding of exactly what the "final terms" are. Therefore, it is advisable to use some form of written document: letter, memorandum, notice, short-form agreement, or attorney-drafted contract. When it is not possible to determine all the details before a contract is signed, state in the agreement itself that the details included are preliminary. Provide that within a certain period of time after signing the agreement, the parties will develop a mutually agreed upon plan.

A contract may be simply defined as a legally enforceable agreement between two or more parties. It may be oral and it may even be implied by circumstances (each party fulfilling substantial independent obligations as though an agreement actually existed).

However, a written contract, whether informal correspondence or formally prepared, accomplishes the following:

♦ Reduces the risk of misunderstanding by providing a written record describing relationships, rights and responsibilities.

♦ Provides a ready reference for settling disputes concerning the intention of each party at the time the contract was executed.

♦ Often specifies the procedure to resolve any controversy arising out of the agreement, such as the use of mediation or arbitration.

♦ Encourages cooperation.

♦ Provides tangible, reliable and convincing evidence when attempting to enforce the agreement in court.

If your bargaining position is not sufficiently strong to demand a formal legal document, compose a shorter, less formal agreement. If that doesn't work, write a letter and have it signed as "agreed to and accepted" by all parties. Invoices and printed forms, work orders and project sheets, bills of sale and consignment receipts can be used as binding written agreements.

The investment you make in your art is considerable in terms of time, money and emotion. It is up to you to protect it—in writing.

# ANALYSIS OF AN EXCLUSIVE GALLERY AND PUBLISHING AGREEMENT

**GREGORY T. VICTOROFF**

*Gregory T. Victoroff is a partner in the Los Angeles law firm of Rohde & Victoroff. He represents artists, dealers, galleries and collectors in connection with fine art and copyright law litigation and contracts. He has been the co-chair of the Committee for the Arts of the Beverly Hills Bar Association since 1987, and is a frequent author and lecturer on copyright, art and entertainment law.*

———

## THIS AGREEMENT

IS MADE THIS _____ DAY OF _____ , 199____

BETWEEN_____ (HEREINAFTER REFERRED TO AS "GALLERY")

AND _____ (HEREINAFTER REFERRED TO AS "ARTIST").

## 1. Term

The initial term of this Agreement shall be for two (2) years, (the "Initial Term") with three (3) consecutive one (1) year options. The Initial Term shall commence on the date of execution hereof. The Agreement is automatically renewed for each option year unless Gallery notifies Artist in writing of Gallery's desire to terminate the Agreement. Gallery's notice shall be given to Artist prior to the expiration of the end of the second year of the Initial Term, or prior to the expiration of each option year.

*From the gallery's perspective, it is desirable to have a unilateral option to extend the term of the agreement for as long as possible, having the choice of dropping the artist after the initial term if his or her work is not selling well, or keeping the artist tied to the agreement if the gallery is profiting in the relationship. From the artist's perspective, it is preferable for any option to extend the term of the agreement to be mutual, requiring the consent of both parties. Ideally for the artist, the agreement should be terminable for any reason on thirty-days written notice to the gallery. At a minimum, the artist should have an express right to terminate the agreement if the gallery fails to pay the artist on time, or breaches the agreement, (see paragraph 14 below), or if the artist's income from the gallery's activities does not meet a specified minimum.*

## 2. Exclusivity

Artist hereby designates and appoints Gallery as Artist's exclusive dealer, throughout the universe during the term of this Agreement, and any extensions thereof, to offer

for sale and authorize others to offer for sale all of Artist's two or three dimensional works, (including, without limitation, original paintings, watercolors, drawings, sculptures, posters, lithographs, etchings, serigraphs, photographic works, as well as all works in analog, digital or electronic media including video, CD-ROM, CD-Interactive, or any other medium now known or hereafter devised, heretofore created or hereafter created by Artist during the term hereof and any extensions thereof, including commissioned works created during the term hereof.

*The gallery's intention here is to acquire total exclusive control over the sale of artist's original works during the term in any medium whatsoever, including resale of preexisting works and commissioned works. From the artist's perspective, it is often desirable to exclude certain works, such as commissioned works, preexisting works, studio sales and sales to the artist's preexisting house accounts, from the scope of the gallery's exclusive rights, or to exclude media in which the artist has not previously worked, or where the artist has ongoing channels of commercial distribution.*

**2.1.** During the term of this Agreement, Artist hereby appoints Gallery as the exclusive publisher of Artist's work throughout the universe to produce, sell and otherwise market fine art limited editions, poster editions, sculpture editions, and other forms of Artist's work as Gallery may decide to publish in its sole discretion.

**2.2.** During the term of this Agreement, Artist agrees not to perform any services as an Artist for compensation other than pursuant to this Agreement, nor to enter into any agreements with others for the use of Artist's name, likeness, signature, or other identification for the reproduction, marketing, sale, or other disposition of artwork, without the written consent of Gallery.

*In addition to having the exclusive rights to control the sale of the artist's work, the gallery will also serve as the artist's exclusive publisher of fine print multiples as well as poster editions. From the artist's perspective, it is unfair to grant exclusive publishing rights to the gallery without a firm commitment from the gallery to publish a guaranteed minimum of editions. (See paragraph 3.7 below.) The artist should also exclude from this limitation any preexisting licenses to use the artist's name, any licenses granted to charitable institutions, or other exceptions requested by the artist.*

## 3. Gallery's Duties

Gallery shall pay Artist fifty percent (50%) of the retail or wholesale selling price of all original paintings, whether watercolor, oil, acrylic, or otherwise, and drawings, except as otherwise agreed to herein. The fifty percent (50%) profit split shall be applied toward all paintings and drawings after twenty-four (24) original paintings no smaller than 36x48–inches are selected by Gallery and purchased by Gallery for the sum of _____ dollars ($_____ ) each, totaling a guaranteed draw of _____ dollars ($_____ ) per month. (See paragraph 5 below.) Gallery has the option to select any twenty-four (24) original paintings no smaller than 36x48–inches out of a guaranteed minimum of fifty (50) originals to be delivered to Gallery during each twelve (12) month period of the Agreement including option years. Oil paintings, watercolors or drawings or other original nonsculptural works sold other than the twenty-four (24) paintings selected by Gallery each year of the Agreement shall be sold by Gallery, and the net selling price shall be split fifty percent (50%) to Gallery and fifty percent (50%) to Artist.

*This is the real heart of this "output" contract. The gallery receives the right to choose twenty-four large original paintings out of a minimum of fifty that must be created by the artist during each year of the agreement. The gallery owns these paintings outright and may sell or dispose of them without sharing any of the profits with the artist. In return, the artist is paid a guaranteed draw each month. On sales of the remaining twenty-six paintings, after the gallery has deducted its framing charges and promotion and advertising fees (see paragraphs 3.1, 3.2 below), the artist and gallery split proceeds fifty/fifty. From the artist's perspective, fifty large paintings per year is an overwhelming burden that few artists could satisfy, regardless of how much money they are paid, especially in light of the additional work required of the artist in connection with published works described below. A more reasonable annual output would be twenty to thirty paintings. Also, the promise of a fifty/fifty split is deceptive; after deducting the gallery's additional charges, the artist's real share is considerably less than 40%.*

**3.1.** Gallery shall frame all original artwork at Gallery's own expense and Gallery shall be entitled to deduct two times the actual cost of framing before calculating Artist's share of the net selling price.

*From the artist's perspective, two times the framing costs is excessive. From the gallery's perspective, doubling framing costs is a good way to recoup expenses involved in arranging for framing. Framing style and costs should be mutually agreed on prior to framing.*

**3.2.** Gallery shall be entitled to deduct a ten percent (10%) promotion and advertising fee from the net selling price of any paintings sold by Gallery before calculating Artist's share of the net selling price.

*From the gallery's perspective, an additional 10% deduction helps defray the gallery's overhead. From the artist's perspective, this additional 10% deduction is unfair "double dipping" giving the gallery an extra 10% for expenses that should be part of the gallery's normal overhead. If there is an agreement to deduct 10%, the artist should be given an annual statement about where the money was spent; and add a contract provision ensuring that any money deducted is actually spent directly on the artist's behalf.*

**3.3.** All funds received that are due to Artist will be held in trust by the Gallery for the benefit of Artist and remitted to Artist every ninety (90) days together with a full accounting.

*The gallery agrees to hold proceeds from sales of the artist's work in trust for the artist and to account for and pay the artist's share every ninety days, or quarterly, rather than twice a year. The creation of an express trust helps guarantee the artist's receipt of his or her money, even if the gallery goes bankrupt. Trust funds are usually exempt from claims of the gallery's creditors, and federal bankruptcy judges accord greater respect to express trusts, than to state law created trusts for consigned artwork, such as contained in the civil laws of many states.*

**3.4.** Unless otherwise agreed to herein, Gallery shall adequately insure all original artwork created by Artist and delivered to Gallery at all times once received by Gallery. Gallery shall pay for all transportation charges relating to the delivery and/or shipping of original artwork of Artist unless otherwise agreed to between Artist and Gallery.

*The gallery agrees to insure all work at its own expense and pay for all shipping costs. These important cost factors are often overlooked in gallery agreements. The gallery should assume the risk of damage, loss or destruction of any work.*

**3.5.** Gallery shall receive fifty percent (50%) of the selling price of any commissioned or portrait artwork and Artist shall receive fifty percent (50%) of the selling price of commissioned artwork, less the specific deductions for promotion and framing set forth above.

*From the gallery's perspective, receiving over 60% of fees paid for commissioned works is a tidy windfall. From the artist's perspective, the gallery's deducting two times framing charges (regardless of whether or not the work is actually framed) and an additional 10% is unfair and excessive.*

**3.6** Gallery shall use its best efforts to market, promote, advertise and sell Artist's artwork created during the Initial Term and option terms of this Agreement, as well as any works previously created by Artist. All marketing and promotional expenses relating to Artist, including exhibitions, gallery shows, art fairs and expos, will be paid by Gallery unless otherwise provided in this Agreement. All marketing and promotion decisions in relation to Artist shall be at the sole discretion of Gallery. Gallery agrees to mount no less than one "solo" show for Artist at Gallery's _____ location during each year of the Agreement.

*From the gallery's perspective, this provision prevents the artist from demanding extravagant promotion, advertising or numerous exhibitions. From the artist's perspective, the gallery should be committed to definite promotional activities (especially if the gallery is receiving a 10% surcharge for promotion and advertising), such as display advertisements in national art magazines, displays at national and international art fairs and expos, at least one solo exhibition at a desirable location during each six or twelve-month period, ongoing display of the artist's work at the gallery, and creation of one or more full color brochures featuring the artist's work during each year.*

**3.7.** Gallery shall publish at least _____ serigraphic editions during the first year of this Agreement, and at least _____ serigraphic editions during the second year of this Agreement. Gallery shall publish a minimum of _____ serigraphic editions during the third, fourth and fifth years of the Agreement. Gallery may publish as many serigraphic or other editions as it so elects, as long as it satisfies the minimum requirements of this paragraph. The selection of the images for said serigraphic editions shall be at Gallery's sole discretion after consultation with Artist, and said selections shall be taken from original artwork created by Artist during the term of this Agreement or may be selected from artwork created by Artist prior to the execution of this Agreement.

**3.8.** The edition size *(tirage)* of the serigraphic editions to be published by Gallery shall consist of _____ pieces, broken down as follows:

**3.8.1.** _____ prints arabic numbered _____ – _____ inclusive, which shall be the property of Gallery, subject to the payment provisions set forth in paragraph 4.1 below;

**3.8.2.** _____ prints arabic numbered _____ – _____ with Remarque, said prints being the property of Gallery subject to the payments to Artist set forth below. Remarques shall be pencil drawings created by Artist on each of the above _____ serigraphs;

**3.8.3.** _____ Artist's Proofs Prints arabic numbered AP_____ –_____ inclusive, said Prints being the property of Artist and being delivered to Artist upon Artist's completed signing of each edition; further, Artist agrees that Artist shall not sell or offer to sell any such Artist's Proofs directly or indirectly to anyone for a period of thirty-six (36) months after delivery of said Artist's Proofs to Artist; provided, however, Artist may sell Artist's Proofs to Gallery at an agreed upon price, and Artist may give gifts of Artist's Proofs without restriction;

**3.8.4.** _____ Publisher's copies arabic numbered PC_____ –_____ inclusive, said copies being the property of Gallery;

**3.8.5.** _____ Printer's Proofs, arabic numbered _____ –_____ inclusive, that shall be the property of the Printer;

**3.8.6.** _____ Washes that are unnumbered and that are painted over entirely on finished or unfinished prints from each edition, in acrylic or oil, that are then mounted on board and sold as Washes. Each Wash shall be signed and dated by Artist. Each Wash shall be of slightly different colors, and are the sole property of Gallery;

**3.8.7.** _____ Prints roman numbered _____ –_____ inclusive, printed on black paper and signed and numbered on the image with a paint brush;

**3.8.8.** Total *Tirage*: _____ ; Pieces on white paper: _____ ; Deluxe Remarques: _____ ; Artist's Proofs: _____ ; Publisher's copies: _____ ; Printer's Proofs:_____ ; Pieces printed on black paper: _____ ; Washes not numbered: _____ ; Total edition size: _____ pieces, signed and numbered, plus ten (10) Washes.

**3.9.** It is understood and agreed between the parties that there may be up to ten (10) dedicated Proofs in each above-stated edition, but only if requested by Gallery. These pieces are not for sale and can be used only for promotional purposes. All other pieces in the *tirage* of an edition may be sold by the party having ownership, subject to the provisions of this paragraph.

*The gallery agrees to publish a minimum number of serigraphic editions each year, including prints, proofs, remarques and washes as well as prints on colored paper. From the gallery's perspective, having a huge inventory of a variety of types of prints and proofs ranging from deluxe editions on the high end to poster prints at the low end, permits the gallery to offer the artist's work at a wide range of prices. Having differently numbered editions in roman or arabic numerals for example, and several types of proofs can enhance collectors' perceptions of scarcity, justifying higher sales prices. Such practices can also be used to deceive collectors. Ethical publishers and artists will usually not authorize releasing a total number of proofs exceeding 10% of an edition. From the artist's perspective, creating washes and remarques, supervising quality printing and signing of what can easily amount to five hundred prints in an edition, is vastly time consuming, intensive hard work. Although the artist receives a certain number of artist's proofs as part of the bargain (sometimes called "H/C" proofs, from the French "Hors Commerce"), to avoid the artist competing with the gallery for sales, it is typical for the gallery to demand an eighteen to thirty-six month holdback period dating from the gallery's first release of the work, during which the artist may not sell such proofs.*

*It should also be noted that under the terms of this agreement, the artist receives no additional compensation for any of the original works created as remarques or washes and the majority of the artist's compensation is not paid until after all pieces have been completed and signed (see paragraph 4.2 below). In some agreements the artist receives the first ten numbered prints of each edition, and the right to contract with a different publisher as to images not selected by the gallery for fine print editions within one year. The artist should also have the right to supervise the printing process and reject any prints that are defective or inferior in color, register, or any other respect, in the artist's sole discretion.*

## 4. Artist's Compensation

Subject to compliance by the Artist with the terms and conditions of this Agreement, Gallery shall pay Artist the sum of _____ dollars ($_____) per month on the first day of each month for the first two (2) years of this Agreement. In option years three (3) and four (4) Gallery shall pay Artist the sum of _____ dollars ($_____) per month on the first day of each month, and in option year five (5) Gallery shall pay Artist _____ dollars ($_____) per month on the first day of each month. All said monthly payments by Gallery to Artist pursuant to this paragraph 4 correspond to the delivery by Artist to Gallery of two (2) original large paintings of the minimum of four (4) paintings to be delivered each month pursuant to paragraph 5 at prices paid to Artist of _____ dollars ($_____) per painting for the first two (2) years of the Agreement, _____ dollars ($_____) per painting for the first two (2) option years of the Agreement (years three (3) and four (4) of the Agreement), and _____ dollars ($_____) per painting for the last option year (year five (5)) of the Agreement. As more fully described in paragraphs 4.3 and 4.5 below, it is Gallery's responsibility to pay Artist for twenty-four (24), of at least fifty (50) paintings delivered to Gallery in this method of monthly payments.

*Artist receives a draw increasing yearly over the term of the contract.*

**4.1.** Gallery shall pay Artist the sum of _____ dollars ($_____) for each serigraphic edition produced and signed in full by Artist for the first two (2) years of this Agreement subject to Gallery's recouping any advances paid to Artist pursuant to paragraph 4.7 below. In year number three (3) (the first option year), Gallery shall pay Artist _____ dollars ($_____) per edition. In years number four (4) and five (5) (the second and third option years), Gallery shall pay Artist _____ dollars ($_____) per edition.

*From the gallery's perspective, paying the artist a lump sum increasing yearly over the term of the agreement may be preferable to sharing royalties on sales of prints. From the artist's perspective, agreeing to accept a lump sum for serigraphic editions should be weighed against the possible income the artist could earn from a 20–75% royalty. An escalating royalty combined with a minimum guarantee lump sum payment schedule is probably the best arrangement for the artist.*

**4.2.** For each edition published, Gallery shall pay Artist twenty-five percent (25%) of the agreed edition signing fee once the Atelier has been selected and Gallery submits the physical painting to that Atelier. Upon the completion of each edition by Gallery and upon the completion by the Artist of signing and numbering of each edition piece, as well as the completion of the ten (10) Washes, Gallery shall pay

Artist in full the balance owed on each edition, or seventy-five percent (75%) of Artist's fee.

*From the gallery's perspective, holding back a significant percentage of the artist's fee is a type of insurance, helping to guarantee the artist's timely signing and delivering all prints and completion of all washes and other materials, especially in light of the onerous burdens imposed on the artist under the terms of the agreement. Unsigned proofs have little or no value to the gallery. From the artist's perspective, a 75% holdback may be totally unacceptable and punitive, indicating a lack of trust between the parties and might create a cash flow hardship for the artist, amounting to something akin to indentured servitude.*

**4.3.** Artist shall receive his twenty-five (25) Artist's Proofs as further compensation for signing a completed edition on the same day as Artist completes his signing of an edition, unless the parties otherwise agree in writing.

**4.4.** Gallery shall collect a fifty percent (50%) deposit on all commissioned work and fifty percent (50%) of that amount will be paid to Artist before the work begins, subject to the terms and conditions set forth below.

*Specially commissioned works, particularly those received from the artist's preexisting clients, are exactly the type of works that are often excluded from exclusive agreements such as this. In any event, the artist should not have to advance the cost of materials on commissioned works.*

**4.5.** All expenses and costs incurred for the production, copyrighting, handling, advertising, insurance, marketing, storage, shipping, selling, accounting and legal expenses relating to the publishing of fine print editions under this Agreement shall be the sole responsibility of Gallery unless otherwise provided in this Agreement.

*In agreements where the artist receives a 20–75% royalty on sales of each print, the gallery commonly has the right to recoup its production costs before paying royalties to the artist. In this agreement however, where no royalty is paid, the gallery's deducting production costs would be unfair.*

**4.6.** Subject to compliance by the Artist with the terms and conditions hereof, and except for other limiting rights and obligations created by this Artist, Gallery guarantees a minimum total payment to Artist of _____ dollars ($_____ ) for the first two (2) years of this Agreement. This amount does not include Artist's share of profits from the sale of the additional twenty-six (26) paintings per year that Artist has agreed to deliver to Gallery during the term of this Agreement and as set forth in paragraph 3 above. The guaranteed minimum of _____ dollars ($_____ ) for the first two (2) years or Initial Term of this Agreement does not include signing fees for Artist's Proofs received by Artist as compensation for Gallery's publishing of the serigraphic editions over and above the minimum of five (5) serigraphic editions for the first two (2) years as set forth in paragraph 3 above.

*For both the gallery's and the artist's financial planning, it may be desirable to have a definite minimum guaranteed payment. In this agreement, signing fees for serigraphic editions during only the first and second years are included in this guarantee.*

**4.7.** Gallery shall pay Artist a nonreturnable, recoupable advance of _____ dollars ($_____ ) upon signing of this Agreement. Said advance shall be

recouped by Gallery from fees for the first serigraphic edition published by Gallery during the first year of this Agreement.

*A nonreturnable, recoupable advance may be appropriate in an exclusive agreement. From the artist's perspective, it is reasonable to request the advance paid by the gallery be nonrecoupable; more of a signing bonus than an advance. From the gallery's perspective, it may be preferable to pay the advance in two installments: half on execution of the agreement, half when the image is selected for publication.*

**4.8.** Artist shall be entitled to compensation equal to ten percent (10%) of all net profits generated by Gallery or its assignees in connection with Artist's works if Gallery exercises any of the rights set forth in paragraph 11.1 below after termination of the Agreement. This does not relate to sales of editions created during the term of this Agreement that are sold after the Agreement is terminated.

*This provision relates to a later paragraph (11.1) wherein the artist grants all copyrights to the gallery in any work created during the term of the agreement. Not only is the assignment of the artist's copyright unusual and unfair, the payment of a meager 10% royalty is an outrageously low price to pay for the granting of such valuable rights. In a rare instance where this provision is agreed to by an artist, the artist should limit its scope to apply to only one or two selected images; the gallery's share would normally not exceed 50% and could be as low as 5%.*

**4.9.** If an original work is chosen to be the subject of a serigraphic edition, and if at the time said original is selected it has not yet been sold to Gallery or to a third party, then Gallery agrees to share in the eventual sale of said original on a 50/50 basis with Artist as provided in paragraph 3 above. If Gallery has already purchased said original as one of the guaranteed works, then Gallery shall pay an additional _____ dollars ($_____ ) to Artist upon the selection of such piece as an edition to be published.

## 5. Artist's Duties
Artist shall deliver to Gallery during each year of this Agreement a minimum of fifty (50) original paintings (size 36x48–inches or larger) painted in either oil or acrylic or both. Artist shall deliver to Gallery no less than four (4) paintings per month during the Initial Term and any option years of this Agreement.

*As stated previously, this is an enormous commitment for any artist regardless of how prolific he or she may be. A greedy gallery may "kill the golden goose" by drafting an agreement that forces the artist to create a large body of work that is mediocre, diminishing the value of all of the artist's previous and subsequent works.*

**5.1.** Artist agrees to sign all artwork, both original and multiples, pursuant to the terms of this Agreement. Specifically, Artist agrees to sign each and every serigraphic edition piece in the *tirage* of each serigraphic edition and agrees to sign a Certificate of Authenticity for each piece in the *tirage* of each edition published by Gallery pursuant to this Agreement within five (5) working days of the completion of each serigraphic edition, unless otherwise agreed to in writing by Artist and Gallery. Further, Artist agrees to sign each Wash created in conjunction with each serigraphic edition. Artist understands and agrees that Artist's failure to sign the completed works shall be a material breach of this Agreement, which breach shall

cause Gallery damages which are unique, unusual, irreparable and not readily calculable in nature, and shall entitle Gallery to Injunctive Relief against Artist if Artist does not cure such breach within five (5) days of receiving written notice from Gallery. The Injunctive Relief sought by Gallery will restrain Artist or any one acting on Artist's behalf from selling, delivering or furnishing to, or completing, exhibiting, publicizing or signing Artist's paintings, watercolors, drawings, graphic works, sculptural works by, any other works to any person or firm other than Gallery until the terms of this Agreement are fulfilled by Artist or Artist's breach has been cured. Further, no bond shall be required for such Injunctive Relief. If any court or law requires a bond to be posted, then the parties agree that a minimum amount for a bond shall be acceptable.

*As discussed in regard to paragraph 4.2 above, from the gallery's perspective, it is crucial to ensure the artist's signing of all multiples without delay. Unsigned multiples have little if any value to the gallery. Recitations that the gallery's damages in such event would be irreparable and not readily calculable are intended to strengthen the gallery's case if a court order is sought to restrain the artist from selling art to anyone else while the artist is in breach. From the artist's perspective, in rare cases, obtaining injunctive relief may be warranted, but the strict scrutiny applied by courts to applications for injunctions provides some built-in protection for the artist. The waiver of the gallery's duty to post a bond in such event, however, is unfair and the artist or the artist's representative should request this provision be deleted.*

**5.2.** Artist agrees to make up to six (6) personal appearances per year upon Gallery's request upon reasonable notice to Artist. Artist's airfare and reasonable accommodations will be paid for by Gallery.

*If the artist has sufficient bargaining leverage, first-class travel and lodging should be requested. A reasonable per diem expense allowance, ground transportation and even the use of a telephone credit card or cellular phone are not unusual courtesies extended to soften the discomfort of promotional travel. A limit on the number of total days spent out of town is also a reasonable request.*

**5.3.** Artist warrants that all artwork created by Artist hereunder shall be the original work of Artist and shall not infringe upon any copyright or any other right of any person or entity. Artist further warrants that Artist is under no obligation, agreement or disability as to any other person or entity to provide any services covered in this Agreement. If a copyright infringement action is brought against Gallery by some person or entity claiming copyright ownership of any work which is the subject of this Agreement, Artist shall indemnify and hold Gallery harmless from any and all costs, attorney's fees and/or judgments resulting from any such action.

*Warranties of originality and an indemnity clause by which the artist agrees to pay for any damages to the gallery resulting from the artist's breach (including attorney's fees) is standard and reasonable. From the gallery's perspective, the indemnity could be broader than stated here, covering all claims in the generic sense, rather than just copyright infringement actions. From the artist's perspective, not only should the indemnity be drawn as narrowly as possible, applying only to claims reduced to nonappealable judgments, for example, but should be made mutual, i.e., the gallery should likewise indemnify the artist from any claims resulting from the gallery's wrongful acts or omissions.*

## 6. Pricing of Artworks

Gallery shall use its best efforts to sell the original works and serigraphic editions or any other fine prints created under this Agreement. It is understood that all marketing decisions shall be in the sole discretion of Gallery, including without limitation the pricing of any prints in editions created hereunder, with due regard to prevailing market conditions. Further, the pricing of all original works shall be at the sole discretion of Gallery although Gallery may, from time to time, consult with Artist concerning the pricing of original paintings. Artist expressly understands and agrees that Gallery may sell original and graphic works at both wholesale and retail prices.

*Price of works is often a disputed issue between artists and galleries. Objective guidelines such as minimum and maximum prices for certain types of works can help ameliorate disagreements between the parties that arise when the gallery's marketing discretion collides with the artist's valuation of a particular work.*

## 7. Advertising and Publicity

In accordance with paragraph 3.6 above, the form and content of any advertising or promotion, including without limitation, the design, printing and dissemination of promotional and publicity materials with respect to the sale of Artist's artworks hereunder shall be determined in Gallery's sole discretion. Artist agrees to supply Gallery with a photograph of Artist and Artist hereby authorizes Gallery to use Artist's name, biographical material and likeness in any advertising material developed by Gallery to promote the sale of Artist's works purchased or published during the term of this Agreement.

*From the gallery's perspective, advertising expenses can be enormous. Four-color exhibition announcements and national magazine display advertisements can cost thousands of dollars and yield negligible results in terms of art sold. For some artists, no amount of advertising or publicity is enough. From the artist's perspective, in an exclusive contract such as this, the artist is entirely dependent on the gallery's sales efforts. Definite, objective advertising and promotion activities should be discussed, agreed upon and spelled out in the agreement. Full color announcements, mailings to the gallery's and the artist's mailing lists, commitments to one-quarter, one-half or full page display ads in prestigious art publications, and color brochures featuring the artist's work, are fair and legitimate requests. Further, the artist should reserve the right to approve the artist's photograph or biographical material contained in any publicity or advertising arranged by the gallery.*

## 8. Sculptures

All projects relating to sculptures shall be agreed to in writing separate from this Agreement between Artist and Gallery. It is agreed that all sculptures shall be published and sold exclusively through Gallery unless otherwise agreed to between Artist and Gallery in writing.

*An agreement to agree is unenforceable and invalid. If the gallery plans to deal in sculptural or other works, at a minimum, the artist's share of income from such sales should be specified in this agreement.*

## 9. Commissioned Monumental Works

If Artist produces a major, monumental mural or sculpture, fifty percent (50%) of the selling price or commission price shall be retained by Artist and fifty percent (50%) shall be retained by Gallery. The profit split will occur after all expenses relating to travel, production and sale of such work are deducted from the net selling price.

*From the gallery's perspective, commissioning monumental work is fair and reasonable, since such works are time consuming and may interfere with Artist's delivery of painting and prints. From the artist's perspective, the artist is bound to deliver a minimum number of paintings and prints, therefore the gallery should not be permitted to commission such special works. The second sentence here is too vague. What happens to the expenses for travel, production and sale? Do they go to the artist or the gallery? This should be specified with greater certainty.*

## 10. Poster Editions

During the term of this Agreement or any extensions thereof, Gallery shall be entitled to create two (2) poster editions per year. These poster editions when produced shall be the sole property of Gallery, however, Gallery shall give Artist one hundred (100) posters as compensation for each poster edition.

*From the gallery's perspective, poster editions create more visibility for the artist and may encourage sales of the artist's more expensive pieces. It is not unreasonable for the artist to be requested to sign a reasonable number of posters. From the artist's perspective, if posters are truly to be used merely for promotional purposes, the gallery should be prohibited from selling posters unless the artist is paid a fair royalty.*

## 11. Copyrights

Artist hereby agrees to affix a proper notice of copyright on each and every original work created by Artist under the terms of this Agreement.

*Since the United States joined the Berne International Copyright Convention on March 1, 1989, copyright notice is no longer required to protect U.S. copyrights. However, affixing a proper copyright notice is nevertheless highly desirable to discourage unauthorized reproduction and to give notice to the world of the name of the copyright owner. In nearly every case the copyright owner will be the artist. Rare exceptions exist however. (See paragraph 11.1 below.)*

**11.1.** Artist hereby expressly grants an assignment of copyright in each and every original work produced for Gallery under the terms of this Agreement or sold or consigned to Gallery by Artist under the terms of this Agreement. Said assignment of copyright in each and every original work to Gallery does hereby irrevocably assign, set over and transfer to Gallery, in perpetuity, any and all rights, title or interest, including the sole exclusive rights comprised in copyright, which Artist may have or claim in or to any of the original works described herein. These rights conveyed to Gallery include but are not limited to the sole and exclusive right to file, claim or renew any copyrights relating thereto, to grant licenses relating thereto, to collect and retain royalties, fees or other payments generated thereby, to copy and produce "copies" of any or all of said works of art at any time by any means in any media, to create different versions thereof at any time by any means and in any media, and to create collective works, compilations and derivative works therefrom at any time by any means and in any media.

*From the artist's perspective, this provision is unusual, unfair and overreaching, and should be deleted. Copyright ownership of the artist's original works (including the right to create reproductions thereof) usually last for the life of the artist plus fifty years. For many artists this is a valuable legacy to be passed on to surviving spouses, children and heirs. From the perspective of most artists, the forfeiture of the artist's copyrights is beyond the*

*bounds of reasonableness, and would be grounds for refusing to sign the agreement. In certain rare cases however, it may be reasonable for a gallery to acquire a perpetual license to specified images embodied in one or two serigraphic editions, or even an assignment of copyright in one or two images, but only in highly unusual instances. Such assignments, of course, may be terminated by the artist or by the artist's surviving spouse or children after thirty-five years pursuant to U.S. copyright law, and the copyright thereupon will revert to the artist or said heirs.*

**11.2.** For each and every serigraphic edition or other fine art limited edition published by Gallery under the terms of this Agreement, Gallery agrees to register the copyright in Gallery's name. Further, Gallery shall affix a copyright notice in Gallery's name on all limited editions, poster editions, brochures, advertising material and other reproductions of Artist's images.

*As more fully explained in the chapter on copyright, although not a prerequisite to copyright protection, copyright registration entitles the copyright owner to statutory damages and attorney's fees if the registration occurs prior to infringement or within three months of first publication of a work. For this reason, regardless of who owns the copyright, it should be registered with the U.S. Copyright Office before copies are sold, offered for sale, or otherwise offered or distributed to the public.*

**11.3.** Artist understands and agrees that the copyrights granted hereunder comprise community property. Artist's spouse _____ hereby grants to Gallery all right, title and interest in and to any community property interest he/she may have in any copyright granted hereunder. Artist's spouse shall indicate his/her consent to said grant of community property by signing a copy of this Agreement in the space provided below.

*In community property states such as California, copyrights, like other personal property earned or acquired during the term of a marriage, are considered community property. From the gallery's perspective, out of an abundance of caution, it is prudent to have an artist's spouse join in any assignment of copyrights.*

**11.4.** Artist may desire to create a book of Artist's collected works at some time after the expiration of this Agreement. Consequently, and only for the express purposes of creating a book of Artist's works, Gallery shall grant Artist a limited license to reproduce said images for purposes of such a "retrospective book" without compensation. Further, Gallery shall cooperate with Artist in making available transparencies or film needed for such a book. Artist agrees to return such transparencies and film used after the making of the book is completed.

*In certain exclusive work made for hire employment contracts, such as agreements often imposed on salaried animation artists or comic book illustrators, the employer is automatically deemed the author and copyright owner of all works created under the contract. In such cases, as here, it is not unreasonable for the artist or the artist's estate to be given a license by the gallery or copyright owner to use the artist's works for a catalog, retrospective exhibition, or book, without payment to the gallery. From the gallery's perspective, such publications cost the gallery nothing and can enhance the artist's notoriety, the value of the artist's works, and the gallery's profits.*

## 12. Life/Disability Insurance

It is understood and agreed by the parties that Gallery shall be entitled but not

required to purchase a life insurance policy and a disability policy taken out on Artist. The disability policy shall be no more than Ten Thousand Dollars ($10,000) per month. The life insurance policy shall be no more than One Million Dollars ($1,000,000). Artist agrees to cooperate with Gallery or Gallery's agents in securing said insurance, including without limitation, upon reasonable notice to appear at medical examinations and shall also disclose prior medical history to Gallery or Gallery's agents. The insurance policies shall run for the term of this Agreement (and option periods, if exercised) and no longer, and Gallery shall be the sole beneficiary on these policies.

*In certain rare cases, a gallery may attempt to protect its investment in the artist by purchasing life and/or disability insurance, naming the gallery as the beneficiary. From the gallery's perspective, although rather morbid, such a policy may be warranted if the artist is elderly, engages in high-risk recreational practices, or commonly works with toxic resins, pigments or other dangerous substances.*

*From the artist's perspective, such a provision epitomizes what could be perceived as crass, mercenary exploitation, permitting an unwarranted intrusion into the artist's medical history and could literally make the artist worth more to the gallery dead than alive.*

## 13. Accountings and Records

Gallery agrees to keep accurate books and accounts covering all transactions relating to the publication and sale of Artist's works. Artist and Artist's authorized representative shall have the right on reasonable notice and at reasonable hours to examine Gallery's books and records relating to the sale of Artist's works. Artist shall conduct no more than two examinations during any calendar year of the term of this Agreement or any extensions thereof. All books and records shall be available for inspection by Artist for at least one year after the term of the Agreement or at the termination of any extension thereof, and Gallery agrees to permit inspection thereof at Gallery's premises during such one-year period. As is indicated elsewhere in this Agreement, Gallery shall account to Artist for the sale of original works or any other works where Artist shares in the profits of such sales, no less than at least once every ninety (90) days during the term of this Agreement.

*From the perspective of both the artist and the gallery, regular accounting and audit rights are reasonable, provided they are done during normal business hours by qualified representatives. From the artist's perspective, quarterly accountings are better than semi-annual accountings. If a shortfall is found in excess of 5–10% of the compensation owed to the artist in any accounting period, the gallery should reimburse the artist for the cost of the audit.*

## 14. Right To Cure Breach

In the event of any breach of any provision of this Agreement or of any warranty or representation of Gallery or Artist contained herein, Gallery or Artist shall have the opportunity to cure said breach within thirty (30) days from receipt of written notice of said breach or notice of default, except as to the provisions of paragraph 5.1 above.

## 15. Arbitration and Attorneys' Fees

If any dispute arises between the parties concerning any matters relating to this Agreement, the parties, the parties agree to submit said dispute to binding arbitration. In the event of any arbitration or lawsuit, the prevailing party shall be awarded its attorneys' fees and costs reasonably incurred in connection with such dispute.

*As with paragraph 15 above, an express mediation or arbitration clause combined with an attorneys' fees clause can help resolve disputes and avoid costly court battles. A party who knows he or she will be entitled to reimbursement of his or her attorneys' fees may be encouraged to protect and enforce his or her rights by arbitration or otherwise. Conversely, a party is less likely to bring a frivolous claim if he or she will be charged with attorneys' fees incurred by the opposing party if such claim is unsuccessful.*

## 16. Assignment

This Agreement shall bind and inure to the benefit of the parties, their legal representatives and successors, provided however that Artist may not assign this Agreement or the performance or services to be performed by Artist herein to any other person or entity unless that entity is entirely owned by Artist, in which case Artist may so assign only with the written permission of Gallery. Gallery may assign its interests or duties to any third party.

*Most artist/gallery relationships are highly personal in nature. The reason such a relationship comes into existence is usually because of a strong personal belief in the aesthetic quality of the artist's work on the part of a principal of the gallery. If the gallery has the right to assign it rights, the artist may find him or herself in a long-term, exclusive contract with an individual having little or no interest in or appreciation of the artist's work, with little or no incentive in promoting the artist's career. From the gallery's perspective, an exclusive long-term contract binding a successful artist is a highly valuable asset that the gallery may wish to sell.*

## 17. Notices

Notices required by this Agreement shall be in writing and mailed to the parties at the addresses set forth below by Certified or Registered Mail, Return Receipt Requested.

Artist: _____ Gallery: _____

## 18. Miscellaneous Provisions

No modification or change to this Agreement shall be valid unless it is in writing, signed by the party against whom the enforcement of such modification or change is sought.

**18.1.** A waiver by any party of any of the terms or conditions of this Agreement in any one instance shall not be construed to be a waiver of such terms or conditions for any future instances, or any subsequent breach hereof.

**18.2.** Time is of the essence in the performance of anything required hereunder.

**18.3.** This Agreement may be executed in counterparts, and the counterparts, taken together shall constitute the original Agreement of the parties.

**18.4.** Each of the parties hereto has been represented by independent counsel during the negotiation of the Agreement, has reviewed the Agreement, and has agreed to its terms upon the advice of independent counsel.

**18.5.** This Agreement shall be construed and enforced in accordance with the laws of the State of _____ applicable to contracts entered into and fully performed therein.

**18.6.** This Agreement contains the entire understanding between the parties relating to the matters discussed herein, and all prior or contemporaneous agreements, understandings, representations or statements, oral or written, are superseded hereby.

Understood, Agreed and Accepted To:

_____
ARTIST

_____
DATED

_____
ARTIST'S SPOUSE

_____
DATED

_____
GALLERY

_____
DATED

# Artist Consignment Contracts

**MADELEINE E. SELTZER**
*Madeleine E. Seltzer is a former practicing attorney and a
partner in Seltzer Fontaine, a legal search firm based in
Los Angeles. She is a volunteer mediator for Arts
and Arbitration and Mediation Services, a program
of California Lawyers for the Arts and an advisory board
member for Sojourn Services for Battered Women
and Their Children.*

It is not uncommon for arrangements between artists and dealers to be based on verbal understandings rather than written agreements. This does not mean that the parties are without rights and obligations or that the artist is necessarily oppressed by the dealer; the parties do function within the limits of legal responsibility, assuming the relationship is viable and productive. If it is not, then no written contract is going to keep the parties together, prevent acrimony, or even adequately compensate an injured party for damages arising out of a dispute. However, in general, it is advisable for the parties to have a written understanding regarding certain basic issues.

There are two basic types of contracts between artists and dealers—an outright sale of the work of the artist to the gallery or a consignment. The least common of the two is the outright purchase agreement where the dealer purchases the work from the artist and then resells it. This agreement may apply to an artist's entire body of work or only a portion of it. It sometimes involves a right of first refusal in which the artist is obligated to offer his or her work to the dealer first and the dealer has the option to buy it, or not. It may also include provisions regarding royalty rights and/or minimum resale prices for the works.

The most common type of contract between artists and dealers is the consignment, the entrusting of goods to another, while retaining legal ownership, so that they may sell the goods for your benefit. In a consignment arrangement, an agency relationship is created in which the dealer (the consignee) acts as the selling agent for the artist (the consignor). The artist maintains his or her ownership of the work, while the dealer is entitled to sell the work on the artist's behalf. This fiduciary relationship requires the dealer to act only in the interest of the artist and to forego all personal advantage from the transaction. Almost thirty states (including California and New York) have passed laws governing the consignment relationship between artists and dealers in which such a trust relationship is explicitly established. An important practical consequence of these laws is to protect the artist's work from the dealer's creditors.

Since the protection provided to artists in a consignment relationship varies from state to state, it is imperative that artists be familiar with the laws that exist where they live. For example, though the laws in California and New York are generally similar, there are distinctions that should be noted. Under California's Civil Code, a consignor may not waive his or her consignment rights, even in a written agreement; while under New York's Arts & Cultural Affairs Law, a consignor may do so under certain circumstances. In addition, the California law requires that the consignee be responsible for the loss of, or damage to, the work of art after delivery of the work, while the New York law is silent on this issue.

## KEY CONTRACT ISSUES

### Commission

Gallery commissions have a wide range—25% to 60%; although the standard commission is between 33% and 40%. The percentage is negotiable and will vary according to the relative fame of the artist, the length of time the work(s) remains with the dealer, the nature of the work and the prestige of the gallery in the art community. Thus, if the gallery is well-known, but the artist is not, the commission to be paid the artist may be on the lower end of the range.

In addition, the manner in which the gallery commission will be computed should be delineated—either as a percentage of the sales price or as a "net price" computation, defined as the sales price less agreed on and specified expenses.

### Duration

When the relationship between an artist and dealer is good, it can span years, even lifetimes. When an artist is unknown, a considerable period of time is needed to develop a market for his or her work. In any event, it is advisable to specify the minimum length of time the artist's work will remain with the gallery, as well as whether or not the parties desire options to extend the term. In addition, it is important that the manner in which the agreement may be terminated by either party be articulated, including the method and timing of the return of the artist's work.

### Payment and Record Keeping

Some mechanism should be agreed upon to handle payment to the artist after sale of his or her work including the time for payment and the accounting of receipts. The gallery's books and records should be subject to review by the artist at reasonable times and places.

### Name of Buyer

The artist should request that the names and addresses of buyers be supplied at the time of payment to the artist.

### Exclusivity

The question of exclusivity applies to three basic matters: geography, type of work and extent of sales. First, will the dealer be the artist's exclusive agent in various geographic areas or just locally? Second, will the dealer handle only one medium such as paintings and not sculpture? Third, will the dealer handle or benefit from all sales,

including studio, juried shows, and commissions whether or not the artist finds a buyer or makes a gift to an individual. Since this matter is such an important part of the artist/dealer relationship, if it is not made explicit in a written or verbal agreement, it probably will not be presumed that the dealer was granted exclusivity.

### Promotion

A crucial aspect of the relationship between an artist and dealer is the manner and extent to which the dealer intends to market the artist's work. Examples of promotion include the number, dates and duration of exhibitions; whether such exhibitions will be solo or group; whether the artist's works will be displayed in the gallery's permanent exhibitions; and the extent of advertising and publicity required on the part of the gallery. In addition, the question of artistic control over an exhibition needs to be dealt with. In some instances, the artist has total control and manages the entire installation; in other cases, the gallery handles everything. In any event, the artist and gallery should work together to insure that the artist's work is promoted and exhibited to its best advantage.

### Expenses

There are a number of expenses that are associated with the consignment of works to the dealer. It should be specified who has responsibility for what. Such expenses include, but may not be limited to: transportation of works; exhibitions; promotion and catalogs; liability and other insurance; storage; and framing. The more established an artist is, the more willing the gallery will be to pick up expenses. However, if the dealer is granted complete exclusivity and can rely on a continuity of representation over an extended period of time, then it is not unreasonable to expect that all expenses will be borne by the dealer. When the dealer and the artist agree to share expenses, their amounts should be agreed upon in advance. The amount of the commission and the nature of the work will also bear on the issue.

### Pricing

There are several pricing issues that should be covered such as retail price or price range, minimum price and discounts for sales to other galleries, museums or institutions. The artist and dealer may set these prices together, or it may be agreed that one or the other will have the power to do so.

### Copyright

The artist should be aware of federal copyright law that provides that the copyright proprietor (the artist) controls the right to copy, publish and sell the copyrighted artwork. Therefore, the artist can withhold and regulate distribution and publication of the work as he or she chooses. Although reproduction rights (use rights) are invested in the artist by federal law and are further protected by laws enacted by some states, the artist may still wish to specifically reserve such rights by requiring that the form of bill of sale or invoice used by the gallery so indicate. (Issues regarding reproduction rights are discussed in many chapters of this book.)

### Arbitration or Mediation Clause

As discussed elsewhere in this book, arbitration and mediation are very attractive alternatives for dispute resolution for the artist. Thus, it is advisable for the artist and

dealer to agree in advance to utilize these methods of resolving conflicts before litigation is considered.

The provisions discussed above apply to the marketing by a dealer of the most common forms of the visual artist's expression—painting, prints and sculptures. Other forms of expression such as concept, performance and electronic art require different treatment and any agreement should be modified to reflect the unique character of the work to be handled by the gallery.

## BILL OF SALE FOR A WORK OF ART

The Bill of Sale is the document you should use in conjunction with the sale of a consigned work of art. It should include the basic information that appears in the example shown below.

The Bill of Sale satisfies at least three important needs:

1. It provides a record of total art sales for purposes of computing taxable income.

2. It provides an accurate inventory of the owners of your work, facilitating provenance and tracing of subsequent purchasers.

3. It provides additional protection for the artist and the artwork contained in the terms and conditions of the sale. This portion of the Bill of Sale may specify assumption of certain rights by the buyer, restoration rights for the artist, installment payment procedures, artist's exhibition rights, reservation of copyright and reproduction rights to the artist, a notice of applicable state law, a requirement that if the work is donated, the donee will be obligated to notify the artist of its intention to sell the work.

---

### BILL OF SALE FOR A WORK OF ART

Artist: _____ Purchaser: _____

Date of Sale: _____ Place of Sale: _____

Title of Work: _____

Description of Work (size, medium, etc.): _____

Price: _____ Sales Tax: _____ Total: _____

Terms of Payment: _____

Terms and Conditions of Sale: _____

© _____ (Date) _____ (Name of Artist). All reproduction rights reserved.

_____   _____   _____
Name of Purchaser (Print)          Date               Signature of Purchaser

_____   _____   _____
Name of artist (Print)             Date               Signature of artist

## ARTIST/GALLERY CONSIGNMENT AGREEMENT (SHORT FORM)

Use this agreement when all else fails in obtaining a formal contract tailored to your situation. Check laws in your state that may provide you with substantial protection when artwork is consigned.

1. **Received from:**

   Name of Artist _____

   Address _____

   City/State/Zip _____ Phone _____

   The following:

   | | TITLE | MEDIUM | SIZE | SELLING PRICE | PERCENT COMMISSION |
   |---|---|---|---|---|---|
   | 1. | | | | | |
   | 2. | | | | | |
   | 3. | | | | | |

   (Etc. Use additional sheets if necessary.)

   for _____ (purpose, e.g., sale, exhibition, etc.) to be held from _____ (date) to _____ (date).

2. **Duration.**

   The Artist agrees to be represented by _____ (specify name of gallery/dealer) for a period of _____ (specify time period) at which time the arrangement automatically terminates unless extended by mutual agreement in writing.

3. **Exclusivity.**

   The Gallery will have exclusive representation of the Artist's work in _____ (specify territory, e.g., city, state, group of states, etc.)

4. **Ownership.**

   All works left in the Gallery on consignment shall remain the sole property of the Artist until sold and the Artist's share is remitted by the Gallery in FULL. In the event of the Artist's death this agreement becomes null and void, and all work left on consignment reverts to the Artist's survivors on demand.

5. **Title.**

   The Gallery shall not be entitled to make or assert any claim or right to any possessory liens against the property of the Artist for any cause whatsoever. Work on Consignment on the premises of the Gallery may not be open to any claim by the Gallery's creditors and continues to remain the sole property of the Artist (or Artist's Estate) unless paid for in full.

6. **Solo Exhibits and Group Shows.**

   Within the consignment period, the Gallery shall arrange and promote (a) a Solo Exhibition of _____ (specify duration); (b) _____ (specify number) Group Shows during the period of this contract.

7. **Commission.**

   The Artist and the Gallery agree on commission of _____ (specify percentage and whether on the wholesale or retail price of the art) on all sales generated by the Gallery's efforts, whether on its premise, or, from the Artist's Studio. Prizes and awards are not subject to Gallery's commission.

8. **Sales.**

   The Gallery shall be responsible for the sales price as mutually agreed upon with the Artist. The Gallery shall, however, have the discretion to lower the agreed upon price by not more than _____ % (specify percentage) especially to museums and institutions.

9. **Payments.**

All payments must be made within (specify period) of an individual sale, or within _____ (specify days) of the termination of a Solo exhibition. All credit verification is the sole responsibility of the Gallery.

A semiannual record of sales shall be given to the Artist by the Gallery on _____ (specify date); and an annual statement not later than _____ (specify date).

10. **Expenses.**

The following expenses shall be borne by the Gallery:

1. _____
2. _____
3. _____
4. _____

The following expenses shall be borne by the Artist:

1. _____
2. _____
3. _____
4. _____

The following expenses shall be equally shared by the Gallery and the Artist:

1. _____
2. _____
3. _____
4. _____

11. **Liability.**

The Gallery shall be responsible for theft, loss, or damage to any and all consigned artwork, however caused, while on the premises of the Gallery or in transit arranged by the Gallery. Proof of such insurance, carried at the expense of the Gallery, shall be supplied at the signing of this agreement.

12. **Copyright.**

Reproduction and Copyright rights remain exclusively with the Artist or the Artist's Estate.

13. **Return of work.**

At the termination of this agreement, all work not paid for shall be returned to the Artist as agreed. The artist shall have the right to withdraw any work on demand unless it is on the walls of the gallery as part of an exhibition.

14. **Cancellation.**

This contract may be canceled by mutual agreement and thirty (30) days written notice by either party.

15. **Mediation and Arbitration.**

Any controversy or claim arising out of or related to this contract or the breach of this contract shall be settled by mediation or binding arbitration in the City and State in which it was executed, the first such hearing to take place within thirty (30) days after demand for mediation or arbitration is received by either party. A settlement will be made before a jointly selected, single mediator or arbitrator, the Graphic Artist Guilds Arbitration Board, or other appropriate organization (such as the American Arbitration Association or Arts Arbitration and Mediation Services, a program of California Lawyers for the Arts, etc.), and upon the rules of such organization, arbitrator or mediator.

If Mediation is not successful in resolving all disputes arising out of this agreement, those unresolved disputes shall be submitted to final and binding arbitration in accordance with the rules of any such mediation program, and the prevailing party shall be entitled to recover its attorneys' fees and costs incurred in connection with resolving the disputes. The arbitrator's award shall be final and judgment may be entered upon it by any court having jurisdiction thereof.

## SHORT FORM ARTIST/GALLERY RECEIPT OF CONSIGNED ARTWORK

RECEIVED FROM: _____

NAME OF ARTIST

ADDRESS:_____  PHONE: _____

THE FOLLOWING:

| | TITLE | MEDIUM | SIZE | SELLING PRICE | PERCENT COMMISSION |
|---|---|---|---|---|---|
| 1. | | | | | |
| 2. | | | | | |
| 3. | | | | | |

ETC. (USE ADDITIONAL SHEETS IF NECESSARY)

for: _____ to be held from: _____ to _____

PURPOSE: E.G., SALE, EXHIBITION, INSPECTION, ETC.          DATE          DATE

Until the works listed above are returned to the possession of the Artist, each will be fully insured against loss or damage for the benefit of the Artist in an amount not less than the selling price less commission. None may be consigned, sent out on approval or removed during the period of the exhibition except as agreed in writing. All of the above works are to be returned to the Artist on demand. Reproduction rights are reserved by Artist. The Gallery shall provide the Artist with a Statement of Account within fifteen (15) days of the end of each calendar quarter commencing with _____ (date). The accounting will state for each work, the title, its sale or rental status, the date, price and terms of any sales or rental, the gallery commission, the amount due to the artist, the name and address of each purchaser or renter and the location of all consigned works not sold or rented. All works delivered and all proceeds from the sale of any consigned work shall be held in trust by the Gallery for the benefit of Artist. Gallery shall be responsible for any loss or damage to any Work.

_____     _____     _____
DATED                       GALLERY NAME                SIGNATURE OF DEALER/AGENT OF GALLERY

_____     _____     _____
DATED                       ARTIST NAME                 SIGNATURE OF ARTIST

*(Based on the Artist's Equity Standard Receipt form, reproduced by permission of Artist's Equity.)*

## SAMPLE SHORT FORM STATEMENT OF ACCOUNT

NAME OF ARTIST: _____  DATE: _____

ADDRESS:_____  QUARTER: _____

| | TITLE | STATUS (SOLD/ RENTED/ OTHER) | DATE | PRICE | GALLERY COMMISSION | AMOUNT DUE ARTIST | PURCHASER/ RENTER & ADDRESS | LOCATION, IF NOT SOLD/RENTED |
|---|---|---|---|---|---|---|---|---|
| 1. | | | | | | | | |
| 2. | | | | | | | | |
| 3. | | | | | | | | |

TERMS: _____  GALLERY: _____

NET DUE ARTIST: _____  _____

SIGNATURE OF DEALER/AGENT OF GALLERY

# ANALYSIS OF A CONTRACT FOR MURAL OR OTHER PUBLIC ART

**AMY L. NEIMAN AND KAREN D. BUTTWINICK**
*Amy L. Neiman is a Los Angeles based art law attorney
and graphic artist. She received her J.D. degree
from UC Berkeley in 1985.*

*Karen D. Buttwinick is a Los Angeles based attorney and
artist. She is co-owner of the Brentwood Art Center,
a private school of fine art located in Los Angeles. Ms.
Buttwinick received her J.D. degree from
Hastings College of the Law in 1989.*

Suppose you have just been notified that your grant application was funded by the National Endowment for the Arts. Or, suppose you are notified that the grant you wrote to a corporate sponsor or nonprofit community organization was funded. Perhaps you are in the process of negotiating a contract with a city or a developer of a business complex to create a sculpture. What if you are asked as an employee of a business to paint a mural on a wall in your office? Who owns the art work and all of the legal rights associated with it? What rights do you, as an artist, retain? Can you, or the entity you have contracted with, reproduce your mural or sculpture? Should you have a written agreement specifying future rights? These are issues that are addressed by federal copyright law, by state statutes and by the contract you negotiate.

The sample contract herein addresses many issues you should be aware of when creating a mural or other public art project and speaks of those laws that protect you and provide the basis for compensation in the event your artwork is altered or destroyed. Be mindful, however, that if your artwork will include a person's likeness or name, you should make yourself aware of relevant state privacy statutes and take necessary precautions.

## FUNDING FOR PUBLIC ART

Here is a list of possible public/governmental and private funding sources:

♦ Your local cultural affairs department.

♦ Percentage for art ordinances that require developers to commit a specified percentage of the entire construction budget to art projects or programs. For example, in 1989, the City of Los Angeles adopted a series of ordinances that established three new arts funding sources: a 1% transient hotel occupancy tax, a 1% for the arts from all city capital improvements and the above mentioned Arts Development Fee that applies to all private development in the city with a total construction value above $500,000.

♦ Local nonprofit arts organizations. In Los Angeles, there is an organization called Social and Public Art Resource Center that is involved in a joint project with the City of Los Angeles called "Neighborhood Pride: Great Walls Unlimited Mural Program." This project funds nine projects each year.

   In San Francisco, Precita Eyes Mural Arts Center has a comprehensive mural program that includes grant writing and fundraising for different mural projects. Precita Eyes also offers mural tours and classes for people who want to learn how to paint murals.

   Chicago Public Art Group does some fundraising to support mural projects in their city.

   In New York City, there are many organizations that concentrate on public art projects such as the Public Art Fund and Creative Time, Inc. City Arts, Inc. is a nonprofit organization that focuses on community based mural projects located in underserved areas.

♦ The United States Olympic Committee has an advertising budget and often funds public art.

♦ Your local law enforcement departments may have money set aside for art to be used in conjunction with anticrime or antidrug projects.

♦ Your local transportation authority may have funding for public art to beautify bus stops or metro stations.

♦ Your local department of parks and recreation may sponsor mural projects around your city.

♦ The National Endowment for the Arts (NEA) funds many varied art programs and projects. It is an independent federal agency that encourages and supports American arts and artists. While it has been a consistent source of funding for artists and arts organizations, it has also been the subject of tremendous controversy because of its policies and wavering criteria. The NEA's funds have decreased over the years, but it remains a source of funding for many projects.

♦ Many individuals and businesses privately commission murals of a specific subject matter, or murals by particular muralists. Typically the patron will see a mural that they like, locate the artist and ask whether he or she will paint a mural for them. There are many murals in private homes ranging from decorative trompe l'oeil to the culturally significant historical.

♦ Private foundations fund muralists. Your local marathon or favorite charitable organization may have money set aside as part of their advertising budget that you may be able to tap into with an appealing proposal. Many large corporations have well established programs for funding of the arts including both individual and community based projects.

## CONTRACT NEGOTIATIONS

Generally, when an individual buyer is contracting for a mural or other public art, the written agreement tends to be simple and short. Conversely, when the funding source is a public entity such as the cultural affairs department of a city, or a quasi-public entity such as a community based nonprofit organization or the developer of a commercial property, the contract tends to be lengthy. These contracts are usually drafted by a lawyer, prior to negotiations with the artist, and specifically delineate each party's responsibilities. Some points may be negotiable, some not, but even when there is little room for negotiation, it is nonetheless important for you to be aware of the legal implications of the clauses contained in the contract you are signing.

Remember, if you do not understand what has been written it is probably not because you are unintelligent, but because it has not been written clearly. You should ask for anything you don't understand to be clarified. You should not sign a contract that you do not fully understand because once you have negotiated the terms and/or have consulted with an attorney, you will be stuck with the contract you sign.

There are as many different ways to write contracts and provisions as there are murals. Each one will be unique to the project and the parties' needs and concerns. If you are unsure of your position or the impact that a specific clause will have on you, you should consult with your attorney.

Set forth below is a sample mural contract: it is a compilation of contract provisions that may arise as issues during negotiations. Some or all of the provisions may be in the contract you are handed and you should be prepared to understand each provision and gain as much knowledge as you can before you begin your discussions. The contract can be easily adapted for other types of public art.

## SAMPLE CONTRACT FOR MURAL OR OTHER PUBLIC ART

### THIS AGREEMENT

MADE THIS _____ DAY OF _____ 199___

BETWEEN _____ (NAME OF THE PAYING PARTY CONTRACTING FOR THE MURAL, HEREIN REFERRED TO AS "OWNER") AND

_____ ("ARTIST").

*This section is standard in virtually every written contract. It is important because it identifies the parties to the contract. As the artist, you must know who you are contracting with. If it is a corporation that you are contracting with, it should say so here and should identify the state of incorporation. If you are contracting with a partnership or a governmental entity, spell out the precise name and business entity. The same advice applies even if you are contracting with an individual. If for some reason the contract falls apart and you do not get paid, you want to know the legal title of the person or entity to sue.*

*If the mural or other public artwork is created as a joint work as defined under the Copyright Act, the names of the other artists would also be included in the agreement. Under Section 101 of the Copyright Act, when a work of art is prepared by two or more artists with the intention of merging their contribution into a single work, it is considered a "joint work." Although muralists and other public artists often use assistants when they paint or create, the assistant is usually paid on an hourly basis and is not considered an "artist," under the terms of the contract.*

### Recitals

WHEREAS, Owner requires the services of an artist to paint a mural on _____ (describe the precise location where the mural will be painted).

WHEREAS, Owner has determined that Artist is best qualified to paint the mural desired based upon the skill, reputation and creativity of Artist; and

WHEREAS, Artist is an artist known to paint murals of recognized quality and is able and willing to perform under the terms and conditions of this Contract;

NOW THEREFORE, in consideration of the foregoing promises and the covenants set forth below and other valuable consideration, the parties hereto agree as follows:

*This section sets forth the parties' commitment to participate in this project and acknowledges the artist's reputation as a fine artist who paints murals of recognized quality. This may be an issue if the mural is ever destroyed without the artist's permission, which is prohibited by state and federal statutes.*

### 1. Preliminary Design

The parties acknowledge approval of the preliminary design for a mural (hereinafter called "Mural").

*or*

Artist shall present a preliminary design (strike-off or maquette) to Owner on or before _____ (date) for approval by Owner prior to commencement of the creation of the Mural.

The preliminary design will include mural dimensions, description of materials used, considerations for longevity and conservation and maintenance requirements.

*Most people need to approve a design prior to commencement of the work. Sometimes the design is approved prior to entering into a contract and sometimes later. If the description*

*of dimension, materials, etc., is not included in this segment, it should be specified in a later segment of the contract.*

## 2. Creation and Installation

a. Artist represents and warrants that the Mural to be created is an original work of art and that the Mural shall be a faithful rendition of the preliminary design submitted by Artist and approved by Owner. All changes to the Mural shall first be approved by the Owner in writing.

*This is a common clause. The owner wants to be assured that the artist is not copying someone else's work that would expose the owner to a copyright infringement action. He or she also wants to be assured that what they will get in the end is what has been previously approved. Since it is very common for there to be discrepancies between the original sketch and the final mural, you should get approval, in writing, when you deviate from the approved sketch.*

b. Artist shall create and be responsible for installation of the Mural. Artist agrees to have the Mural completely installed including all touch-up work within (number of weeks or months) of completion of wall preparation by Owner. (See paragraph 6 below.)
or
Artist shall create and be responsible for installation of the Mural. Artist agrees to have the Mural completely installed including all touch-up work by _____ (date certain). Upon completion of installation, the Owner shall acknowledge its completion in writing.

*The costs for installation, including scaffolding, laborer wages, insurance and any other costs necessary for installation, shall be paid by Artist.*

*Sometimes an artist will create a mural off-site and then install the mural or mural panels onto the wall. The nature of the costs should be specified as some of the clauses below also refer to them. Keep the language consistent. If the owner has agreed to pay for any of these costs, the contract should so specify.*

*Deciding when the mural is complete can be a cause for controversy. Most contracts specify that artist decides when the mural is finished and has the owner acknowledge it in writing. If, however, the owner is dissatisfied and the dispute cannot be resolved then you need to mediate your dispute in conformance with paragraph 19 below. For this reason, it is important that your preliminary design be as complete as possible, and any changes that are made during the process of painting or installing the mural be agreed on in writing.*

c. If work on the Mural is delayed by adverse weather conditions, or any other cause beyond the Artist's reasonable control, then the completion date shall be extended for such reasonable time as the parties may agree.

*This is an important provision. There are any number of things that can go wrong with the creation and installation of a mural and it is important to protect yourself in the event that something happens to slow down the project.*

d. If work on the Mural is delayed by any fault, neglect, act or failure of the Artist, then the Artist shall take all necessary steps to complete the Mural within the agreed upon time. In the event Artist is unable to complete the Mural within the agreed upon time, Artist may be required to pay all costs incidental to the

**112**

completion and installation including, but not limited to, scaffolding, laborer wages, insurance and any other costs necessary for installation.

*Provisions such as the one above are frequently included by owners. You need to be careful of language that reads "including but not limited to." The question you should ask each and every time that you see this phrase is "what else?" There may be hidden costs to the project that you are unaware of and you don't want to be stuck with them.*

e. If work on the Mural is delayed by any fault, neglect, act or failure of the Owner, then the Owner shall take all steps necessary to enable the Artist to complete the Mural on time and shall pay all costs associated therewith including paying for additional scaffolding, laborers, additional insurance costs and any other costs necessary to complete the Mural.

*This is the companion to paragraph d. If the Owner does something to throw the Artist's schedule off, then the Owner must pay the additional costs incurred in order to complete the Mural.*

f. Except as set forth in this Agreement, Artist shall pay for all materials, scaffolding and any other costs necessary to complete the installation of the Mural.

*Make sure you know exactly what you are paying for. If there are certain things that the owner should pay for and not you, this is the place to spell it out.*

## 3. Protective Coatings or Antigraffiti Coatings

Artist shall be responsible for applying a coat of graffiti guard to the Mural upon completion. Any subsequent treatments of graffiti guard or antigraffiti coating shall be applied by and paid for by Owner under Artist's supervision. In the event Artist is unavailable or unwilling to supervise the application of subsequent coatings of graffiti guard, Owner shall pay for and apply same in a manner that conforms with currently acceptable standards of antigraffiti coating application.

*Note: Antigraffiti protective coatings are standard in this age of graffiti madness. This type of clause is typical and self-explanatory and a good one for any contract. There are several coatings that are available to protect murals from graffiti. They all employ a sacrificial top coat or wax coating. All employ a specific chemical process for removing the graffiti and they need to be reapplied once they are removed to clean off the graffiti. Test the coating before you cover your mural with it. Some can crack, fog, yellow or change the color of the mural.*

## 4. Permits

(Artist or Owner)_____ agrees to procure all necessary permits including any easements, encroachment permits, signage permits, scaffolding permits, alley closure permits or otherwise.

*This clause is a potential minefield. Typically, an owner will want the artist to obtain necessary permits. The problem is that it is very difficult to know what permits are necessary for a project. For example, what if you, the artist, did not know that the mural was being painted on an historical landmark and that you needed to obtain permission from the local historic preservation society or worse, the Department of the Interior. What if the city that you are painting in does not differentiate between signs and fine art murals. Cities usually have lots of rules and regulations about the content and size of signs. What if the city has an obscure municipal code section that prohibits painting within five feet of a fire escape without a variance. Variances can be time consuming and costly to obtain. If you overlook one of these*

*permits, your project could be shut down temporarily or worse, permanently. This could jeopardize not only the project but your career.*

*What is best is to require the owner to obtain all necessary variances and permits and pay for their costs. You're off the hook and can focus on what you do best—paint murals.*

## 5. Compliance with all Laws

Artist hereby agrees to comply with all local, state and federal laws and ordinances that pertain to the creation and installation of the Mural.

*This is another problem area. You probably do not know what all of the local laws and ordinances are that could arguably apply to the creation and installation of your mural. There can be time restrictions regarding when you can and cannot be up on a scaffold working. There can be requirements regarding the type of paint and/or solvents you use and their disposal. There can be local ordinances pertaining to specific permits and licenses you must have in order to perform any work on a wall. For instance, you can discover that you need a contractor's license to work on a wall and you may therefore need to hire a general contractor to sponsor the project for you. You can have problems with the local transit district if you are putting a mural close to a roadway. Someone must research and find out what laws will impact the installation and placement of the mural but, should it be you or should it be the owner? Think about this because if you are on a tight time deadline and you are shut down pending a permit or failure to comply with a law or ordinance, you could have a big problem.*

*What is best is to require the owner to do the research and outline any laws that you need to be aware of. Any extra costs that are incurred for permits or for failure to comply with laws that haven't been specified by the owner should be the responsibility of the owner.*

## 6. Wall Preparation

Owner shall be responsible for preparing the wall for the Mural pursuant to Artist's written specifications submitted at the time the preliminary design is submitted.

*This clause requires the owner to fill cracks and prime the wall pursuant to the artist's requirements. You may not need a pristine, smooth surface to paint on and sometimes this clause is not necessary depending upon your style and the condition of the wall. But if you want the owner to prepare the wall before you begin, you should have it in the contract. Also, you may have specific requirements. For instance, if you identify in the contract that the mural will be removable, there are substances that must be painted on the wall prior to installation to facilitate removal. You probably want the owner to assume this cost and effort.*

## 7. Amount of Payment

Owner hereby agrees to pay Artist _____ (specify amount) within five (5) days of receipt of Invoice, which shall be submitted at the end of each phase of the project as set forth below.

## 8. Method of Payment

Payment shall be made as follows:

a. _____ (specify percentage) upon signing of this contract.

b. _____ (specify percentage) upon approval of Preliminary Design.

c. _____ (specify percentage) when the Mural is one-half complete.

d. _____ (specify percentage) upon completion of the Mural, as determined by Artist.

*It is common for payments to be made in the progress payment style. You should*

*estimate how much money you will need to purchase supplies, pay laborers, rent scaffolding, procure insurance if necessary, etc., prior to committing to a specific progress payment schedule. You may need to obtain the largest chunk of money upon approval of the preliminary design. If the design is approved prior to signing the contract then you will only need three payments instead of four. Although equal payments are not atypical, they may not work for your project. Figure out what you need and work that into the payment plan.*

### 9. Increase In Payment

If additions or deletions are approved and made to the Mural and result in an increase in cost, such payments shall be made within five (5) days of receipt by Owner of an invoice. In the event any such payment is not timely made, Artist may cease all work until such time as payment is made and the completion date of the project shall, at the Artist's discretion, be adjusted accordingly.

*Obviously, changes from the preliminary design will require an adjustment in price. It's very important that such changes and concomitant changes in price be approved in writing. Otherwise, you may be confronted with an owner who does not want to pay for a change that he or she did not approve, even if it makes the mural look better.*

### 10. Timely Payment

If Owner fails to make any payment within five (5) days of the date it is due, Artist may cease all work and the completion date of the project shall, at the Artist's discretion, be adjusted accordingly.

*You may want to give the owner more than five days to pay you but be careful not to give him or her too much time. You cannot be expected to work without pay and it is likely that you will need the funds to further the project. Be sure that you do not walk into a trap whereby the owner does not have to pay you until some unspecified period of time.*

### 11. Mural Maintenance

Owner recognizes that the maintenance of the Mural on a regular basis is essential to the integrity of the Mural. Therefore, for the length of time that the Mural is on the site, the Owner shall be responsible for maintaining and repairing the Mural under Artist's supervision, pursuant to the conservation and maintenance standards presented by Artist to Owner at the time of the preliminary design, which such standards shall be in conformance with recognized principles of conservation. If Artist fails or refuses to supervise such maintenance and repairs, Owner shall have the right to do so. All maintenance, repairs and restorations shall be made in accordance with recognized principles of conservation.

*This is a very important provision to have in your contract. Most of the older mural contracts overlooked this extremely important area of maintenance and repairs and as a result many of the older murals are in very poor condition. Since the murals that you will be painting today will withstand perhaps centuries to reflect our culture in generations to come, it is important that we provide care for them to the best of our abilities.*

### 12. Independent Contractor

Artist is an independent contractor and not an employee, agent or other representative of the Owner. Artist shall have the right to select the means, manner and method of performing the services described herein and has complete artistic discretion and control over the subject matter and execution of the Mural. The Artist understands and

agrees that he or she is not authorized to incur any expenses or any liability whatsoever on behalf of the Owner and has no authority, expressed or implied, to obligate or make representations on behalf of the Owner.

*Under copyright law, a "work made for hire" occurs when the work is prepared by an "employee" within the "scope of his or her employment..." and/or when the work is a specific type of "commissioned work." If a work of art is a work for hire, the owner retains the copyright to the work and the artist thereby loses a large portion of the residual rights to the artwork. This clause merely clarifies that the artist is an independent contractor and not an employee and therefore, the artist and not the owner maintains the rights granted by the Copyright Act. If you are in an employee/employer relationship with the owner, this clause will likely be omitted and you will likely lose your copyrights in the work. If you think your mural may be considered a work made for hire and you wish to retain some or all of the copyrights, you should consult with an attorney. For a more detailed discussion of work for hire contracts, see the chapter titled "Contracts for Employment."*

## 13. Copyright

Upon final payment by Owner to Artist, Artist assigns his or her copyright interests in the Mural to Owner and Owner becomes copyright holder for all purposes.

*U.S. copyright law provides that no individual who is a joint author of a copyrighted work can sell or "assign" the copyright or grant an exclusive license, without permission of the other joint authors. Therefore, it is very important that copyright ownership and rights be spelled out clearly.*

*Although it is not typical for the mural artist to sell the copyrights along with the physical piece of artwork, it is sometimes requested and sometimes demanded. Some artists absolutely refuse to sell their copyrights in a work of art. Others are willing to do so. You need to think about your position with respect to this. Owning the copyrights gives you the power to determine when, if, and how your artwork will be reproduced. Without the copyrights you have no control and no ability to profit from the reproduction of your work. Remember to sign your name to the mural and date it.*

*Here are two alternative options:*

*(a) "Artist reserves to himself or herself all copyrights in the mural, the preliminary design and any incidental works made in the creation of the mural. Artist agrees not to unreasonably refuse the owner permission to reproduce the mural for noncommercial purposes, such as reproducing the mural on publicity notices."*

*Although a certain amount of unauthorized reproduction of a work of art without written authorization is permissible under the "fair use" clauses of the copyright, such as for educational or noncommercial purposes, it is always best to clarify this issue in a written clause.*

*(b) "Upon final payment by owner to artist, artist and owner shall jointly hold the copyright to the mural. Neither shall reproduce the Mural without the prior written consent of the other and any and all profits from any such reproduction shall be divided equally."*

*For more detailed information on copyright and use rights, see the chapters titled "Copyright: An Artist's Tool" and "Licensing Rights to Use a Work of Visual Art."*

## 14. Artist's Insurance

Artist shall procure the insurance coverages listed below and provide certificates of insurance to the Owner prior to the commencement of the Mural:

a. Worker's Compensation Insurance and/or

b. General liability insurance in an amount not less than _____ (amount) and listing Owner as an additional insured.

*It is standard for the artist to obtain Worker's Compensation Insurance for a project. It's simple to obtain and relatively inexpensive.*

*Liability insurance costs more. Most often the owner will carry liability insurance and, for an additional charge, name the artist as an additional insured on the policy for the duration of the design and installation of the mural. The owner may have additional insurance requirements and it is important to discuss them prior to signing the contract.*

## 15. Owner's Insurance

Owner shall obtain and keep in force a comprehensive general liability insurance policy, in standard form, protecting Owner against any and all liabilities arising out of or related to the installation and maintenance of the Mural in a combined single limit amount of one million dollars ($1,000,000) per occurrence in respect of injuries to or death of any person or persons and destruction of or damage to any property. Such policy of insurance shall be issued by an insurance company with general policy holder's ratings of not less than "A" and financial ratings of not less than "B plus" as rated in the most current Bests insurance reports, shall list Artist as an additional insured, and shall provide that it may not be canceled by the insurer or lapse of its own accord or by its own notice upon all parties named as insured and additional insured. Such policy shall also (i) contain a provision that Artist although named as an additional insured, shall nonetheless be entitled to recovery thereunder for any loss suffered by Artist by reason of Owner's negligence and (ii) be written as a primary policy not contributing with any other coverage which Artist may carry. Artist may, at Artist's option, delay shipment and/or installation of the Mural until receipt of evidence from Owner establishing Owner's coverage under an insurance policy which meets the requirements of this paragraph.

## 16. Indemnification

Owner shall defend, indemnify and hold harmless the Artist, his or her agents, and subcontractors from any and all claims, demands, damages, costs, expenses (including attorneys' fees), judgments or liabilities arising from the negligence or willful misconduct of Owner not otherwise covered by insurance. Artist shall defend, indemnify and hold harmless, Owner, from all claims, demands, damages, costs, expenses (including attorneys' fees), judgments or liabilities arising from the negligence or willful misconduct of Artist not otherwise covered by insurance. With respect to any and all claims, demands, damages, costs, expenses (including attorneys' fees), judgments or liabilities arising from the joint or concurrent negligence of Artist and Owner, not otherwise covered by insurance, each party shall assume responsibility in proportion to the degree of its respective fault as determined by arbitration as set forth in section 18, below.

*This standard boilerplate clause is the one most lawyers would like to change, or, preferably not include. What this type of clause obligates you to is paying for the defense of any negligent acts that may have occurred, and the ensuing liabilities, no matter who is at fault, and no matter what insurances are carried. The assumption here is that an injured person will sue artist and owner. A good way to add protection is to require the owner to carry insurance for negligent acts.*

## 17. Art Preservation

Owner agrees to preserve the integrity of the Mural and agrees not to alter, damage, desecrate or obstruct the Mural in any manner. If Owner desires to modify, change, alter or remove the Mural, Owner must obtain prior written approval and consent of the Artist for the proposed modification, change, alteration or removal. Owner agrees to adhere to the Visual Artists' Rights Act of 1990, 17 U.S.C., as well as any applicable State Statutes.

*This clause is optional, because it restates rights granted under the Federal Copyright Act that prohibit the alteration, damage or destruction of a work of art. Many states also have laws that further protect fine art from destruction. You are automatically protected by these laws even when there is no express provision in the contract. The only exception is that if your work cannot be removed without substantially damaging it, the provisions of the statute will not protect your artwork.*

*Do not automatically assume that because a mural is permanently attached to a wall, that it cannot be removed without substantial damage. Many types of murals are removable with new technologies that have improved on age old processes. Murals have been removed from walls for centuries. Become knowledgeable about mural removal processes with a view towards protecting your work from destruction or alteration. If your work does need removal, a good conservator is essential.*

*If the Owner does not suggest putting an Art Preservation Section into the contract neither should you. If you raise this issue, the owner might try to get you to expressly waive your rights to protection. If you waive your rights under these laws, the owner can destroy your art at will, without your permission or consent and you will have no recourse. Think long and hard about how you view your artwork and the place it holds in history. If you do not care if it is painted out or otherwise altered then waiving your rights under these laws is not problematic. If you want your art preserved then you should not waive your rights.*

*Assigning your copyright to the owner or signing a work made for hire agreement does not give the owner permission to alter or destroy your mural (if the mural was created after the VARA was made into law).*

*If you have not "expressly waived" your rights under these laws and you learn one day that your mural has been altered or destroyed you have legal recourse. You may sue the person who damaged your work. For a more detailed discussion, read the chapter "Art Destruction: An Overview."*

*The phrase expressly waived means putting any agreements to do so in writing.*

## 18. Termination

Either party may terminate this Agreement for cause if the other party fails to perform any material obligation hereunder. In the event the Artist abandons the Mural, defaults on any material term of this Agreement or otherwise causes it to be terminated without cause prior to completion of the work, the Artist shall not be owed or paid any further compensation by the Owner. If the Owner fails to perform any material obligation hereunder, including failure to pay Artist, Artist may cease work and exercise any remedies available in law or equity.

*This section is standard in most contracts in one form or another and acknowledges the parties' rights in the event the other party breaches the agreement.*

## 19. Mediation and Arbitration

Any controversy or claim arising out of or related to this contract or the breach of

this contract shall be settled by mediation or binding arbitration in the City and State in which it was executed, the first such hearing to take place within thirty (30) days after demand for mediation or arbitration is received by either party. A settlement will be made before a jointly selected, single mediator or arbitrator, the Graphic Artist Guilds Arbitration Board, or other appropriate organization (such as the American Arbitration Association, Arts Arbitration and Mediation Services [a program of California Lawyers for the Arts], etc.), and upon the rules of such organization, arbitrator or mediator.

If mediation is not successful in resolving all disputes arising out of this agreement, those unresolved disputes shall be submitted to final and binding arbitration in accordance with the rules of any such mediation program, and the prevailing party shall be entitled to recover its attorneys' fees and costs incurred in connection with resolving the disputes. The arbitrator's award shall be final and judgment may be entered upon it by any court having jurisdiction thereof.

*Many major cities have arts organizations with effective programs in alternative dispute resolution, among them mediation and arbitration, that are employed instead of litigation (court).*

## 20. Attorneys' Fees

a. Prejudgment. If legal proceedings other than mediation are instituted to enforce or interpret any part of this Agreement, the successful or prevailing party shall be entitled to recover reasonable attorneys' fees and other costs in connection with such proceeding or action.

b. Postjudgment. The successful or prevailing party in legal proceedings brought to enforce or interpret any part of this Agreement shall be entitled to recover reasonable attorneys' fees and other costs incurred after an award or other relief. The parties agree that this post-award attorneys' fees provision is a distinct contractual agreement which is severable from the rights and obligations set forth elsewhere in this agreement, and that this provision shall not merge into any award or other relief based on enforcement or interpretation of this Agreement.

*This is a very important section to have in your contract. Having the ability to recover attorneys' fees will enable you to pursue an action for breach of this contract or for copyright infringement or art preservation violations that you may not otherwise be able to pursue, due to lack of funds. In contract actions you do not get attorneys' fees unless there is a contract provision specifically so providing. If you do not have this provision in your contract, you will not be able to recoup your attorneys' fees.*

## 21. Entire Agreement

This Agreement represents the entire Agreement of the parties and may not be amended unless agreed to in writing by the parties against whom enforcement is sought.

DATED: _____    NAME OF ARTIST: _____

DATED: _____    NAME OF OWNER: _____

# The Artist's Reserved Rights Transfer and Sale Agreement

**ROBERT PROJANSKY**
*Mr. Projansky is an attorney practicing in New York.*

This contract gives you a legal tool you can use to establish continuing rights in your work after it is sold.

It has been used by many artists, well-known and unknown. Use it. It's enforceable. The more artists and dealers who use it, the better and easier it will be for everybody to use it. It requires no organization, dues, meetings, registration or government agency—just your desire to protect the integrity of your art.

We realize this contract disturbs some dealers, museums and high-powered collectors, but the ills it remedies are universally acknowledged to exist and no other practical way has been devised to cure them.

Its purpose is to put the artist in the same position as the man behind the rent-a-car counter. He didn't write his contract, either, but he says: if you want it, sign here. You do the same.

Using this contract doesn't mean all your art world relationships will be strictly business hereafter or that you have to enforce every right down to the last penny. Friends will still be friends and if you want to waive your rights you can, but they will be your rights and the choice will be yours.

This contract has been created, for no recompense, by the author for the pleasure of attacking a challenging problem, and it is based on the belief that should there ever be questions about artists' rights in reference to their art, the artist is more right than anyone else.

## WHAT THE CONTRACT DOES

The contract is designed to give the artist:

♦ 15% of any increase in the value of each work each time it is transferred (the California resale royalty law requires a royalty of 5% of the gross sale price);

♦ a record of who owns each work at any given time;

- ◆ the right to have the work remain unaltered by the owner;

- ◆ the right to be notified if the work is to be exhibited;

- ◆ the right to show the work for two months every five years (at no cost to the owner);

- ◆ the right to be consulted if restoration becomes necessary;

- ◆ half of any rental income paid for the work, if there ever is any;

- ◆ all reproduction rights.

The economic benefits would last for the artist's lifetime, plus the life of a surviving spouse, plus twenty-one years, so as to benefit the artist's children while they are growing up. The aesthetic controls would last for the artist's lifetime.

## WHEN TO USE THE CONTRACT

The contract form is to be used when the artist parts with each work for keeps:

- ◆ whether by sale, gift, or trade for things or services;

- ◆ whether it's a painting, a sculpture, a drawing, a nonobject piece or any other fine art;

- ◆ whether to a friend, a collector, another artist, a museum, a corporation, a dentist, a lawyer—anyone.

It's not for use when you lend your work or consign it to your dealer for sale; it is for use when your dealer sells your work (or buys it). Note that the contract speaks in terms of a "sale"; the word "sell" is used for the sake of simplicity (likewise we use the word "purchaser" because it's the most all-inclusive word for this purpose). In a sense, even if you are giving or trading your work you are "selling" it for the promises in the contract plus anything else you get.

## HOW TO USE THE CONTRACT

1. Photocopy the contract form. You'll need two copies for each transfer. Save this original to make future copies and for reference.

    If there are things you wish to delete or modify, cross out what you don't want and make any small changes directly on the form, making sure that both parties initial all such strikeouts and changes. If you don't have room on the form for the changes you want, add them on separate sheets entitled "Rider to Contract" and be sure both are signed by all parties and dated. You should consult an attorney for extensive changes.

2. Fill out both copies, using the checklist instructions in the margin. You may want to enter "Artist's address" as care of your dealer.

3. In Paragraph 1, enter the price or the value of the work. You can enter any value that you and the new owner agree upon. If they sell it later for more they will have to pay you 15% of the increase, so the higher the number you put in originally (as opposed to the actual price), the better break the purchaser is getting. If you are giving a friend a work or exchanging with another artist (be sure to use two separate contracts for the latter situation) you might want to enter a very low value so you would get some money even if they resell it at a bargain price.

4. You and the purchaser sign both copies so each will have a legal original.

5. Before the work is delivered be sure to cut out the "Notice" from the lower right corner of one copy and affix it to the work. Put it on a stretcher bar or under a sculpture base or wherever it will be invisible yet findable. Protect it with a coat of clear polyurethane or the like.

   If your work simply has no place on it for the "Notice" or your signature, you should always use an ancillary document that describes the work, bears your signature and is transferred as a (legal) part of the work—glue or copy the NOTICE on that document.

## RESALE PROCEDURE

When a work is resold, the seller makes three copies of the transfer agreement and record ("TAR") from the original contract, fills them out, entering the value that he or she and the next owner have agreed on, and both of them sign all three copies. The seller keeps one, sends one to the artist with the 15% payment (if required) and gives one to the new owner along with a copy of the original agreement, so he will know his responsibilities to the artist and have the TAR form if the work is sold again.

## THE DEALER

If you have a dealer, they will be very important in developing your use of the contract. Your dealer should make use of the contract a policy of their gallery, thereby giving the artists in the gallery collective strength against those collectors and institutions who don't really have artists' interests at heart.

Remember, your dealer knows all the ins and outs of the art world; they know the ways to get reluctant buyers to sign the contract—the better the dealer the more ways they know. Dealers can do what they do now when they want something for one of their artists—give the collector favors, exchange privileges, discounts, hot tips, advice, time and all the other things buyers expect and appreciate. It even gives the dealer an opportunity to raise the subject of prospective increase in the value of your work without seeming crass.

The contract helps dealers to keep track of the work they have sold, and avoid

relying on hit-or-miss intelligence and publicity. It creates a simple record system that automatically maintains a biography of each work and a chronological record of ownership. It makes giving a provenance no trouble at all. And it's almost costless to administer, needing only a few minutes of typing for each sale.

Using the contract is mostly a state of mind. If your dealer doesn't think the benefits of the contract are important they will have dozens of reasons why they can't get the buyers to sign it; if they care and want those benefits for you, the contract will be used every time without a loss of sale.

## YOU, THE ART WORLD AND THE CONTRACT

The vast majority of people in the art world feel that this idea is fair, reasonable and practical. Reservations about using the contract can be summed up in two basic statements:

"…the economics of buying and selling art is so fragile that if you place one more burden on the collectors of art, they will simply stop buying art…"; and

"I will certainly use the agreement, but only if everyone else uses it…."

The first statement is nonsense. Clearly, the art will be just as desirable with or without the contract, and there's no reason why the value of any work should be affected, especially if this contract is standard for the sale of art. This brings us to the second statement. If there's a problem here, it's the concern of artists or dealers that the insistence on use of this contract will jeopardize their sales in a competitive market. Under careful scrutiny this proves to be mostly illusory.

All artists sell, trade and give their work to only two kinds of people: those who are their friends and those who are not their friends.

Obviously, your friends won't give you a hard time. The only trouble will come with someone who isn't your friend. Since surely 75% of all serious art that's sold is bought by people who are friends of the artist or dealer—friends who drink together, weekend together, etc.—resistance will come only in some of those 25% of your sales to strangers. Of those people, most will wish to be friendly with you and won't hesitate to sign the contract to show their respect for your ongoing relationship with your work. This leaves perhaps 5% of your sales that will encounter serious resistance over the contract, and even this should decrease toward zero as the contract comes into widespread use.

In short, this contract will help you discover who your friends are.

If a buyer wants to buy but doesn't want to sign, tell them that all your work is sold under the contract, that it's standard for your work.

You can point out to the reluctant buyer:

♦ the contract doesn't cost anything unless your work appreciates in value; most art doesn't;

♦ if he or she makes a profit on your work you get only a small percentage of it—about the equivalent of a waitress's tip;

♦ if you like you can offer to take your prospective 15% payment in something other than money, or to give the buyer a partial credit against a new work; or

◆ you can offer to put in an original value that's more than what they are paying, giving a free ride on part of any prospective profit.

Of course, if a collector buys a work and refuses to sign the contract they will have to rely on good will when they want you or your dealer to appraise, restore or authenticate it. Why they should expect to find good will there is anybody's guess.

Is a buyer really going to pass up your work because you ask them to sign this contract? Work that they like and think is worth having? If the answer is "yes," given the fact that it doesn't cost a thing to give the creator of the work the respect deserved—if that will keep them from buying, then they are too stubborn and foolish for anyone to tell you how to educate them. Nonuse of this contract is a dumb criterion for selecting art.

## ENFORCEMENT

First, let's put this in perspective: most people will honor the contract because most people honor contracts. Those who are likely to cheat you are likely to be the same ones who gave you a hard time about signing the contract in the first place. Later owners will be more likely to cheat you than the first owner, but there are strong reasons why both first and future owners of your work should fulfill the contract's terms.

What happens if owner #1 sells your work to owner #2 and doesn't send you the transfer form? (Owner #1 isn't sending your money, either.)

Nothing happens. (You don't know about it yet.)

Sooner or later you do find out about it because the grapevine will get the news to you (or your dealer) anyway. Then, if owner #1 doesn't come across you can sue. He or she will be stuck for 15% of the profit he made or 15% of the increase in value to the time you heard about it, which may be much more. Also, note that if you have to sue to enforce any right under the contract, Paragraph 14 gives you the right to recover reasonable attorney's fees in addition to any other remedy to which you may be entitled. Clearly, owner #1 would be foolish to take the chance.

As to falsifying values, there will be as much pressure from new owners to put in high values as there is from old owners to put in low values. In 95% of the cases the amount of money to be paid the artist won't be enough to make them lie to you (in unison).

## AGREEMENT OF ORIGINAL TRANSFER OF WORK OF ART

Artist: _____ Address: _____

Purchaser: _____ Address: _____

WHEREAS Artist has created that certain Work of Art ("the Work"):

Title: _____ Dimensions: _____

Media: _____ Year: _____

WHEREAS the parties want the Artist to have certain rights in the future economics and integrity of the Work, the parties mutually agree as follows:

1. SALE: Artist hereby sells the Work to Purchaser at the agreed value of $_____.

2. RETRANSFER: If Purchaser in any way whatsoever sells, gives or trades the Work, or if it is inherited from Purchaser, or if a third party pays compensation for its destruction, Purchaser (or the representative of his estate) must within 30 days:
   (a) Pay Artist 15% of the "gross art profit," if any, on the transfer; and
   (b) Get the new owner to ratify this contract by signing a properly filled-out "Transfer Agreement and Record": (TAR); and
   (c) Deliver the signed TAR to the Artist.
   (d) "Gross art profit" for this contract means only: "Agreed value" on TAR less the "agreed value" on the last prior TAR, or (if there hasn't been a prior resale) less the agreed value in Paragraph 1 of this contract.
   (e) "Agreed value" to be filled in on each TAR shall be the actual sale price if the Work is sold for money or the fair market value at the time if transferred any other way.

3. NONDELIVERY: If the TAR isn't delivered in 30 days, Artist may compute "gross art profit" and Artist's 15% as if it had, using the fair market value at the time of the transfer or at the time Artist discovers the transfer.

4. NOTICE OF EXHIBITION: Before committing the Work to a show, Purchaser must give Artist notice of intent to do so, telling Artist all the details of the show that Purchaser then knows.

5. PROVENANCE: Upon request Artist will furnish Purchaser and his successors a written history and provenance of the Work based on TAR's and Artist's best information as to shows.

6. ARTIST'S EXHIBITION: Artist may show the Work for up to 60 days once every 5 years at a nonprofit institution at no expense to Purchaser, upon written notice no later than 120 days before opening and upon satisfactory proof of insurance and prepaid transportation.

7. NONDESTRUCTION: Purchaser will not permit any intentional destruction, damage or modification of the Work.

8. RESTORATION: If the Work is damaged, Purchaser will consult Artist before any restoration and must give Artist first opportunity to restore it, if practicable.

9. RENTS: If the Work is rented, Purchaser must pay Artist 50% of the rents within 30 days of receipt.

10. REPRODUCTION: Artist reserves all rights to reproduce the Work.

11. NOTICE: A Notice, in the form below, must be permanently affixed to the Work, warning that ownership, etc., are subject to this contract. If, however, a document represents the Work or is part of the Work, the Notice must instead be a permanent part of that document

12. TRANSFEREES BOUND: If anyone becomes the owner of the Work with notice of this contract, that person shall be bound to all its terms as if he had signed a TAR when he acquired the Work.

13. EXPIRATION: This contract binds the parties, their heirs and all their successors in interest, and all Purchaser's obligations are attached to the Work and go with ownership of the Work, all for the life of the Artist and Artist's surviving spouse plus 21 years, except the obligations of Paragraphs 4, 6 and 8 shall last only for the Artist's lifetime.

14. ATTORNEYS' FEES: In any proceeding to enforce any part of this contract, the aggrieved party shall be entitled to reasonable attorneys' fees in addition to any available remedy.

15. MORAL RIGHT: The Purchaser will not permit any use of the Artist's name or misuse of the Work which would reflect discredit on his or her reputation as an artist or which would violate the spirit of the Work.

_____ _____
DATED: ARTIST

_____ _____
DATED: PURCHASER

## TRANSFER AGREEMENT AND RECORD

Title: _____ Dimensions: _____

Media: _____ Year: _____

Ownership of the above Work of Art has been transferred between the undersigned persons, and the new owner hereby expressly ratifies, assumes and agrees to be bound by the terms of the Contract dated _____ between:

Artist: _____ Address:_____

Purchaser: _____ Address:_____

Agreed value (as defined in said contract) at the time of the transfer: $_____

Old Owner: _____ Address:_____

New Owner: _____ Address:_____

Date of this transfer:_____

### SPECIMEN NOTICE

Ownership, transfer, exhibition and reproduction of
this Work of Art are subject to a certain Contract dated
_____ between:

Artist: _____

Address:_____

Purchaser: _____

Address:_____

Artist has a copy.

### NOTICE

Ownership, transfer, exhibition and reproduction of
this Work of Art are subject to a certain Contract dated
_____ between:

Artist: _____

Address: _____

Purchaser: _____

Address: _____

Artist has a copy.

CUT OUT, AFFIX TO WORK

*The Reserved Rights Transfer and Sale Agreement was originally conceived by Seth Siegelaub,*
*drafted by Robert Projansky and subsequently revised to its present form by Mr. Projansky.*

### SAMPLE NOTICE TO PURCHASER OF RESALE ROYALTIES AND MORAL RIGHTS (ART PRESERVATION)

Pursuant to the laws of the State of California, the sale of this work is subject to the provisions of the California Resale Royalty Act (California Civil Code Section 986) and the California Fine Arts Preservation Act (California Civil Code Section 987).

Under the Resale Royalty Act, you are responsible, when the work is sold or transferred in any form, to pay to the artist five percent of the gross sales price received by you for the work providing that amount is $1000 or more (in the event other artworks or property are part of the sales price, the five percent royalty will be calculated from the fair market value of such goods). This provision shall not apply if the gross sales price for the work is less than the purchase price paid by you to the artist.

Pursuant to the California Fine Arts Preservation Act, you may not intentionally deface, mutilate, alter or destroy the work or authorize another to do so.

**Note to Artist using this Notice:**

This notice may be used only with regard to original painting, sculpture and drawing.

It should be given to a purchaser accompanying a Bill of Sale when the purchaser has refused or is not likely to sign an Agreement of Original Transfer of Work of Art.

It can also be used, at your request, by your gallery or representative and in conjunction with other contracts for the sale of your work.

Similar notices can be drafted to reflect the laws of other states.

# Analysis of an Artist and Representative Agreement

**RONALD G. BAKAL, ESQ.**
*Ronald G. Bakal, Attorney, has been practicing for over twenty years in the field of copyright and contracts. He has also taught courses in law and copyright at UCLA, USC, Pepperdine and Otis Parsons.*

The following agreements illustrate well-thought-out professional contracts between artists and their representatives. Each is tailored to the needs of an agency relationship in a specific area of the visual arts and each is annotated to explain the meaning of and reasons for each point of agreement between the parties.

As noted throughout this book, these agreements cannot replace consultation with an attorney and should be used only as information and reference when negotiating or preparing your own contract. Nor can these samples replace adequate investigation of and discussions with the representative prior to signing any agreement.

Since these contracts formalize very personal relationships, all of the participants should make sure that all conditions of the business relationship are in writing. Both participants should have finalized contracts reviewed by an attorney representing their interests.

## SAMPLE ARTIST AND REPRESENTATIVE AGREEMENT

The purpose of this Agreement is to provide a clear working arrangement and a fair method of termination of this Agreement between the Illustrator/Designer/Photographer (hereafter referred to as "Artist") and the Representative (an agent who solicits work and negotiates fees).

Artist _____

Representative _____

**1.** The Representative will receive 25% commission on all work for clients in town and 30% commission on all work for clients out of town. In town shall be defined by _____(specify mileage radius from Representative's place of business). The Representative will pay his or her own out of town travel expenses. The Representative will take a full commission on all work that originates in the Representative's assigned

geographic territory that is produced by the Artist and is not written on the house account list that follows. This commission will be taken on all fees resulting from this artwork including the sale of the original artwork itself whether these fees are negotiated all at one time or over a period of time unless the Artist and Representative have terminated their working agreement and a settlement to the Representative has been made.

*This clause clarifies the representative's commission. This is a standard commission percentage. A rep asks for 30% commission on out of town work because the expenses are higher; telephone, delivery, etc. The rep, whenever possible, tries to get the client to pay the delivery costs on out of town jobs, but there is often travel time, additional telephone, promotional mailings, and portfolio material delivery costs involved.*

*If the artist is located out of town the commission is usually a straight 30% on all work so the rep can recoup long distance calls and delivery to the artist.*

*There is no "law" that the representative's commission should be 25%. Although it is the most common fee, an artist in high demand may get a representative to work for 15–20%.*

*There is a statement that refers to making a commission on all sales resulting after the first sale. Artwork may be commissioned originally for one time usage (usually a reproduction in some visual publication). Later, the client may come back and purchase additional usage and even request to purchase the artwork for display. This clause clarifies that the rep is entitled to commission on all revenues resulting from any sale any time if the artwork is one on which he or she is entitled to an initial commission, unless the artist and rep are no longer working together and have made a settlement according to the later terms of this agreement.*

*The phrase "out of town" should be defined as a specific mileage radius: beyond a one hundred mile radius may be reasonable.*

**2.** The Artist reserves the following clients as House Accounts to be serviced by the Artist without compensation to the Representative under specified conditions with a partial commission to be paid to the Representative. When full commission is paid, the account is no longer a House Account.
House Accounts_____(name, address, phone).

*The term "house accounts" should be more specifically defined. For example, all those accounts that are listed by the artist prior to the execution of the agreement as those on which no commission is to be paid to the representative.*

*Some reps expect an artist to turn over all existing accounts to them with the rationale that the artist either needs their services totally or not at all.*

*Other reps do not care if the artist keeps a few long standing accounts that the artist has worked to establish. Some reps stipulate in their contracts that house accounts must be active, meaning at least one transfer of work has occurred in the last year. Sometimes the artist is happy to relinquish the account at a later date to the rep so the client is better serviced. However, if the artist has a long local list of house accounts that he or she wishes to keep and they include clients that the representative regularly services for other artists, the representative may decline to represent the artist because the artist does not seem in serious need of the rep's services and the rep may end up in competition with the artist for certain clients. Another consideration from the rep's point of view is that if the artist has a long list of house accounts, their time may be so booked up they will be turning away the rep's jobs in favor of their own accounts. If the rep does not have a fair chance to make money with an artist, there is little reason to represent him or her.*

**3.** The Representative will actively show the Artist's work and pursue new business. All referrals and leads coming to the Artist directly and not listed under House Accounts or otherwise restricted under this Agreement, will be turned over to the Representative. The Representative will pursue, negotiate, pick up (when appropriate), provide written Assignment Confirmation forms for (as required), invoice, collect sales tax, and receive full commission therefrom.

*This explains what the rep's responsibilities are. Note that some reps will pick up or deliver the job "when appropriate." Sometimes the client may insist on explaining the job to the artist or it may be a rush job and the rep may be booked solid and unable to pick up the job and it may be lost.*

*Representatives are not lawyers and/or accountants and the artist should not presume that they will handle either legal or accounting problems for the artist in conjunction with the handling of his or her work.*

*The clause referring to the artist turning over all leads is important because some artists feel if the call comes directly to them the rep had nothing to do with it. It is impossible to trace where a rep's promotion of an artist stops. Even if the rep has no traceable connection to the job, the account is his or hers to pursue if it is not listed under house accounts. The rep is entitled to income only on the jobs that come in. Therefore, it is reasonable he or she lose no opportunity to earn a living.*

**4.** The Artist will be responsible for delivery of the interim sketches and the final artwork unless the Representative's assistance is needed (but the Representative is not to be considered a messenger).

*Some reps pick up and deliver all phases of the job to both the artist and the client, especially if the reps are new and have fewer jobs and more time. Others pick up the work and have the artist come to their offices to get it and return it so the rep can deliver it to the client. Some reps pick up the work and the artist does the leg work from then on (as in this contract). There are endless variations regarding delivery. The most important issues are that the client be well serviced, and the arrangement between the rep and artist be flexible enough to allow for prompt pickup and delivery. More and more, reps are resisting being a delivery service, as it interferes with pursuing new business, which is the rep's most important function.*

**5.** The Artist does not discuss or agree to a price or terms of a job without consulting the Representative first.

*This clause is very important because if the rep is not available or the artist is consulted first on a job and agrees to any terms, the rep may not have a chance to get the top fair price. The rep may have information on pricing and usage that the artist is unaware of or may have already discussed the work with the client and the client is trying to get a different deal (usually less favorable for the artist) through the artist. As mentioned before, artists need to support their rep's position as negotiator to the fullest because clients who insist on speaking to the artist directly about the business end (not the art end) when they know the artist has a rep, usually have a hidden agenda.*

**6.** If the Artist actively pursues new work in competition with the Representative contrary to the terms as stated in this agreement, the Artist shall be put on thirty (30) day written notice and all the termination procedures will begin to apply.

*This clause makes clear the rep does not intend to compete with the artist in obtaining work. If an artist is in a slow period and takes his own portfolio out he or she may be going to clients already serviced by the rep, thereby weakening the rep's (and the artist's) position with those clients. If an assignment or project results from the artist showing his or her own work, for whatever reason (a legitimate reason for an artist to show his own book would be if their rep is on vacation), the rep is still entitled to full commission. The artist should always inform the rep of these situations beforehand, if possible. Complete candor between artist and rep makes for a long-lasting, trusting relationship.*

**7.** The Representative will solicit work for the Artist to the best of his or her ability in the following areas:

Geographic Territory of the Representative:_____

Fields of Work in Which to Represent the Artist: _____

*Examples of geographic territories are: all states west of the Rocky Mountains, California only, the United States only, Los Angeles, Orange and San Diego Counties only. This is especially important if the artist has more than one rep. Some have two or three in the United States, so geographic boundaries should be clearly defined.*

*Examples of fields of work are: commercial photography (not stock photography), illustration (not graphic design), movie poster illustration (not editorial illustration).*

*The more the artist restricts the rep, the less business he or she can expect. A thorough discussion should be held on these two areas. A good rep will not take on territories or fields of work they are unwilling or unable to actively pursue.*

**8.** During the term of this Agreement, the Artist agrees not to use any other Representative in the same geographic locations or fields of work.

*This clause makes the rep's territory and fields of work listed above exclusively his or hers.*

**9.** The Artist will provide updated portfolio material of acceptable format on a regular basis. It will be the Artist's responsibility to pick up artwork and tear sheets from the client, for the portfolio and promotional purposes, after an assignment is completed.

*If the rep shows his or her other artists' work in slide form or laminated printed pieces or 8x10–inch transparencies, then "acceptable format" would mean the new artist would provide the same. It is very important, no matter how busy the artist gets, that he or she keeps the rep supplied with new samples. It is most logical for the artist to get the samples from the client after a job is completed because they can keep track of their own work better than the rep, who may represent many people and handle dozens of clients at the same time.*

**10.** The Artist will provide promotional material on a regular basis, no less than once a year, with the Representative's name and phone number on it. On mass mailings of promotional materials to clients, the Artist shall pay 75% of the costs incurred and the Representative shall pay 25%.

*New promotional material is essential in marketing talent. It is appropriately professional to advertise that you have a rep (all new business must go to the rep anyway), so the rep's name and phone number are essential. If promotional material is in a catalog or reference book form reps pay a percentage of the page fee. Some reps pay 25% of the page fee and the artist 75% (or whatever their standard fee breakdown percentage is).*

*Sometimes the rep prefers to deal with this on an individual basis rather than putting it in the contract, i.e., the artist may decide to go into the Black Book, which is national, and the rep's territory may be limited so the rep would want to negotiate this out of contract each time a catalog opportunity comes up.*

*The cost of mass promotional mailings is prohibitive, therefore, the standard 25%/75% breakdown.*

**11.** The Representative will exercise great care in the handling and safekeeping of all portfolio materials left with him or her. However, the Representative will not be financially responsible for loss or damage of the portfolios in his or her care. To prevent undue loss the Artist will keep all original artwork and will provide the Representative with duplicates or reproductions only.

*It is next to impossible for representatives to insure work that does not belong to them. It is up to the artist to do so. No artist should show or allow his or her rep to show original artwork, if possible. There are countless horror stories of theft, accidentally spilled coffee, fire damage, rain or flood damage, and other acts of God that have destroyed irreplaceable transparencies and original artwork. Better safe than sorry.*

*If a client retains original artwork, they should sign an acknowledgment of the value of the original artwork and assume full responsibility for its loss or damage.*

*It may be advisable for the rep and artist to take out a personal property insurance policy to protect against lost or damaged materials. The premium should be paid in same proportion to the fee arrangement (75% by artist and 25% by rep).*

**12.** The Representative will provide invoicing and collecting (including sales tax) services for the Artist and will pay the Artist on receipt of the moneys after the checks have cleared the bank. If collection or legal fees are involved in the resolving of client nonpayment, the Representative will pay 25% of the fee and the Artist will pay 75% of the fee for those services.

*Most professional reps do all the billing so that they can make sure that the prices charged are those negotiated, that the proper sales tax has been added, and that the correct conditions of rights and usage and who owns the original work is stated on the invoice. Prompt, professional billing by the rep provides greater control of accounts (including follow-ups on late payment and return of original artwork) that increases the likelihood the artist will be paid on time. As stated here, the rep should not be required to pay the artist before the checks have been cleared.*

**13.** The Artist and the Representative must have valid resale sales tax numbers or permits, as is applicable for their state.

*Artwork and photography is taxable in many states. In those states, both the artist (for his or her house accounts) and the representative must have valid sales tax licenses in order for the state to allow them to do business.*

**14.** The Artist has the right of approval on fees and assignments and may refuse any assignment before it has begun.

*The representative is only the agent. The artist should have the final say-so on any job before it begins. However, once the work is in progress the artist must continue on the terms as agreed in order to insure good working relations with the client so that future work is not jeopardized.*

**15.** The Representative does not acquire any rights to the Artist's work, and will return it promptly on demand.

*Only the artist owns his original artwork (unless the client has purchased it). The rep must return any work the artist requests to have back. The rep, however, does make a commission if the artwork is sold (see contract clause 1). The representative does not have a 25% interest in the copyright to the works of the artist, but merely an interest in receiving a fee for the sale of its uses or fee for the outright sale of the work. The representative has no control of the artwork regarding modifications or changes in it, although some knowledgeable representatives can be very contributive and helpful critics.*

**16.** The Artist and the Representative are independent contractors and their relationship is not that of a joint venture or employer/employee.

*Neither the artist nor the representative is the other's employer and neither should treat the other as an employee. Each runs their own business in their own way and their relationship is governed only by this mutual agreement. This clause should also make clear that this relationship is not a partnership. If deemed a partnership, both sides are totally liable for each other's errors and omissions, and they may be further liable for any debts incurred.*

**17.** If the Representative or the Artist should die, any moneys due either party will go to the heir listed below:

Artist's Heir: _____

Address: _____

Representative's Heir: _____

Address:_____

*This is an important clause. If death occurs and any money is outstanding it is important to know to whom and where to send it.*

**18.** This Agreement is personal between the parties and is unassignable.

*This agreement cannot be turned over from one rep to another or from one artist to another. It is between only the parties who are signing it.*

**19.** This Agreement constitutes the entire understanding between the parties and no modifications will be valid unless made in writing and signed by both parties.

*Any verbal agreement that is a modification or change should be written down, signed by both parties, and added to this agreement.*

**20.** This Agreement will be interpreted in accordance with the laws of the State of California (or the state in which the Rep resides).

*If a rep handles an artist who lives out of state, this clause stipulates that this agreement will be bound by the laws of the state in which the rep lives and not the state where the artist lives.*

**21.** This Agreement will terminate thirty (30) days after receipt of written notice of termination given by either party, subject to the following terms.

*A thirty-day termination notice is necessary to allow all current business to be wrapped up. It gives both parties time to mutually decide whether a cash settlement or six months of continued work is acceptable.*

a. The Representative will receive his or her full commission for six (6) months after the termination on all the jobs he or she is entitled to under this Agreement. Commissions to be paid within the six (6) month time period shall include work that has been completed prior to termination notice and not yet paid, and work that is started or completed within the time period whether the fee has been collected by the end of that six (6) month period or not.

*This clause explains that when the six month termination period is over what is terminated is any business dealings between artist and rep, and rep on behalf of artist, with the exception of the collecting of fees that are outstanding. The rep is still entitled to a commission from these fees if they were earned during the agreement, even if they are collected after the end of the final date of termination.*

b. The Artist agrees to continue to provide artwork for the Representative during the six (6) month termination period unless a cash settlement is made to the Representative, pursuant to 21(e).

*There have been cases where an artist refused to make a cash settlement with the rep after terminating and also refused all new work, including jobs that had been arranged for and agreed to, thus causing the rep loss of earned income. The phrase "agrees to continue to work with" should be more clearly spelled out to reflect the fact that the artist, during the six-month period, will cooperate in completing work accepted prior to termination and maintain the usual business relationship with the agent regarding that work.*

c. Any controversy or claim arising out of or related to this contract or the breach of this contract shall be settled by mediation or binding arbitration in the City and State in which it was executed, the first such hearing to take place within thirty (30) days after demand for mediation or arbitration is received by either party. A settlement will be made before a jointly selected, single mediator or arbitrator, the Graphic Artist Guilds Arbitration Board, or other appropriate organization (such as the American Arbitration Association, Arts Arbitration and Mediation Services, a program of California Lawyers for the Arts, etc.), and upon the rules of such organization, arbitrator or mediator.

If mediation is not successful in resolving all disputes arising out of this agreement, those unresolved disputes shall be submitted to final and binding arbitration in accordance with the rules of any such mediation program, and the prevailing party shall be entitled to recover its attorneys' fees and costs incurred in connection with resolving the disputes. The arbitrator's award shall be final and judgment may be entered upon it by any court having jurisdiction thereof.

*This clause is aimed at preventing costly litigation and providing a neutral and objective outside mediator or arbitrator or use of established mediation or arbitration boards in the community that can provide a fair method of settlement. The nonprevailing party should pay the costs of litigation, attorneys' fees and/or mediation or arbitration.*

d. If litigation becomes necessary (as a last resort after mediation or arbitration has been completed) to settle any disputes between the two parties, the loser of the

suit will pay all attorneys' fees.

*A reason for litigation after mediation would be if one of the parties agreed to pay certain moneys through mediation and refused to pay and the other party had to sue to collect.*

e. An optional cash settlement can be made to the Representative of an agreed upon amount reflecting the estimated work which might be expected in that six (6) month period, and additional fees from resale of artwork usage or sale of the original artwork that may reasonably occur during that time period. This settlement would complete this Agreement and no additional money would be paid the Representative except for the moneys due him or her for work previously billed and not yet collected.

*If the artist has to move or if the artist and rep no longer wish to have any contact with each other this clause assures a quick separation and solution regarding any future money disbursement. Because this settlement terminates this agreement immediately, it releases the artist from six months of commissions to the rep on new work or work not yet completed as of the termination date (see 21b above).*

f. Notice will be given to the Artist at: _____ (address)
g. Notice will be given to the Representative at: _____ (address)

*(f) and (g) It's important to establish in writing (not just a phone call) that this agreement is being terminated as of a particular date (month, day and year).*

**22.** This Agreement is accepted by:

_____
ARTIST                                                    DATE

_____
REPRESENTATIVE                                            DATE

_____
CITY                                                      STATE/ZIP

# Contracts for Employment

**PAUL D. SUPNIK**

*Paul D. Supnik is a past chair of the Intellectual Property
and Entertainment Law Section of the Los Angeles
County Bar Association, a co-editor of the 1980 edition of
Committee for the Arts' publication,* The Actors Manual,
*co-editor of the publication* Enforcement of Copyright and
Related Rights Affecting the Music Industry, *and author
of the chapter "Copyright" in* Proof in Competitive
Business Litigation *published by California Continuing
Education of the Bar. He practices entertainment, copyright
and trademark law in Beverly Hills.*

**A**rtists frequently enter into employment agreements and sign related documents. These contracts may allow someone to acquire or attempt to acquire rights to the artist's creations. This chapter discusses several types of artist related employment agreements.

## The Artist as Initial Owner of Creative Works

When an artist has no business relationship either as an employee or as a commissioned artist, copyright law states that "copyright in a work (subject to the copyright laws) vests (i.e., is owned) initially in the author or authors of the work." If the artist owns the materials used to create the artwork, then the actual original work itself and the exclusive rights to reproduce and do all the other things that copyright allows are initially owned by the artist.

These rights can be granted, licensed or sold, individually or collectively in one media or in a plethora of media. Licenses can last for a limited period of time or run concurrent with the copyright term. You can base the sales price of a work on the extent and variety of rights that you grant. Even if you assign the rights to the work now, you may have the opportunity to terminate that assignment in the future (which can be important if your work becomes particularly valuable in later years) under special provisions of the copyright law.

## Works Made for Hire

The copyright law gives the initial copyright ownership to the artist's employer in

certain situations, even in the absence of any agreement, contract or other oral or written statement. Thus, the copyright law states:

> *In the case of a work made for hire, the employer or other person for whom the work was prepared is considered the author (the word "author" has a broad meaning in the copyright law and can include "artist") for purposes of this title (the author is the initial owner of copyright), and, unless the parties have expressly agreed otherwise in a written instrument signed by them (the employer or other person for whom the work was prepared) owns all of the rights comprised in the copyright.*

The term, work made for hire, has a special meaning under the copyright law. It exists in two situations. The first is where the artist is employed. The law states:

> *A work made for hire is: (1) a work prepared by an employee within the scope of his or her employment....*

Sounds simple. But how do you know if you are an employee? The following will give you clues as to whether you are truly an employee, but there may be other determining factors. Does the employer dictate the place and times that you work? Does the employer withhold income tax? Does he or she pay unemployment insurance and deduct disability and social security from your paycheck? If you can answer "yes" to all these questions, you are probably an employee within the meaning of the copyright law. But if you have difficulty answering some of these questions with a "yes," it is possible that you are not an employee within the meaning of this provision of the copyright law. If you are not paid for your work, either for supposed employment or for commissioned works, and you do not sign a written copyright transfer, you may still own the copyright in your work. If money was not paid, an employment situation might not exist and you could still be the owner. Also, it might be possible to rescind the contract by which you were commissioned to create the work on the grounds that the failure to pay is a material breach of contract. Rescinding a contract means that each party gives back what it had previously received under the contract. It is more difficult to rescind a contract after you have received any significant payments.

Not only must you be an employee, but the work must have been created in the scope of your employment. This is sometimes difficult to determine. Suppose you were hired to put together an exhibit and during work hours you created a painting. The painting might not be within the scope of employment, and would thus not be a work made for hire owned by the employer.

More difficult questions arise when using materials, time, and supplies of the employer. In that situation, the employer owns the canvas and original artwork, but

## UNITED STATES SUPREME COURT RULES ON EMPLOYER STATUS

In the case of *Community for Creative Nonviolence v. Reid*,[1] a sculptor had been commissioned by a nonprofit organization to create a sculpture for a organization that helped the homeless. The U.S. Supreme Court went through a list of about a dozen factors that it said must be considered to determine whether or not the artist was indeed to be considered as an employee of the nonprofit organization in creating the sculpture. It ultimately found that there was no employment relationship, but because representatives of the organization had participated in suggesting how the sculpture was to be created, the court indicated that the organization could have indeed been a joint author of the work and sent the case back to the lower court to consider that issue.

---

1 109 S. Ct. 362, 102 L. Ed. 2d 352 (1989).

you own the exclusive rights provided by the copyright laws, such as the right to reproduce the work and to license others to do so.

Although preexisting works, according to current law, cannot "become" a work made for hire, it may be advantageous to avoid creating a work as a work for hire. A work made for hire may take all rights away from the artist, including the right of termination.

## COMMISSIONED WORKS

The Copyright Law provides a second basis for determining if a work is a work made for hire. Generally these are certain specific types of commissioned works. The copyright law provides that a work made for hire is:

> (2) a work *specially ordered or commissioned for use as a contribution to a collective work, as a part of a motion picture or other audiovisual work, as a translation, as a supplementary work, as a compilation, as an instructional text, as a test, as answer material for a test, or as an atlas, if the parties expressly agree in a written instrument signed by them that the work shall be considered a work made for hire.*

Note the various requirements. It must be specially ordered or commissioned. Thus a general agreement to create, but not for a specific purpose, does not fall within this definition of a work made for hire.

The law specifies the words "for use as" before enumerating in detail specific categories of works. If the work is not specially ordered or commissioned for use as one of these types of work, it will not become a work made for hire. Thus, if you are a photographer or painter and take a photograph or do a painting of an individual, just for an individual, it will not be a specially ordered or commissioned work made for hire. But if the photograph or painting is for a book of photographs or reproductions of paintings, for example, it could be part of a collective work and therefore qualify as a specially ordered or commissioned work made for hire.

Of primary interest to artists are the first two categories specified in the Copyright Act. "A contribution to a collective work" may be a painting for a multimedia work, a photograph for a book of photographs or perhaps some aspect of a performance piece. Thus, if you are specially ordered or commissioned to create such a work for use as a contribution to a collective work, it may be deemed a work made for hire, and you may not be the author or owner of the work. The word "may" is used since the work may not be work for hire if all the formalities are not followed. Thus, both parties must sign the agreement that it is a work for hire, prior to the time when creation of the work begins.

"A part of a motion picture or other audiovisual work" may include set designs, photographs, drawings, or other artistic aspects of a filmed or taped performance piece.

A "supplementary work" is defined as:

> A work prepared for publication as a secondary adjunct to a work by another author for the purpose of introducing, concluding, illustrating, explaining, revising, commenting upon, or assisting in the use of the other work, such as forwards, afterwords, pictorial illustrations, maps, charts, tables, editorial notes, musical arrangements, answer material for tests, bibliographies, appendixes and indexes....

An illustration made for a book jacket or a record album cover could be a

supplementary work, as could materials for teaching aids, texts, atlases, and the like, that involve the use of photographs, pictorial illustrations or drawings.

## Work Made for Hire—There Must Be a Writing

Even if the commissioned or specially ordered work is one of the specific types of works set out in the Copyright Law, it does not automatically become a work made for hire. It becomes a work made for hire only when there is a signed written instrument expressly agreeing that the work shall be considered a work made for hire. The instrument must be signed by both the artist and the commissioning person or other commissioning entity. The document does not have to be formal but it must be written. This is a change in the law, that benefits artists, made since the enactment of the Copyright Act of 1976. If a work does not fall within one of the specified categories and an agreement is signed, it is possible to effectuate a transfer of the copyright to the commissioning party. Even if a work made for hire agreement is not signed, it does not necessarily mean that the commissioning party ends up with no rights. They can have limited or nonexclusive rights in copyright to the work, since the payment of money creates an implied nonexclusive license to use the work in a manner contemplated by the parties.

> ### Does Check Endorsement Prove an Artist has Created a Work Made for Hire?
>
> —
>
> Recently, in a case involving the paintings of Patrick Nagel,[2] a court ruled that a check endorsement does not create a work for hire at least under certain circumstances. During his life, Patrick Nagel had received checks as payment for the publication of his paintings in *Playboy Magazine*. The court said that the artist Nagel was not an employee of *Playboy*, and the checks were signed after the works were created. The works were not "specially ordered or commissioned" since they were not created at the risk or expense of *Playboy*. Once the works are created, they are owned by the artist and any transfer of ownership must be made by assignment. Although you may not want to rely on the findings of this case, it could be a way out, if you find that you have already cashed a check bearing a work made for hire notation.

Recently, there have been a few cases, beneficial to artists, which suggest that a work made for hire agreement for a commissioned or specially ordered work must be signed before the starting of said work or a work made for hire agreement will not result under the Copyright Act. Several recent copyright cases have favored the artist in suggesting that a work made for hire agreement cannot be established after the fact. Once the artist has started to create the work, the commissioning party cannot then create a work for hire agreement (although the artist can still transfer or assign copyright ownership in the work). However, it is better for the artist to simply avoid entering into a work made for hire agreement if they don't understand its consequences.

## Reserve Rights

As long as a written instrument has to be signed, the artist should consider reserving certain rights, such as the right to reproduce the works in other media or the right to reproduce them after the commissioning party has had a specific period of time in which to exploit the work.

Some work made for hire agreements will look like routine paperwork. Some will

2 *Playboy v. Dumas,* 831 F. Supp. 295 (S.D.N.Y. 1993).

be form contracts and some will be typeset. They can be found in the fine print of purchase orders and stamped on checks. They are frequently found in agreements with newspapers, magazines and in the publishing industry and they also appear in other areas. Photographers have paved the way in negotiating around and out of work made for hire agreements. Try to limit the scope of work made for hire agreements. For example, suppose you wish to use a mark, that appears in your work made for hire, to promote yourself. You may need permission from your former employer to use that mark. The employer should not have any need to acquire those rights and it should not be too difficult for you to negotiate for them before you sign an agreement. Try to split out or withhold rights for specific purposes and take these out of the work for hire agreement. If you are able to carve out rights from a work made for hire agreement, make a very good archival copy of the work so you will be able to make quality reproductions of the work for other purposes.

The justification for the laws relating to works made for hire are based on the rationale that the employer risks the funds, provides the environment and working arrangements, and pays the artist. Therefore, the employer should own the rights in the work. This has some justification in a large business environment.

In the case of specially commissioned works, the work made for hire justification is based on the fact that the categories specified by the law typically involve group or team situations. It is burdensome to require an employer or owner to secure rights separately from all parties involved in such works. If the artist has bargaining power, he or she may not have to sign a work made for hire agreement.

## CONTRACTS FOR IDEAS

An artist may be asked to come up with ideas for a project or may have ideas of their own to promote. Are ideas protectable? Can they be sold? Ideas, by themselves, can be protected to only a limited extent. Ideas cannot be protected by copyright, trademarks or patents. Copyright only protects expression of ideas; trademarks protect goodwill and designations of origin; and patents protect new and nonobvious designs and inventions. Ideas can be protected by keeping them secret. They can be sold to another person or business, but make sure you have an agreement not to use or disclose the idea without permission or appropriate compensation and credit—before the idea is disclosed. If the idea is disclosed first, there will be nothing secret to protect. You should present ideas to a person or business only under circumstances of confidence, or where there is an express agreement or where, by the conduct of the parties it appears that an agreement was intended, or where the law implies an agreement to prevent unjust enrichment of the party taking the agreement.

Ideally, the artist submitting the idea to another should obtain an agreement in writing stating that if no express written permission is made to use the ideas submitted, then the ideas may not be used in any manner or disclosed to anyone. However, many people in business, especially those who have legal counsel, will not accept ideas under those constraints. A verbal agreement to the same effect might be easier to obtain and be almost as good, at least if a friendly witness is present. But, if the idea does get disclosed to another person who is not aware of the confidential relationship, the artist has a legal claim against only the person or business with whom the confidential agreement was made, and only if there is proof that the idea was disclosed in

violation of the agreement. Usually, if the idea is not novel, the person receiving it can prove that they already possessed the idea. If the idea is overly broad, the artist will not be able to protect it. Frequently, a particular stimulus, such as a world event or trend, causes many people to think of the same idea at about the same time.

## WRITTEN EMPLOYMENT AGREEMENTS

Sometimes new employees are requested to sign an employment agreement. Often, the agreement is regarded as a mere formality by both the employer and employee. But it can have substantial significance in determining which valuable rights are given to the employer and which are retained by the employee. This is important for artists as to ownership of their creative efforts. It is important to know what the agreement says, even if you have no bargaining power to make changes at the time the agreement is entered. You can determine what changes to seek if your bargaining position changes. You will also know who owns the rights to your creations before you create something in which you want to retain ownership.

### Art School Contracts

Artists are frequently required to sign agreements upon entering art school that stipulate any art created in the course of their studies may be used by the school in some manner or is owned by the school in some manner. They should be aware of the scope of the contract, and should read it carefully and consider what is being said about the following questions. At what point is the artwork owned by the school? Does it own all art created during the time of enrollment, or only the art that is created for class assignments? What rights are given to the school? Are they for the physical work of art? Do they include copyright? If they include copyright, does the artist obtain a royalty for subsequent sales? What will happen if the art school assigns rights in the artwork to a commercial business? If the copyright in a work of art created during art school is owned by the school, will that later prevent the artist from creating a similar work of art commercially? Often, these concerns are raised later on, especially if the artist becomes successful. It is not likely that the art school will be considered as an employer of a work made for hire, but that is a possibility. It is more likely that a student be required, under the contract, to assign an artwork created during that period of time to the school.

### Trade Secrets and Confidential Information

Two types of clauses in the employment contract are of interest to the employee-visual artist. The first is a statement requiring that the employee not disclose any confidential information or trade secrets of the employer. This restriction does not usually present significant problems to the artist. The second type of clause, however, is one in which the employee agrees in effect that everything created in connection with the employee's work is owned by the employer.

A trade secret can include such things as patterns, charts, compilations of information or other materials used in a business (e.g., art gallery, design studio, advertising agency) that gives a competitor an advantage over others who do not know of it. It is generally something that is continuously used in the operation of a business. A customer list (e.g., patrons of a particular art gallery) is also an example of a trade secret,

## CALIFORNIA'S WORK MADE FOR HIRE LAWS

In an effort to limit the routine and improper use of work made for hire contracts, the California Legislature enacted several statutes amending the California Labor and Unemployment Insurance codes (Senate Bill No. 1755; Chapter 1332 of the Statutes of 1982). Although California is the only state to date to pass these laws, this is reprinted to help artists lobby for similar statutes in their states.

Here is a summary of key benefits:

Requires an employer who uses a work made for hire contract to maintain workers' compensation insurance coverage for work made for hire employees.

Makes the employer liable to the work made for hire employee for any injuries suffered by the employee in the course of the work, even if it was not the employer's fault. This means that if you have signed a work made for hire contract with a client, and you are injured in an auto accident while driving at the client's request, the client may be legally liable to you for injuries you sustained, even if the accident was completely another driver's fault.

Requires the work made for hire employer to contribute to the California Unemployment Insurance Fund, based on the amount of money you are paid under the work made for hire contract. The employer must also deduct from your agreed pay, State Disability Insurance Fund withholdings. An employer who fails to do this may have the amounts assessed against him by the state, plus penalties and interest.

Allows the Labor Commission to impose penalties against the employer for "waiting time." In most cases, the employer is required to pay all compensation earned by the employee upon termination of employment. Penalties equal to the full amount owed, multiplied by the total number of days payment is owing, up to thirty days, may be assessed against the employer by the Labor Commissioner, and paid to the employee, if the employer's failure to pay is willful. Technically, this means that an employer using a work for hire contract who deliberately and willfully waits thirty days beyond the due date to pay you an outstanding $100, could be liable for $3,000 in penalties for waiting to pay you. In practice, however, you may be required to prove an actual employment relationship, (as opposed to independent contractor status) to obtain waiting time penalties.

Even if the Labor Commissioner declines jurisdiction, you nevertheless have the absolute right to bring a civil lawsuit in court for waiting time penalties, pursuant to other parts of the labor code.

*Gregory T. Victoroff*

while it is used in the business and is maintained in confidence.

For drawings, patterns and designs to be trade secrets, they must be treated as such. If they are generally exposed and available to the public, or if they are not treated in confidence, they may lose their character as trade secrets and may not be protectable.

The law protects trade secrets from employee disclosure where there is a contract specifically referring to trade secrets. The problem for the visual artist is to determine what the employer believes is a trade secret. For example, you can question the employer as to whether the specific pattern you are interested in using in your own ventures is considered a trade secret. You should try to get a written response to your inquiry. If the employer does not consider the information a trade secret, it is doubtful that a court will later define it as such.

Trade secrets can be protected by the court, even where there is no trade secret agreement. A court can base its decision to protect an employer on a breach of

confidence or breach of trust by an employee. The courts consider many factors in determining whether trade secrets have been taken.

A trade secret can be enforced by obtaining an "injunction." An injunction is a court order, generally requiring that certain named persons or businesses refrain from taking certain actions. The failure to obey a court order can result in "contempt of court." This means that the court has the power to jail one who disobeys the order. The court can also award a money judgment for damages resulting from the disclosure of a trade secret.

### Absence of Agreement

Even in the absence of an employment agreement, an employer may acquire certain rights in a visual artist's work. Some states have attempted to define what creations are owned by an employer and employee. Section 2860 of the California Labor Code, for example, states that: "Everything which an employee acquires by virtue of his employment, except the compensation which is due to him from his employer, belongs to the employer, whether acquired lawfully or unlawfully, or during or after the expiration of the term of his employment."

You should investigate your state laws that define the relationship between artist and employer.

### Limit the Scope of Agreement

An employment contract may state that everything created during the term of employment belongs to the employer. This is too broad and should be eliminated from the contract. If a court were to rule on the matter, it could limit the scope of the agreement to those creations that were conceived during office hours or to those that were related to the company's business. In fact, the law in your particular state may place limitations on such provisions.

If you have the bargaining power, consider limiting the scope of the agreement to creations that are made with company materials during business hours, and are related to projects being currently worked on by the company, and that you were hired to create.

Consider the situation where you are hired by an advertising agency to work on the creations of another employee within the company. Assume you are promoted a year later to a more creative position. The agreement that you signed previously may not have had much meaning for you at the time. Now it's important with respect to various designs and layouts that you have made on your own time. There may also be restrictions in the agreement on your ability to engage in other work activity during your term of employment that could limit additional income from outside projects. At this point, you should have the agreement clarified and reexecuted.

The agreement may attempt to prevent you from competing with your employer after your termination. Such agreements may be void. Generally, they have to be limited to a reasonable period of time and a reasonable geographical area to be valid.

### Maximum Term

The concept of binding a person to employment for an inordinate period of time is abhorrent to our legal system. California specifies a maximum time period of seven years. Any options or extensions may not total more than seven years. Thus, once the seven-year period has elapsed, there must be at least a brief time during which the artist can be on the open market to render services for others.

### Can You Be Stopped From Working?

Can an employer prevent you from working elsewhere by an employment contract? Yes, that may occur where the artist is particularly unique, but only under certain limited conditions. California has a complex provision that requires an artist be guaranteed a certain minimum compensation and though this clause is of primary interest to the entertainment industry, it could conceivably apply to visual artists as well. To prevent the artist from seeking other employment, an employer must generally establish that the services of the artist are unique and personal. Words to that effect may be in the employment contract. The employer must go to court and ask the court to enjoin or stop the artist from seeking related employment elsewhere during the term of the contract (not more than the seven-year period). If the court grants an injunction (an order by the court requiring the artist to not be employed elsewhere), an artist disobeying the order would be in contempt of court. Obviously, this power is not likely to be used unless the services of the artist are particularly important to the employer.

### Printed Form Contracts

What if you sign a printed form contract at the beginning of your employment that you are given on a take it or leave it basis. Assume the contract has lots of verbiage and is not particularly understandable to you as a lay person. Are you going to be clearly bound by it? Contracts of this nature, if particularly unfair and if presented by those in a superior bargaining position, may be considered in the law as a "contract of adhesion" (you are stuck to the contract and don't have any choice in the matter if you wish to work for the employer). It may be possible to find relief from a contract of adhesion sometime after you have signed it. This type of contract will be construed in a manner most favorable to the employee, and least favorable to the employer who drew up the agreement. A court may try to find a way to relieve you of the contract if it finds it unconscionable. However, it is not a wise practice to sign an agreement on the grounds that you might be able to get out of it in the future. A better approach is to know what you are signing, and not sign any agreement you are not able to live up to.

## INDEPENDENT CONTRACTOR OR EMPLOYEE

When you are commissioned or engaged to use your creative skills, you may be called an employee or an independent contractor. Sometimes the choice will be yours. What are some of the differences? If you are an employee, the employer has the right to determine and control the manner, place and time when you work. If you are an independent contractor, you have that right. You are more able to control what uses are made of your art work and are able to work on assignments for more than one employer.

If you are an employee, the employer will maintain workers' compensation insurance. That is required by law and it is a misdemeanor for an employer not to carry this insurance for you. Should you be injured in the scope or in the course of work, you can file claims for medical costs and disabilities. However, you will not be able to recover for what is called "pain and suffering" as a result of any such injury. Should you be injured in the scope of your employment and the employer did not carry workers' compensation insurance, you may have a greater legal claim against the

employer. But if the employer is not financially responsible, the claim may be worthless. Even if you are called an independent contractor, if you are acting as an employee (i.e., the employer has the right to control the manner in which you work), the employer may still be required to carry workers' compensation insurance.

An employer will deduct state disability insurance premiums, currently at about 1% depending on the particular state, from your pay. In the event that you are disabled in the course of your employment, you could obtain disability benefits.

An employer is required to make payroll deductions and withhold state and federal income taxes. In addition, the employer will usually deduct a percentage, (currently about 8%), from your earnings for social security and medicare. The employer matches this amount and deposits those sums on a regular basis.

The independent contractor must take it upon himself or herself to make certain deductions as well. Although the independent contractor is relieved from state and federal income tax withholding, they must usually make estimated tax deposits on a quarterly basis and may have to make larger tax payments if insufficient amounts have been deposited. While the independent contractor does not have to have social security benefit payments deducted from amounts earned, they will have to pay self-employment tax of approximately 14% of their independent contractor net earnings at the end of the year. As an employee, you will probably be subject to the protections provided by the labor laws of your state for employees, relating to prompt payment of wages and other matters. But you will also be subject to labor law provisions that typically provide that everything you acquire in the course of employment belongs to the employer.

## ANALYSIS OF A WORK FOR HIRE AGREEMENT

### THIS AGREEMENT

MADE THIS _____ DAY OF _____ , 199__ ,

BETWEEN XYZ COMPANY_____(HEREINAFTER "EMPLOYER")

AND VISUAL ARTIST_____(HEREINAFTER "ARTIST").

## Recitals

*"Recitals" are statements of fact that typically explain the purpose or objectives of the agreement. They have legal consequence as they are conclusively presumed to be correct. This means that you should assume that anything stated in the recital can not be disproved in a court. Recitals should be read carefully; make sure that they are accurate.*

Employer is in the process of preparing a collective work tentatively titled "Orange Arrows" consisting of color lithographs of paintings to be created by various artists. The theme of the book is to be images of the fall season.

*A collective work is one of the specially enumerated works that may be commissioned as a work made for hire, if a work made for hire agreement is signed by both parties. This helps the employer make sure that the work is indeed a work made for hire.*

Artist is willing to specially prepare five (5) original art works for the collection as employee of Employer.

NOW THEREFORE, the parties agree as follows:

## 1. Commissioned Art

Artist agrees to prepare five (5) watercolors (hereafter "Original Work(s)") for Employer. Each Original Work shall evoke the theme of the fall season, shall be not smaller than 5x7–inches nor larger than 16x20–inches and shall be of suitably high quality in execution for reproduction and publication.

## 2. Work Made for Hire

The parties agree that the works so prepared for Employer shall be works made for hire as that work is defined in the United States Copyright Laws.

*The parties must agree that the work is a work made for hire in writing and the agreement must be signed by both parties.*

*This agreement may not be enforceable in foreign countries, as most do not have laws comparable to the work made for hire provision of the U.S. Copyright Law. If foreign law is a concern and the dollar value of the agreement is large, consult with a lawyer having knowledge in these areas.*

*Usually the concept of work made for hire embraces all rights of copyright. It may be possible to limit the scope of the work for hire agreement by specifically stating exclusions. An example of an exclusion is, "However, the parties agree that the work shall be a work for hire only for publication rights."*

*It may also be possible to limit the effect of the work for hire agreement by reassigning rights not needed by the employer. An example of this is: "Employer hereby assigns and agrees to assign to Artist all right, title and interest in the Original Works for their entire copyright terms throughout the Work, for publishing outside of the print media, for electronic publishing, for merchandising uses, for theatrical, home video home delivery, and for all analogous forms of media and delivery now known or hereafter devised."*

*If the work is not published, there may be no reason for the publisher to keep the art work. Consider adding the following language: "In the event that the Work is not published within eighteen (18) months of delivery, this agreement shall be of no force and effect, Employer shall not be the author of any work created by Artist and the copyright shall instead remain that of the Artist. Employer agrees to execute any necessary documents to establish title of copyright in the name of Artist."*

## 3. Assignment

Artist assigns and agrees to assign and transfer any and all right, title and interest in copyright of Artist throughout the world for the entire terms of copyright in the watercolors accepted under this agreement, to Employer and agrees to sign and execute any documents reasonably required to effectuate the purposes of this provision, and further grants the Employer the Power of Attorney to sign any assignment documents, register the copyright in its own name or in the name of the artist.

*In some circumstances, the works of art might not be considered works for hire by a court. To insure that the employer obtains at least most of the rights it is seeking, it may add this clause to acquire such rights by using it.*

*Recently, there have been a few cases, beneficial to artists, which suggest that a work made for hire agreement for a commissioned or specially ordered work must be signed before the starting of said work or a work made for hire agreement will not result under the Copyright Act. Several recent copyright cases have favored the artist in suggesting that a work*

*made for hire agreement cannot be established after the fact. Once the artist has started to create the work, the commissioning party cannot then create a work for hire agreement (although the artist can still transfer or assign copyright ownership in the work).*

*The artist can try to limit what can be acquired by assignment. For example, "Artist assigns and agrees to assign only such rights in copyright in the watercolors accepted under this agreement for publication as set forth below. Rights assigned shall be limited to the right to publish the paintings in the form of lithographs embodied in a single edition of a book published in the United States, Canada and England."*

*Think of time, territory, and specific media when limiting the scope of an assignment or license.*

### 4. Reserved Rights

Notwithstanding the foregoing, Artist reserves the following rights in the Original Works:

a. Print media of the Original Works: other than the use in "Orange Arrows" in anyplace throughout the world during the entire copyright terms of the works.

*This section virtually negates the point of acquiring the copyright as a work for hire and may be over broad for the employer.*

b. Electronic publication or distribution (including Photo, CD-ROM and online services) and analogous rights of any or all of the Original Works: during the entire copyright terms of the works.

c. Using the Original Works as part of Artist's portfolio and resume in seeking further commissions, engagements or employment.

d. Television (including cable, free, pay, on demand and other home delivery) and analogous rights throughout the world during the entire copyright terms of the works.

e. Theatrical (including other forms of public display and uses for public performance) and analogous rights throughout the world during the entire copyright terms of the works.

f. Merchandising and analogous rights throughout the world during the entire copyright terms of the works.

### 5. Delivery

Each watercolor shall be personally delivered to the Employer at the address given below not later than noon on June 30, 1994.

### 6. Acceptance

Employer shall have seventy-two (72) hours in which to accept or reject the watercolors.

*Consider the consequences of not accepting the watercolors. The consequences should be spelled out in this segment of the agreement.*

### 7. Ownership of Art Works

Artist shall own and be entitled to the original physical art works and any copies thereof which shall be returned to Artist within sixty (60) days of acceptance.

*Ownership of physical art work may not be consistent with the concept of works made for hire, yet nothing should prevent the artist from retrieving his art works within a reasonable period of time.*

## 8. Rejection

In the event the watercolors are rejected, Employer shall have the right to demand additional watercolors which shall be delivered within thirty (30) days from the date of rejection.

## 9. Compensation

For each watercolor accepted, Artist shall receive $1,000 on acceptance and an additional $500 on publication.

*Consider requesting a portion of the payment on signing of the contract and remainder on delivery, rather than on publication. A significant bonus should be requested if payment is delayed.*

## 10. Not Previously Published

Artist represents that she will be the creator of the art works, that the art works have not yet been created nor have any preliminary sketches for the art work begun, and that Artist will not permit the publication of any such art work prior to delivery to Employer. Artist agrees to make copies, versions or variations of the Original Watercolors only for Employer.

## 11. Warranties

Artist represents that the art works will not infringe any copyrights or rights of privacy of any person or entity and that any required permissions will have been obtained. Artist indemnifies Employer against any claims asserted in violation of said warranty.

*These provisions may be insisted on by the publisher. However, the cost of indemnifying claims for infringement can be high. Some limitations that might be added could include limiting the artist's risk to the amount of payment received, only to claims reduced to a final judgment, the exclusion of attorneys' fees, and an agreement to provide a defense subject to a judgment being entered against the artist. The artist might try to limit his or her liability to knowing violations of copyright or violation of warranties.*

## 12. Credit

Employer agrees that the name of the Artist will appear as the creator of the lithographs in the following locations:

The name of the Artist will be no less prominent than any of the other artists whose lithographs appear in the publication.

*Although credit provisions are not likely to be included in a work made for hire agreement provided by a publisher, there is a significant value in specifying minimum credit provisions. While in some situations, the employer may want to emphasize the names of the creators, in others, if the artist is not well known, it may be more important to the artist than to the employer.*

## 13. Notices

All notices required hereunder to Employer shall be effective within five (5) days after mailing, addressed to:

EMPLOYER, ADDRESS, CITY, STATE, ZIP

All notices required hereunder to Artist shall be effective within five (5) days after mailing addressed to:

ARTIST, ADDRESS, CITY, STATE, ZIP

If any of the parties hereto shall, during the term of this agreement, change address, then upon giving written notice to the other party of the new address, the new address shall be the address for notice.

*You can insist that written notices be sent by registered mail to avoid mail service problems.*

## 14. Attorneys' Fees, Suits of Action, Applicable Law

If any legal action or other proceeding is brought for the enforcement of this agreement, the prevailing party shall be entitled to recover reasonable attorneys' fees and other costs incurred in that proceeding, in addition to any other relief to which that party may be entitled.

*A clause of this type may provide an incentive to litigate the case if you are sure you are correct and a disincentive if you have less confidence in your case.*

## 15. Integrated Agreement

This Agreement constitutes the entire agreement between the parties and no modifications or revisions thereof shall be of any force or effect unless the same are in writing and executed by the parties hereto.

## 16. No Waiver, Entire Agreement

None of the terms of this Agreement can be waived or modified except by an express agreement in writing signed by both parties. There are no representations, promises, warranties, covenants, or undertakings other than those contained in this Agreement, which represents the entire understanding of the parties.

*Don't rely on any statements that were made to you before you signed the agreement. This agreement supersedes all such statements and you are limited to what is stated in the agreement. About the only way out is to prove fraud, which is difficult at best.*

## 17. Controlling Law

This shall be considered as having been entered into in the State of California, and shall be construed and interpreted in accordance with the laws of that State, and each of the parties hereto agree to submit to the jurisdiction of the applicable federal and state courts located in said State.

*It can be costly to litigate a case outside of your state, generally requiring the hiring of separate counsel where the court is located.*

## 18. Arbitration

Any controversy or claim arising out of or relating to this contract or the breach thereof shall be settled by arbitration administered by the American Arbitration Association under its Commercial Arbitration Rules and judgment on the award rendered by the Arbitrator(s) may be entered in any court having jurisdiction thereof.

*Arbitration can save some expenses, but the party initiating the arbitration must post fees, usually a percent or two of the amount demanded in the request for arbitration. Unless provision is made for "discovery" in the agreement, the party seeking a monetary compensation will not be able to find out how many copies of a work have sold. Also, the arbitration provision will bypass your right to a jury trial, which could be beneficial to you should the*

*matter have significant value. The existence of an arbitration clause could even prevent you from seeking relief in a small claims court.*

## 19. Headings

Headings or titles to paragraphs or subparagraphs in this Agreement are for the convenience of reference only and shall not affect the meaning or interpretation of this Agreement or any part hereof.

_____

EMPLOYER SIGNATURE AND DATE

_____

ARTIST SIGNATURE AND DATE

# ANALYSIS OF A MUSEUM EXHIBITION AGREEMENT

**EILEEN L. SELSKY**
*Eileen L. Selsky is the editor of the*
Entertainment Law Reporter.

The benefits of museum exhibition of an artist's work include critical notice, a likely increase in the market value of the artist's work, greater exposure to national and international markets, and a wider audience for the artist's work in the future.

Agreements between an artist and the parties who control and administer a public exhibition facility (whether a museum or a nonmuseum) should set forth the responsibilities of the parties with respect to the collection, organization, transportation, insurance, display and return of the artist's works. The agreement should specify which party will bear the costs for these activities, as well as for publicity and advertising, and who will control matters ranging from admission policies to the right to reproduce the artist's work on posters and other merchandise.

The agreement below includes typical clauses and presents issues for further consideration.

## MUSEUM EXHIBITION AGREEMENT

This EXHIBITION AGREEMENT is made between _____("Museum") and _____("Artist") effective as of _____("Date") for the purpose of loaning said art works for display in an exhibition tentatively entitled _____("Exhibition").

Museum desires to display the Exhibition; and

Museum and Artist, in consideration of the conditions, mutual covenants and promises set forth herein, agree as follows:

### Term and Location of Exhibition

**1.1** The Exhibition shall be displayed on the Museum premises at _____ from _____("Opening Date") through _____("Closing Date").

**1.2** The Exhibition shall be located at _____(describe the specific location and size of the installation space for the exhibition).

### Preparation of Exhibition

**2.1** Artist shall assemble for the Exhibition _____(specify number) art works as are consistent with and appropriate to the Exhibition. The Museum is not responsible for

locating or procuring the art works for the Exhibition or for any expense incurred by Artist in connection therewith.

*The parties should identify works "consistent with and appropriate to" the exhibition by referring to certain periods of the artist's work, particular media, or subject matter.*

*If the museum agrees to locate or procure any of the art works, the parties should agree on who pays for the costs incurred in doing so, including insurance for the art works while they are in transit and on display.*

**2.2** Artist shall provide Museum with an accurate and complete written inventory list of art works to be included in the Exhibition and the estimated value thereof, as determined by Artist prior to_____(date), including the title, a written description, and the mathematical dimensions of each art work (or weight for each sculpture) included therein. Museum shall sign a receipt for each work that sets forth these specifications.

*Artists generally value their works at current market value, cost to repair or replace, or an agreed value using such factors as the size of the canvas or medium.*

**2.3** If the Museum determines that the quality of the art works submitted fails to meet a standard of quality, or that Artist has failed to adhere strictly to Museum guidelines, Museum may cancel the Exhibition by giving written notice to Artist as hereinafter provided. Cancellation shall be effective upon dispatch of written notice. Upon cancellation, Museum shall not be liable for any expenses incurred to date of cancellation other than those incurred by Artist in the good faith preparation of the Exhibition, and Museum shall incur no additional obligation or liability whatsoever to Artist in connection with the Exhibition.

*Any "standard of quality" or other guidelines should be set forth. And, rather than cancellation, the parties may provide that the artist, within a specified amount of time, propose alternate selections; the agreement should state that the museum's approval of such works will not be unreasonably withheld.*

**2.4** It is understood that certain details of the Exhibition, including, without limitation, catalog budget, preparation and publication; display design, floor plan and installation; educational information; publicity; inventory list; invitation and mailing; lectures and workshops; Travel of Exhibition and final title for the Exhibition are not provided herein. Prior to Opening Date, Artist and Museum shall enter into a Supplemental Agreement setting forth such details. The Supplemental Agreement shall be in a form similar to the attached agreement.

**2.5** Artist shall cause all other lenders of Artist's art works for the Exhibition to execute a separate loan agreement directly with the Museum, pursuant to the Museum's requirements.

## Design and Installation

**3.1** The design and installation of the Exhibition shall be undertaken by Artist following consultation with and approval by Museum. Artist shall submit a Display Design to Museum for approval pursuant to the schedule set forth in the Supplemental Agreement, and shall cooperate with reasonable requests of Museum in connection therewith. Museum shall retain supervisory control over all aspects of the Exhibition, including final authority with respect to Display Design and Installation.

**3.2** If Museum rejects Artist's Display Design, Museum may, at its option, either undertake to design and install the Exhibition at Museum premises in such manner as Museum shall determine, or cancel the Exhibition.

*Artist should retain the right, if a work is not displayed as agreed, to withdraw the work and not incur any expenses or damage for the withdrawal. The agreement should allocate costs incurred in connection with the installation, with the anticipation that museum will bear all or most of the expenses.*

**3.3** Artist shall be present at Museum Premises on such dates prior to Opening Date as Museum may reasonably request in order to assist in the installation of the Exhibition. Artist shall be present at the opening of the Exhibition and shall be available to fulfill obligations in connection with the Exhibition that are set forth in this Agreement and in the Supplemental Agreement, including providing orientation lectures as specified and cooperating with Museum's media relations efforts.

*Artist may request a fee in connection with the installation of the exhibition; air fare and per diem costs for installation at other venues; and air fare, per diem costs, and a daily fee for a designated assistant, if necessary, for installation and removal at each venue.*

**3.4** An identifying label or plaque shall be placed next to (or on, if appropriate) each art work stating that the work is on loan from the Artist (or other source); the label shall bear the copyright notice as follows: _____(place appropriate notice). Any reproduction of the work shall bear the required identification and copyright information.

### Exhibition Budget

**4.1** The total sum committed by Museum in connection with Exhibition is _____(specify amount). Museum commits the following sums to be spent in connection with the exhibition of the Artist's artworks as follows:

| | |
|---|---|
| Design, preparation and printing of poster | $_____ |
| Preparation and installation of exhibit | $_____ |
| Transportation of artworks to Museum | $_____ |
| Transit and display insurance | $_____ |
| Opening reception for Museum members | $_____ |

*Include any other budgeted items such as the exhibition catalog, postcards, maintenance and security services. Artist shall receive a copy of the budget.*

**4.2** Museum will reimburse Artist for agreed-upon expenses incurred by Artist in connection with the design and preparation of the Exhibition. Such sums, if any, to be paid Artist shall be the sole and only sums payable to Artist for performance of all obligations required of Artist herein and for all expenses of Artist incurred in connection with the Exhibition.

It is expressly understood that Artist is an independent contractor and not an employee of Museum. In no event shall Artist have the right to bind Museum to an undertaking to any third party nor represent that Artist is an agent, employee or representative of Museum.

*List expenses agreed to be reimbursed to artist by museum.*

**4.3** Artist agrees to accept and abide by the exhibition budget established by museum. Museum shall not be responsible for any expenses incurred by artist in excess of budgetary limits unless artist has obtained prior written approval from museum.

*The parties should determine whether artist's failure to adhere to budgetary limits would be a sufficient ground for the cancellation of exhibition by museum.*

**4.4** Artist acknowledges and agrees that additional funds by way of grant, corporate sponsorship or otherwise may be solicited and accepted by Museum and applied to the funding of the Exhibition, all in the sole discretion of Museum.

*Artist may consider restricting museum's acceptance of grant or corporate sponsorship based on artist's political or ideological views.*

## Transportation

**5.1** If the Exhibition is a traveling Exhibition, Artist shall arrange transportation of the Exhibition to Museum by shipper and mode of transport designated by Artist. In such cases, Museum shall be responsible for costs of insurance and redelivery, as may be agreed to by the parties.

*Agreement should specify whether artist will assemble the art works for exhibition and then ship works to museum or will coordinate the delivery of works from various locations. The agreement should specify who pays for packing, shipping and transit insurance.*

**5.2** The parties shall cooperate to arrange an Arrival Date at Museum mutually acceptable both to Artist and Museum. It is acknowledged that Arrival Date shall in no event be later than ten days prior to Opening Date. Museum shall incur no liability to Artist for delay in Opening Date due to late arrival of Exhibition at Museum.

*If the arrival date is delayed due to natural forces beyond artist's control, such as weather conditions, museum may agree to bear some costs resulting from such a delay.*

**5.3** Within ten days after Closing Date, Museum shall arrange transportation of the Exhibition to the destination designated by Artist by carrier and mode of transport selected by Museum ("redelivery"). Artist will deliver packing and shipping instructions to Museum no later than Closing Date.

*If artist seeks to specify mode of transport, parties should agree on allocation of any additional costs.*

## Insurance

**6.1** Conditioned upon the Artist's providing Museum with a complete and accurate written inventory list of art works, Museum will insure works exhibited wall-to-wall, under its fine arts policy, for the value set forth by the Artist, against all risks of physical loss or damage from any external cause while *on location* during the period of the exhibition.

*Artist should determine whether the museum's fine arts policy contains exclusions for loss or damage due to wear and tear, gradual deterioration, moths, pests, vermin, war and other hostilities or for damage resulting from any authorized repair, restoration or retouching process.*

*Artist may request information about museum's carrier and extent of coverage. What are the policy exclusions? Will artist be a party to any action brought by museum or its carrier to recover for any loss? Will museum be liable for any injury not covered by the insurer?*

*If objects on extended loan are insured only when on display, the parties should arrange for coverage when these objects are stored by the museum.*

**6.2** The cost of insuring the Exhibition art works shall be the sole obligation of Museum. The cost of all insurance shall be included in the Exhibition budget as part of the total sum committed to Exhibition by Museum.

**6.3** The Artist shall have the right to maintain his or her own insurance as a supplement to either the amount of the insurance coverage or the time when the objects are insured, provided the Artist complies with the following procedure: the Museum must be supplied with a Certificate of Insurance naming the Museum as an additional insured, or waiving subrogation against the Museum.

## Care and Maintenance

**7.1** Museum will exercise the same standard of care with respect to art works in the Exhibition as it ordinarily exercises in the preservation and safekeeping of comparable property of Museum. In the event of damage to a work, Artist reserves the right to have an appraisal of the restoration costs by a professional conservator of his or her choice.

> *The parties should agree on the allocation of costs for any necessary cleaning, restoration or repair of the art works. Any disputes concerning the care or condition of the art works may be referred to a designated party.*

**7.2** Art works should be returned in original frame and mat unless other arrangements are made with Museum in writing.

## Travel of Exhibition

**8.1** Museum will attempt to arrange for the Travel of the Exhibition for a period of up to _____ (specify number) months following Closing Date. Artist shall cooperate with Museum in such arrangements. Costs of Travel shall be independent of any other expenses to be provided for the Exhibition.

Museum may decide to terminate Travel of the Exhibition and return art works to Artist at any time.

> *Artist should obtain prior approval of travel itinerary, budget, commitments of artist's services, and prior notice of the return of any art work(s).*

**8.2** Museum undertakes to obtain assurances that Host Museum(s) will provide standard conservation, insurance and security for the Exhibition and that all other procedures followed by Host Museum(s) meet standards acceptable to Museum.

**8.3** The parties understand that details of Travel of the Exhibition are not included herein and that the parties undertake to agree upon such details at a future date. Failure of the parties to agree upon details of Travel of the Exhibition shall relieve Museum of any obligation to arrange Travel of the Exhibition.

> *Parties should determine responsibilities for insurance, customs duties and any applicable taxes.*

## Advertising

**9.1** Unless the Museum is notified in writing to the contrary, it is understood that the art works exhibited may be photographed, sketched, or reproduced for noncommercial purposes only.

> *Even though a museum has some "fair use" rights under the Copyright Act, artist*

*should seek to restrict the use of noncommercial materials to those directly publicizing the exhibition. The artist should require approval or consultation in the preparation and use of the materials. Artist may request reasonable access to such materials for artist's use; and to receive _____ (a specified number of) copies of all exhibition materials and catalogs prepared for noncommercial use.*

*The parties should agree that museum's use of above-cited materials does not infringe the copyrights in the art works in the exhibition, and that museum will include the appropriate copyright notice specified by the artist on all exhibition materials and merchandise on which the artist's artwork appears.*

**9.1** (Alternate.) All publicity and educational materials created or manufactured for or used in connection with the Exhibition, including, without limitation, posters, photographs, motion picture films, slides, and textual materials shall become the property of Museum and remain so upon termination of the Exhibition. Museum reserves the right to use said materials in any manner which it deems appropriate, including, without limitation, reproduction, reduplication, sale and transfer to another medium. Proceeds from the sale of any and all materials herein described shall remain the property of Museum.

*Artists may also find the above clause 9.1 (Alternate) in museum agreements: In such a case, artist should ask for the substitution of clause 9.1 above.*

**9.2** If there is to be any other commercial use of the art work, except as specified above, a separate "use" agreement will be executed as a supplement to this agreement.

## Other Provisions

**10.1** Museum agrees that it shall instruct its representatives that art works provided by Artist for the Exhibition shall not be available for sale unless Artist shall instruct otherwise and Museum also agrees.

It is the policy of Museum not to participate in arranging or effecting purchases of art works exhibited at Museum. In the event Artist desires the sale of art works in connection with Exhibition, and Museum agrees thereto separately and in writing, Museum shall refer any and all inquiries pertaining to the sale of art works to Artist or any duly authorized representative thereof whom Artist may designate.

*If the parties agree that a work of art included in the exhibition may be sold, the parties should consider whether museum will be entitled to any handling fee, and set forth provisions concerning price, time of payment to the artist, and any risks with regard to the purchaser's credit.*

*The museum may decide to waive its standard handling charge on sales of the work of a living artist when the artist or his or her gallery is the seller. If a sale is conducted as an installment sale, there shall be no transfer of title until the payment of the final installment.*

**10.2** Any notices required hereby or desired to be given by either party to the other shall be given in writing and personally delivered or mailed by first class mail (certified) to the addresses set forth below.

To Artist:_____      Copy To:_____

To Museum:_____      Copy To:_____

**10.3** This Exhibition Agreement shall not be assignable by either Museum or Artist without prior written consent of the other.

**10.4** This Exhibition Agreement may be amended only by an instrument in writing by Artist and Museum.

**10.5** It is mutually acknowledged that the State of _____ has the most significant contacts with this Exhibition Agreement and with the relationship between Museum and the parties of any particular state. It is therefore agreed that this Exhibition Agreement shall be construed and the legal relationship of the parties hereto shall be determined in accordance with the laws of the State of _____ applicable to contracts wholly executed and wholly to be performed within the State of _____.

All actions or proceedings arising directly or indirectly from the Exhibition Agreement shall be litigated in a court having a situs in _____ and the parties hereto agree and hereby consent to the jurisdiction of any local, state or federal court in which such an action is commenced that is located in _____.

**10.6** This Exhibition Agreement, the Exhibit(s) attached hereto and the Supplemental Agreement(s) herein shall constitute the entire agreement between the parties hereto.

**10.7** Artist shall not arrange for art works included in Exhibition or similar works to be displayed within a _____ mile radius of Museum without the prior written consent of Museum for a period of _____ years from Opening Date.

*Artist should not agree to this provision unless the parties can agree on reasonable geographic and term restrictions.*

**10.8** Museum may mention Artist's identity in such announcements, invitations, press releases and other publicity or publications as Museum shall find appropriate.

*Artist may request prior approval of publicity materials and impose standard of good taste for such materials. Artist may wish to provide his or her own photographs or have one (or more) taken at museum's expense.*

*The parties should consider that the ownership of an art work may change during the exhibition or the travel exhibition. The artist should be entitled to substitute, within a reasonable time, a "consistent" art work if a work is withdrawn for any reason. It should be noted that if the legal ownership of an art work should change during the period of the Exhibition, museum may request that the owner, prior to the return of the art work, establish his or her legal right to receive the work by proof satisfactory to museum.*

**10.9** In the event that any provision of the Exhibition Agreement is deemed to be invalid for any reason whatsoever, the remainder of the Exhibition Agreement shall remain in full force and effect.

In Witness Whereof, Museum and Artist have executed this Exhibition Agreement on the date first herein set forth.

Museum _____

Artist _____

# Selling Your Work

Portfolios and Other
Promotional Tools

Promotion and Marketing

Obtaining Gallery Representation

Packing and Shipping Artwork

Museum Accession Policies

Art Fraud: Scams, Counterfeits,
Fakes and Forgeries

# Portfolios and Other Promotional Tools

**NAT DEAN**

*Ms. Nat Dean is a visual artist whose work has been
shown worldwide in more than 400 group and solo
exhibitions. Since 1978 she has taught workshops,
lectured, and provided individual and group counseling.
Ms. Dean has developed academic programming on the
subjects of "survival and career development skills
for artists" and "the business of art" at over 450
sites, including most major art schools and
numerous arts organizations.*

The portfolio is a common method used to introduce your work. It's purpose is to spark a viewer's interest by accurately representing your work, convincingly communicating your artistic strengths and documenting your accomplishments. Artists are asked to present their portfolios to galleries, dealers, art representatives, corporate buyers, etc. Artists will use elements from their portfolios for grant applications, for fulfilling the requirements of a juried show, and for promoting gallery openings, exhibitions and shows.

## INITIAL CONSIDERATIONS

The portfolio is an expensive investment and the following checklist will help you prepare the components you need to create a portfolio appropriate to your purpose. Approach the process in a systematic and organized manner.

♦ Target your goals. To whom will you be showing the portfolio? What do you want to accomplish? Answers to these questions will help you design an appropriate portfolio.

♦ Select the work that will be most impressive in the context of the goals you have identified. Will you be presenting only your latest work; only work in one media; a developmental history? Artists working in diverse media, sometimes choose to present each media in a different portfolio; others treat each media as a chapter within the same portfolio. If there is a developmental history that took you from one media to another, you should show that in the way the portfolio is assembled. Usually, no more than ten to twenty pieces are selected for an initial presentation, unless more are requested.

◆ Select the medium for reproduction. Although 35mm slides and 4x5–inch transparencies and prints are customary, the rapid development of new technologies is changing art marketing practices to include portfolios in the form of videos, photo CDs and electronic transmittal of portfolio components. Although fine art photographers may be initially required to submit 35mm slides or 4x5–inch transparencies of their work, a second stage review may require original or work prints.

    The important questions to be addressed here are: What is the most effective method to communicate your artwork, what is customarily required in your target marketplace, and what can you afford? Some galleries want to see only 4x5–inch transparencies; some juried shows want only 35mm slides. Some media cannot be accurately represented with photography and you will need to investigate alternative mediums for presentation. You will want to ensure that your target market has the equipment to view such media. Many arts organizations do not have the budgets to buy equipment to view videos or photo CDs. Sometimes specialized media are not allowed as documentation during jurying to keep the process democratic and address such issues as equal access and objective evaluation for all applicants.

◆ Gather documenting material about the artwork you have selected, including the title, date of completion, size of the work, media description and any other special notes. Prepare a brief narrative of each work, describing it in simple and objective terms. Don't assume that the viewer will know something about the work or media. They may have never seen your work or heard your name. A well prepared portfolio will speak for you.

    When listing dimensions of your artwork, indicate only the work's unframed size or image area unless the framing or pedestal is an integral part of the piece.

◆ Finally, consider consistency of image and presentation. You want to capture a viewer's attention and help them remember your name in association with your work.

## PORTFOLIO COMPONENTS

    The components of your portfolio should be coordinated in a style appropriate to your artwork. Your name and address should appear on every component.

### Letterhead Package

    Printed or laser copied stationery letterhead and envelopes, business cards and mailing labels are essential materials. They establish your professionalism and present legible information of your address/phone/fax. The addition of a logo (symbol) or special lettering style helps create and maintain your image. If you are marketing a product such as earrings, prints, or notecards, a company or product name is appropriate. However, many fine artists include only their name, address, and phone on their letterhead, feeling that labeling themselves as an artist is redundant.

    Your business card should be placed in your portfolio, in any correspondence, on the cover of your folders and can be used to label artwork for authorship/ownership. A 2x3 1/2–inch standard card designed so that text and images, if any, cover a 2x2–inch area of the card doubles as slide sheet identification when trimmed to fit in the last pocket of the slide sheet.

Unless you have been trained in graphic design, have the letterhead package professionally designed and prepared for printing. Printing a letterhead package all at once will help save money, especially if it will be printed in more than one color.

### Labels

Many copy machines and computer printers (jet and laser) can print your logo and address/phone/fax information onto $8^{1}/2$x11–inch self-adhesive label sheets available at office supply stores or by catalog. One variety allows you to print and trim labels of various sizes for different needs.

### Cover Letter

A cover letter should be included with every portfolio you send out or hand deliver. It is usually placed so as to be seen first when the portfolio is opened, or it is clipped on top of the portfolio cover.

Your cover letter adds a personal touch, it indicates what materials are enclosed and presents an opportunity for you to demonstrate awareness of the activities the receiver is engaged in. The end of your letter should thank them for their consideration and suggest what their next step might be in making contact with you. The cover letter is also a good place to indicate such information as invitations to current or upcoming shows or exhibitions of your work.

Use a typewriter or word processor. Hand-written letters are unprofessional and indicate a lack of care about your presentation. Keep the letter short. Do not list all of your accomplishments or write a long statement about your work. The other components of the portfolio will do that for you. State the purpose of your presentation and describe your reason for writing in one or two sentences. If you feel it necessary to introduce the type of artist that you are, keep it to one or two sentences. Indicate what portfolio components should be kept and which should be returned. Keep a copy.

### Application Forms

If you are applying for a grant or residency, entering a competition, or joining a slide registry requiring an application or entry form, place or clip the completed form underneath the cover letter. If a signature is required, sign it in blue or red ink, so the signature does not appear to be photocopied. If you are required to submit several copies of the application, copy it and sign each copy with an original signature. When you package them for delivery, keep each set together with a clip or a folder of its own.

### Resume

Your resume is a document of your activities and accomplishments in list format. Here is a list of possible headings and a suggested sequence: (1) education (including degrees and honors); (2) solo exhibitions; (3) group exhibitions; (4) bibliography (articles about you); (5) publications (authored by you); (6) professional appointments (art related); (7) awards and honors; (8) collections; and (9) professional memberships.

Every entry should indicate the inclusive dates (by year, not day and month), title of show, site, city and state. If your work has been included in numerous solo or group gallery exhibits, use the prefix, "Selected" in front of appropriate headings. Except for state names, do not use abbreviations or acronyms. If you must use them, spell out the name the first time you use it and follow it with the acronym in parenthesis.

The information in your resume should be organized in reverse chronological

order, the most recent activity or accomplishment first within each category. This resume does not usually discuss employment history, job skills or duties. Such information is more appropriate for a job search resume.

Keep the resume simple and to the point. Keep it factual. Do not pad your resume or falsify information: the art world is small and insular and lying will only do damage that is difficult to repair. There is no need to apologize for lack of activity or gaps in time. If you are in doubt about layout ideas, collect quality resumes of other artists and read books on resume design. Use your letterhead stationery as the first page and clearly label successive pages. It is not necessary to use the title "resume," since the format, headings, and subheadings communicate this.

If a situation requires that your resume be contained in one page, you should make a special abridged version that is clearly titled "Abridged Version," "Edited Resume," Condensed Resume," etc. Most of the time you will also be able to include a separate full length resume.

A separate artist's statement, discussed below, should accompany the resume.

### Narrative Biography

A narrative biography is usually a shortened version of your resume, prepared in the style of an article or story, highlighting significant education, shows, awards, and other important experiences and accomplishments in your artistic life. It is generally written in the third person. Type it double-spaced, and, as with other materials, use your letterhead. A page is usually the appropriate length. Many galleries and grant applications require both a resume and narrative bio. The narrative bio is often reproduced in catalogs, brochures, newspaper articles, news releases, programs, etc.

---

### EXAMPLE OF AN ARTIST'S STATEMENT
#### Panel Works

This series of work by artist Nat Dean combines stark black and raw wood panels, 18–inches square by 1³/₄–inches deep, which fall together in angular mosaics. The panels are linked together as a surface that presents basic linear images painted with various metallic compounds. Using strokes of gold, mica, pewter, stainless steel, graphite, bronze, opal and other elements, she delineates sometimes painfully simple images and fragmented views of primary life passages. Through the use of occasional text and a visual alphabet composed of nearly featureless hands and everyday objects as signifiers for story, memory, evidence or prediction, she provides us with segments of our own lives and life we have yet to experience. Although each panel measures only 18–inches square, a complete piece can measure over ten feet. Some works include panels that open, revealing special messages. This particular series of works is a unique exploration of life, illness, hope and death with a sidelong glance towards the world of magic and illusion.

---

### Artist's Statement

The artist's statement describes the style of your work, media used and artistic goals. Like the narrative bio, it is often written in the third person. It should begin with a concise one sentence description of the artwork. This short description can be repeated in your cover letter and other materials when appropriate. It answers the question: What type of artwork do you do? One double-spaced typed page on your letterhead stationery is the standard length.

### Slides

Slides are frequently utilized for reviewing visual art when you can't make a presentation of the original work. The slides can be 35mm or 2x2-inch. Four by five

inch color transparencies (color positives) can be used to replace or augment slides. Although it is much more expensive to photograph and prepare 4x5–inch transparencies, many professional artists and dealers prefer this format for portfolio presentations and for reproduction use. Transparencies are the preferred format when work will be reproduced in full color in printed materials because of the high quality of reproduction. Work that will be reproduced in large posters is often shot on even larger format films. When you can afford it, including two or three 4x5–inch transparencies in your portfolio will enhance your presentation of 35mm slides.

It is of utmost importance that you choose your best work to be photographed and make sure that your work is photographed to its best advantage. As your work will be judged very quickly in a competitive field, you must ensure that your slides are of the highest quality. Each slide or transparency should show only one work, against a black, white or neutral background, free of any extraneous images. Proper use of lighting helps keep colors accurate and can dramatize and bring out detail and perspective in 3-D works.

Your work should be photographed unframed. If this is not possible, care should be taken to ensure that the frame and glass do not interfere with the artwork. Appropriate polarizing filters should be used when the artwork is enclosed behind glass, acrylic or plastic wrap.

The artwork should be in sharp focus and its color accurately reproduced. There should be no glare spots from wet paint or photo lights. Avoid making duplicates further than two generations from the original: quality will suffer greatly.

The camera must be square and parallel to the surface of the work, or the reproduction of your piece will not be in square, but "keystoned," wider on one end than the other as is the keystone placed in an arch.

If you don't have the equipment, lighting and skills to ensure that your slides and transparencies will be of the highest quality, invest in hiring a photographer with experience in shooting visual art. Try to anticipate all your photo needs for the year and have the photographer shoot in all the formats you can afford. To reduce costs, you can get a group of artists together and hire a photographer by the hour or at a fixed rate.

Never send out your last set of original slides or transparencies. It is wise to have several sets of originals to work with for promotion, as well as one original set to archive. This is cost-effectively accomplished by shooting multiples of each piece at the same film speed and exposure; sometimes in different formats, such as 4x5–inch and 35mm.

If you can only afford to shoot your work in a 35mm format, the cheapest way to ensure the highest quality "dupe" slides is to shoot as many "in camera dupes" as you anticipate you will need. There will be a decay in quality when slides and transparencies are reproduced at a photo house. When 4x5–inch

transparencies are used as originals for 35mm dupes, those dupes will be of higher quality than original 35mm slides.

Use a photo processing house that specializes in photo reproductions. The savings can be as much one-sixth the cost of making dupes at a custom lab. The same photo processing house can also make multiple copies of black and white or color prints to be used for promotional purposes. If quality dupes are a priority, however, using a custom lab is the best way to get them.

**Slide Preparation and Labeling.** You will customarily prepare a group of twenty 35mm slides, the number required to fill a standard 8 $^1$/2x11–inch slide sheet. Slides should be mounted in plastic or paper mounts *without* glass, free of dust, dirt and fingerprints.

If your work was photographed in a frame, you should mask out the frame so that only your work catches the viewer's attention. Masking can also be used to isolate art work that is too large to shoot against a black, white or neutral background.

Masking is accomplished by carefully applying a special self-adhesive silver foil tape that is opaque to projected light. Remove the slide film from its original mount, carefully mask it, and then place it in a new mount.

Before sending off any slides, view them in a situation similar to the way you think they will be viewed by whomever receives them. It is very important that you project your slides to see what they really look like before including them in your portfolio. A tiny flaw in masking or a minuscule scratch is amplified to remarkable proportions when a slide is projected.

Labeling should be typed or computer printed on labels made to fit a slide mount. Although dot matrix labeling is a service offered at some photo labs, much of it is difficult to read. It is best to prepare your own.

Label your slides in the manner customary in our industry. Slide mount top (horizontal images): first line: title of work (in caps, quotes or underlined), year completed; next lines: media, dimensions (H x W x D); last line: copyright notice. Slide mount bottom: first line, artist's name (in caps); other lines, address and phone. For vertical images, the information is placed on the horizontal sides of the slide. A red dot placed in the lower left corner of your slide mount indicates the correct orientation of the image and correct placement for projection. It is also helpful to add a small arrow or the word "TOP" to the front upper right corner of the slide as further clarification. If appropriate or requested, number your slides and/or photos and use corresponding numbers on your inventory sheet. Placing a number on the orientation dot is a good spot, since it is easy to change when you regroup your packet for its next marketing opportunity.

If you are instructed to label your slides in some other fashion, do so. You can relabel them when you get them back.

Mounting of transparencies for viewing and storage can be accomplished with commercially available black cardboard frame style mats that come in various outside dimensions with uniform 4x5–inch holes (windows) cut either vertically or horizontally out of a sandwich of mat board. A pocket allows the transparency to be slipped in with its protective clear sleeve protecting the film from scratches and dirt. Some holders also include a foil or plastic envelope-style cover for the full mats.

You can make your own transparency mounts with two-ply mat board or two sheets of card stock. Place a sheet of tracing paper over your transparency on a light

table, trace a window opening isolating the area to be viewed. Next take two pieces of card stock cut to fit your portfolio in black, white, or a neutral color and position them together. Place the tracing paper guide over the card stock where you want the opening, tape with removable tape, and cut the opening through the tracing paper and both sheets of card stock. Remove the cut out, separate the two sheets, and spot-tape the transparency in its protective transparent sleeve onto the bottom sheet over the window. Then place the second sheet on top, securing it with spray or transfer adhesive.

Labels should include artist's name, date of completion, media, size, artist's copyright notice, and credit line for the photographer, if requested. Because of the mount's larger area, you can elaborate on the work. For example, instead of writing mixed media, you can list the materials used or the techniques used to achieve visual effects.

***Inventory Sheet/Documentation List.*** Every portfolio should include a detailed inventory sheet of the slides and transparencies that are enclosed. This list allows you to provide greater detail than is on your slide labels.

An inventory sheet is often requested on visual arts grant application forms as an additional document, or it may be built into the application form. Its purpose is to provide the review panel with a checklist of the information on your labels and give them a quick idea of what visuals are included.

This list is often used as the basis for an exhibition checklist, price list, and insurance valuation list.

Unless requested, the inventory list should not include prices.

The list should be in the order of the slides in the slide sheet, or the order in which transparencies are presented. If your slides and/or photos are numbered (see Slide Preparation and Labeling), your list should be numbered correspondingly. A tabbed column format is best, with a column for each item. However, if a particular project guideline tells you to number things some other way, do it their way, and change it back upon return.

## Prints

A selection of color or black and white prints of your work can enhance a slide presentation and add to the overall attractiveness of your portfolio. They are also useful in promoting and marketing gallery openings, exhibitions and shows. Fine art photographs or reproductions of fine art should be hinged (hinges specially prepared for use in mounting photographs for presentation are available through the Light Impressions catalog), or mounted on two-ply mat board. If weight is a consideration, use the same card stock matting technique as on your transparencies, but leave the back sheet whole and cut the window in the top sheet. This is also a good way to deal with the problem of having only a snapshot of a recently completed piece: matting it between two sheets of card stock and affixing a formal label can help take such documentation into a more respectable form. The format of the labels should be consistent with that of your slides or transparencies.

Portfolios can also contain one or two 8x10–inch glossy black and white unmounted photographs of the artist as well as one or two black and white photos of art work to be used for promotion and publicity. In most cases, label photos on the back: do not write on the photo itself, front or back. Use a self-adhesive label that you have typed or preprinted and captioned appropriately.

To obtain quantity copies of prints, use a photo lab that specializes in promotional

## SAMPLE SLIDE INVENTORY LIST

| SLIDE # | TITLE | MEDIA | DATE | DIMENSIONS | PRICE |
|---|---|---|---|---|---|
| **PANEL WORKS SERIES: 1990** | | | | | |
| 1. THE EIGHT BALL | | graphite, mica, gold, acrylic on wood | 1990 | 36"x56"x1 3/4" | $3,000 |
| 2. ROCK, PAPER, SCISSORS | | graphite & acrylic on wood panels | 1990 | 36"x56"x1 3/4" | $2,500 |
| **LARGE SCALE DRAWING SERIES: 1986-1988** | | | | | |
| 3. UNTITLED DRAWING (tape) | | graphite, latex on paper | 1986 | 80"x180" | $1,800 |
| 4. UNTITLED DRAWING (wishbone) | | graphite on paper | 1986 | 80"x180" | $1,800 |
| 5. (continue list for all slides presented) | | | | | |

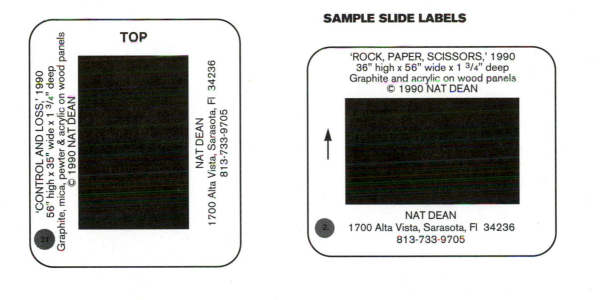

SAMPLE SLIDE LABELS

reproductions. The cost can be as low as $50 for a hundred 8x10–inch prints of the same image. As part of their service, these labs can "strip" in your name, address, logo, caption, or any other desired information, on the front of the print for a small extra cost.

### Reviews/Articles

If you have favorable reviews, articles or mentions, include copies in your portfolio. Although it has been said that even bad publicity is good publicity, it is up to you to decide what to include. You should not, however, edit an article to deceive by placing a critic's statement out of context. This does not mean that you cannot reprint a small portion of a longer article or reduce an essay or chapter, just be certain that you clearly indicate the segment and its source as being an excerpt.

The method for presenting articles and reviews is to make neat, quality photocopies. Here's a good procedure to follow. First, buy two copies of the publication:

one for archival records; one to cut and paste. Then make a reduced version of the publication's masthead (logo) and date of publication. If the article was included in a special section, such as "Style," "Calendar," "Social Scene," make a slightly smaller reduction than the one used for the publication's masthead. Then use the original or a copy of the article, including the headline and writer's tag line. If the article is long or spills onto two pages, neatly cut the columns.

Use 8 $1/2$x11–inch graph paper with light blue lines to help align all the elements. The blue lines will not reproduce when you make copies.

Neatly cut out each element that you have reproduced and paste them to the graph paper with the masthead and section head at the top. Next, place any photos and their captions in position. Splice the columns to fit the remaining space. Using a fine-line rolling pen, or self-adhesive rules, add a border, column rules (vertical lines between columns), and other lines between the headline and the article to balance the layout. Make copies.

Do not limit yourself to just major articles. You can take a calendar section of the paper that lists your first group show and another listing of your open studios tour in the same year, and combine the two on one page.

To emphasize particularly favorable comments, use a highlight marker and neatly mark them with spot color.

Reviews are usually placed after your artist's statement or after the slide inventory.

For major articles, that have color reproductions, or even a color cover, the publisher will often offer tear sheets or quantity copies of the article at a special price.

Keep the final pasteup in a protective plastic sleeve with the original articles and store them in a safe place as part of your archival records.

***The Critic's Essay.*** If you have not had any published critical review, or have been unhappy with what you have received, an option is to hire an arts writer or critic whose work you respect to write an essay concerning your work.

Some individuals feel that this smacks of vanity press, but handled correctly, it can be a satisfying experience for all parties concerned. Critics and writers work for a living too, and are hired by galleries, museums, publications, and others as a matter of course. The only drawback might be a future conflict of interest if the critic you select is the only art writer for your local paper and you hope to get a review in the near future.

## Catalogs/Catalog Excerpts

The publication of a catalog chronicling an artist's work and history is a fantastic tool because it gathers together most of the portfolio components in an easily distributed form. Galleries and other promoters make catalogs of particularly important or well funded shows and events and use them long after the event is over. Because of their value, many artists have found it worthwhile to make catalogs of their work. A catalog presents an excellent opportunity to show off your best work and to secure critical writing from a critic, historian or other art aficionado. Catalogs can range from low-cost tri-fold brochures with a brief resume, essay and selected reproductions; to full color booklets; to elaborate, substantial works that can be sold and marketed through museum stores, university book shops and so forth.

If you know that your work will be the major focus of a catalog try to negotiate with the person preparing the catalog, before publication, to print extra copies for you to use for promotional purposes. The issue of who pays for the design and printing of

gallery catalogs is covered in the chapter "Promotion and Marketing."

If your work is part of a group of other works featured in a catalog, try to obtain as many copies as you can afford to include with your portfolios. You can create a page containing only the reproductions of your work or parts of an essay that speak favorably about your work in the catalog to include in your portfolio.

### Audio and Videotape

Some work, such as performance, multimedia, computer animation and kinetic sculpture can be better documented on video.

It is important, however, to determine whether your targeted market has the proper equipment to view video tape and, if so, what type they have. If you are using your video as part of your application for a juried competition, make sure that the guidelines allow them and abide by any length restrictions.

Tapes should be clearly labeled on the case and box, include their duration in minutes and seconds, and be in the format that will meet the needs of the reviewer. They should include on-screen titles and credits.

Tapes should be cued to the spot where the reviewer should begin. A written documentation sheet should indicate the same information required for slides, appropriately transferred for what is contained on the video.

If you have been given a television or radio interview, it is appropriate to ask for a copy of the tape that can be duplicated for your portfolio. You should supply the blank tape.

## POSTCARDS

A relatively inexpensive promotional tool is a four-color postcard showing one of your artworks. These can be used as thank you notes, to invite people to special events, and as reminders to return portfolios. A poll of 1994 prices revealed that the cost can be as low as $500 for thirty-five hundred, including color separations.

## PORTFOLIO FOLDERS AND BINDERS

The case folder or binder for your portfolio materials acts as a protective cover. It organizes your materials and is an image maker that frames the viewing of your work. A messy packet or one that is difficult to handle does not make a good impression or create an environment conducive to acceptance.

Because your portfolio will change as you add examples of new work and accomplishments, select one that will allow for flexibility. If you are going to be carrying it, choose a size and weight that will be comfortable for you. If you are going to be shipping it, select a sturdy one. Be aware that the poor condition of portfolios upon return is often due to improper repackaging.

**Portfolio Contents (suggested order)**

Here are the most common types of binders and folders used by artists.

♦ Pocket folders, either ready-made in an 9x12–inch standard size or designed and printed with your logo, name, address and phone.

♦ Pronged folders and three-ring binders.

♦ Cloth and leatherette covered cases, both soft and hard-sided.

Some artists customize briefcase interiors with felt, fabric, or covered blocks of Styrofoam to contain fragile materials.

Some choose fabric or paper-backed leatherette covered boxes used by museums for protecting fine books, commonly called "solander cases," "clamshell boxes," or "drop back boxes."

Many art, library, photography and archival supply mail order catalogs offer substantial discounts over the prices found at local art supply stores.

## METHODS OF DELIVERY AND RETURN

As a matter of etiquette, when materials are requested from you in writing or in person, you are expected to cover costs of delivery and the requesting party will cover the cost of return.

If you are sending out unsolicited materials for review, the return postage or shipping is your responsibility. To insure their return, you must provide a self-addressed, stamped envelope or box (SASE).

If you are dropping off your portfolio, ask for a receipt from the receiver. It's not only good business practice, but is helpful in tracking down lost or misplaced portfolios, particularly when the package is not given directly to the party you wish to reach. You can provide a preprinted receipt form to facilitate this process.

Invest in a supply of sturdy cardboard boxes for mailing or shipping your portfolio: precut boxes in a variety of sizes are available from most office supply companies. Complaints about rough handling are legion. Soft padded envelopes do not offer enough protection.

To help avoid damage, your cover letter should indicate any special instructions about packing. Some artists also enclose a new, unfolded box to be used for repacking and return.

## INSURANCE

Most carriers will insure your portfolio and its contents against loss or damage. Some, like United Parcel Service, build a maximum limit into their carrier charges and require an extra fee if what you are shipping exceeds those limits. Most carriers, however, also add the proviso that the insurance will not cover items that are irreplaceable. Original transparencies fall under this category. (See the chapter "Packing and Shipping Artwork.") Your copy of the inventory sheet included in the portfolio and receipts for dupe slides or videos, will be required as proof in case anything is lost or damaged.

# PROMOTION AND MARKETING

**NAT DEAN**

*Ms. Nat Dean is a visual artist whose work has been
shown worldwide in more than 400 group and solo
exhibitions. Since 1978 she has taught workshops,
lectured, and provided individual and group counseling.
Ms. Dean has developed academic programming on the
subjects of "survival and career development skills
for artists" and "the business of art" at over 450
sites, including most major art schools and
numerous arts organizations.*

Gallery, museum, and site-specific exhibitions, and less formal events such as marketplace shows, open studios, and cafe shows create opportunities to invite people to a reception or opening, create a stream of interested visitors, and get publicity.

Now that you have created a portfolio package, you can use selected components to help take advantage of these opportunities.

You can develop and execute the marketing plan yourself; you can work cooperatively with a gallery or museum; or you can work with other artists.

All marketing plans start with the four "Ps": product, price, promotion and place. You must have a *product* (your art work), a set *price* for that product, a system of *promoting* the product at the set price, and a *place* for all of these elements to occur. For many artists, an event or exhibition provides the focus around which to organize a marketing plan for garnering attention, attendance and ultimately sales.

As your career develops, so will your reputation, therefore the price for your work will increase. If you go about marketing in an organized, perseverant fashion, support and success will follow.

By creating your portfolio, you've already accomplished a difficult task: the description of your artwork. In your artist's statement you have described the direction of your work and artistic philosophy. You have also created a one sentence description of your work to help hook the reader's interest. Your resume, bio and previous press coverage establishes your track record and reputation. Your slides and photos visually describe your work.

The more difficult tasks, however, are learning to price and promote your work so that it can be sold. To do this you must reach out of the studio into the marketplace using a language of symbols that the marketplace you are targeting understands and embraces. You must also consider your promotional goals, what time frame you have

at your disposal to accomplish these goals, and most of all, what resources are available to put the plan into action.

Unfortunately, many artists function under a value structure involving the concept of "gift exchange" (self-expression, independence, recognition of work, meaning through works' recognition) vs. "marketplace exchange" (money, status, materialism, meaning through status and money). As a result, artists often find themselves underpricing their work or giving it away, and are subsequently left without the ability to support their maintenance needs (rent, food, insurance) and their arts expenses (supplies, tools, frames, slides). It doesn't help that artists are asked over and over again to accept much less than they deserve. Often, artists are asked to pay for the privilege to show and sell their work via such ransom-like demands as huge exhibition entry fees, unrealistic consignment fees or commission percentages, a high share in advertising costs, and the "honor" of exposure through publication without pay, etc.

Learning to use the tools of the marketplace will help you communicate with business professionals and negotiate for a fairer distribution of rights and profits. It will also help you to effectively lobby for changes that create more equality between artists and businesspersons in the art marketplace and create situations of mutual support and sustenance.

## PRICING

Now it is time to answer one of the most frequently asked questions of artists: What is the price of your artwork(s)? Until you've come up with a price, you can't address subsidiary issues like commissions, discounts, creative payment plans to entice reluctant buyers or budding collectors, and so forth.

Once you overcome attitudes of gift exchange and want to deal with marketplace exchange, you are ready to look at some of the methods that are commonly used to help set prices.

♦ Profile current and potential buyers. Artists who exhibit at galleries with defined customer profiles know that they gear pricing to fit those profiles. Factors to investigate include: income bracket, interests, professional activities, place of business, recreational activities, age, family or nonfamily groupings, sexual orientation and gender.

♦ Consider the tangible and intangible expenses of creating your artwork and build them into the price. Tangible expenses include art materials, framing, portfolio materials; intangible expenses include the hours you've put into creation and manufacture.

♦ Review your status in your community: Are you just starting out; has your work been reviewed, received awards?

♦ Find out what other artists with similar status are charging for artwork in the same genre.

Whatever price you set, keep it consistent: it's very important that you do not charge one price for your work at one site and another someplace else. Variable

pricing practices automatically undermine consumer confidence and ultimately, your business reputation.

## GETTING THE WORD OUT

Getting people to come to an event is a function of getting the word out. This includes telephone calls and mailings to your personal list; having news of your event or show published in print media or talked about on radio or television; and advertising.

Getting your news published in magazines or talked about on the radio or getting critics to come to an event is accomplished by sending media persons information and asking them to present or publish it—over and over again.

Buying advertising can accomplish the same goal at much greater expense, but a straight news story about your work sometimes carries more credibility and information than paid advertising.

In fine arts marketing, the three most commonly used methods to announce events are: news releases; direct mail announcements in the form of postcards, posters, brochures, or catalogs; and display advertising.

How many of the following promotional methods you will execute as part of getting the word out will depend on your goals, what time frame you have at your disposal, and the resources that are available to put your plans into action. Resources include money, people, services (donated or otherwise), use of equipment, and so on.

Even when your show, event or exhibit is being sponsored by a gallery or other promoter who will use some of the same methods outlined below for getting the word out, your efforts will enhance theirs. You must recognize that quite a few galleries and art promoters don't know as much as they should about carrying out a successful promotion, or are under-budgeted, or just plain cheap. A tactful way of finding out their experience and plans is to ask what you can do to help enhance their promotional efforts.

Persons who are paid to do promotion are called public relations specialists; they are used by galleries and artists who can afford their services. Good ones are very valuable.

### Media Lists

Before you can send out information to media people, you must assemble a media list (press list) of the names, addresses and phone/fax numbers of people who write about events or review art or publish calendar listings. Who reviews art in your community? What media outlets provide free listings of art and related events?

Reviewers and art department editors and their addresses and phone numbers can be researched by reading newspaper and magazine mastheads. Listing or article deadlines (lead times) can be learned by phoning the newspaper and magazine and asking the receptionist. In general, Sunday newspapers have lead times of ten days; while monthly magazines have lead times of two or more months, and so on.

You should also call local radio and television stations and request the names of the people to whom art related news should be sent.

If you are a nonprofit organization or working with a nonprofit you will want to know the public service announcements (PSAs) policies of radio and television stations, who may have a legal obligation to provide time for publicizing news from nonprofits.

Libraries have media directories in their reference section you can use to research

outlets outside of your local community. A good one is *The All in One Directory*, from Gebbie Press. Other useful directories are those listing professional and trade associations, such as the *National Trade and Professional Association Directory* (NTPA) and *Art Marketing Sourcebook for the Fine Artist*.

Become familiar with what local critics are responding to and what they are saying. Study the art magazines. Although few feature articles are written about artists who do not purchase advertising in these magazines, they do offer extensive free event listings and other opportunities for emerging artists to be mentioned. Listen to or look at programs that feature art.

By carrying out this simple research, you can effectively target your mailings to the correct people and, hopefully, gain some response. Your goal is to identify writers and critics who might be interested in your artwork and avoid sending mailings to the wrong people; or inappropriate information to the right people. Even if your news is not consistently published, your work and mission will eventually become familiar to them.

## News Releases/Press Releases

"News release," "press release," or "media release" are the terms commonly used to describe information sent to print media (newspapers or magazines), radio and television stations, or other media. The purpose of a news release is to provide information you want the media to share with their readers, listeners or viewers and to invite critics to receptions and openings so that they may review your work.

Think of a news release as an article that you provide to the media about a timely event: an exhibition, a gallery opening, a group show, a seminar. The news release can also supply information about an important sale or commission, a special award, or a controversy. They are often the way the media is first alerted to news. Hopefully, they will share it with their audience.

A news release is typically one to two pages in length, with one inch margins, double-spaced (to allow space to edit). Use letterhead stationery from the source of the news.

The format of the news release is important. Either the words "News Release" or "Press Release" and a date are placed in the upper right hand corner; or the words "News Release" or "Press Release" titles the page and the words "For Immediate Release" and a date are placed in the upper right hand corner.

Use the words "News Memo" for shorter announcements. These are usually no more than half a page double-spaced and contain little more than factual information about the event. They are typically used for calendar listings, community bulletin boards and public service announcements.

The date alerts readers to the timeliness of the information. If you would like to see the release published at specific dates, indicate it with words like "For release weekly from June 1 to September 15, 1995."

In the upper left hand corner, place the name of a person they can call for more information, referred to in media language as the "contact person," and a phone number.

You may use a headline to catch the reader's attention and alert them to what the release is about. The first paragraph of the release will contain the facts about the event: dates, times, location, address, sponsor, opening reception, and so on.

The next paragraphs will present more detail and contain information derived from your narrative bio and artist's statement. There will be a paragraph describing the

## O.C.C.C.A.

Contact: Mary–Linn Hughes
Phone: (714) 846-1777

**FOR IMMEDIATE RELEASE**
September 25, 1990

### Exhibitions by Nat Dean, Mary–Linn Hughes, Joan Popovich-Kutscher
### to Open at OCCCA on November 1, 1990

Three exhibitions of works by Nat Dean, Mary–Linn Hughes, and Joan Popovich–Kutscher open November 1 at the Orange County Center for Contemporary Art (OCCCA) and remain on view through November 30. All three artists explore various levels and methods of visual, verbal and nonverbal communication, both private and public. The exhibitions' opening reception, featuring a special artists' presentation, will be held on November 3, from 7–9 p.m. OCCCA is located in the Harbor Business Park, Space 111 at 3621 West MacArthur Boulevard in Santa Ana. OCCCA is wheelchair accessible and invites people of all ages and levels of interest to attend. The reception and exhibition is free of charge.

During the reception presentation, the artists will discuss their work, their lives and art and their challenges to communicate. They hope to offer positive role models for people who are considering art as an integral part of their life and as a bridge to reach others. The presentation will be interpreted in sign language.

East and West Coast based artist Nat Dean exhibits stark black and wood raw panels that fall together in angular mosaics to present linear images that are painted with various metallic compounds. Her sometimes painfully simple images delineate fragmented views of primary life passages through use of an alphabet of hands and everyday objects as signifiers for story, memory evidence or prediction. This new series of works include panels that act as doors, revealing special messages to those who dare open.

Mary–Linn Hughes creates striking installation works/environments using materials common to our everyday experience. The house-sized work that will be exhibited pushes us to explore our definitions of shelter, home, nature and progress, while forcing us to confront change that cannot be sealed up and sent away in a simple package. Framed walls filled with chopped wood, caged birds, and jars of pond and salt water, and evoke our schizophrenic relationship with the natural world. Viewers are invited to enter this shelter and contemplate the idea that it is quite impossible to live outside of nature.

The work of Joan Popovich–Kutscher utilizes printmaking, collage, drawing and handmade paper to explore and document her experience of growing up with the challenge of deafness.

Joan met Nat while attending Cal Arts seventeen years ago, and brought her to sign language classes. Nat's fascination with visual languages led her to the study of signing and has influenced her extensive use of hands as a frequent "universal symbol" in her work. Mary–Linn and Joan met at OCCCA and have based their communication on common experiences, developing a relationship without regard or need for standardized language. Both Mary–Linn and Joan are California Arts Council Artists-in-Residence: Joan at Taft Elementary School where she works with hearing-impaired youth, and Mary-Linn at Laguna Shanti where she teaches photography and book arts to people living with AIDS.

Further information may be obtained from the OCCCA by phoning (714) 549-4989.

Color transparencies and black/white photos available on request.

*Orange County Center for Contemporary Art, 3621 West MacArthur Boulevard, Space 111, Santa Ana, California 92704  714/549-4989*

work that will be displayed, perhaps how many pieces, genre, and so on. Another paragraph may summarize your artistic accomplishments or describe artistic philosophy and direction. If there is particularly commendable sentence from a review about your work, weave it into the release.

Avoid jargon and hype. Keep to the point. Make certain the information is accurate. Don't be blatantly self-serving.

Mail the release to every one on your media list with a short cover letter and a black and white photograph, when appropriate. The photo can be of a work that will be part of the exhibition; or a portrait of the artist, or, in the case of a benefit, the artist with the promoter in some context to the cause being promoted. Some print media prefer glossy 8x10–inch prints; others prefer 5x7–inch prints that allow the use of hand-held scanners. As more and more daily and weekly publications move into color printing, you will want to send color prints or transparencies.

It is also appropriate to say "Color transparencies and black and white photos are available on request," at the end of your news release or in your cover letter.

Some artists include the announcement card, catalog or copies of published reviews to help spark added attention.

A cover letter gives you an opportunity to personalize your approach and extend invitations to a reception or exhibit to special persons on your list.

Follow your mailing with phone calls to introduce yourself and ensure that your material was received. It is appropriate to repeat invitations to gallery openings or shows that were mentioned in your cover letter. Keep these conversations friendly, brief and to the point: a good rule is no more than a minute.

Be aware that you may see no results from the first or second time you send off a news release. Persistent mailings, however, and polite phone calls begin to make you familiar and real to the persons receiving them. The proliferation of information about new openings and exhibits also alerts them to the fact that your reputation in the community is growing and that you are becoming worthy of their attention.

Be polite, perseverant and patient. At some point they will respond. When your news is published or your event is reviewed, write a thank you letter.

### Getting Feature Articles or Interviews

At some point, your stature in the artistic community or work for a worthy cause will merit a feature article or interview. Although these stories are customarily initiated by a gallery owner or other events promoter, many artists are now beginning to initiate them.

Your work may be interesting for a feature article or interview outside of the context of the art world. Perhaps it has political or social impact; perhaps you've created a special outdoor exhibit for the homeless; maybe your plaid-patterned designs will interest textile designers and clothing manufacturers in your community. It is your responsibility to alert media people to special areas or content of your work.

One method to generate feature stories is to send selected media people a news release highlighting the subject or the idea. Indicate in your cover letter that a longer story or interview on the subject would be worth their looking into. Follow up with a phone call.

Expenses in relation to reviews and articles, or a special interest story on you or your work, are generally paid by the media that produces them. Mailings of news releases are generally paid for by the sponsoring venue.

However, the selection of who to write about and when, particularly in art and other magazines that depend on paid advertising for their profits, may be based on the amount of advertising space purchased.

If you are asked to contribute to the costs of researching or publishing an article, you are essentially purchasing advertising space. Some unscrupulous companies will pressure unknowledgable individuals and new businesses into cost participation, so beware, and decide whether or not you want to buy that advertising space.

Sometimes staff writers and critics for a newspaper or magazine will moonlight, and try to freelance an article to another publication. Sometimes they will query the magazine first to ensure that there is interest; other times they will produce an article "on spec," taking the risk of writing something on the speculation that the publication will purchase it. If you are approached by a free-lance writer, ask to see the article before it is sent for publication to check for factual information. If the article is particularly favorable, and is not published, you may wish to purchase the rights to reproduce all or part of it as part of your promotional material, for use as a catalog essay, or didactic placard (text about a work).

## Mailing Lists

A good mailing list is one of the key elements to creating a successful event.

Most galleries are diligent in acquiring and updating their mailing lists; you should be too. Start by collecting names and addresses of family and friends, alumnae, colleagues, people you buy art supplies from, visitors to exhibits, and buyers of your artwork, etc.

Research the names and addresses of people who you want to attract to your work: interior designers and architects, gallery owners, public art commission officials, arts council members and officers, curatorial staff and board members of local museums and arts organizations, and so on. As your budget and status warrants, make use of directories that list trade and professional associations, locally, nationally and internationally.

Cooperatively trade or share your list with any gallery or museum that will be featuring your work. They too, are interested in increasing their audience.

You can trade lists with others artists and offer to barter work at nonprofit organizations for the use of their mailing lists.

Also available, for a price, are direct marketing mailing lists: most useful when artists are selling prints and other merchandise by mail and want to do bulk mailings of five thousand pieces or more. Research carefully, as some lists are better than others.

## Exhibition Announcements

Exhibition announcements are a very valuable and frequently used tool allowing you to directly reach individuals on your mailing list. Sending regular notices about events to your mailing list helps get people to your events and helps familiarize them with your work and growing success. Although direct mail is a form of advertising, many of the people whose names you've gathered will be somewhat familiar with you or your work, and will give it a moment of attention.

What should you include in your mailing? You can send personal announcement letters on your letterhead stationery, postcards showing one of your artworks with printed information, fliers, brochures, posters, catalogs, and pamphlets. The more personal you can make your announcement, such as adding a few personal words to

If you are preparing less than a hundred invitations, you may want to create a special announcement with collectibility potential. Artists have elaborately hand-colored drawings or photographs; used special textured paper; folded hand-done cut-outs into pop-ups, and so on. One artist parodied their own credit card debt with a faux credit card with the gallery and artist's information printed on it. The card was placed into corner slots on a generic invitation. It helped create a stir at the opening, and attendees carried the "credit" card long after the exhibit closed.

special people on your list, the more effective the mailing will be.

Even when galleries or other event promoters mail out invitations, posters or catalogs, an additional announcement from you to particular people on your list will make them feel special, and act as a second reminder to attend and hopefully spark added excitement.

The cost of direct mail can be high, between 50¢ and $2 each, after all the costs are factored: design and production, printing, mailing labels, assembly and addressing, postage and so on. Although postage can be saved by investing in a bulk mail permit, be aware that bulk mail can take up to three weeks to deliver.

***Announcement Design.*** Two rules of thumb are: the artist's name should be in the largest type; and if planning to include an image on the front and text on the back, be certain to repeat the artist's name in a caption on the image side.

When a one-sided piece is being designed, place the gallery name and show date so that it can be trimmed off the side or bottom. Have the printer print more copies than needed for the event announcement, so you will have extra cards to use for marketing communications, such as reminders and thank you notes.

When a two-sided piece is designed, you can gain extra mileage by asking the printer to do an overrun of just the image side, leaving the text side blank.

If you are part of a group event or a special "art walk" or community show, or help to organize one, you may be able to share a mailing and thus reduce costs.

***Checklist of Information to Include in News Releases and Announcements.*** Here is a checklist to help prevent you from leaving out some important detail when preparing news releases and announcements. A sure sign of poor organization and lack of attention to detail is the receipt of a release or announcement with a cross-out, rubber stamped correction, or a sticker over incorrect data. Carefully check spellings of all names.

♦ Artist's name or list of artists' names;

♦ title of show, if any;

♦ place of event;

♦ address, city, state, zip code and phone;

♦ directions to address, if needed, or a location map if the site is difficult to find;

♦ parking information;

♦ dates of event or exhibition, including the year to allow the announcement to be a historical record and portfolio tool;

♦ reception date, day and time;

♦ regular viewing hours;

♦ any special tours or artist lectures planned;

♦ if there is a reproduction of the artist's work on the announcement, or photograph included with a news release, include a caption, proper copyright notice and photographer credit.

### Display Advertising

At some point, you and/or your gallery will purchase display or classified advertising in print media or commercial time in the broadcast media.

Display ads cover a larger area than a simple classified ad, and usually contain an image to entice the public to come out and learn more about your art. Ads that picture the artist's work are usually more effective than display ads that feature only text.

Text-only ads are sometimes referred to as "tombstone" ads, and are usually effective on a large scale only if the artist and their work are a household name. Instances where it is difficult to prepare anything but a tombstone ad, are when the exhibition is a group show with many participants, or the budget doesn't warrant a graphic.

Display advertising is expensive, and each ad will have only a brief moment to win over an audience. For this reason the graphics and copy must be of very high quality. The next time you flip through a magazine or drive by a billboard, think about what catches your attention in those few seconds. Getting people's attention through advertising is a pretty tough assignment.

If you are going to spend money on paid advertising, it is usually best to hire an expert in creating ads that stand out. If you must do it yourself, first create a mock-up of your ad in the correct size and paste it into place on a past issue of the publication you are considering. If it does not stand out, change it until it does or you will be wasting money and time.

If you are buying display advertising, be aware that you will be charged extra to reserve the premium spaces of back cover, inside back cover, center spread, inside front cover, and front cover, if they are available. Without the purchase of premium space, you have little or no control over the placement of your ad. Color always costs more than black and white.

Display advertising prices, size of readership, and readership profiles are gathered together in a "media kit" available to you free from the advertising representatives of newspapers, magazines, and radio and television stations. The term used by the media for describing the cost of reaching readers of a display ad is "cost per thousand" (CPM). This figure is arrived at by dividing the cost for the display ad by the estimated readership (often audited), and multiplying by one thousand. The readership estimate is calculated by adding the number of paid subscriptions, newsstand sales, and a guess of the number of "pass along readers" (the number of people who might read a single copy, such as all the members of a household; the total staff members at a particular

business location). For example, a publication that claims to be read by 80,000 readers and sells a full page ad for $8000 has a CPM of $100, equivalent to a cost of 10¢ to contact one person. Magazines that have audited readership can also provide extensive profiles of their readership in their media kits.

Display advertising can be a long shot, but only *you* can determine if you can, or should, take the risk. Advertising works by saturation and repetition. Some advertising agencies report that an ad has to be seen ten times before it registers in a viewer's consciousness.

If you are having your first showing at a gallery or a venue that advertises regularly in numerous media, and has achieved strong recognition for their name and logo, then adding your name and/or a reproduction of one of your artworks to their ads will greatly benefit you. This represents a win-win situation for both you and the gallery.

Artists and galleries have also used inventive (though not necessarily low-cost) methods of advertising. These include the use of billboards, murals, computer bulletin boards, promotional videos, matchbook covers, and bumper stickers.

### Directories, Sourcebooks and Slide Registries

Artist directories and sourcebooks are assembled so that they can be repeatedly used as a reference tool over a period of time. They can be an effective means of reaching your target audience. Some directory publishers randomly distribute large quantities of their books for free that end up in the wastebasket. Others make certain to place their directories in the hands of only highly motivated users and buyers, thereby benefiting everyone. As most charge a fee to include you, you should make sure that they can provide a nonbiased, audited study of how much actual use their book receives and by whom. Do some additional checking by calling several businesses and galleries you would hope to reach through such a publication and inquire if they actually buy it, read it, and regularly refer to it. Better yet, call some of the artists featured in these directories who do work similar to yours and ask if they are pleased with their results. You may find that some directories are exceptionally beautiful and well designed but are, unfortunately, underutilized by those who frequently purchase art. If you do your homework, you will find the directories that will best fulfill your goals.

A less costly option for exposing your work to potential buyers is to research museums, nonprofit galleries, arts councils and professional associations that have slide registries. Inclusion in these registries is offered to artists for no or only a nominal setup fee. The additional cost to you is to provide one or more sets of portfolio materials (resume, artist's statement and inventory) and from three to twenty slides. As with directories, do your homework. Ask who uses the registries; ask other artists if they are pleased with the results. Find out if the organization providing the registry service provides viewing equipment or viewing rooms; if they hold special events or meetings in which they show slides, or if they compile videographies. Your inclusion in these registries can be listed on your resume.

### Catalogs

When a catalog is produced as part of an event, you have an additional promotional marketing opportunity that will help you extend your reach far beyond the duration of a single show, allowing you to bring the show to a larger audience through mailings and or/sales to bookstores, libraries, museum archives and so on. You can send the

catalog to places that develop and maintain extensive arts libraries, such as museums, colleges, and nonprofit arts organizations; you can include them in promotional mailings and as part of a grant or competition application; you can use them to bring your work to other galleries and other events promoters. Potential buyers like to see an artist's work reproduced in catalogs as evidence of their stature and worth.

Catalogs need not be of only solo shows to be of value; they are also put together for group shows, theme shows, to examine a certain phenomenon or period, or as companion tools for arts auctions and arts and crafts fairs. Promoters of benefits who use the sale of artists' works to raise money for worthy causes sometimes offer donating artists inclusion in a substantial catalog to offset the loss of income from their artwork, thereby providing them with a valuable tool.

## WHO PAYS FOR PROMOTIONAL COSTS?

Once an artist has found a gallery, dealer or artist representative to help sell their work, who pays for promotional costs becomes a negotiating issue. Both entities have the same goals: to sell the work for a profit; and both will create and use portfolios and other promotional materials to do so, generating expenses that need to be recouped.

Although many contracts specify that a percentage of the commission will be used for promotion, artists should insist that any and all contracts stipulate exactly what promotional costs will be paid for as part of that percentage. Some important things to decide are:

Who pays for extra sets of slides, prints or tear sheets needed for promotion?

Who pays to have additional photographs or transparencies taken of your work, as part of a sales catalog or brochure?

Who pays for such promotional expenses as news releases, purchase of display advertising space, announcements, catalogs, tear sheets, brochures, and the like?

A contract should also discuss what promotional materials will be produced, at what design and production expense, and how the expense will be shared, if at all.

If the gallery argues that you should pay with phrases like "the honor of appearing in their gallery" tell them that you are as much in the business of making a profit as they are, that you wish to help them in every way that you can, but not at the expense of your losing money. Both you and the gallery want to sell enough work to cover expenses and make a profit. It is in both your interests to build a lucrative relationship where each of you makes an equal investment in the other.

## COMPETITIONS

Competitions can be an effective means of promotion as well as a way to have one's works viewed not only when the work is selected for an award, grant or exhibition, but when a competition holds curatorial review sessions for museum curators and directors, dealers and collectors.

Unfortunately, many artists feel they must enter juried competitions as the only way to introduce their work and establish credibility. The process of choosing which pieces are appropriate to enter is difficult because more competitions are charging expensive entry fees, or are asking artists to pay additional exhibition booth fees or

## LOBBY AGAINST EXORBITANT FEES

Support the efforts of The National Endowment for the Arts (NEA), National Association of Artists Organizations (NAAO), and National Artist's Equity (NAE). These organizations have taken a stand against the charging of unjustified fees for juried shows. They argue that artists should not have to pay to make the work, and then pay unreasonable fees to gain a small chance of being selected to show it. Unless they can be documented as expenses that will benefit every entering and selected artist, the demand for exorbitant entry fees is unacceptable.

When entry or jury fees pay expenses such as gallery staff salaries, space rental, juror honoraria, prizes, promotion and other costs, entering artists, in effect, become the sponsoring organization and underwrite the competition.

Sometimes booth rental fees are disguised as entry fees or jury fees. A site that charges $1–$15 per slide to enter a competition and requires no further charges identifies itself as an a competition. A site that asks for an additional fee of $50–$500 with the application or as a requirement after selection or, worse, sneaks an exhibit fee on the artist at the last minute is a commercial enterprise that may or may not be profitable for the selected artists. Is it a "vanity exhibition," where an artist pays for a rental space that exhibits their work regardless of quality, or a more legitimate and prestigious exhibition where a rigorous selection process by accredited jurors guarantees that only quality work will be sold?

When you learn of a competition or exhibit that is abusive and unrealistic, write and say so. When you learn of a no fee competition, send a postcard of praise, even if it's not in your media

Lobbying for change will help produce change.

other promotional charges. The experience can become degrading and much more expensive than originally portrayed by the sponsoring party.

Generally, a competition should offer artists the opportunity for exhibition at various sites; acquisition of their work; and cash awards or grants, based on the merit and quality of the work.

If you sit at home or in your studio, you won't find collectors and curators knocking on your door. Legitimate competitions are but one method for getting information about yourself and your artwork into the world.

When considering a competition, ask yourself what you stand to gain by entering it. Try to evaluate why your work should be selected and what that selection will mean to you in terms of prestige and/or sales. Weigh the benefits of entering several expensive competitions against sending out a handsome portfolio at some other time to the same art officials who will be jurying the show. What about using the money you will spend entering competitions to plan and finance an open studio reception or your own weekend exhibition at a rented space? You could consider helping to start a good co-op gallery with honorable practices.

Read competition offerings and brochures carefully. Here are some of the considerations that can help you make a judicious choice:

♦ Can I approach the promoter on my own and gain just as much attention from the decision making parties? Would it be advantageous to bypass the competition and introduce my work to the juror at another time?

◆ Is the venue, show or exhibit one to which I would otherwise not have access?

◆ Does my work fit in with the exhibition theme? Do the jurors have a history of selecting work similar to mine?

◆ Do I have a good chance of winning an award?

◆ Does the location, sponsor or exhibit have a strong and well respected reputation, or is it poorly considered by my peers and by other arts organizations and businesses?

◆ Does the competition receive local, regional or national attention?

◆ Does the jury process for the selection of exhibition artwork and/or awards seem to be legitimate and fair?

◆ Who is likely to attend the exhibition beyond the opening reception?

◆ How will the event be promoted? Will the exhibit sponsors mount a strong publicity campaign that will present me with an opportunity for coverage in newspapers and/or magazines? Are they paying for highly visible advertising? Will a quality catalog be produced that I can use for my own promotions or will there be only a photocopied list?

◆ If there is a catalog, will the sponsor make an effort to place copies in major museum libraries or will I have to buy them and do it myself?

◆ If I am selected, are there guarantees my name will be on the announcement and/or appear in any advertising?

◆ Will I receive enough copies of the announcement to send to my mailing list? If I make my mailing list available, will the promoter mail announcements to the names on my list?

◆ Will there be a photo of someone's work on the announcement? If so, will the image selection process be democratic?

◆ How prestigious is it to be a part of this event? Do I need to pay money for this possible addition to my resume?

◆ What will the competition cost in entry preparation and fees? Can I afford to travel to the opening reception to meet potential collectors, the site's staff, and the jurors?

◆ Will my art work be insured while on display and in transit? Who pays?

◆ Will I be able to get copies of the guest log after the show for future promotion?

♦ What efforts will be made to sell the work on display? How will buyer interest be communicated to the artist?

♦ If my work sells, does the venue keep a percentage, or do I get the entire sales price? If they keep a percentage, does it go toward something that I would support anyway?

Don't hesitate to contact the competition promoters and ask the questions outlined above. If they are evasive or defensive, they probably won't look out for the best interests of the competing artists. Call upon your personal network of other artists and arts organizations to make inquiries about the event and its sponsor.

# OBTAINING GALLERY REPRESENTATION

**WILLIAM TURNER**
*William Turner is the owner of William Turner Gallery
in Venice, California. He is also an attorney with a J.D.
degree from the University of San Francisco. He has a
B.A. degree from Colorado College where he majored in
philosophy and fine art. Mr. Turner is on the board of
California Lawyers for the Arts, is president of the Santa
Monica/Venice Art Dealers Association and is
the art editor for Venice Magazine.*

Whether you have very good training
and background, or you are self-taught, when you first seek gallery representation you
are embarking on a quest for which there is no exact process or system.

As prominent California artist Joe Goode recently underscored when discussing how
he got started, "One of my teachers at Chouinard (now Cal Arts), told me that there
was this guy on La Cienega Boulevard in Los Angeles who was looking for artists. So I
took these drawings over there and he liked them and asked me if I knew anybody else
whose work I respected. I said, 'Well, there's this guy named Larry Bell and a guy
named Ed Ruscha.' Anyway, the guy turned out to be Henry Hopkins and he gave me
my first show." (Hopkins later became the director of the Museum of Modern Art in
San Francisco. He is a noted author, curator and current Art Department Chair at UCLA
and acting director of the Armand Hammer Museum). Clearly a great start. Yet Goode
says, "It is very difficult when students ask me how to get started. I always say the same
thing, which is essentially true, that there is no *way* to get started. However it happens to
you is the way it happens. For me I just walked in off the street with some drawings."

## MISCONCEPTIONS ON HOW TO GET STARTED

Stories abound of artists like Joe Goode walking into a gallery and beginning a
relationship with a prominent dealer. Roy Lichtenstein did indeed start with Leo
Castelli that way. But there is no formula anyone can give you for gaining entry into a
gallery relationship.

The most common misconception of many artists in search of a gallery is that they
must first engage in a massive slide assault.

However, this is not a traditional job search and your resume and slides, while
important, are not generally your ticket into a gallery. Very few dealers find their artists
this way. Why?

Part of the answer is in the amount of submissions that dealers get. There is simply an overwhelming number of artists relative to the number of galleries. I, and most dealers I know, receive countless resumes and slides from artists, seeking gallery representation, who have never been to our galleries. Or if they have been to them, have remained completely unaware of how their work relates to the gallery's focus.

However, the fundamental reason slide submissions are almost always ineffective is that the nature of the artist-dealer relationship is very personal. You should not expect to begin a meaningful gallery relationship through a random shotgun of proposals.

## OBJECTIVES OF THE ARTIST-GALLERY RELATIONSHIP

Beyond the obvious function of providing a public forum where the artist's work can be seen, there are a number of other important functions that galleries can perform:

♦ Expose the work to collectors, museum personnel, and critics who then become aware of, and ideally, interested in the work.

♦ Insert the work into a formal exhibition context that allows the artist to gain focus and perspective.

♦ Critiques of the work from an interested and objective source.

♦ Sales of the work.

♦ Career management, through advice and consultation with a dealer who believes in the work.

♦ Development of other exhibition venues for the artist.

♦ Development of special commissions and projects.

♦ Submission of work to museums, juried exhibitions and selected group exhibitions.

♦ Documentation of the work.

Whether some, or all, of these are objectives of the relationship you are seeking, they are all accomplished best by a dealer who really believes in the work. The successful artist-dealer relationship is a partnership and a shared vision. Unless the dealer relates to the artist's work on a fundamental level, there will not be the chemistry and unique energy that lies at the heart of every successful artist-gallery relationship.

## HOW TO CHOOSE A GALLERY

First, you have to do some homework. Seek out galleries that you feel are most compatible with your work. Each gallery has a focus or theme. Some show

contemporary work by established artists, emerging artists, or a combination; at some the style is figurative, landscape, abstract, abstract expressionist, minimal, conceptual or neopseudo faux pop; the medium can be sculpture, painting, prints, photography, video or any number of other things. They may be a gallery who appeals to a mass market, or one who appeals to a select market. Each has a focus. Even if they show anything and everything, that's a focus and you need to analyze how you might fit in, or more importantly, if you even want to.

### An Example of a Trapped Artist

I know an artist who was thrilled that he got signed with a gallery to an exclusive contract. The contract provided that the artist would consign so many works to the gallery, and the gallery would be the exclusive seller of that artist's work. But as it turned out the artist's work wasn't very compatible with the dealer's client base. After several months of exhibition in the gallery, the work was removed to the storage area. No sales had occurred, and yet the artist was precluded from selling his work elsewhere and from approaching other dealers. The artist was trapped by this much sought after relationship. He should have done more research on the gallery and he should have set conditions to the exclusivity, such as:

♦ Duration of the exclusivity.

♦ Number of works the dealer would sell to maintain it.

♦ Length of time the dealer would exhibit the works in the gallery.

## TAKE A CAREER APPROACH

Successful artist–dealer relationships develop over time.

### Develop Your Talent

Many artists who go through the search for a gallery have not really approached their work with the level of dedication, research and discipline that one would expect from someone holding themselves out as a professional. Although a number of brilliant artists have been self-taught, Francis Bacon (1909–1992) comes to mind, they have applied as rigorous a process of self-education as if they had gone through graduate school. By the same token, simply going to graduate school does not qualify you. It is the spirit, attitude, dedication—and yes, talent—that you bring to the endeavor of being an artist that will.

### Be Persistent Without Being Obnoxious

I have taken on a number of artists whose work I followed for several years before feeling that they, or sometimes I, were ready to begin a fruitful relationship. The patient persistence and long-term perspective of these artists was a tremendous asset in our developing a successful relationship.

For example, I saw an artist's work several years ago that showed promise but was not up to the level of consistent quality that I required. She told me that she loved the gallery and its direction and supported her comments with observations that made it

clear she had been following the gallery's activities. Although I doubted her work would ever coincide with the gallery's focus, her continued interest and enthusiasm, regardless of my initial rejection, set her apart from many of the other artists who had submitted their work. Consequently, I was more willing to review her work periodically. As she grew and developed, I began to see her work mature, and what began as vague interest, developed into sincere enthusiasm to represent her work, which I proceeded to do.

### Present Yourself As a Professional

Dealers love exchanging stories of artists who have approached them unprofessionally. Everyone has a few classics. Mine is an artist who backed his car up to the front door of the gallery, popped the trunk and started unloading work into the gallery for my review. No appointment, no introduction, no clue.

*Appointments.* Dropping in without an appointment to show your slides, or even worse your actual work, is frowned upon. Even calling to make an appointment is often met with a less than enthusiastic response. Dealers could spend all of their time doing nothing other than meeting with artists and reviewing work. In order to manage their time, most of them have scheduled a specific time to review slides. They generally do not make in-person appointments to do this because it is too time consuming. Calling to find out about a gallery's review procedure is a good first step. But if you have no prior introduction to the gallery the odds are often against you.

It is more effective to gain an introduction to a dealer through an artist that the dealer represents or respects, or through a friend of the dealer, or a collector, critic, curator etc.

*Slide Submissions.* When you do present slides of your work include enough to give a good idea of what it is you do. Ten to fifteen slides is usually plenty. Never include slides for which you don't have a duplicate. Unfortunately, few dealers ever look at slides through a loupe or slide projector, they simply hold them up to the light. Admittedly this is not the best way to look at work, but it is the reality of the situation. Including some good color prints greatly augments what the dealer is seeing.

Your cover letter, slide sheet and artist's bio should all be typed. You should include your business card and a self-addressed stamped envelope, if you want the slides returned.

### Be Resourceful

While you are seeking gallery representation, there are a number of things you can do to get exposure for your work, develop a collector base, make dealer and artist contacts, and occasionally, even support yourself.

◆ Explore "alternative venues" such as restaurants, corporate offices, art fairs, juried exhibitions, donations to charity or museum auctions, submissions to museum rental galleries, etc.

◆ Have "open studio" cocktail parties, in effect, your own exhibition, so that you can invite friends and associates to see and perhaps acquire your work. This is an excellent way to develop a following of supporters for your work who will help get the word out.

♦ Offer to "intern" at a gallery, or with a successful artist you admire. Volunteering one or several days a week is an incredible way to get an inside track with dealers, artists and the gallery system.

## Set Goals

It is important to set goals for your relationship with a gallery and then structure the relationship accordingly. Initially you may not be sure whether a particular gallery is the right one for you, even if they are interested in exhibiting your work. An approach that lets you each test the waters, such as a consignment for a limited time, is a good way to begin.

Your success is intertwined in many ways with the gallery's success. Thus, there is essentially no killer deal that you need to worry about negotiating. However, you should be wary of becoming committed to a contract that, as with our friend above, is one-sided.

If you are clear about your goals, then setting up the terms of your relationship can be very easy.

## APPROACHING GALLERIES - NETWORK, NETWORK, NETWORK

Almost all of the artists I represent have come to me, or I to them, through other artists, dealers, friends, collectors, critics and curators. Many successful artists network as much as successful dealers. I will see them over and over again around town at various events. It is amazing how many relationships you can develop this way.

♦ Get to know dealers. Go to their exhibitions and openings, see what, who and how they exhibit.

♦ Get to know the artists that dealers represent. Ask them if you can show them your work and whether they think it's compatible with the gallery in which they are exhibiting. Most dealers will give serious attention to the recommendations of their artists. There is nothing like developing a peer or mentor relationship with an artist who can give you honest feedback and advice. If you have studied with, or were a classmate of, an artist who shows with a gallery they can be a great contact.

♦ Go to lots of gallery and museum openings, fund-raisers, and art-related events. Get a real feel for what the galleries, museums and movers and shakers in town are doing and showing. This can help narrow your focus and is a great way to meet collectors, critics, artists and dealers.

♦ Enter juried competitions and exhibitions. Acceptance can help you develop a following and it provides a foundation of credibility for your work.

♦ Go to art fairs and art expos. These are held annually in cities such as Los Angeles, Chicago, Miami, New York, Seattle and San Francisco. Attending one or two of these is a terrific way to develop a sense of which type of gallery best suits your work and start a national or even international network of contacts.

♦ Consider working with an artists' rep. An artists' rep can introduce your work to dealers, corporate collectors, foundations, etc. They usually work on a consignment and commission basis, but will sometimes charge a fee. When they do, it usually involves the creation of a printed bio, illustrated brochure or even an exhibition. Ask to speak with other artists the rep has worked with to see if they are right for you.

## CONCLUSION

It's tough out there. You have a lot of competition. Success may not happen immediately or in a logically predictable way. In fact it almost never does. But if you work hard at developing your talent and are smart and industrious in developing your professional career, you may just make it and in the process have one of the most fulfilling and rewarding careers I can imagine. Next to being an art dealer that is.

# Packing and Shipping Artwork

**MARLENE WEED**

*Marlene Weed, motion picture screenwriter
and attorney, represents a wide variety of artists and
writers in America and Europe. She is the author of*
A Consumer's Guide to Insurance Policies. *As a
member of the Writers Guild of America, West,
Plagiarism Committee, she led the search for lawyers
willing to represent artists and writers on a contingent
fee and co-authored the Guild publication,*
Plagiarism & Copyright Infringement.

Space-age technology has greatly improved the art of preparing goods for transport. Packaging has become an engineering science with degree programs in highly regarded universities. But it's doubtful that this amazing progress has kept pace with the decline in the care given transported goods.

Unless you're prepared to make the trip yourself, the artwork you ship is going to be handled roughly by many common carriers. This is a fact of life and it's up to you to handle and package the piece so that you diminish the likelihood of its destruction.

## HANDLING

After considering all of the problems involved you may decide to use a professional to crate and ship your artwork. Even so, you are going to be responsible for preparing the piece for packing. This preparation can determine the condition of your piece when it arrives at its destination.

Much of what we suggest for proper handling of artworks is little more than common sense, but it may run counter to personal habits. At the handling stage you and your friends or employees may present as great a danger to the art as a disgruntled freight handler, if you are not willing to observe the simple cautionary rules that expert art conservators have developed.

Do not smoke in the room in which you are handling artwork. It's a fire hazard, the odor permeates everything and the oily, yellowish film of tobacco smoke will damage original art. Some works will suffer more immediately apparent damage from tobacco smoke than others, but none can escape it.

Smoke is not the only airborne danger. Tar-lined paper should be kept out of any room in which you're preparing art for shipment. Changes in temperature can cause the tar to emit vapor that will damage paper and textiles. Insect repellents present the

same danger. Be skeptical of the presence of any substance that produces a distinctive odor. If the air is carrying something to your nostrils, it may well be carrying a damaging substance to your work.

The room in which you prepare art for shipment should be clean and tidy. A vacuum cleaner (ideally the type that draws dust laden air through water, as with the old RexAire) should be used to reduce the dust that will damage fine fabrics and paper. Don't sweep the room while art objects are about. This will simply fill the air with dust and increase the probability of damage.

Those same talented hands that enable you to be an artist can irretrievably damage a watercolor, etching or archival print photograph simply by touching. Hand smudges often do not appear immediately, but the damage from the oil, secretions and transferred residue will eventually appear and is irreversible.

Scroll and screen paintings are normally on silk or fibrous paper. Both substances will absorb the dampness from hands as readily as they absorbed the original ink. Once absorbed, that smudge is as permanent as that ink.

Even hands that are well washed produce oil secretions. Fingerprints will not necessarily appear as you handle an early etching or original negative, but will appear later and cannot be removed. The permanent damage that fingerprints do to damp old pewter is apparent immediately but slower with other metals.

No matter what type artwork you're preparing for shipment your first investment should be in a dozen pair of white, cotton gloves such as those used by film editors in their daily handling of motion picture negatives and prints. These washable gloves are available from any motion picture supply house and most photography shops.

Before you take up the art object that is to be shipped consider the following: did you remove all the sharp objects that the piece could rest on or bump against? Is the surface of the table washed clean and thoroughly dried? Is there any object whose surface could adhere to the piece?

One last question before you uncover your art piece for preshipping examination. Do you want to block out sunlight and turn off any fluorescent lights in the room? The degree of damage from sunlight or strong artificial light varies with the materials involved. The potential damage to inorganic substances (metal, metal alloys) is so slight as to make this precaution unnecessary, but light is extremely damaging to organic substances. Vegetable and animal dyes in tapestries suffer from the slightest exposure to any light and suffer greatly upon exposure to strong light. It is not just direct sunlight that will fade watercolors, destroy yellow dyes, and discolor ivory. Reflected sunlight and fluorescent lighting will do as badly and will damage paper. High quality paper resists light damage, but it will ultimately succumb.

You're now ready to examine the work and to prepare a written record of its condition. The written record should be thorough, detailed and accurate. Future disputes on condition may well be resolved on your written record. Comparison of your record with the piece may contribute to determining either the cause of the damage or even the culprit. If your recipient complains, or a claim is to be made against the shipper or an insurance company the record you made will be significantly more persuasive than your unsupported recollection.

If any damage or any weakness is noted prior to shipping, a copy of the report should accompany the artwork. When the receiving party is alerted to some weakness in the item, precautions against damage are more easily taken.

It is a practice of the Los Angeles County Art Museum to X-ray artworks to

determine structural flaws and weak points prior to shipping. You will not likely have the facilities for such thorough inspection, but you can certainly note previous repairs and restorations and, if the piece is framed, check the frame for breaks and open miters and make certain the painting is secure within the frame.

If someone has stapled or clipped the artwork that you are about to ship remove the metal pieces immediately. A staple remover will only aggravate the damage, so use extreme care and tools with which you are skilled.

All tape, no matter how attractively named (water soluble, pressure sensitive, or whatever) will damage artwork, especially art on paper. If you have to use an adhesive, use only rice or wheat flour paste. Avoid synthetic adhesives and rubber cement. They will stain indelibly.

When framing a work before shipping, avoid glass. Glass breaks easily and will surely damage the work (whether painting, print, photograph, drawing, etc.) in the course of the break. If you desire a cover use Plexiglas coated with antistatic film. Don't skimp here, buy the more expensive Plexiglas. It will give your surface unbreakable protection. It will *not,* however, protect the surface against sunlight.

Plexiglas is easily scratched so you're going to have to protect it as carefully as you would have protected the surface of your painting. The notion that Plexiglas filters out harmful ultraviolet sun rays is incorrect.

Often the proper way to handle an art piece is not obvious. The Los Angeles Art Museum prepared over 500,000 art objects for the move to its present Wilshire Boulevard location. The only significant damage was to a Tuscan vase, broken because an employee did the obvious and picked it up by its handle.

Ceramics should be carried singly with one hand on the bottom supporting the weight and the other on the side, near the top but below the rim. Unless it's your own creation, in which event you presumably know its structural strength, never use the handles. Handles are the portions that have most often been broken and restored or replaced. The mending may not be apparent, but the mended portion will be structurally weak.

Other than handle misuse, ceramics usually do rather well in shipping. They are so obviously susceptible to breaks that even the most careless packer usually does a decent job with them.

Glass shares the advantage of obvious breakability. It should be handled only on a padded table and carried in compartments separated by soft, resilient material or singly on a padded device.

Framed paintings should be carried with one hand at the mid point of the bottom frame and the other hand on one side for balance. If the painting is so large that this handling would be awkward two people must move it. Each must place a hand at a bottom, weight bearing corner with the other hand toward the top of the near side. No painting is sufficiently small to warrant different handling. There is no safe way for one person to carry two paintings.

Folding screen paintings cannot be moved safely by hand. If you must move one to prepare it for shipment call in assistance. You and your helper, in clean clothes and gloves, should cover the screen with acid free tissue paper, fold it and gently move it onto a clean, padded hand truck.

Move only one screen at a time. The frames are not designed to bear weight and will not survive stacking.

Textiles, rugs and tapestries are particularly awkward to handle in preparation for

shipping because there is no way to move them without some folding or rolling and there is no way to fold or roll them without some damage to the fabric.

If it is your own work, the threads or fibers are new enough that damage will not be apparent, but it will be there nonetheless. Careless handling can produce visible fiber damage even in new products.

Fire and water take their toll, but the major destructive forces for fabric art are light, folding, dust, dry heat, insects and mold.

Prior to shipping you must examine the fabric for insects, larvae, eggs, fungus and mold. Wool and silk are especially liable to attack by insects. The same silverfish that endangers your paper artwork will happily eat fabric. If the examination reveals any foreign substance a good airing (in dry darkness) should be followed by fumigation. If it is a new or an older intact (unfrayed, unbroken threads, not restored) piece it should be cleaned with a slow vacuum cleaner in even, vertical strokes, repeating each stroke in the opposite direction.

Ivory is not a medium you're apt to be using in your own work, but you may be asked to ship ivory art. The best thing would be to refuse. Ivory simply does not lend itself to being carted about and shouldn't be shipped.

Don't grasp any ivory piece by a projecting part, rim or edge. If it must be carried, examine all sides before touching it. Delicate carvings and fragile projections are often on the back or lower portion of carved ivory.

Sunlight damages ivory as do sudden changes in temperature or humidity that can cause it to crack as you watch. Your fingers will discolor ivory and cotton lint will become lodged in the crevices of intricate carvings. If you're going to have to ship it consult an expert and pray a little.

Metal objects that are small enough to be carried on a tray should be in separately padded compartments, as with glass, or cushioned by wadded acid free tissue paper. Silver and bronze can be wrapped in Saran Wrap for surface protection if it is certain they will remain dry and warm.

Photographs and negatives require clean, dry hands and surfaces and a prohibition against paper clips or any object resting on the surface. Plastic sleeves will keep slides and negatives dust free. Sunlight can be damaging.

## PACKING

To some extent your method of packing will be influenced by the mode of transportation and the shipping personnel. If you're going to travel with the piece and it can be carried onboard, sturdiness of crate can give way to ease of handling. If you have to ship by sea the packaging must work against the serious problem of salt in the atmosphere. In planes that do not have a pressurized cargo hold, the package must survive extreme cold and rapid changes of temperature and air pressure.

Economic factors will certainly influence some choices. The immediate or long-range importance of the particular artwork to your career is a legitimate factor in considering the cost of various forms of packing.

The type of work must also be considered. Before packing, determine the conditions facing the work from the moment it leaves your studio until the moment it is unpacked at its destination. Will it travel through desert or mountains, or both? Will it go from Beverly Hills to Santa Monica by way of Memphis? (This is no joke. That's

exactly the route it will take if you give it to Federal Express.) If it's going to New York you must know and prepare for the fact that the cargo is unloaded into an open air shed at Kennedy Airport.

Rain is an obvious consideration. Dampness can be just as destructive. Even a short storage in damp quarters encourages the growth of mildew and mold. Unsealed work is constant prey to cockroaches (they love to eat pigment), silverfish (they prefer paper), and even termites. Don't ignore these pests, in transit or in the studio. One cockroach in one night can eat the better part of a watercolor surface.

## INFORMATION RESOURCES

Secure copies of *Soft Packing Methods and Methodology for the Transporting of Art and Artifacts* and *Technical Drawing Handbook of Packing & Crating Methods*. Both books can be purchased at modest cost from the Nelson Atkins Museum of Art, 4525 Oak, Kansas City, Missouri 64111.

Another publication of value is John FitzMaurice Mill's *Look After Your Antiques*. Perhaps more useful is the cleverly illustrated *The Care and Handling of Art Objects* by Marjorie Shelley, published in 1987 by the Metropolitan Museum of Art.

Brent Powell, Chief Preparator of Packing and Storage at the Nelson Atkins Museum of Art, is chairman of Packing and Crating Information Network (PACIN), a task force of the Registrar's Committee of the American Association of Museums. Perhaps America's leading authority on packing and shipping artworks, Powell graciously granted the author permission to include his direct line telephone number (816) 751-1294, for use by the serious artist seeking information on current developments in art packing.

Powell also recommends that any artist planning to ship artwork secure copies of *Way to Go* by Stephen Horne, Gallery Association of New York, Hamilton, New York, and *Art In Transit,* published by the National Gallery of Art, Washington, D.C.

Two books I also strongly recommend are, unfortunately, out of print. If your library or museum has copies be sure to read *Handbook of Package Materials* by Stanley Sacharow and *Art Objects, Their Care & Protection* by Frieda Kay Fall.

## Adapted Containers

The easiest packaging for your art objects, if it will fit and withstand the expected handling, is an existing container adapted for your particular piece of art. The easiest of all is a sturdy suitcase or abandoned typewriter case, especially if you're going to deliver the item personally. You can carry it with you on plane or train, or securely packed into the luggage compartment of your automobile.

You can convert the case by cutting two pieces of flexible urethane foam to completely fill each portion of the case. Securely glue each piece to the interior of the case. When the case is closed the two layers should touch.

Wrap your small sculpture in tissue or plastic film and place it on the surface of the urethane. As the case is closed the urethane will cushion and hold your piece it securely.

If the size of the case or the object warrant it, you can also cut an appropriately shaped piece from one or both of the urethane surfaces to provide a cradle for the artwork.

Another adaptation is to line the bottom of the case with 2, 3 or 4-inch Ethafoam, spread a 2 to 3-inch layer of Pelaspan-Pac (commonly called peanuts because of the shape), place your glass sculpture or bronze on the spread

peanuts and fill the case to overflowing. This will only work if you have a large and a very narrow side when the case is open because it is important that the peanuts be pressed tightly when the lid is closed.

Old wooden soda pop cases are excellent containers for small objects. The twenty-four compartments should be felt lined and tissue wrapped objects can be nestled in each. Some of those wooden cases were for six-packs and have four large compartments. They can be felt lined for carrying or lined with $1/2$–inch Ethafoam (two pound density) for shipment. In the latter event a $3/8$–inch plywood lid should be cut and also lined with $1/2$–inch Ethafoam. The short ends of the case will be thick enough to handle small T-bolts.

Jim Marshall, San Francisco photographer, advises that Kodak film boxes are the perfect mailing cartons for negatives and original slides. Marshall uses cardboard for filler and completes the package with simple brown paper and paper tape. He mails prints in manila envelopes between layers of cardboard. He ships all negatives by Registered mail because the Post Office system (every person who handles the piece signs for it) makes it easy to trace a lost item.

### Tubes

The least desirable, but occasionally most practical, shipping container is a tube. When you use a tube you accept a certain amount of inevitable damage to the artwork you're shipping. Every year untold hundreds of paintings are pushed on their way to eventual destruction by one major moving company that informs all callers that rolling is the best way to move an oil painting. Rolling squeezes the inner surface and stretches the outer surface. Squeezing causes wrinkles and chipping, stretching causes cracks.

If the painting you are shipping is so huge that it cannot be moved without rolling, give serious thought to leaving it where it is. If it has to be moved, carefully vacuum the front and back of the painting and thoroughly clean the surface on which you must lay it to roll.

Select the thickest available pole of light wood or strong fiberboard. Never use a metal pole. Place a sheet of clear polyethylene on the cleaned table top (or given the assumed size, the carefully scrubbed floor) and place the painting face down on the polyethylene. You have selected a pole at least a foot longer than the width of the painting so that a person on either end can hold the pole a quarter inch above the back of the painting as you slowly roll the painting and the polyethylene onto the pole. The back of the painting is to the pole. The front of the painting and the covering polyethylene face outward as it rolls. The edges will be even if the rolling has been done properly.

Wrap the roll in waterproof paper and seal it. Don't tie it because that will pull the canvas unevenly and cause further damage.

The painting should be unrolled immediately after the move. It will have suffered some damage. However, if you're quite lucky and have done an excellent job the damage will be imperceptible.

Textiles, tapestry and rugs should be shipped perfectly flat and unfolded. The next best way is by tube. The rolling will weaken the fibers, but not as severely as folding.

Clean both surfaces. Carefully clean the floor or table where the fabric will be rolled. Select a suitable pole of wood or cardboard. The pole must extend several inches beyond the fabric on either end. A metal pole cannot be used because it will oxidize and stain the fabric. The cardboard tube must be covered with acid free tissue paper.

## PACKAGING EXAMPLE: SMALL, FRAMED OIL

• Measure the piece carefully. (Assume for this example it is $^{15}/_{16}$ x 12 x 24–inches.)

• If cardboard is your choice of material cut two pieces with identical grain or corrugation running horizontally 18–inches long by 30–inches wide. Then cut two pieces the same size with the grain or corrugation running vertically. Take one horizontally corrugated and one vertically corrugated piece and paste them together for each side of the package. (If you've chosen Masonite or plywood cut two 18x30–inch panels for the package.)

• Wrap your painting in acid free tissue or polyethylene film to protect it from dust and abrasion. Measure the inner pack again. (We'll assume that the covering has added $^{1}/_{32}$–inch to each surface.)

• If you're using cardboard sides, cut 1–inch thick Styrofoam for filler. Two strips 30 x 2 $^{31}/_{32}$–inches and two strips 12 $^{1}/_{16}$ x 2 $^{31}/_{32}$–inches will be required. If you have free cardboard and plenty of patience you can cut enough cardboard strips in these two sizes to combine into 1-inch thick fillers. (If you've chosen plywood or Masonite, cover the inner layer of each of the two panels with $^{1}/_{8}$–inch Ethafoam or a layer of felt. This protective layer should be firmly glued to the hard surface. For your fillers you can forget the $^{1}/_{32}$–inch tolerance and cut 1–inch thick Ethafoam strips 3x30–inches and 3x12–inches [two each].)

• Use a hot glue gun to coat the perimeter of the bottom piece of the developing package then attach the fillers to make a snug trench for the framed, wrapped painting.

• Place the painting in the trench. You'll note that the frame gives the painted surface floating space. If you package an unframed piece you have to create this space with packing material.

• Place the second side on top of the painting (cushioned surface inward).

• Tape the package with gaffer's (duct) tape. Address the surface of the container to insure delivery in the event the covering is destroyed. Label the top side.

• Wrap with paper and seal with paper tape unless it is going by bus, in which case seal it in a cloth bag. Mark the top face and add any special instructions for handling.

The fabric is usually covered with a layer of glassine or plastic (if glassine then the outer roll is encased in plastic) so that the protected object never touches itself.

Now roll slowly and carefully so that the edges are even and no crease is rolled in. Roll against the pile with the face inward (opposite the way you roll an oil painting).

It will be worth the effort to take a cloth or rug of similar size and shape and have a couple of practice runs with your crew before undertaking the rolling of a valuable piece.

### Light Weight Packing

If you're shipping something you've sold for a hundred dollars or less you will probably want to gamble on something less sturdy than a wooden crate. A small textile, drawing, or archival print photograph, mounted between sheets of Plexiglas, will justify a cardboard container. The Plexiglas will protect the work and the cardboard will prevent scratching of the Plexiglas surface. After delivery the Plexiglas mounting can be retained for both storage and show.

Three materials substantial enough to use in light weight packing are cardboard, plywood and Masonite (a trade name, a similar product is called hardboard). Your choice may be influenced by what you have around the studio. Free material shouldn't be ignored: Cardboard from liquor store boxes serves perfectly well. Most good lumberyards are patient if you want to examine different materials. Remember that you'll need a saw for plywood and Masonite. A razor cutter will do for cardboard.

Both plywood and Masonite are sold in 4x8–foot sheets. However, you can purchase cut to size panels at most lumberyards. These panels are, of course, more costly per square foot than 4x8–foot sheets.

These materials are appropriate for photographs, illustrations, matted watercolors, etchings, signed prints and small framed oil paintings.

### Wooden Crates

During his long tenure as head of the Los Angeles Art Museum Technical Services, James T. Kenion carefully supervised the construction of wooden crates by his museum carpenters. Kenion had an overwhelming sense of the obligation of art handlers to preserve art for future generations. He insisted that every crate going out of the museum be built with three-way corners, and every wooden crate be tailored exactly for the particular piece of art it was to carry.

Kenion believed that there could be no such thing as a standard wooden crate for artwork because every piece has its own unique requirements. It was this attention to detail and to the needs of each piece of art that enabled Kenion to move over half a million pieces of art with only one loss when he supervised the 1964 move of the entire museum.

Future generations of Chinese owe a great debt to James Kenion. When the Chinese government encouraged the American tour of Chinese art objects as part of its reopening to the West it shipped irreplaceable pieces to Los Angeles in the shoddiest of packing. When the surviving pieces left Los Angeles Kenion had them in permanent containers that would carry them safely to other museum hosts and back to their country of origin without further harm.

A typical Kenion-designed art crate will have three, 2x4–inch frame pieces overlapping at each corner, supporting sides of $3/4$–inch plywood. Immediately inside the plywood is a layer of waterproof paper covered by recompressed foam, a thick, heavy, multicolored recycled foam, or ethafoam.

The side of the crate that opens is secured by sheet metal screws that thread into a casement sunk into the frame. These screws can be used repeatedly without wearing away the threaded hole as quickly as wood screws do.

Kenion shares the conviction of Bryan Cooke, owner of Cooke's Crating, that every crate should be built with cleats, 2x4s with one beveled edge nailed to the bottom of the crate. The primary purpose is to raise the crate from the floor so that the blades of a fork lift will slide under it without opposition. Cooke points out that cleats raise the crate above puddles.

Both men have been in the business long enough to know that the work they ship will be handled roughly. They try to build crates that will preserve the contents no matter how rough the handling. As Kenion remarks, "We build them to be handled by idiots."

## INSURANCE

If you use a professional art packer they can arrange insurance on your shipment. However, you must know that your only satisfactory protection is proper packaging and careful handling.

Making an insurance claim is not a pleasant experience. Unless the shipment involved a provable sale you'll have difficulty getting agreement on the value of the lost art. If a controversy over value persists and the amount is significant there will be inquiries made into your lifestyle, economic situation and personal history.

Some insurance agents who write coverage for collectors, museums and special

## A Brief List of Materials for Art Shipment

- Bubble pack has replaced kimpak, because it is more resilient and easily reusable.
- Cotton is still one of the best products for cradling fragile items. Keep it away from faceted glass and damaged enamel.
- Ethafoam, a close-cell material that comes in densities from two to nine pounds, is widely used by expert packers. It comes in thicknesses from $1/8$ to 4–inches and is nonabrasive and highly resilient. It can be purchased in rolls or sheets.
- Felt, an old standard, is still ideal for lining crates and covering work tables.
- Gauze, in the thousands of yards, swathed the Chinese porcelains when they left Los Angeles on exhibition.
- Laminated paper, appropriate for waterproofing the inside of your crate, is manufactured by three companies, Kadimah, Fortefiber and Ivex. Each has at least eight varieties of reinforced papers, Kadimah's Blue Shield 40/20/30 being roughly the equivalent of Fortefiber's Seekure and Ivex's Weatherex 44.
- Masonite or hardboard should be checked before using as some compressed boards of this type contain oil.
- Peanuts, the common term for Pelaspan-Pac, is an excellent cushioning material for fragile art objects.
- Popcorn is excellent as a cushioning material, but has been replaced by the cleaner Pelaspan-Pac.
- Plywood comes in 4x8–foot sheets. Although thickness varies, $3/8$–inch is strongly preferred, as thicker plywood would increase the weight substantially and thinner plywood does not provide the preferred strength. Order construction grade. It's cheaper and fine for packing. On an exhibit crate that will be painted you may want a higher grade.
- Polystyrene is a thermoplastic widely used with bronze because it is inert, and resistant to acids and alkalis. You'll want to use this product a lot. Acquaint yourself with its characteristics by reference to the *Handbook of Package Materials*.
- Quilted pads are routinely used in the transport of bronze and other heavy art work. Never send a pad out that has not been freshly laundered. The accumulated dust of a used pad will damage the art object.
- Urethane foam or polyurethane is the generic term for a widely available popular packing substance. The manufacturer, Polymer Development Laboratories, warns that the mixture and use of urethane requires some knowledge and that it can be affected by temperature, humidity and method of mixing. An example of its limitations: heat would cause the substance to stick to the oil in an oil painting. The popularity of urethane has stemmed largely from the ease with which it can be shaped and the wide variety ($1/8$ to 30–inches) of thicknesses available.
- Excelsior is no longer used because it retains moisture and is highly flammable.
- Shredded paper is no longer used. It has the drawbacks of excelsior plus the soiling from ink when newsprint is used.

collections refuse to insure individual artists. An agency that does insure working artists is Huntington T. Block.

Block's premiums vary depending on where your studio is located (type of building, neighborhood, fire protection) and the medium in which you usually work. All else being equal, the artist who works in glass will pay a higher premium than one who works in oil on canvas.

Fine Arts Express specializes in insurance for art in transit.

(Listings for Huntington T. Block and Fine Arts Express can be found in the resource appendix of this book.)

Insist that your insurance be with an American company. There is no effective way for an artist (or small business person) to check on the financial stability and claims practices of a foreign insurance company.

## PROFESSIONAL PACKERS AND SHIPPERS

Many professional movers with highly recognizable names will offer to pack and ship your artwork. Most of them are not as good as they claim to be with ordinary household furniture. They can be deadly with artwork.

However, there are a precious few, truly specialized in the shipping of artwork, who know what they're doing. These art specialists should be seriously considered if you're making an important shipment. Importance doesn't necessarily relate to money. If it's your first show, or a job that can affect your future, you'll want every piece to arrive just as it left your studio. Unless you've done a lot of art crating and know shippers and shipping problems, you'd better turn to a professional *art* shipper.

In addition to the dangers of doing it wrong and to the fact that it is a lot of work, there are two more excellent reasons to consider using an art packing specialist. First, you should be working at your art, not building crates. Second, freight handlers, cargo loaders, insurance adjusters, shippers and claim agents are sometimes not the nicest people of the world. The professional art packer and shipper can insulate you from unpleasantness, frustration and anger that can be devastating to your work.

## SHIPPING BY COMMON CARRIERS

### Airlines

Check with airlines for information about cargo shipments, such as minimum and maximum sizes; cost for insurance; travel time; and policies about pickup. Some airlines are particularly helpful on special services. For example, American Airlines will permit you to go to the plane and oversee the loading of your shipment; and hire an armored vehicle to deliver your work if the consignee fails to pick up the work within three hours, billing you for the charges.

You may fly your item to the destination yourself if it will fit in the overhead compartment or the garment bag section and is under seventy pounds and no more than 55–inches in combined length and width. If it's a cello sized object you'll have to buy it a seat.

### Bus

Although prices for shipping are fairly reasonable, your package is going to be handled by drivers and must fit in the baggage compartment. Most bus companies specify a maximum weight of one hundred pounds.

Be especially careful to inquire about and obtain insurance.

### United Parcel Service (UPS)

In the United States all shipments go in UPS vehicles, whether on the ground or in the air. UPS has one of the largest air fleets in the world. It now guarantees to deliver to any physical address in the United States. They cannot deliver to post office boxes, but they will notify the box holder of the shipment and arrange delivery if they get a response. UPS offers automatic coverage to $100 valuation. You will pay an extra charge for excess valuation. There is a $50,000 limit. UPS will not pay for damage caused by packing error.

The guaranteed travel time is determined by the rate paid. Ground time Los Angeles to San Francisco is one day. Los Angeles to New York, six days. All air packages carry a bar code for tracking. A small additional fee is added if the shipper desires a bar code for tracking packages shipped by ground vehicles. An additional fee is charged for ground shipments to residential addresses. Commercial and residential rates include pick up and delivery to the designated address.

## A Brief List of Art Packers and Shippers

On the West Coast you can rely on Cooke's Crating and Fine Arts Transportation, Inc., 3124 East 11th Street, Los Angeles, California 90023, Telephone (213) 268-5101, FAX (213) 262-2001. The *Los Angeles Times* refers to Cooke as the "Da Vinci of art movers."

East coast artists will want to contact James Ikena of Atlantic Van Lines, Baltimore, Maryland, (410) 368-4008. As is Cooke, Ikena is an active member of Packing and Crating Information Network (PACIN), working constantly to upgrade packing and shipping techniques and to improve the quality of packing materials.

Other art shippers of good repute are: Scott Atthowe, Atthowe Fine Arts, Oakland, California (510) 654-6816; Fine Arts Express, Boston, Massachusetts (617) 566-1155; and Bill Zamprelli, Eagle Transfer, New York, New York (212) 966-4100.

### United States Post Office

Send all packages first class or express class. Most packages are shipped by air. Do not ship parcel post.

Register the package. Registration will slow down delivery slightly, but it greatly improves the likelihood of your package arriving intact and provides a complete paper trail in the event of loss or damage. Every person that handles a registered piece signs for it.

As with any insurer, you will have to establish value by a bill of sale, invoice or recent public sale record. But if you compare insurance prices offered by other carriers you'll notice that the Post Office is a real bargain. In setting the rate the Post Office will accept your valuation. In the event of loss it will require real confirmation.

# MUSEUM ACCESSION POLICIES

**ANDREA MILLER-KELLER**

*Andrea Miller-Keller, Emily Hall Tremaine Curator of
Contemporary Art, has been on the curatorial staff at the
Wadsworth Atheneum in Hartford, Connecticut since
1969. Miller-Keller has organized over one hundred
twenty-five one-person museum shows in the Atheneum's
MATRIX program. In 1992, she was awarded a Nation-
al Endowment for the Arts Fellowship to study "Paradox
or Prisoners Dilemma? Contemporary Art in the Context
of the Traditional American Art Museum."*

Just as each artist's body of work needs to
be understood on its own terms, it is important to recognize that each museum is an
individual entity, with its own history, personality and style. For this reason, one can-
not easily generalize about museum accession and exhibition policies.

There is a broad range of policies among art museums in the areas of both acces-
sioning and exhibition practices. This extends from museums that do not collect work
by living artists to ones that collect only works by living artists. There are also Insti-
tutes of Contemporary Art, that do not collect at all but have significant exhibition
and publication programs, and Museums of Contemporary Art, that both collect and
exhibit works of contemporary art. Then there are the tiers of regional and local
museums in every state, and the museums that specialize in particular kinds of collec-
tions, such as ceramics, glassworks, sculpture, and so forth, that have developed policies
appropriate to their size, budget and mission.

## ACCESSIONING PROCESSES

Generally, museums that do collect are cautious in their choices, intending to
acquire only works that they believe merit care in perpetuity. To acquire an object is
to commit the institution and future generations to care for it for the lifetime of the
object, which can mean for several centuries or more. The acquisition of a work is
serious business. It is a marriage of sorts. Since one does not enter marriage with
thoughts of divorce, it is a commitment by the accessioning institution to house and
care for the object "until death do us part." (Deaccessioning practices *do* exist.)

Unlike collectors, curators and directors are spending other people's money. They
must offer a clear and detailed justification to their Boards of Trustees that their pro-
posed accession is a rational and wise purchase.

Curators and directors often initiate acquisitions and exhibitions, and their choices will, therefore, reflect their strengths and interests. That is often why some museums have very active periods of contemporary activity alternating with less interest in or commitment to contemporary art.

There are some museum directors and curators who feel a moral obligation to support contemporary artists in some way, since all art in all museums is, in fact, art that was once contemporary.

It is also fair to say that local institutions are inclined to be more responsive to artists of their own region.

Many museums, by the way, are being as selective with gifts as with purchases. Many have policies of turning down almost all gifts. One exception is when a very wealthy patron offers a particularly generous gift.

## How to Initiate Contact With a Museum

Before making contact with museums on behalf of their work, it is very useful for artists to know the interests and inclinations of the directors and curators. It is equally important for artists to observe the programming of a particular museum to discern the character of its activities and to learn if their work is a good match with the pre-vailing interests at that institution. This is also a good way for artists to find out whether the museum has cautious or liberal attitudes towards challenging and contro-versial works and towards artists who push the edges.

This can be done by attending museum events and getting to know some of the staff members and the director. Many museums have libraries, and artists can read annual reports to review a museum's exhibitions, acquisitions and budget. Also, many museum libraries collect information about other museums. There, artists can find out about other museums that may be worth their while to visit or to learn more about.

The benefit of this research is that once an artist decides to make an approach, he or she can contact professionals who are likely to have an openness to their kind of work. They will appreciate the homework the artist has put into his or her efforts.

It's a buyers market. Given the many fine artists at work today, there are relatively few opportunities to exhibit and even fewer opportunities to have works purchased. Even when the match is good and the curator and director are sympathetic to the artist, they still have to deal with the reality of budgets, trustee influence, community pressures, and so forth.

### Direct Contact

Few museums reply easily to questions of policy. They are more likely to tell you what their procedures for reviewing work are. Often, policies relating to contemporary art are not written out.

Writing directly is fine, but it is important to do some initial homework.

My department at the Atheneum, for instance, receives ten to twenty sets of unso-licited slides a week, and much of those are inappropriate matches. If the artists had done some homework, they would have saved both the time and money used in preparing these submissions.

Acquisitions and exhibitions are not made by chance. It is not like winning the lottery. Sometimes I receive requests that are clearly blanketing the field. It would

be far better for artists to target their approach to a few museums that would be likely to respond favorably than to send out twenty-five or fifty submissions with the salutation, "Dear Museum Director," or "Dear Curator." This approach is rarely successful.

Most of the museums I know, including ours, try to acknowledge promptly receipt of every submission, so that the artist knows that the material has arrived. Unfortunately, most museums are understaffed and overscheduled and cannot keep up with the influx, so there are frequently long delays in returning material. This is a lamentable fact of life.

It is true that it is often easier to get a foot in the door of a museum if you have a friend in common, be this a trustee, another artist who is well respected, or an outside curator. Such connections do help get things started. However, I think these connections have very little effect on the final outcome of whether or not a purchase is made or an exhibition is scheduled.

### The Role of Trustees and Donors

On occasion, trustees and major donors can have undue influence on museum accession and exhibition policies, especially if they're very wealthy or very persuasive, particularly when the institution is small and poor. In some larger museums, where the social stakes are high and the trustees themselves are avid collectors, trustees sometimes succeed in shaping acquisition and programming policies.

It is also true that there are many trustees and donors who don't choose to meddle and give only gentle guidance.

## PAYMENT AND PRICING POLICIES

Usually museum purchases are not a major source of income for artists. However, museum exhibitions and acquisitions represent professional and public recognition and such recognition often enhances future sales.

Museum purchases should be made at a fair market price, though it is customary for museums to be offered at least a 10% discount. In the current sluggish market, museums are often offered very generous considerations. Payment from museums to artists and galleries should be made promptly, following receipt of the work and completion of the museum's internal review process.

## NONMONETARY CONSIDERATIONS

The fragility and condition of a work can be important accession considerations. An artist's desire to have a work exhibited widely is offset by the museum's obligation

to protect the work. As "guardians," curators and directors feel obliged to protect works from wear and tear. Curators are rightly concerned about deterioration and difficult or costly repair and maintenance of acquisitions.

## Protection of Works

Usually museums do their very best to protect works. Sometimes, however, especially in times past, indifference or lack of expertise does lead to serious problems. Important works have been known to deteriorate unnecessarily while in museum collections, but this usually has been due to ignorance and/or minuscule staffs.

Acquisitions are insured along with all other objects in the museum's permanent collection.

## Placing Works on Public View

A museum will not accept a binding commitment to exhibit a newly purchased work. Occasionally, however, the offer of a particularly generous gift will persuade a museum to agree to exhibit a work or collection for a certain amount of time or periodically, or for a percentage of the collection to be continuously on view. As museums face growing limitations of gallery and storage space, such commitments are increasingly rare. Most artists and donors have relatively little bargaining power on such issues.

Much that an artist would like to see happen once a work has been acquired cannot be agreed to in writing. Hopefully, the artist and his or her dealer have a sense that the museum making the purchase has interests and concerns in common with the artist. But these things are very rarely codified.

# POLICIES REGARDING USE AND OTHER RIGHTS

Many museums follow and observe the restrictions of the Copyright Act of 1976 that gives artists control over the uses of their work. Thus purchasing a work for its permanent collection does not grant a museum the right to reproduce the work or to use it on subsidiary merchandise, such as posters and coffee mugs. These rights must be negotiated separately. For a detailed discussion of use rights, read the chapter titled "Licensing Rights to Use a Work of Visual Art."

# ART FRAUD: SCAMS, COUNTERFEITS, FAKES AND FORGERIES

**GREGORY T. VICTOROFF**

*Gregory T. Victoroff is a partner in the Los Angeles law firm of Rohde & Victoroff, handling litigation and commercial transactions involving fine art, copyright and entertainment law. He has presented his art fraud lecture "Crimes of the Art" before the California Art Dealers Association, the Los Angeles International Contemporary Art Fair, and the Beverly Hills and Los Angeles County Bar Associations.*

**A**rt fraud, including art theft and sales of inauthentic artwork, is estimated by the International Foundation for Art Research (IFAR), to be the second most profitable illegal enterprise in the world. Art crimes hurt art dealers, galleries, collectors, museums and artists. This chapter will provide an overview of the most prevalent forms of art fraud and related legal rules and remedies. Hopefully it will help art sellers, buyers and artists avoid getting ripped off in the risky art world.

In general terms, other than the outright theft of art, art fraud usually occurs when a work of art is sold. In many, but not all cases, the seller of the art is the perpetrator of the fraud. For this reason, laws and liability pertaining to art fraud have special significance to art dealers and art galleries. Selling art under any type of false pretense can result in either civil or criminal legal liability. Art sellers may incur legal liability for selling stolen or inauthentic artwork, even if they are totally innocent of any intentional wrongdoing or have no knowledge that the art being sold is fake.

For the purposes of this chapter, the broad topic of art fraud is divided into seven areas, which occasionally overlap, and are neither official art nor legal terms: 1) counterfeiting; 2) forgery; 3) reproductions or fakes; 4) mail order scams; 5) appropriation; 6) theft, investment and insurance fraud; and 7) fraudulent appraisal.

## COUNTERFEITING

Counterfeit art is like counterfeit money. It can look real and it may even fool a qualified appraiser or curator, but by virtue of the manner in which it is created, it is not truly the article it is represented to be.

Methods of counterfeiting art include the following:

♦ Unauthorized reproductions of two-dimensional multiples.

For example, a color photocopy of a limited edition serigraph, lithograph, etching, woodcut, lino cut, embossing, wood engraving, dry point, mezzotint, aquatint or photograph. Sophisticated photocopying, Iris printing, digital scanning and other photographic printing processes can faithfully reproduce both the gross image and subtle details of certain fine prints. Where a seller (knowing or unknowingly) sells a photographic reproduction, representing orally or in writing that the fake is an original fine print, the buyer obtains counterfeit art.

♦ Unauthorized reproductions of three-dimensional originals or multiples.

For example, where a cast bronze, slip cast ceramic or cast glass work is formed, not from a cast or mold created by, or under the authority and supervision of the artist, but from a bootleg cast or mold, usually resulting in sculptures of inferior quality, some distorted or altogether missing certain details found in first quality pieces. The inferior knock-offs hurt purchasers and damage artists' reputations, making the jobs of the dealers and galleries more difficult and less profitable.

♦ Unauthorized two-dimensional works that are reproduced by the same process as authentic lithographs, serigraphs or photographic prints, but created from inauthentic masters.

For example, lithographs or aquatints created from canceled plates, serigraphs printed using canceled or stolen stencils or screens, or photographs printed from a second generation internegative. Occasionally the unauthorized prints will be sold on aged or antique fine print paper. Some even include forged artists' signatures and fake edition numbers to appear to be part of an authorized edition.

## FORGERY

For the purposes of this discussion, forgery refers to an inauthentic signature. Although many counterfeits also contain forged signatures, not every counterfeit is a forgery. One of the most notorious examples of this is a number of lithographs attributed to the late surrealist master Salvador Dali. Dali is reputed to have signed a number of pieces of blank paper. The blank paper bearing Dali's genuine signature was reportedly sold by and to several unscrupulous dealers and publishers who printed unauthorized, inferior, counterfeit images on the presigned paper. As a result, dozens, possibly hundreds of inferior, counterfeit works bearing authentic signatures were sold and resold, diminishing the value of, and rendering suspect, a vast number of Dali's limited edition reproductions. But blank paper bearing genuine signatures is very rare.

More commonly, an artist's signature is forged onto counterfeit works, either on two- or three-dimensional multiples and sometimes even on what appear to be original works. In recent years forged signatures have been placed on what were purported to be limited edition prints by Salvador Dali, Joan Miro, Pablo Picasso and others.

Another type of forgery appeared in connection with sales of fine prints purportedly signed by contemporary artist Mark Chagall. In truth, the signature was affixed on unauthorized counterfeit prints by use of an engraved metal stamp.

## REPRODUCTIONS OR FAKES

Sometimes referred to as artigraphs, this category covers slavish copies of well-known two- or three-dimensional artwork.

There is nothing inherently wrong or illegal in copying artwork that is in the public domain, since there is no copyright infringement. Several legitimate businesses around the country specialize in faithfully recreating works of classical masters such as Renoir, Monet, Rembrandt, Manet, Van Gogh and Matisse, and modernists such as Picasso. Donald Trump is reported to have knowingly purchased over a thousand such reproductions to decorate various hotels and office buildings. Problems arise when unethical sellers misrepresent the origin or provenience of reproductions, passing off fake copies to unwitting (and often unsophisticated) buyers, as genuine original works.

In 1983 the International Foundation for Art Research published an alert on a Chicago-based mail order business called "Forgery of the Month, Inc." For $100, subscribers received a high-quality Toulouse–Lautrec reproduction, complete with bogus documentation printed on fake letterhead of Sotheby Park Bernet.

A legitimate artist, Jacques Harvey is famous for creating paintings in the style of Matisse and Degas. When commissioned to create such a work however, the artist includes a prominent disclaimer on the back of each canvas. Many reproduction artists complete the illusion by including a skillful forgery of the signature of the original artist, imitating both the style and placement of the signature as it appears on the original work.

Reproductions are very common in the ethnic, textile and antique markets. Many rugs and tapestries sold as handmade Chinese, Persian or Navaho rugs are, in reality, machine-made reproductions made in Belgium or the United States. Crooks, fakes and scams abound in the antique market. At Sotheby's, a single antique chair sold for $2.75 million. At Skinners in Massachusetts, a wall box sold for $187,000. Elsewhere a Windsor chair sold for $77,000 and a Shaker chair sold for $88,000. In the world of high-end antique sales, the potential for enormous profits presents tempting opportunities for illegal abuses.

Three-dimensional fake ethnic art appears in the form of pre–Columbian pottery, Chinese ceramics and terracotta works, Alaskan and Canadian ivory carvings, African trade beads, neolithic black and white pots from China's Stone Age, and Mexican, Central American and North American Indian masks.

Finally, the ever-increasing practice of posthumous castings of Rodin sculptures, Erte figurines and other articles poses an almost metaphysical question of what constitutes genuine three-dimensional multiples.

## FAKE CERTIFICATES

Although a few states have laws requiring dealers to provide written documents authenticating prints to prevent art fraud, nothing keeps fraudulent dealers from using fake certificates or from providing genuine certificates to accompany the sale of fake art. Ironically, art forgers prepare certificates of authenticity, to appear legitimate almost as often as legitimate dealers use them.

## MAIL ORDER, TELEMARKETING SCAMS

Combining high-end magazine display advertising and high-pressure telemarketing campaigns, scam artists solicit mail-order or telephone-order sales of expensive art pieces, cash the checks, redeem the credit card vouchers, and then quietly disappear with the money. If any address is provided in the solicitation or advertisement, it is usually a post office box, mail drop, or storefront rented for a month or two, just enough time to have phone lines and bank accounts set up. Eager buyers patiently wait weeks or months for their precious art to arrive. When the operation is located in another state or across the country it helps the scam artists cover their tracks and evade criminal prosecution.

## APPROPRIATIONS

Not strictly a type of fraud, the appropriationist school of art borrows images created by other artists and incorporates them into new works. Contemporary artists Andy Warhol, Sherry Levine and Jeff Koons have built careers appropriating the works of other artists, sometimes making only minor changes, and selling the derivative work as an original. An extreme example is the drawings of "Mickey Mouse" attributed to Andy Warhol, that were reportedly actually drawn from Disney artwork using a tracing machine, operated not by Warhol, but by a Warhol employee. A discussion of the many copyright and other legal and ethical issues presented by appropriationist art is found in the chapter, "Protecting Postmodern Art."

## ART THEFT, INVESTMENT SCAMS AND INSURANCE FRAUD

The most blatant form of art crime is the outright theft of art. In 1994 Edvard Munch's famous painting, *The Scream* was stolen from the National Gallery in Oslo, Norway. It was recovered approximately one month later. Six years before, Munch's painting *The Vampire* was stolen from the Munch Museum in Oslo and recovered by police within a year. In August 1993 Munch's *Portrait Study* was also stolen from Norway's National Gallery, and has not yet been recovered.

Every year numerous less famous works disappear from galleries. Most are shoplifted by petty thieves, but the value of these widespread thefts of small paintings, jewelry, prints, artifacts and sculptures, amounts to millions of dollars in losses for galleries and dealers nationwide.

Another type of theft occurs where a valuable original work is loaned on approval. The thief takes the original and commissions the creation of an exact duplicate, which is substituted for the original and returned to the gallery.

A type of insurance fraud is sometimes perpetrated by owners of valuable artwork covered under expensive insurance policies. Working in cahoots with a cooperative "thief," the insured owners choreograph elaborately-staged burglaries and robberies, then submit fraudulent claims and collect on insurance policies.

In recent years sophisticated art investment schemes have been used to bilk unknowing investors out of millions of dollars. Investors are asked to contribute large sums of money, ostensibly to be pooled to purchase valuable artworks. They are promised that the art will be resold for a large profit, and a share of the profit will be returned to each investor. In reality, most of the investors' money goes into the pockets of the scheme's organizers; eventually, the organizers disappear, leaving the investors with nothing.

## FRAUDULENT APPRAISALS, VALUATIONS AND ATTRIBUTIONS

Finally, cases have been reported where unethical museum curators and private art appraisers conspired with owners of questionable artwork to defraud the Internal Revenue Service and others. The fraud arises where a work of dubious origin or questionable authenticity is donated to a museum or submitted to an appraiser. The unscrupulous museum curator or private appraiser then prepares a fraudulent report, giving a vastly inflated value to the piece, or falsely attributing the piece as the work of a famous artist, or both. The piece is then donated to a museum or other charitable institution, and the donor takes a large, undeserved tax deduction. The curator or appraiser generally receives a substantial cash kickback for his or her assistance in the scam. This kickback is rarely reported as income on the co-conspirator's tax returns, resulting in a second tier of tax fraud.

## LEGAL REMEDIES

Civil laws against fraud and breach of contract are enforced by bringing lawsuits in civil courts. Criminal penalties for criminal fraud and art theft are enforced on the local level by police, on the national or interstate level by the FBI, and on the international level by the International Criminal Police Organization (INTERPOL).

A civil lawsuit for breach of contract can be brought against a seller for money damages arising out of the sale of a counterfeit or forgery if the contract between the seller and the buyer makes the authenticity and provenience of the art (i.e., its origin, title, attribution, etc.) a material term of the sales contract. For example, a written or oral promise that a piece is "print number seven of an edition of twenty signed by Pablo Picasso," if false, would present grounds for a lawsuit for breach of contract. If the false statement is made knowingly or intentionally, grounds exist for a lawsuit for fraud. Grounds for such a lawsuit would not exist however, if no representation is made as to the title or creator of the piece, or if the sale occurs at an auction where buyers are informed by notices in the catalog, posted in the auction hall, or otherwise, nothing more than that all lots are sold "as is." Sensitive to the potential liability posed

by sales of art of questionable origin, world-famous art auctioneer, Christies, gives only limited warranties. Representations of authorship are carefully qualified, using the terms: "attributed to," "circle of," "studio or workshop of," "school of," "manner of," "after," "signed," "bears signature," "dated," and "bears date," each with its own distinct definition and qualification of terminology, including "in our opinion a work by the artist _____."

Another type of civil lawsuit is the remedy of "rescission of contract," where the buyer must return to the seller the thing purchased to be entitled to a refund of the price paid.

Even if you are successful in winning a civil lawsuit against a fraudulent seller, you may have problems collecting judgments. Bankruptcy of the seller, idiosyncrasies of foreign laws, disappearance of the debtor and prohibitive legal fees and court costs can make collecting judgments difficult, if not impossible.

In many states, art dealers are bound by detailed statutes imposing complex regulations and civil penalties for violations, particularly upon dealers selling fine art multiples. A discussion of these regulations is found in the chapter, "Regulation of Fine Art Multiples."

### Criminal Prosecution

Criminal fraud is an action brought by the state, rather than by a private individual. Publicly funded prosecutors in the district attorney's or city attorney's offices will usually undertake a criminal prosecution only where the fraud is widespread or exceeds a certain dollar amount. "Major fraud" is sometimes defined as involving transactions exceeding $100,000. If fraudulent art transactions occur across state lines or involve interstate telephone solicitations, the Federal Trade Commission and Federal Bureau of Investigation may assist in the investigation and prosecution. The Racketeer Influenced Corrupt Organizations Act (RICO Act) can be invoked to prosecute fraudulent art sellers running boiler-room phone sales operations or other scams that are done repeatedly or in a pattern, crossing state lines.

## PRACTICAL TIPS TO AVOID ART FRAUD

♦ Know with whom you are dealing. Check with local art dealers, art dealers associations, the Better Business Bureau, even local police and the FBI. Ask for references.

♦ Trace the history of the piece from the place and date of creation through the date and manner in which the seller claims to have acquired the piece. Locate as much information as possible.

♦ Ascertain the name of the publisher of fine prints. Cross-check edition numbers with the publisher's records.

♦ Ascertain the name of the previous owner/seller. If purchasing work in the secondary market (i.e., pre-owned art not being purchased from the artist's dealer), inquire as to the names of the previous owners and sellers.

♦ Verify fine prints through catalogs. Comprehensive and highly accurate catalogs are published that document authorized editions, including the name of the publisher or atelier, size of the edition, type of paper or other material, size of prints, number of artist's proofs and other proofs, etc. If the print you are about to buy does not fit into the history of the image reported in the catalog, caution should be exercised.

♦ Beware of artist's proofs. Disproportionate numbers of artist's proofs (unnumbered "a/p" or "h/c" prints) may diminish the value of prints, particularly if the value is based on a perceived scarcity of the work. Most ethical publishers will not print proofs exceeding 10% of the total edition.

**One key factor affecting court decisions in confiscating stolen art from collectors and museums, is whether the buyer used due diligence in acquiring the work, and verifying clear title. The diligence required increases with the value of the lost property, although due diligence is not clearly defined anywhere in the law. Another key factor is whether the buyer is considered a "bona fide purchaser," meaning that the buyer acquired the art for a fair market value in the regular course of business without notice that it was stolen. In certain countries, such as the United States, even bona fide purchasers cannot acquire clear title to stolen art. In other countries, such as Switzerland, a true bona fide purchaser can obtain a clear and valid title to a work of art, even if it is stolen.**

♦ Beware of bargains. If the price seems too good to be true, it probably is. A good illustration is the case of Peggy Goldberg, an art dealer who purchased four 6th Century Byzantine mosaics for $1.2 million outside the Geneva Airport. Goldberg was sued by the Greek Orthodox Church and the Republic of Cyprus, whose lawyers alleged that the mosaics were looted by a Turkish art smuggler after the Turkish Invasion of Cyprus in 1974. Goldberg called the Customs Services in a number of countries, including those in the portions of Cyprus belonging to the Turkish Republic, regarding importing the mosaics into the United States, but she failed to check with the last known owner of the mosaics, the Greek Orthodox Church.

The Republic of Turkey is suing the Metropolitan Museum of Art regarding the return of a collection of silver works. The estate of Georgia O'Keefe sued in New Jersey to recover two of her paintings that had been stolen. In another New York case, the Guggenheim Museum unsuccessfully sought the return of a work by Mark Chagall entitled *Menagerie*. In the Chagall case, the court found that during the twenty years that the Museum knew that the picture was missing, it did not use due diligence to find it.

♦ Beware of originals. It is a common misconception that the majority of fake art is sold in the form of multiples or prints. The largest number of inauthentic art pieces sold are oils attributed to masters such as Van Gogh, Rembrandt and others that fetch six, seven and eight-figure prices. Even experienced art experts can be fooled. In 1989 the *Los Angeles Times* reported that the Rembrandt Research Group had discredited the Rembrandt self-portrait owned by the famous Norton Simon Museum in Pasadena, California.

♦ Beware of appraisals. For the right price, certain unethical appraisers will provide written appraisals verifying the provenience, authenticity or value of a piece without adequate expertise, experience or documentation. Deal with well-respected, experienced appraisers. Demand references. Obtain second and third opinions. The American Society of Appraisers provides professional certifications of member appraisers who have passed certain tests of experience and technical expertise.

♦ Verify the date of ancient wood objects by carbon dating. Mexican and Central American masks are carved from random hardwood; imitations are usually from soft, pulpy woods. Check the interior of the masks for grime and wear.

♦ Verify the date of pottery by thermal luminescence testing. In one recent case an American tourist returning from China discovered that only one leg of a Chinese terracotta horse she had bought for several thousand dollars was actually Tang Dynasty; the rest had been restored by a counterfeiter with new clay. No scientific test exists to test jade and jewels, although cuts and settings can give an indication of heirloom status. Jade is judged by color, hardness, translucency and coolness. But owenite, quartz, dyed jadeite and serpentine, may be sold instead of jade. Further, remember the quality of the carving is as important as the material from which it is carved.

The final test is whether the buyer finds the artwork aesthetically pleasing. If the work is acquired for its subjective artistic merit, rather than for some perceived value, its provenience or pedigree may be of secondary importance.

# LICENSING VISUAL ART

**Licensing and Merchandising
a Work of Visual Art**

**Licensing Rights to Use
a Work of Visual Art**

**Artworks in the Digital Era**

# LICENSING AND MERCHANDISING A WORK OF VISUAL ART

**SUSAN A. GRODE**

*Susan A. Grode, Esq. is a partner in the law firm of
Kaye, Scholer, Fierman, Hays and Handler and
specializes in matters relating to creators and their creations
in the fields of entertainment, publishing and the visual
arts. Ms. Grode is counsel to many artists' groups
and foundations and has lectured to members of
the bar as well as artists at UCLA and USC.
She is a graduate of Cornell University and the
University of Southern California Law School.*

In today's climate of commercial marketing
and reproduction, artwork is enlarged, miniaturized, duplicated, and transferred into
other media and onto objects. Bart Simpson, the original artwork of Matt Groening,
appears on book covers, posters, tableware and dolls; Robert Indiana's *Love* painting
has been transmuted into brass paperweights, greeting cards and beach towels; and
scarves, bathroom tissue and linens bear the logo of Ralph Lauren. What's in demand?
A particular artwork so distinctive in and of itself that it can be associated with a line
of products, or person whose reputation, identified in his or her logo, is sufficient to
promote sales.

One need not have worldwide notoriety to engage in some form of licensing
arrangement. The copyright law provides that an artist retains all rights to the artwork
that are not specifically granted in writing. Therefore, a painter can sell an original
painting to a collector and license one publisher to reproduce it on posters, another on
greeting cards. A photographer can sell one-time reproduction rights for use of an
image in a magazine and license a different use of it on lunch boxes.

Each time an artist receives an offer for the use of his or her work, some form of
license (and not outright sale of all rights or work for hire agreement) should be con-
sidered. The ability to negotiate terms favorable to the artist (maximizing the number
of different uses to which the work can be applied, approval of each use, a substantial
advance and royalties based on retail sales, to name but a few) depends largely on the
bargaining power of the artist. If the artist or the particular artwork is in great
demand—when either the art or the artist has achieved sufficient recognition in the
minds of consumers that it is able to generate sales of products that would be less sal-
able without the notoriety—it should be possible to obtain many of the advantages
and protections articulated in a merchandising and licensing agreement.

In licensing your work for fine art print publication, commercial art, merchandising or other purposes, remember that you need not grant all the rights in the work to the licensee and the rights need not be granted forever (although for uses such as book publication, motion picture production, limited edition prints, etc., and to avoid competition by the work in another form, some licensees may ask for the right to reproduce the artwork in any and all forms for the term of the copyright, which is your life plus fifty years). An example of a negotiated solution in a poster license might be to grant the right to reproduce the work for purposes of a poster only in the United States for a period of three years with the possibility of renewing the right to reproduce if your royalties on poster sales exceed a certain amount after the third year.

Other considerations to note during negotiations:

♦ That the product or artwork, packaging, advertising and promotion as reproduced must bear your signature and copyright notice (and trademark notice if applicable).

♦ That the original artwork be returned to you within thirty days of approval of final film for reproduction or negotiated for separately as a sale with a separate purchase price.

♦ That payment of a reproduction fee upon signing the licensing agreement shall not be treated as an advance against your future royalties.

♦ That you have the right to approve the product in all stages, from initial concept to final proof, and the right to receive a specified number of Artist's Proofs, prints or licensed articles without charge.

♦ That you have the right to review and approve in writing all publicity about you and your work and receive copies of all ads and promotions.

♦ Where your royalty is based on net sums, make sure that there is a definition of what expenses will be subtracted from the gross selling price to arrive at such net amounts (actual costs of producing the prints are acceptable expenses, amounts paid for the publisher's overhead are not). Naturally, if possible, attempt to negotiate a royalty on the gross selling price or on the gross amount received by the publisher or licensee.

# Licensing Rights to Use a Work of Visual Art

**GREGORY T. VICTOROFF**
*Gregory T. Victoroff is a partner in the Los Angeles
law firm of Rohde & Victoroff, handling contracts and
litigation matters involving fine art, copyright, book
publishing and media law. He is a panel attorney and fre-
quent lecturer for California Lawyers for the Arts and is
co-chair of the Committee for the Arts of the
Beverly Hills Bar Association.*

As an artist or creator of visual art, you should carefully monitor how your creations are used and charge additional fees for additional uses. For example, if you are asked to paint or draw an illustration for a company newsletter, you should specify in writing the use for which the drawing was created (i.e., January newsletter) and charge a reasonable fee reflecting that limited use. For each additional use, such as reprinting the illustration in the company's annual report or in promotional calendars, you should be paid an additional fee.

## COPYRIGHT OWNERSHIP

If you own the copyright in your artwork, you have the exclusive right to decide what use is made of your work. Artists profit from granting permission to others to use certain rights, usually for a limited period of time.

As the copyright owner, you are entitled to adjust the fee you charge according to how the artwork is used. By carefully negotiating and documenting the terms of the deal, you can substantially increase the compensation you receive for a particular piece of art.

When you specify the nature of the use to which your artwork is put, you are grant-ing the user a copyright "license." In the publishing industry, copyright licenses are sometimes called "permissions." "Releases," "licenses," "permissions," "grants of rights," "supplemental uses," and "ancillary markets," are all different names for authorizing a work to be used. All mean basically the same thing: an agreement between the art buyer and art seller limiting the manner and extent to which an artwork may be used.

## OWNERSHIP OF ORIGINAL ARTWORK

Regardless of whether you are selling or licensing all or part of the copyright in a work, it is important to distinguish between selling the copyright to a work, and selling the physical work itself. In most cases, when you sell a physical work, such as an original painting, reproduction rights and the other parts of the copyright in the work are not sold with the physical object. Conversely, if you are granting a user a copyright license to make and distribute copies of your artwork, the user does not acquire ownership of the original artwork itself, and should promptly return it to you (at their expense) undamaged, as soon as they have completed the process of reproducing the work.

As of this writing, Oregon, California and New York laws expressly provide that the original physical work of art remains the artist's property, even if a copyright license to reproduce the work has been granted, unless the parties specify in writing that the artwork itself is being sold. The law similarly provides that no reproduction rights (or other copyrights) are conveyed when the physical art object itself is sold, absent a written agreement expressly granting such rights.

## PRIVACY RIGHTS

An important issue to be considered before granting any license or permission is whether the work violates the rights of any third party. Totally separate from the issue of copyright ownership are so-called "rights of privacy" that apply to people and even to certain buildings, landmarks and national parks that may be depicted in your artwork. Although you are the exclusive owner of the copyright in the work, privacy rights can be violated if a use exceeds the permission given by the person or owner of property appearing in the art. For example, if a model poses for a drawing class, even though you may own the copyright to your drawing, if you license or sell the drawing for any purpose not agreed to by the model, such as for an advertisement, you and anyone else using the drawing may be liable for violating the model's privacy rights, also called "rights of publicity." For this reason it is essential to obtain a written "model release" stating that the model's likeness may be used for any purpose, in perpetuity, before you grant use rights to anyone.

## PRACTICAL AND ETHICAL CONSIDERATIONS

In the motion picture industry, screenwriters, musicians and even cartoonists have unions that set minimum wages and re-use fees in certain circumstances. Unfortunately, visual artists do not enjoy the protection of collective bargaining agreements and must usually negotiate the terms of each job for themselves, including the right to fees for supplemental uses. In attempting to maximize income by licensing your copyrighted artwork, it is important to keep in mind certain practical and ethical considerations.

As a result of years of unwritten tradition, in certain situations, it is highly unusual for an artist to attempt to negotiate re-use fees or written copyright licenses. In some cases, requesting (or even mentioning) a written copyright license may frighten,

## MOTION PICTURE SCREEN CARTOONISTS UNION

The Motion Picture Screen Cartoonists Union, Local 839 of the International Alliance of Theatrical Stage Employees and Moving Picture Machine Operators of the United States and Canada (the IATSE), is the only local union in the United States with an exclusive jurisdiction over screen cartoonists. (New York Local 841, which covered animation workers merged into Camera Local 644 in 1987.) Screen cartooning traditionally covers motion pictures and television, but is now expanding into the areas opened by multimedia and other new technologies. The union is the collective bargaining unit for everyone involved in the creative process of animation: writers, artists, directors and technicians.

Most of the major studios involved in animation are signatory to the union contract, which sets minimum rates of compensation and administers health and pension plans for members. Signatory companies in Los Angeles include Disney, Universal, Warner Brothers, MGM, Hanna-Barbera, Chuck Jones, Graz, Hyperion, New World Entertainment, Marvel Entertainment, and Rich Entertainment. Because it is a union shop contract, anyone who works for thirty days for a signatory company (either on staff or as freelancer) is required to join the union as a condition of continued employment. However, anyone can join the union from the first day of employment by a signatory company and begin accumulating the hours required to be covered by pension and health plans.

Animators' attempts to protect themselves with a union date to the early 1930s when artists in New York were expected to provide voluntary overtime work, meaning they received no overtime compensation. In 1936, the Screen Cartoonists Guild was formed in Los Angeles and by 1941, all West Coast animation studios were organized. One of the most notable events in Hollywood labor history was the nine-week strike of Disney's cartoonists in 1941 when Walt objected to their attempts at organization. The Motion Picture Screen Cartoonists union as it now exists dates from 1952.

Although the Motion Picture Screen Cartoonists Union covers animation writers as script persons, writers receive no residuals or merchandising fees as they might under the live-action contract of the Writers Guild of America, (WGA), Inc. Although previous attempts of animation writers to form a separate union or guild have been unsuccessful, the recent explosion in animation has prompted the Writers Guild to form the "Animation Writers Caucus" as a way of possibly providing medical coverage and other support to these writers (many of whom are already members of the WGA). *—M. CHRISTINE VALADA*

*Ms. Valada is a lawyer and professional photographer who has written and lectured on copyright and other issues affecting creators.*

confuse, anger or alienate a potential buyer. In other situations, the goodwill that you can get from selling all rights (including copyrights) to a work can be more valuable than additional payments for additional uses.

For these reasons, it is a good idea to be acquainted with industry customs and practices (if any), before entering into a negotiation over use rights. If you are unsure of the standard procedures in a particular industry, locate artists working in the same field and ask about standard rates, contract terms and how the industry typically deals with the issue of re-use fees. Good business judgment suggests that it is better to be flexible in negotiating with a buyer who may offer a long term relationship. People prefer to do business with people they like and trust. Understanding the needs and expectations of the buyer is essential to cultivating good business relationships. The person buying your art may have less of an understanding of use fees and copyrights than you do. Openly and directly discussing the extent of the rights being purchased and issues of copyright ownership at the beginning of the relationship can avoid disputes later.

Many provisions of the U.S. copyright law were written to protect, reward and encourage artists, sometimes at the expense of unsuspecting buyers. Because copyright laws reserve copyright ownership to artists (absent a work made for hire or other agreement), generally even without any copyright registration or copyright notice, the artist retains ownership of copyright and, with it, re-use and reproduction rights. As a result of this legal presumption, it may come as a surprise to a buyer to discover that he or she did not acquire reproduction rights, re-use rights or other rights after paying what they believed to be a fair price for the art. To maintain good relationships while still enforcing your copyright, be sure to discuss with a potential buyer your respective intentions regarding the extent of the rights granted, and confirm the terms of the deal in writing before delivering the artwork and accepting payment.

A good way to raise the issue of re-use fees is to ask a potential buyer during the initial meeting what he or she intends to do with the art. What does the buyer need from you? For example, greater rights are needed by a corporation commissioning a logo design, or an advertising agency mounting a national print media advertising campaign, than are needed by a private collector seeking to hang a piece of art on the wall. To satisfy a buyer, before finalizing the agreement, be sure they are getting what they need, without giving up valuable rights that you can sell later. Does the buyer need exclusive rights to the work? Does the buyer need worldwide rights? By interviewing potential buyers and confirming in writing the exact nature of the rights being sold, you will earn respect as a professional while maximizing your income from each piece of art.

## AGREEMENTS: GET THEM IN WRITING

Remembering all the details concerning the nature and extent of a use agreement can be difficult or impossible without an accurate written record. If you are dealing with dozens of images licensed to several different users, it becomes essential to use written contracts.

Legally enforceable contracts exist in many different forms. Under U.S. copyright law, even an oral agreement for a nonexclusive use is valid and binding. However, a written contract is better than an oral one. Contracts for using visual art can be as short as a few sentences or a single page. But it is not unusual for complex licensing agreements that cover many uses of multiple images over several years and include royalty formulas, to be thirty pages or longer.

Whether called a "permission," "release," "license," "contract" or "agreement," and regardless if it is a printed invoice or other form, a typewritten letter, or scribbles handwritten in crayon on a napkin, all can be considered legally binding contracts.

It is not necessary to have an attorney prepare and negotiate, or even review, every use license. For example, where there is a small amount of money involved, or under informal circumstances such as when dealing with friends or relatives, or possibly where the use rights are being granted as part of a long-standing course of dealing with an established client, an attorney approved contract may not be necessary.

The most cost-effective way of protecting your use rights is to develop your own printed contract form, with blank spaces that can be filled in for each deal you do. The form also serves as a handy checklist to make sure you cover common issues important to every deal. Another easy way of creating your own use license is to note

the agreed terms in a letter to the user. Artists and others unfamiliar with, or intimated by, legal forms and language may find that confirming deal points in plain English in a personal letter is more their style. Of course, where there is a significant amount of money at stake or where the deal is unusual or complex, it is wise to have an experienced copyright lawyer prepare a formal license.

## PARTIES, PROPERTY, PERFORMANCE AND PRICE

Regardless of how it looks or what it is called, your permission, license or use agreement should, at a minimum, include four broad categories of information, easily remembered as the "Four Ps": Parties, Property, Performance, and Price.

"Parties" means your name and the name of the person or company to whom you are granting use rights. It is a good idea to include current and correct addresses and telephone numbers for both parties. Discourage users from merely giving a post office box as an address; it can make serving a lawsuit and delivering or recovering your art or fees difficult or impossible. It is also wise to refer to an individual's title or authorization if dealing with a person claiming to be acting on behalf of a company, such as "Vice President," "Office Manager," etc.

"Property" identifies the title of the artwork being licensed and the specific rights being transferred, including media, duration, territory and copyright ownership.

"Performance" specifies what each party has agreed to do. Details concerning rights and manner of reproduction, quality control, dates of use, edition size, completion, delivery, approval and publication dates, and a myriad of other specifics that define how the transaction will work, should be clearly spelled out in this part of the agreement.

"Price" is how much you get paid and when. Are you being paid a flat fee upon delivering the art, in installments over time, upon completing various elements of a job, or by receiving royalties? Are you paid in cash, a certified check drawn on a local bank, or in foreign currency? Is there a kill fee if the job is canceled or not used? Are you reimbursed for your expenses? Is sales tax collectable? Remarkably, definite information about how and when the artist gets his or her money is often overlooked in use licenses, so be sure to pay attention to that important detail.

### Media

Never before have there been so many ways to use and reproduce works of visual art. In addition to traditional fine art reproduction methods such as lithography, serigraphy and casting, visual art is reproduced on or in books, magazines, posters, merchandise, apparel, television, video programs, motion pictures and many other products. Computerized digital scanners can capture a visual artist's work and transmit, store, alter, display and print the image in a myriad of ways. Future interactive computer games and television programs will rely heavily on visual art.

The great variety of media in which a work can be used offers tremendous opportunities for additional income to artists. To help ensure that you receive fair compensation when your art is exploited in different media, the written agreement you enter into each time permission to use a work of art is given, should specify and define the exact media covered by each deal.

## Transposition

Another important use right often arises in connection with works of fine art, when a user "transposes" a work from one medium to another.

For example, use rights may be licensed to permit a sculpture to be sold as a painting or a photograph, or for a mural to be sold as lithographic or serigraphic prints; a photograph may be used to create textile designs, or a single sculpture in stone may be cast into multiples in plaster, bronze or concrete. The right to transpose a work from one medium to another is more limited than a grant of merchandising rights, since it generally specifies one particular form in which the work will be re-used. In contrast, a broad grant of merchandising rights often permits the work to be embodied in a variety of forms, such as coffee mugs, key chains, or apparel such as T-shirts or baseball hats.

## Quality Control

Whether you are licensing the right to transpose a work of fine art into a different medium or material, or granting merchandising rights, terms of the license agreement should include a right to monitor and maintain a high level of quality in the licensed goods. An artist who fails to maintain quality controls may suffer serious damage to his or her reputation if inferior copies are displayed or distributed. Even greater problems can arise if the work is licensed to be used as part of a useful article, such as a sculpture incorporated into a lighting fixture. If defects in the fixture cause injury or death, claims may be asserted against the artist in a product liability lawsuit.

Quality control provisions appear, most commonly, in use contracts involving merchandise of various kinds. They generally give the artist rights to approve goods bearing the artist's work, including the right to veto or rescind the user's license to use the work if the goods are of inferior quality, or if they may harm the artist's reputation or physically injure purchasers.

### THE GRAPHIC ARTISTS' GUILD

The Graphic Artists' Guild (GAG) is dedicated to uniting all professional artists and designers within the communications industry; advancing economic and social interests; establishing and maintaining educational, recreational, social and charitable enterprises that help them professionally and aid their general welfare; and promoting and maintaining high professional standards of ethics and practices.

Membership is open to those graphic artists who earn over half their income from graphic work.

The GAG publishes the *Graphic Artists' Guild Handbook of Pricing and Ethical Guidelines*, the industry's primary reference for pricing, services and professional standards and practices. It discusses in considerable detail many of the ways commercial and graphic art can be used. For each type of use, the GAG suggests a range of ethical practices and reasonable fees to be paid to the artist. The rates are merely suggestions and you are free to negotiate higher or lower fees, depending upon the particular circumstances of each deal.

The GAG spearheaded the coalition "Artists for Tax Equity" that convinced Congress in 1988 to repeal the unfair tax capitalization rules, saving artists millions of dollars in taxes; helped make the return of original artwork an accepted industry practice; continually fights against work for hire abuses.

The GAG maintains an attorney and accountant referral system and offers group health insurance and disability coverage policies.

Graphic Artists' Guild
11 West 20th Street
New York, NY 10011
(212) 463-7730

Licenses involving works of visual art have different quality control provisions. In the publication of limited editions of fine art multiples, such as lithographs or serigraphs, the artist is usually required to sign or initial the numbered prints offered for sale. It is not unusual for dozens of prints to be rejected and destroyed in this process due to irregularities in paper or print quality, uneven register, lack of color uniformity or other defects. In some contracts, the artist is not paid until he or she has inspected and signed a fixed number of prints. This scrutiny results in better quality reproductions being sold, which enhances the artist's reputation, guarantees the quality of the pieces and justifies a higher price.

An artist's right to approve copies is also found in contracts for three-dimensional works such as castings of a sculpture. However, when the artist is the party responsible for making the copies, and the user is licensing distribution rights, the user may have the right to approve or reject the quality of copies. In many fine art use licenses, the parties must agree on a printer, atelier or foundry to produce the reproductions and help with quality control.

Museum and gallery exhibition contracts usually permit the artist to approve the selection and arrangement of works in the exhibition. If merchandise embodying the artist's work is distributed or sold in connection with the exhibition, the artist should have the right to authorize only such products that are manufactured using the highest quality materials, and are compatible with the artist's image and aesthetic sense. The contract should also specify the royalties due the artist from sales of this merchandise.

### Payment

One of the most important terms of any contract or license to use art is the amount of money paid to the artist. Specific rates for various uses are beyond the scope of this article. Artists should research current fees paid for similar uses by inquiring of other artists, artists' reps or art users in the same area, or by referring to one of several pricing guidelines published and updated annually, such as *Guide to Newspaper Syndication* (updated yearly) and *Humor and Cartoon Markets* (updated yearly).

### Fees

Buyers requesting rights to use art in media, not previously licensed by the artist, should pay for such permission. Unfortunately, reasonable license fees for many media, including fine art reproductions and electronic media, are not published in any rate book. Artists and their reps, agents and attorneys must investigate the customs and standards of the media and industries in which they are dealing. Licensing fees for using a work in different media can be charged either as a flat fee, in installment payments, or on a royalty basis. Again, inquire about standard rates and industry practices before entering into a negotiation over licensing fees.

For lithographs, serigraphs and other fine art editions, artists should receive in the neighborhood of 50% of retail or wholesale selling prices, possibly with a recoupable or nonrecoupable advance. For other use rights, if the work essentially comprises the product being sold, a royalty of between 10–50% of the retail or wholesale selling price of each article is reasonable. Where the art comprises only a small part of the product, such as a single illustration for a book or magazine, a flat fee is appropriate based on industry standards. Established artists generally command higher fees than novices.

## THE VISUAL ARTISTS AND GALLERIES ASSOCIATION

The Visual Artists and Galleries Association, Inc., (VAGA) is an artists' rights organization and copyright collective formed by artists in 1976 to administer and protect artists' copyrights and moral rights. A network of sister societies worldwide allows every artist from each society to be represented the world over.

More specifically, VAGA protects artist members' copyrights; provides art licensing and reproduction rights clearance and royalties collection for artists; promotes members' works for reproduction; maintains a slide and book library of fine art for licensing purposes; provides advice concerning copyright and artists' rights issues; maintains a legal hotline; provides important lobbying power to ensure that legal rights of artists are protected and stay protected; maintains dialogues with galleries, museums, publishers and other art related businesses concerning art issues. Nonmembers can call with basic questions on copyright or artists' rights, but detailed help is reserved for members.

VAGA is open to painters, sculptors, graphic artists, photographers, architects, video artists, filmmakers, crafts artists and other visual artists. *—Robert Panzer*

The Visual Artists and Galleries Association
521 5th Avenue, Suite 800
New York, NY 10017
(212) 808-0616

*Robert Panzer has been Executive Director of the VAGA since 1989.*

### Flat Fees

Payment of a single lump sum fee in return for the right to use a work may be particularly appropriate where the use being licensed is relatively minor, for a short duration or is nonexclusive. For example, granting a writer or publisher the right to reproduce a work in a monthly magazine can be fairly compensated by a one-time license fee, payable in full on delivery, in advance of the publication. A full-page color use, or a use on the front or back cover of a magazine should command a significantly higher fee than a quarter-page use inside the magazine. Similarly, exclusive rights warrant higher fees than nonexclusive rights. State sales tax (where required) must be collected by the artist and the agreement should specify an additional charge for sales tax, based on the total fee paid.

### Royalties

Flat fee payments are not appropriate where the user requests exclusive rights, intends to make numerous copies of a work, or has the potential for making large profits. If a publisher intends to reproduce a work on ten thousand posters to be offered at a retail price of $10 each, it is unwise for the artist to grant exclusive poster rights for a number of years for only a few hundred dollars. However, it may be financially impossible for a licensee or publisher to pay a large up-front license fee, based on what the artist's fair return would be, if all the posters were sold at the full retail price. To make the deal workable for both sides, a royalty or percentage of the retail or wholesale price of each piece sold, can be agreed on as a condition of the license. This reduces the publisher's up-front financial risk, while guaranteeing a fair return for the artist. Royalty agreements are common in the book publishing industry and in connection with licensing merchandising rights.

The amount of the artist's royalty should be negotiated with reference to standard rates paid by publishers selling posters embodying similar works. Royalty escalations or increases are a good way for an artist to share in the profits as a work proves its commercial value in the marketplace.

For example, on an edition of ten thousand (books, posters or T-shirts), a royalty

formula could provide an 8% royalty on sales of the first twenty-five hundred, 10% on the next twenty-five hundred, 13% on the next twenty-five hundred and 16% on the last twenty-five hundred. If the edition sells out and the publisher has requested the right to do a second printing, the artist's royalty on the new deal would start at 16% or higher, and possibly escalate from there.

### Recoupable, Returnable Advances

An advance on royalties is a lump sum payment made by the user in respect of royalties due on future sales. Beware of advances that are returnable or recoupable. An artist who accepts a returnable advance may have to pay the advance back if sales of products do not earn back the amount of the advance calculated at the artist's royalty rate, or if the publisher or manufacturer cancels the project for any reason. A recoupable advance means that the amount of the advance paid to the artist must be earned back by the licensing party, calculated at the artist's royalty rate, before any royalties are payable to the artist.

### Time Limitations

One method for setting a range of fees for uses beyond the time period in the initial license agreement is to prorate the original fee for each fraction of the original term requested in the extended license period. For example, if you grant a publisher the right to use an image for one year for a fee of $1,000, and the publisher later wants to use the image again for one month, an appropriate license fee is one-twelfth of your original one-year fee, or about $83. If the publisher originally paid $100 for a one-month use and later wants to use the image for one year, an appropriate fee is twelve times $100, or $1,200 for the one-year use license.

### Hourly Fees, Day Rates

Occasionally an artist may be asked to render services on an hourly or day rate (per diem) basis. In either case, it is important to confirm whether the artist is an independent contractor or an employee. Hourly rates for commercial-type artist's services run between $50–$150. Per diem rates should specify the maximum number of hours included, and usually reflect a modest discount over what the artist would normally receive on an hourly basis. Of course, if a complete buy-out of the artist's copyright is a condition of the deal, the hourly or day rate should be five to ten times higher.

### Kill Fees, Cancellation Fees, Rejection Fees

A popular misconception among certain advertising agencies, publishers and others, is that if the buyer chooses not to use the art, no payment is due. This notion is unfair to the artist who has delivered satisfactory work, but for reasons totally beyond their control, the art isn't used. To avoid disputes, include a kill fee in the agreement. This is generally 40–60% of the total compensation that would otherwise have been due had the art been used, plus reimbursement of your out-of-pocket expenses, if the buyer changes their mind after a substantial amount of work has been performed. If the art is rejected as unsatisfactory, or not in keeping with the specifications of the job, an artist will have a difficult time collecting partial payment unless a specified rejection fee (usually 30–50% of the full fee) is agreed to in writing in advance.

### Buy-outs

It is not usually necessary for artists to sell all of their rights in a work. The whole concept of multiplying income by licensing limited rights to limited uses is defeated when an artist permits a buy-out of the entire copyright in a work. Nevertheless, in certain situations, for the right price, an artist should permit an outright sale of all rights to a work.

When a piece is an older work generating little sales interest, a buy-out is not so great a sacrifice. Or, if a valued user insists on a complete buy-out, offers the artist five to ten times what a fair limited use fee would be, and promises additional work in the near future, the outright sale of all rights in all media could be worth more in good-will and immediate cash, than rights that may never be licensed in the future. The important rule is that buy-outs should be given only in exceptional circumstances and always by choice, not by chance or intimidation. Under U.S. copyright law, transfers of copyrights (including copyright assignments and buy-outs) can be accomplished only by a written document.

### Termination of Transfers

Special provisions of copyright law permit you or certain of your heirs to terminate transfers, thirty-five years after a complete copyright assignment or buy-out has been made. Even though you may have sold all of your rights to a work in 1990 for example, for a five-year period beginning in 2525, you or your surviving spouse or children have the right to reclaim and reacquire your copyright without having to pay a dime. Termination of transfer rules are one more reason to keep good records of all copyrights in your artworks; even works you have sold years or decades before!

### Territory

License agreements should specify the geographic area in which the artwork may be distributed or sold. Often, buyers initially only require rights to distribute a work locally, such as in a particular city or region. Since the enactment of the North American Free Trade Agreement (NAFTA) buyers may request distribution rights in the United States, Canada and Mexico. Licensing use rights in countries outside the U.S. is sometimes done on a country-by-country basis, with a separate fee being paid for each additional territory. Higher use fees should be paid for distribution rights in the "major territories": England, France, Germany and Japan, than in "minor territories," such as Belgium, Israel, Spain, Sweden, etc. Fees are often 50–75% of the U.S. licensing rate for major territories; 25–50% for minor territories. Of course if the artist is a foreign national, or has a particularly large following in a specific country, a higher use fee may be warranted, even for a minor territory.

### Duration

The period of time during which your art may be used is another important variable that can increase income. This is particularly true where the work is used in periodicals such as newspapers and magazines, or in calendars or annual reports. License agreements should specify that the work is to be used in a particular issue or edition with reference to a specific month and year. Alternatively, you can grant use rights for a set period of time, such as one month or one year. Rental agreements for the use of art in television or motion pictures usually last only a week or two, and can even specify that the art may appear on screen for only a stated number of seconds.

### Credit

In certain situations, a guaranteed credit line, in an agreed upon form and prominence, can be more important and valuable than payment of a license fee. A highly visible attribution can enhance an artist's reputation, heighten the public's awareness of the artist's name, increase the value of his or her existing works, and attract numerous new opportunities.

A work on the cover of a glossy program for a highly publicized charity event, can bring an artist to the attention of influential critics, designers, art collectors and people who otherwise may have never noticed the artist's work. For this reason, it is not unreasonable for a license agreement to specify that the artist's name and gallery association must appear in a particular location, type size and style on each copy or product embodying the licensed work. In some cases, an artist can require payment of a penalty surcharge of 50–100% of their fee, if credit is omitted.

For additional visibility, and as a general business practice, you should also require that a proper copyright notice appear whenever the image is used. This gives you a second chance to be recognized for your artistic ability, provides notice to the world that you claim ownership in the image, and may discourage unauthorized duplication.

### Representations, Warranties and Indemnifications

Often, an artist is required to state (represent) that he or she is the original creator of the art and owner of the use rights sold; that the rights have not been previously sold to anyone else (if the license is exclusive), and that nothing in the agreement will violate the rights of any third party. These statements rise to the level of guarantees or warranties under the Representations and Warranties section of a typical use agreement.

An "indemnification" provision commonly refers to the artist's representations and warranties. If anything warranted or represented turns out to be not true, and a claim or lawsuit results, the artist may be responsible to reimburse the user for any damage, cost or expense (including the user's attorneys' fees), arising out of any representation that was breached. Sometimes the user's right of indemnification extends beyond the warranties and representations to a breach of any term of the use agreement.

In any case, it is not unreasonable for an artist to request that the right of indemnification be mutual, rather than a unilateral indemnification that protects only the user. This is particularly helpful if the user provides the artist with source material or adds material to the artwork. In such cases, the user should indemnify the artist from any liability arising out of material provided by the user.

### Accountings and Audit Rights

If the use agreement includes royalty payments or conditions or limitations on the number of copies, or duration of the license, it is customary for the user to give periodic written accountings to verify that the user is abiding by the terms of the license. Accountings can be made monthly, quarterly or semi-annually, and are usually accompanied by payments due. Accounting statements should be current, detailed and complete. They should include information such as the total number of copies manufactured, sold, lost, damaged, discounted or returned, and the manner in which the artist's royalty is calculated.

Audit rights are contract terms giving the artist or the artist's representative (such as an accountant or lawyer), the right to examine the user's books and records to confirm the accuracy of royalty payments and accounting statements. Users may attempt

to limit the books and records that may be examined, or the manner in which audits are conducted, requiring that they be done only by a certified public accountant within one or two years after an accounting has been rendered. Artists should demand full access to all relevant documents needed to verify data set forth in the accountings, at reasonable times, by any qualified individual, for at least two to three years after the accounting has been made. If an audit discloses an underpayment of more than 5% in any statement period, the user should reimburse the artist for the cost of the audit.

## Default, Cure, Termination

At the beginning of a licensing relationship, both sides are usually friendly and optimistic about the future of the deal. To minimize the hassles and economic loss that can occur when one party fails to live up to the contract terms, it is wise to agree at the beginning of the negotiations on specific procedures that must be followed if problems arise. When either party fails to do something promised in the agreement and the failure (breach) is important (material), such as the artist's failure to deliver artwork or the user's failure to pay royalties on time, it is called a default. For certain types of defaults, a "cure provision" gives the defaulting party a chance to correct (cure) the failure within a specified period so that the contract can continue. For certain types of defaults however, such as a failure to pay royalties on time, a cure provision can be abused, treated by the party owing overdue royalties as an automatic extension of time within which to make late payments.

When a default is not cured in a timely manner, or is not curable by definition in the contract, a "termination" provision gives the nondefaulting party the right to end the contract and discontinue any use rights that may have been granted.

## Infringements, Retroactive Licenses

If you discover that an unauthorized use of your work has been made, you may have grounds for a claim of copyright infringement. Unfortunately, federal court copyright infringement lawsuits are very expensive. Lawyers' fees can run as high as $150,000 to bring a single case to trial, and it can easily cost you more to sue than you could ever win in court.

To avoid the enormous expense and delay involved in a lawsuit, it is often more practical to contact the infringing party and attempt to negotiate a "retroactive license" for the unauthorized use. This means offering not to sue the infringer, in return for payment of a fair fee—approximately what you would have charged had a license been requested in the first place. If the infringer is a legitimate, honest business and the infringement was innocent or occurred by mistake, it is better to negotiate a quick and profitable settlement and avoid years of legal expenses, courtroom hassles and the uncertainties inherent in every lawsuit.

## LICENSING USE CHECKLIST

MEDIA

ORIGINAL ART (no
reproduction rights)

Medium: _____
Dimensions: _____
__ Framed
__ Unframed

FINE PRINTS

Type paper: _____
Dimensions: _____
Edition Size: _____
__ lithograph
__ serigraph
__ linoleum print
__ aquatint
__ mezzotint
__ other: _____

POSTER

Dimensions: _____
Edition Size: _____
__ merchandise
__ concert
__ theater
__ event
__ other: _____

PERIODICALS
__ Magazine
__ Advertising
__ Editorial

Location: _____
*(cover, inside)*
Size: _____
__ national
__ regional
__ local
__ consumer
__ trade
__ other

__ Newspaper    __ Advertising
__ Editorial
Location: _____
*(cover, inside)*
Size: _____
__ national
__ regional
__ local
__ other: _____

PROMOTIONAL LITERATURE
__ business cards
__ brochures
__ stationery
__ catalog
__ press kit
__ flier
__ annual report
__ logo
__ other: _____

**Territory**

__      worldwide
__      United States
__      U.S., Canada and Mexico
__      foreign (specify countries):

__      regional
__      state
__      local
__      other: _____

**Quantity and Duration**

__ day(s)
__ week(s)
__ month(s)
__ year(s)
__ hour(s)
__ minute(s)
__ second(s)
__ perpetual
__ times
__ revocable at will
__ editions – type(s): _____
__ edition size
__ numbered prints
__ remarques
__ artist's proofs
__ printer's proofs
__ publisher/galley proofs
__ H/C proofs
__ printings

ELECTRONIC
—     video game
—     interactive
—     CD–ROM
—     digital scanning
—     other: _____

MOTION PICTURES
—     theatrical (high, medium, or low budget) (circle one)
—     made for television (network, cable, local)
—     industrial
—     documentary
—     other: _____

VIDEO
—     cassettes
—     videodiscs
—     broadcast (national, regional, local, foreign) (circle one)
—     other: _____

TELEVISION (national, regional, local, foreign, closed-circuit)
                    (circle one)
—     network
—     cable
—     public access

BOOKS
—     textbook       Location: _____
—     consumer             (cover, inside)
—     trade          Size: _____
—     hardcover     Edition size or printing size: _____
—     paperback
—     art
—     other: _____

MERCHANDISE
—     board games
—     apparel/jewelry – type(s): _____
—     toys – type(s): _____
—     textile – type(s): _____
—     useful articles – type(s): _____
        (household, furniture, etc.)
—     greeting cards
—     calendars
—     packaging – product type: _____
—     jewelry
—     other: _____

OUTDOOR
—     billboards
—     bus cards
—     other: _____

**Territory**

—     worldwide
—     United States
—     U.S., Canada and Mexico
—     foreign (specify countries):
               .
—     regional
—     state
—     local
—     other: _____

**Quantity and Duration**

__ day(s)
__ week(s)
__ month(s)
__ year(s)
__ hour(s)
__ minute(s)
__ second(s)
__ perpetual
__ times
__ revocable at will
__ editions – type(s): _____
__ edition size
__ numbered prints
__ remarques
__ artist's proofs
__ printer's proofs
__ publisher/galley proofs
__ H/C proofs
__ printings

# Artworks in the Digital Era

ROBERT C. LIND

*Robert C. Lind is a professor of law at Southwestern University School of Law in Los Angeles. He received his Bachelor of Elected Studies degree, summa cum laude, from the University of Minnesota in 1976, his J.D. degree from George Washington University in 1979 and his Master of Laws degree, with highest honors, from George Washington University in 1983. Professor Lind teaches courses in copyright, trademark, entertainment, defamation, privacy, museum and art law. He is a member of the District of Columbia and California bars.*

We are pioneers in the establishment of a universal language. It is an extremely useful language that humans do not speak or write. This language is known as machine language or object code. It is the language of computers and it is revolutionizing the world. A computer is a machine that operates on electrical impulses. It responds to instructions presented as a series of 0s and 1s, a series of on/off switches. These 0s and 1s are the digital commands, the machine language, which operate today's cutting edge technology. Without it there would be no fax machines, no compact disk recordings, no computer networks, no on-line computer services and no information superhighway.

This new technology presents a two-edged sword for artists. Artists are benefited, not only by the ease of communication and accessible storage of information that benefits us all, but by the development of a new creative tool. This tool gives the artist the ability to create computer generated graphics and edit images in a manner heretofore unavailable. Digital technology is already responsible for new and innovative kinds of sculpture, painting, music and dance. Digital multimedia artists are gaining recognition in performances and exhibitions. Virtual reality pieces have begun to be exhibited in art museums. In addition, these computer assisted artworks, as well as predigital artworks, are provided with additional uses and means of distribution that will heighten the impact of the artist's work as well as increase the artist's sources of income.

Two decades ago, the photocopier made each person capable of becoming a publisher. Today, digital technology has the capability of making each home and office the repository of a large library and each individual the disseminator of vast amounts of material to a degree never dreamed possible. Much of this material, including the works of artists, will consist of items protected by intellectual property rights. A crucial issue for artists and other creative individuals will be whether the current intellectual

property laws will provide sufficient protection of works that are distributed digitally.

There is another edge of the digital sword. The technology that makes these creative tools available and permits this ease of distribution also allows for an unlimited number of perfect reproductions and permits uses and adaptations of material that may be difficult to trace. Works that have been encoded digitally are defined in machine language. This allows a computer to read the digital information and copy it, rather than copying the image itself. Whereas the standard photocopier relies on the image placed on the machine, a computer relies on the information contained in a computer file to reproduce the image. Whenever the computer is asked to copy the image, it reads the same information from the file, thereby making an identical copy each time.

Of equal concern is the ability to manipulate digital images and information easily. Once an image or other work is digitized, it can be manipulated, transformed and merged with other works to such a degree that the intellectual property rights of the artist may become buried in the final product. Since the advent of "morphing," computer users are able to take two or more images and combine them into a single image that retains aspects of each source image. The resulting image is not a collage effect, but a seamless  product that has entirely new characteristics. While this process is creative and presents new means of utilizing prior material, it makes such unauthorized uses difficult to detect. As a result, copyright owners' policing of their intellectual property rights becomes a very daunting task.

The music industry has been concerned with the effect digital technology will have on the authorized sales of music. Digital recording devices allow users to make perfect copies of recordings. Unlike the traditional analog tape recorder, the quality of the digital recording does not degenerate from generation to generation. Congress has responded to the music industry's concern by instituting a levy system whereby a percentage of the price of a digital recorder or blank recording medium is distributed to copyright owners to compensate for lost copyright revenues. In an effort to contain mass-produced pirated goods, Congress has also required that each digital recorder contain an electronic device that limits the ability to record from recorded copies.

Nothing is yet in place to protect graphic artists in a similar manner. The means of authorizing uses of protected works and collecting fees for uses in electronic bulletin boards, electronic databases, on-line services and the Internet have not been fully devised or implemented. Some argue that all information should be free for all to use. A current example of this thinking is the Internet. A web of computer networks initially developed by academic and government computer users, which now reaches 20 million users in more than a hundred countries, the Internet does not require any payment other than an access fee that is usually paid by an institution rather than the individual user. The use of the Internet, however, has become more commercial and its basic premises are now undergoing a reevaluation.

Others argue that intellectual property rights, particularly copyright law, has been made obsolete by digital technology. The response, they argue, should be the institution of a governmentally imposed compulsory license. This would continue to provide ease of access and continued use of digital material, while providing the copyright owner with payment and the incentive to continue to create. This approach, however, would fail to discriminate based on the perceived value of individual works and would prevent the market from dictating user fees.

Still others argue that the digital revolution makes it even easier to determine payment for the uses of protected material. Under this approach the information superhighway would become a toll road. Digital technology allows for the collection of very precise information regarding who has access to material and whether it is downloaded or simply viewed. These digitized records may greatly assist copyright owners in billing users of such material, but it also presents a tremendous concern for the user's privacy. No politician would want it known that they spent two hours on the "Muskrat Fun For Everyone" network increasing their sexual knowledge.

Because future dissemination devices and royalty structures are currently unknown, the artist is left with the present and past means of licensing or assigning rights in their works. After an introduction to the variety of current digital uses of artworks, present day contractual considerations will be discussed. A discussion of the application of past contractual agreements to new digital uses will follow.

## CURRENT DIGITAL USES OF GRAPHIC IMAGES

Artists should be aware of the varied uses and formats for digitally processed images. While some uses have been available for several years, others have become available only recently. The best known uses of digitized images include "clip art," computer files containing an image that may be printed by itself, inserted into a literary work such as a newsletter, or manipulated by the computer user. These are often simple black and white figures, but more elaborate color images are being marketed. Similarly, photographs have been digitized and made available on floppy computer disks, on photo CDs and in connection with CD-ROM disks. These images can be cropped or manipulated in other ways. Some are made available royalty free, others prohibit any commercial use.

Perhaps the most lucrative use for digitized images is with computer games. Despite the ups and downs of the computer game industry, it has come a long way from the days of "Pong," the first computer game. Computer games are increasingly becoming more complex, with higher production values and greater resolution. Currently, there are a number of computerized systems, or "platforms," on which these computer games are available. Cartridge based systems, such as those marketed by Nintendo, Atari and Sega, were the first computer game systems to be accepted into the home. Once the multipurpose personal computer found its way into the home, computer games for the IBM and Apple systems quickly became available.

The most recent developments have centered on interactive multimedia systems that use interrelated sounds, images and text that can be manipulated by the user. There are currently two general categories of such systems. The most prevalent type of system consists of high speed personal computers that are configured with CD-ROM drives and are viewed through a computer monitor. The use of CD-ROM disks, which contain large amounts of information, allows for very sophisticated programs.

The second category is known as the "set-top," a single-purpose computerized device that is designed to sit on top of a television set through which the computer program, usually a game, is viewed. A number of incompatible set-top systems are currently vying for market share. These include: Panasonic's 3DO, Phillips' CD-i, Atari's Jaguar and Sega's Genesis. These systems vary in terms of speed, capacity and software availability. Although they use CD-ROM technology, they are not compatible with personal computers.

The development in multimedia systems has increased the use of artworks other than in the computer gaming field. One of the fastest growing areas of development has been that of "edutainment," educational programs that are entertaining at the same time. These programs often use artworks as a vehicle to assist in the learning process. At other times the artwork is itself the subject of the interactive program. Many museums are involved with multimedia projects that display the museum's collection and provide audio and textual analysis of the works visually displayed on the screen. Work has begun on a "virtual museum" where instead of visiting a building, the exhibit is delivered to the user electronically.

It is anticipated that the same technology that permits digitized photographs and other graphic images to be transmitted through telephone lines to anywhere in the world will be used to transmit those works into the home to be displayed on a television screen on an interactive basis. This interactive television will be an important component of the information superhighway. The advent of fibre optic cable and digital compression technology will make it possible to provide the average home with five hundred channels of programming. This explosion of television capacity will greatly expand the need for artwork of various types. Although the digital revolution will continue to increase the need for artwork, the artist must be aware of the variety of uses and means of distribution that are currently available and that may be available in the future.

## THE LICENSING OR ASSIGNING OF GRAPHIC IMAGES

Artists have the right to license the use of their works on an exclusive or nonexclusive basis. An exclusive license gives the person purchasing the license (licensee), the sole right to use the work in the manner indicated in the license. An exclusive license must be in writing and must be signed by the copyright owner of the work being licensed. A nonexclusive license grants permission to the licensee to use the work being licensed. The licensee is not the only person entitled to use the work in such a manner. A nonexclusive license need not be in writing. An assignment is the sale of any or all of the rights granted by the copyright in the work. An assignment must be made in a document that is signed by the copyright owner. Artists who have granted an exclusive license or have assigned their work cannot thereafter use the work themselves in a manner that conflicts with the rights of the licensee or assignee, unless special permission has been written into the agreement. In any case, the copyright in the licensed or assigned work may revert to the author of the work after thirty-five years from the date of the agreement.

Artists should be aware of their rights regarding the increased varieties of uses of graphic images outlined above, sometimes referred to as "electronic rights," and determine whether an agreement they are about to sign incorporates those rights. If so, the amount and type of payment made for those uses should be reflected in the contract.

An artist should be conscious of these rights even when the agreement is intended primarily for another purpose. If an artist is entering into an agreement with a comic book company for the use of a character created by the artist and the contract grants to the company "all publishing rights," this may include the publishing of the character not only in printed comic books, but also computerized comic books on computer disks or the use of the character in an interactive computer game. The artist must be careful to specify in the contract the exact nature of the rights being licensed or assigned and to explicitly identify and limit the extent of the intended use of the work.

The artist should be careful not to focus merely on the payment or royalty clause of the agreement. Two equally important clauses are the granting of rights clause and the reservation of rights clause. The granting of rights clause sets forth the nature and extent of the rights being transferred. The broader the nature of rights transferred and the wider the scope of permitted use, the greater the ability of the party purchasing the rights to use the artwork in ancillary areas, such as digital works. If the parties have agreed on a very specific use of the artwork, this limited use should be expressly reflected in the written agreement.

Also of great importance to the artist is the reservation of rights clause. This clause states that the artist retains all rights to the artwork that are not expressly conveyed in the agreement. This clause will help protect the artist from future uses of the work that may not be known at the time of the agreement. At a time when digital technology is constantly expanding the possible uses of artworks, it is important for artists to retain the rights for these future uses. Ten years from now holographic halls filled with holograms may be a very profitable entertainment endeavor. The artists who licensed their work for comic book publication, but who signed contracts, without reservation of rights clauses, which granted the right to use the work "throughout the universe by any means or methods now or hereafter known," may not be able to stop the use of their work in a holographic hall. If artists sell the rights to their artwork for a lump sum, they will not be able to profit from this new use. Even if they retained a royalty interest in uses of their work, the contract may be interpreted as giving the artist a royalty that is below market value for use of the work in such a new technology.

Agreements for interactive multimedia projects involving electronic rights are particularly sensitive to the need for adaptation rights. While it is technically possible for an artist to prohibit the creation of a derivative work by the licensee or assignee, such a provision will be increasingly more difficult to negotiate when a digital use is at issue. The value of digital rights will be based upon the ability, on the part of the licensee or the ultimate purchaser of the computer program, to make derivative works. Therefore, artists who insist on retaining derivative work rights either will not be able to attract a licensee or will be paid substantially less than other artists who license the ability to make adaptive uses of artworks.

Care should be taken to identify the types of digital uses covered by the agreement. The more limited the uses initially transferred by the artist, the greater the possibility of additional income sources by licensing the work for additional digital uses. Many licenses are limited to a single platform. Some of the larger computer game companies want the rights to all of the platforms they currently use, such as systems that use both cartridge and CD-ROM devices. Personal computer CD-ROM publishers tend to want exclusive rights for all laser interactive optical uses. It may be in the artist's best interest, however, to agree to a broad grant of rights to a well-known computer program publisher as the publisher will have all the rights

cleared for one platform and can more easily convert a work to a new platform.

The artist may want to refrain from granting open ended uses. Considering the various types of uses available to computer program creators and publishers, the artist may want to remain circumspect about the content and context in which their work will appear. This is especially true in the era of concern over video violence or with sexually explicit uses. It may be possible for the artist to contract for approval rights. Generally, licensees do not want to grant approval rights for fear that a hypersensitive or fickle artist will try to stop production immediately before the release of the program. However, a provision that gives the artist an approval right, not to be unreasonably withheld, at a point early in the development of the computer program, such as at the script, story board, or product demo stage, may be acceptable.

An important consideration is the protection of ancillary rights, such as merchandising. Particularly where the artist is creating a graphic character, the merchandise rights may become more lucrative than the use of the character in the computer program. If possible, the artist should retain sequel rights, or provide for increased economic incentives for any sequels that are created. Traditional linear motion picture rights should also be kept in mind. Although the segue from computer program to feature length motion picture is rare, the recently produced Mario Brothers movie demonstrates that it can happen. In fact, as the number of computer programs and platforms continue to grow, their influence on traditional motion pictures is likely to increase. Other ancillary rights would include foreign versions of computer programs and the use of artwork on interactive television.

The term of an agreement can conceivably be from one year to perpetuity, though the most common license is from five to ten years. This is a fairly long period of time, considering the half-life of the average computer program. In any event, provision should be made for a reversion of rights under certain circumstances. Such a provision would prove helpful in dealing with the notorious delays some computer programs have encountered. Under a reversion of rights provision, the rights to a work would revert to the artist if production of the product is not commenced or completed by a certain date.

## RELIANCE ON EXISTING AGREEMENTS

Where the prior purchaser of rights is now embarking on an expanded use of the artist's work in a digital product, the existing agreement must be analyzed to determine the proper ownership of such electronic rights. The issue of whether the proposed use of a work in the new digital medium falls within a preexisting grant is not a unique legal question. The twentieth century has seen numerous technological innovations that brought into question the use of previously licensed works in the new technology. The expansion of silent films to sound motion pictures, the exhibition of motion pictures via television, the translation of authorized radio programs into television programs, and the issue of whether the right to exhibit by means of television encompassed distribution via video cassettes and laser discs all required judicial review of contracts entered into before the new technology was developed. The same issue must be determined now with digital technology, which permits not only the reproduction of the licensed work, but its manipulation, transformation and adaptation dictated by the computer user. The issue fundamentally becomes one of who shall benefit from the

windfall brought about by unforeseen new media, the creator or the licensee who has previously invested in a derivative use based upon the licensed work. The same legal principles that have guided the interpretation of contracts when new uses of licensed works have become an issue will be used to interpret these digital and electronic rights.

Where novel technological developments generate unforeseen applications for a previously licensed work, the scope of the license must be determined. In the absence of evidence of the specific intent of the parties, a court will attempt to identify any indicia of a mutual general intent to apportion rights to "new uses." These indicia may be discerned from the language of the license, the surrounding circumstances and trade usage.[1]

Where no reliable indicia of general intent are discernible, the courts are divided on how to resolve the issue on policy grounds. Some courts will place the burden on the grantor to negotiate an exception where the possibility of nonspecific new uses was foreseeable by the contracting parties at the time the licensing agreement was drafted. Under this view, all uses reasonably interpreted as being within the media stated in the agreement would be permitted.[2] This approach favors the grantee, which generally will assure a greater degree of distribution of the work to the public.

Other courts follow a stricter form of interpretation. These courts assume that a license of rights in a given medium includes only such uses as fall within the unambiguous core meaning of the term, therefore, any rights not expressly granted are reserved to the copyright owner.[3]

Even with these two general approaches, the language used in the granting and reservation of rights clauses has great importance. The use of broad language in the granting clause will benefit the grantee.[4] The use of broad language in a reservation of rights clause will benefit the grantor.[5]

## CONCLUSION

Artists today live in an exciting period of creation. Some liken the present stage of development of digital technology to the importance of the development of the Gutenberg movable type printing press. Whether or not digital technology brings about all the revolutionary changes that are now anticipated, artists must be cognizant of their rights and protect the possible future uses of their work in the digital era.

1 *Rey v. Lafferty,* 990 F.2d 1379 (1st Cir. 1993).
2 See, e.g., *Bartsch v. Metro-Goldwyn Mayer, Inc.,* 391 F.2d 150, 155 (2d Cir.), cert. denied, 393 U.S. 826 (1968).
3 See, e.g., *Cohen v. Paramount Pictures Corp.,* 845 F.2d 851, 854 (9th Cir. 1988); *Tele-Pac, Inc. v. Grainger,* 570 N.Y.S.2d 521, appeal dismissed, 580 N.Y.S.2d 201, 588 N.E.2d 99 (1991): broadcast rights do not encompass videocassette film rights.
4 See, e.g., *Rooney v. Columbia Pictures Industries, Inc.,* 538 F. Supp. 211 (S.D.N.Y.), aff'd, 714 F.2d 117 (2d Cir. 1982), cert. denied, 460 U.S. 1084 (1983): license to exhibit films "by any present or future methods or means"; *Platinum Record Co. v. Lucasfilm, Ltd,* 566 F. Supp. 226, 227 (D.N.J. 1983): synchronization license to perform a musical composition "perpetually throughout the world by any means or methods now or hereafter known."
5 See, e.g., *Cohen v. Paramount Pictures Corp.,* 845 F.2d 851, 854 (9th Cir. 1988). See also *Rey v. Lafferty,* 990 F.2d 1379 (1st Cir. 1993): reservation of rights implied from the situation of the parties and the "general tenor" of the agreement.

# The Economics of Art

**Grant Writing and Other Fund Raising Strategies**

**When to Hire a Lawyer**

**Collections: Get the Money**

**Mediation for Visual Artists**

**Artists and Insurance**

# GRANT WRITING AND OTHER FUND RAISING STRATEGIES

**ELAINE WINTMAN**
*Elaine Wintman, consultant, has been Director of Devel-
opment at Pacific Asia Museum in Pasadena, California;
Manager of Corporate, Foundation and Government
Relations at the California Institute of the Arts (CalArts);
Associate Director of SPACES (Saving and Preserving
Arts and Cultural Environments); Gallery Director
and Program Director of the Woman's Building in
Los Angeles; and has served on several boards.*

I am writing this chapter primarily because knowledge may be empowering. As a result of reading this material, you may write a grant or you may get a grant or you may achieve something you want.

I have strong opinions about fund raising. Some of them are:

♦ You have already done fund raising.

♦ Grant writing is a craft that can be learned.

♦ Successful fund raisers remember what their donors' needs are.

♦ If you are producing something you believe in, your conviction will sell the work.

♦ If you are doing something that the community needs, the community will support your work.

♦ If you don't ask, you don't get.

♦ Miracles happen.

## FRIEND MAKING AND FUND RAISING

When people ask me how to obtain the resources they need in order to do what they want to do, I often respond by asking this question, "If you needed $500 right now, and you didn't have it, what would you do?" The answer I get usually boils

down to this: "I would ask my mom, my dad, another relative, my significant other, a good friend." Fund raising is friend raising. People give to people—those they like, believe in, trust, and whose dreams they share. People give to their friends, or to potential friends.

Then I ask, "Do you give away money?" Most people do. So I ask, "Why do you give away money?" And this is the clincher, "What does it take for you to put your hand in your pocket, take out money, and give it away? What does it take for you to write a check?" The answers usually boil down to this: "I believe in what the person (or organization) is doing. I think it's important that the work get done. I think that person (or organization) can get it done. It's a good use of my money. My money will make a difference." We invest in things and people because we believe they are important. We give for any number of reasons, including recognition. So who are you and why should people give money to you? What are you doing that's important?

Successful fund raising involves conscious marketing, and a good place to begin the process of selling yourself/your work/your ideas is by defining who you are. If you don't define, package and market yourself, someone else will—a reviewer, a buyer, an agent, the public. Why not keep as much power as possible?

Here are some questions you'll need to answer in order to position yourself within the community and to decide who to approach for funding and how you'll frame the approach.

♦ Who am I speaking for? What constituency do I represent? What constituency does my project serve?

♦ Who are my companions on this road? In whose footsteps am I following? Who else is serving this constituency? Who else has a similar project? Who can I learn from? With whom might I collaborate?

♦ What's the purpose of what I'm doing? Is it filling a community or public need? What need?

♦ Who benefits from my project? In whose interest is my project? Who is my audience? Who would have an interest in helping me? Who are my funders?

### Are You an Individual Grant Seeker?

Some grants are awarded to individuals. These grants, often called fellowships, are awarded primarily on the artistic merits of the artist's work. Some grants to individuals are project grants; generally they are awarded based on the value of the project to the community or to the individuals being served; criteria often include artistic merit as well. Usually, individual grant applications are relatively simple to fill out.

### Do You Want to Align Yourself with an Organization?

An important concern of potential funders is whether or not they can take a tax deduction for their contribution to your project. Contributions are tax-deductible only if you have nonprofit status, or if you are formally aligned with an organization that has nonprofit status. The Internal Revenue Service designates an organization as charitable, tax exempt and nonprofit in Section 501(c)(3) of the IRS Code, and most corporate and foundation funders require that an organization seeking support have

501(c)(3) status. Organizational grant proposals are often more complex to prepare than individual grant applications.

Most grants are awarded to organizations. There are several ways to work within or in collaboration with an organization. For example, your project may be "adopted" by an organization, or you may want to find a fiscal receiver. Each has its own benefits and drawbacks.

A nonprofit organization may act as your fiscal receiver; this means that the organization receives the money, and subsequently passes it (or most of it) on to you. Why would an organization want to do this? One reason is because the organiztion's mission and your own overlap. For example, the Woman's Building in Los Angeles has acted as fiscal receiver for certain artists' projects presented in its galleries. Should you choose to ask a nonprofit organization to act as your fiscal receiver, the organization likely will charge you 5–10% of your grant and/or of any funds you raise to offset their administrative costs. These are allowable and reasonable charges, because the organization is assuming legal responsibility for your project. If you neglect to pay project-related bills, your creditors may take their case to the nonprofit organization. Having a fiscal receivership is being in a relationship, and it's most often successful when based on a clear understanding of each party's obligations. Mutual trust and shared values also help to ensure success.

### Do You Want to Form Your Own Nonprofit Organization?

Forming your own nonprofit organization is a time-consuming process that is a viable option for a long-term project or series of projects. Remember that a nonprofit organization exists in the public interest, usually to meet a community need. Nonprofit incorporation is handled on the state level; up-to-date books on incorporation in your individual state likely are available. Tax-exempt status is a federal procedure, and information may be obtained from the IRS.

### Where are You in Your Arts Career? Where are You in Terms of Fund Raising?

There are many stages in an arts career. You may be a student; you may have just graduated from school; you may be emerging or established; you may have a five-page single-spaced list of credits. Some funders are interested in artists at particular stages in their careers; look for the best match between your status and the funder's interests.

Create a fund raising plan that is possible for you to implement. If this year you only have the time and interest to research ten potential funders, make that your goal. If you feel that you are in a position to apply for three grants, set that as your goal. Develop a realistic schedule and objectives that you can meet, even if they seem very modest. Nothing is more encouraging than success. Identify your career priorities and make time for your fund raising effort, but try to be kind to yourself. If you haven't done this before, you may find it difficult and more time consuming than you anticipated. Be patient.

## MAPPING THE TERRAIN

Once you've identified who you are, the next step is to learn about the funding environment.

## Funding Sources

There are two basic sources for funding: public and private.

Public or government funding comes in three forms: local or municipal, state, and federal. You are probably best known in your own community, and people generally give to people they know or who are known to them. Also, people like to see what happens with their money. Therefore, when you're starting to fund raise, look close to home first; your town or city may give money to artists. Your county may be a potential funding source. Expand to the state and regional level as your reputation and experience warrants. Most states fund artists and art/cultural projects through state arts agencies. Finally, apply to the National Endowment for the Arts (NEA) after you have some solid experience behind you. But don't wait forever. Often, your first approach to a funder will be rejected. Don't be discouraged. Try again next year.

There are three primary sources of private funding: foundations, corporations and individuals. Foundations are set up to give money away. They are nongovernmental, nonprofit organizations established to serve the common welfare primarily through the making of grants. A private foundation must pay out a minimum of 5% of the average market value of its assets on an annual basis.

Corporations are set up to make money. Corporate giving programs are established and administered within profit-making companies; their giving budgets often are directly related to current profits. Corporate foundations maintain close ties with the profit-making business, and they reflect the company's strategic interests, i.e., are part of a marketing plan.

Individuals do what they please with their money. Historically, 80–90% of all philanthropy comes from individuals. Surprisingly, almost half of all individual giving in the United States is made by people earning $20,000 a year or less. Annually, religious organizations receive more than 50% of all individual giving, education receives more than 10%, and health, human services and the arts receive less than 10% each (traditionally, the arts receive fewer contributions than health or human services).

In most private giving situations, individuals and organizations work within annual giving budgets. However, there are often discretionary funds that may be smaller in amount but easier to obtain; they may be available outside of the regular giving cycles; it's worth investigating as you develop personal relationships with funders.

## Grants and Alternative Funding Strategies

Normally, written proposals are submitted to potential funders requesting a grant or support. There are several types of grants: operating grants underwrite the general operating expenses of an organization; program grants support the particular activities or services of an ongoing, model or new program; project grants are for special, often one-time projects; capital grants support projects with an expected use value of five or more years, such as the purchase of equipment and the construction of buildings; matching or challenge grants require that additional funds be raised, often one dollar in new revenues for every dollar of support awarded; grants for endowment require that the principal be invested in perpetuity and only the income from the investment be expended. Most funders specify the types of grants they award in printed information. Identify appropriate sources of funding by recognizing prospective funders' giving patterns.

Applying for grants is time-consuming; it's also a very effective way of raising funds. However, it's not the only way. Although space constraints prevent a full discussion of

all the alternative methods of fund raising, it's important that you consider alternative strategies, not only because they are tried-and-true methods, but also because they might be particularly appropriate to your situation.

One especially effective method is individual solicitation. It sounds imposing, but it's what you do when you run out of money and either call or visit the folks to ask for a gift or a loan. Studies show that the most effective way to solicit the largest gifts is to do so in person.

Special events include bake sales and black-tie dinners, auctions and intimate receptions at private homes. A simple, low-key special event might go something like this: an artist invites friends and family to her or his studio or home, serves wine and snacks, describes the work she or he wants to do, and asks for cash donations. It works.

When you write someone a letter asking for money, it's a form of direct mail solicitation. Large organizations may send direct mail packages to 200,000 potential donors; as a volunteer board member, I've found that sending out fifty to seventy-five letters really isn't very much trouble. I write a general letter, and I personalize each letter with a hand-tailored note. Personalizing form letters increases your chances for success astronomically; I recommend that you avoid sending impersonal mailings of any kind or letters with salutations such as "Dear Sir or Madame." How much money would you give to someone who doesn't even take the trouble to find out what your name is?

Sometimes, what you want most is not necessarily money. Artists need time to do their work. That's where artist colonies and residencies come in. Support may include space, a stipend, technical assistance, access to equipment, room and board and/or exhibition space.

Soliciting nonmonetary or in-kind contributions for projects is extremely effective. In-kind contributions have monetary value but are not received as cash. People often are more willing to donate goods or services than cash. If you need paint, approach your local paint store. A major expense may be rehearsal space; these days, there are often unrented commercial spaces available free of charge from a landlord. If an accountant, lawyer, photographer or other professional donates needed services, the fair market value of these services may be reported as an in-kind contribution. You may know a printer who will print invitations or fliers for free or at cost. Remember to ask yourself what you need, and who might be able to provide it for you.

## RESEARCHING POTENTIAL FUNDING SOURCES

Now that you know who you are, what the environment is, who's giving away resources and how to get them, it's time to make your personal short list of likely funding sources. You must match your needs with the funder's desires and mission. Funders say that the most common reason for rejecting a proposal is that the project does not fall within the funder's guidelines. That means the funder gives money for health care and someone tried to convince her or him to give money for children's art classes; don't argue with the funder's assumptions.

Research, research, research, but don't spend too much time doing it. There's an overwhelming amount of information available, and you can get lost in research. Printed reference materials are readily available at public, private and university libraries; these sources include *The Foundation Directory, The Taft Corporate Giving*

*Directory, The Chronicle of Philanthropy* and *Source Book Profiles.* The Foundation Center, with more than one hundred affiliated cooperating libraries in all fifty states, publishes numerous reference books and offers information through online databases. The Grantsmanship Center in Los Angeles provides training and publishes *The Grantsmanship Center News.* You can spend days in research libraries looking up and compiling lists of hundreds of potential sources. Decide up front how much time you want to spend doing research in libraries. Consider no more than two or three three-hour sessions annually: really, that's a lot of time and there are other efficient methods of identifying funding prospects.

If you are doing research in books or using computer databases, identify the easiest and fastest filters to be able to narrow down the field. Funders give in certain interest areas (health, not culture), in certain geographic areas (that's a fast one), certain types of support (capital grants, not operating), in a certain dollar range ($50,000, not $5,000), according to particular demographics (to seniors, not children) and to organizations just like yours or not like yours at all (to Queer Nation, not the John Birch Society). Find giving characteristics that narrow the field immediately so that you can eliminate less likely prospects easily.

Concurrently, ask everyone you know who they know. Personal contacts are your best resources for information about funders; ask friends, family, teachers, colleagues, business associates, individuals and organizations with similar objectives and projects. If you're an independent film maker, carry a pad of paper and a pencil to film screenings; the funders are always credited on-screen. If you're a visual artist, go to galleries and read artists' resumes; see what fellowships and grants they've received. Pay particular attention to the funding histories of those artists with whom you identify.

When you've narrowed the universe of prospective donors to a reasonably short list through whatever means, you'll want to get current information on the sources you intend to approach. Anything you've read in a book published this year may be a year or two old or more: someone had to compile and edit the information before it was published. Many funders will send you, at your request, application guidelines (which are periodically revised) and/or annual reports in which the funder's interests and priorities are spelled out succinctly. Annual reports are critical tools, because they often include who has been funded in the past, the amount of the funding, and what particular projects were funded. If you really need to know more, the public has access to a Foundation's 990–PF, an IRS form that lists, among other things, assets, expenditures, grant recipients and trustees. Foundation Center libraries in major cities keep 990s, or you can request them from the IRS (allow three months lead time for this process).

## DEVELOPING RELATIONSHIPS WITH FUNDERS

Your long-term objective is to develop excellent relationships with those who are in a position to provide you with the resources you need. It is easier to raise money from funders who have supported your work in the past than to cultivate new donors. Every contact you have with a donor or potential donor is part of a long-term relationship, and as such, is important.

### Making Initial Contact with Potential Funders

Depending on the potential funder's interests and desires, you may choose to make

initial contact in one of several ways: by phone call, letter of inquiry, or in a face-to-face meeting. Unless you're known to the funder, or you have a prior relationship, it's highly unlikely that the funder will want the initial contact to be in person. It's perfectly acceptable to pick up the phone and request application guidelines and an annual report, if the funder produces one, or a list of recent grants and grantees, if such a list is available. If you feel more comfortable writing a short note requesting this information, do so. Be courteous to everyone, especially secretaries, because it's the right thing to do and the right thing to do strategically.

Once you've got the most current available information, read it carefully. Although you've been careful in your research, the funder's priorities may have changed. If the guidelines state "No unsolicited proposals," don't send one. If an application form is included, use it; if a format is suggested, follow it closely. Follow the funder's directions in all matters.

If requested by the funder in written materials, or if it seems appropriate because no written materials are available, you may want to write a one- or two-page letter of inquiry. A letter of inquiry includes most or all of the following: a brief description of your work, your project or your organization, including its purpose and goals; the community or constituency you serve; key personnel involved; past successful similar projects and significant achievements; a statement on the problem or issue you are addressing; and a rationale. Remember, this is an introductory summary, not a proposal. Offer to develop a full proposal or supply more information or offer to follow up by phone. Invite the funder to make a site visit; although not often possible given the large number of applications to most funders, this is the best way to make your case. In your letter of inquiry, also enclose a project budget or a statement of the amount of funding needed. Writing to funders is addressed in further detail in the section on grantsmanship.

### Seeking Help with Applications

Grant writing workshops are offered at regional meetings of art associations such as the American Association of Museums (AAM). To help grant seekers fill out application forms and present themselves as competitively as possible, state and municipal art agencies often sponsor such workshops as well. Regardless of whether or not you are planning to approach a particular funder, these workshops provide information that is applicable to other and future situations. If help is available from your prospective funder, make use of it. Funders have varying resources, and most staff at funding agencies are hard pressed for time, especially as the number of requests for funds continues to increase. If you have a question, however, and printed material does not address your concerns, call the funder, making the conversation as brief and professional as possible.

### Funding Agency Review and Analysis of the Proposal

It's important to ensure adequate lead time for planning and writing your proposal. It may take three or four months for a private foundation to review your request; government funding agencies can take even longer; eight to twelve months is not uncommon. The review process varies from funder to funder, and it usually is noted in the application materials. Some funders review annually, some quarterly; some have strict deadlines, some accept requests throughout the year. If information is not provided, it's appropriate to ask questions about the review process.

## General Review Criteria

Each funder has specific criteria that are used in evaluating proposals. Some common questions asked by funders are:

♦ Does it fall within our guidelines?

♦ Can the individual or group accomplish the stated goals? Is there a track record or experience with a similar project? Are there qualified staff or project participants? If the applicant is an organization, is there an active board and is the organization well-managed? Does the organization have tax-exempt status? Does it have an audited financial statement? Who are the people who serve on the board?

♦ Is the project significant? What social, cultural, or community needs does this project address? How will it impact the community?

♦ Is the amount requested reasonable and appropriate?

♦ How will the project be evaluated?

♦ How will the project support itself when the money runs out?

♦ Will the foundation's grant make a real difference?

## Time Passes

If a significant amount of time will elapse between the initial submission and the application's review, you may choose to send additional information, with a cover letter, subsequent to submitting a proposal. This information may include reviews or other press, invitations to events, or news of other funding as appropriate.

## Responding to a Final Decision

Should your application be successful, write a letter of thanks promptly, if possible within twenty-four hours. Review the grant award letter (or package) to determine reporting or other requirements. Generally, a final narrative report is required describing the use of the funds. A financial accounting of the grant or interim reports also may be required. Make sure all appropriate people receive invitations to programs, events and/or openings. Additional communication is advised if you encounter problems with the project or if there is exciting news to share. Your funder is your partner and will understand challenges and difficulties, especially if you communicate as soon as possible after the problem presents itself. If you're running behind schedule, if the exhibition must be postponed, if all your pieces blew up in the kiln, by all means, tell the funder. Things happen, and your funder deserves to know. Most funders require final reports; submit them in a timely fashion.

If your proposal is rejected, give yourself time to deal with your anger and disappointment. Then, if it seems appropriate, make a telephone call to try to ascertain why the proposal was unsuccessful. If possible, speak with a program officer or someone who has real information about the specifics of the review process. Thank the funder for her or his consideration, note your disappointment, and ask why the proposal was turned down. Ask how you might improve the presentation. Funders often offer the

most intelligent constructive criticism, and I encourage you to listen as objectively as possible. I also recommend a letter of response to thank the funding source for its consideration. Feel free to reapply to the same source at a future date or with a different project. Don't get discouraged; many initial requests are rejected; as the form letters say, rejection does not imply that your project is unworthy; it simply means you weren't picked this time (the letter usually states that the funder has limited resources and cannot respond favorably to many very worthy requests). If, however, you can determine the *real* reason and solicit advice from the funder, you'll set yourself apart from 95% of grant seekers, who give up at this point. You are also developing your relationship with the funder.

### Maintaining and Cultivating a Relationship with the Funding Source

Once you have established a relationship, update the funder periodically with news of your progress even after the grant period is over. Include a description of the evolution of the project or the direction of your work, administrative news, an increase in community support or a fabulous review. Add the names of program officers, executive directors and other appropriate individuals to your mailing list. Nothing, however, substitutes for a personal letter or phone call. Create opportunities to sustain and deepen the funder's involvement and interest.

### Assessing Funding Potential

If you believe you have clearly articulated your case, and have adhered to generally accepted administrative procedures, and your attempts to secure funding are still unsuccessful, face the fact that your project, although it may be of great value, is difficult to fund. Expand your research to identify individuals and organizations whose interests and priorities coincide with your own.

Reassess the community's need for your project and the community's understanding of that need. If you believe that antioxidants will help prevent cancer, that's fine, but your conviction may not be enough to convince your best friend to take an assortment of vitamins and supplements. If others in your community do not share a belief in your work, it's going to be a hard sell. Be realistic. If you see the need but your funder and your community don't, you have a great deal of educating to do before you write a proposal.

## GRANTSMANSHIP

Many books have been written on grantsmanship, and more certainly could be written. I've tried to indicate the breadth of the territory and make some of my favorite points.

There are several kinds of proposals. Letter proposals are often appropriate for private funders—individuals, foundations, and corporate and business sources (try to make your approach to businesses as short as possible). Formal proposals usually include a cover letter and a separate proposal with or without funder-generated application forms.

As you are preparing your proposal, review and re-read the funder's guidelines, instructions and annual report (if available). It's amazing how many times even seasoned professional grant writers miss, misread or forget something. Follow directions

to the letter; you want to give the funder exactly the information she or he wants in precisely the requested form. Double-check; things can slip through.

Writing and editing skills are critical in proposal writing. If you're not comfortable writing, pay someone who is, or pay someone to edit your work, or trade services or artwork with someone to edit the final draft. You don't necessarily have to hire a professional, but you need a good writer and editor involved in the process. If you can do both, that's great, but find someone to edit your final draft anyway. Even if you've hired someone to work with you, you're not off the hook. A grant proposal that is written exclusively by someone not involved in the project is rarely as effective as a proposal by one who passionately believes in the work. Ensure that your intention and perspective are well represented.

You're not writing the Declaration of Independence; you're not writing the great American novel or even the great American short story. Proposals should be written in clear, simple English with as little jargon as possible. If you have to use technical language, explain it, and keep it short.

I cannot overstate the importance of the application package in establishing credibility for yourself and your project.

If you cannot complete the application form correctly, what evidence does the funder have that you can complete your project? If there is a coffee stain on the application, what is the implication in terms of craftsmanship? On the other hand, don't emboss the proposal in gold or use fancy binders; funders seldom are impressed and most would rather you spend your money on the project.

### What to Include in the Application Package

♦ A brief summary of your request. You should be able to describe your project in twenty-five words or less. Include who you are, what you propose to do, why you are the best person to do it, and what you need, specifying the amount of the request. The summary comes at the beginning of the proposal, but it helps to leave writing it to the end, after you've clearly thought through and articulated your project in detail.

♦ A statement about the problem or need your project is trying to address.

♦ A description of you or your organization including goals and significant past projects or accomplishments.

♦ A list of sources of support, including financial and volunteer help, and a list of current and past funders.

♦ A statement of your goals and objectives for the project and a description of the activities you'll undertake during the project. Don't suggest that your project will change the world and don't promise more than you can deliver; be realistic and specific. Tell the funder that you will teach sixty fifth graders how to make paper and help them with issues of self-esteem.

♦ A discussion of the project's evaluation process and its future potential. Funders want to know about the success (or failure) of the project as well as what will happen after the funder's money is used; will the work go on?

♦ Resumes or biographies of key staff members or project participants.

♦ Other supporting information (attachments), such as documentation of past work or projects, news clippings, invitations, promotional materials and reviews. Choose documentation that clearly represents your work and make sure the presentation is professional. Don't overload the reviewers with information; two or three outstanding reviews may be sufficient supporting information.

♦ Letters of support, which are often extremely helpful. Submit letters from respected colleagues in the field, from people who have benefited from past projects or who are likely to benefit from this project and from people who are likely to be known or respected by your funder. Letters of support are endorsements that establish credibility and suggest widespread support. Most people don't want to be pioneers. Many of us feel more comfortable if whatever we're signing on to has whatever we define as the "Good Housekeeping Seal of Approval." Sometimes it's a letter from another funder; sometimes it's a note from an audience member.

♦ A time line of activities.

♦ An itemized and realistic budget. Many grant seekers find budgets particularly difficult. I love budgets, and I hope the following discussion will make constructing a budget possible for even the most discalculic (people who are not good with numbers).

### Budget

Spend as much time on the budget as necessary to make it work. In my experience, people reviewing proposals check out the summary, see who's involved in the project, and flip directly to the budget. They want to know where the money goes.

A budget is simply another way of describing a project. Once you've constructed an intelligent budget, you've truly planned a program, because you've identified, in a very concrete way, what it's going to take to get the job done.

The first rule in budgets is that income always equals expenses. To those of you who wonder how that's possible, since you haven't raised the money yet, and that's why you're writing a grant in the first place, I say that you will raise the money, and your job is to convince the potential funder that you will raise all of the money, except for one piece, and if she or he gives you just that one piece of the total money needed, everything else will fall into place

Here's how it goes: the project is going to cost $10,000 and you're going to raise $10,000. Your mother has given you $2,000; that's listed under "individuals" on your budget and it has already been received. You've submitted a proposal to Foundation X, and they have written you a letter stating that they are going to award you $2,000; they have made a commitment. You've submitted a proposal to Foundation Y and you haven't heard yet; it's pending; you think they may give $1,000 (you've asked for $2,500). You're going to approach other private foundations as soon as you figure out who might be interested; that's the plan; possibly $1,000 will be awarded. There's a good chance the company your Uncle Harry works for will make a contribution; that's part of "corporate gifts'; name the company if possible (another $1,000). You're going to apply to a municipal funding agency; that's "government support" of possibly $1,000. What's left? Only $2,000. That's the amount of your request to whomever you're approaching now. See, it

adds up to $10,000. It's not all real, but it's not pie-in-the-sky either. Figure out where the money is most likely going to come from, and create the income side of your budget.

To the extent that it reflects reality, indicate in a note at the bottom of the budget the individual in-kind donations, such as performance and rehearsal space, bookkeeping services, equipment rental and box office personnel, which are not reflected in the budget. Because they represent resources and individual/community commitment to your work, you want to share this information with potential donors.

**SAMPLE INCOME SIDE OF BUDGET**

| | |
|---|---:|
| Individuals (received) | $ 2,000 |
| Foundation X (committed) | 2,000 |
| Foundation Y (pending) | 1,000 |
| Other private foundations | 1,000 |
| Corporate gifts | 1,000 |
| Government support | 1,000 |
| Request to Foundation Z | 2,000 |
| **TOTAL INCOME** | **$10,000** |

When you produce the expense side of the budget, make sure that all of the figures look and are reasonable. Get estimates; talk to colleagues involved in similar projects; find out what other people are paying for similar items. You should know the going rates in your field—for documentation, materials, rentals, for all your professional needs. Don't pad and don't skimp. If your Cousin Louise said she would take photographs of your work and you would rather hire a professional, put money in the budget for a pro. If you don't raise the whole budget, you've still got Cousin Louise. On the other hand, don't say your photographer is going to charge $900 an hour, unless that's reasonable and customary in your field. If any particular number doesn't seem reasonable at first glance, explain it. That's what footnotes are for.

Try to think of absolutely everything, because if it's not in the budget, you're probably not going to raise the money for it. Also, funders are very smart; they'll notice you didn't include the expense of carting your forty thousand pound sculpture from the studio to the gallery, and your forgetfulness won't inspire confidence. Potential funders will wonder what else you forgot. I don't recommend a contingency fund, because I think you should know what the project is going to cost. Besides, everything always costs more than you think it will. Before the unexpected occurs, you want to have a plan for dealing with it—by scrimping somewhere, by getting some materials or services in-kind, and by having produced a budget that is neither bare bones nor extravagant.

Artists' projects require expenditures in several areas. Expenses can be divided into three main categories: personnel, materials and supplies, and other expenses. If a significant percentage of your expenses falls in a particular category or subcategory, modify the budget to reflect the situation. Under the category of personnel, list costs for the project director, artistic personnel, technical personnel and administrative personnel; name each by title if you can. The materials and supplies category is comprised of duplication, office supplies, photography and art supplies, and fabrication materials. Other expenses include rentals, printing, postage and telephone, contracted services and publicity. Although this list is not exhaustive, it will serve as a basis for planning your own budget.

If your budget runs over two pages, create a one-page budget summary and also enclose the detailed budget.

## Review of the Proposal Before Submission

Before submitting the proposal to the funder, carefully review the guidelines. Have you followed directions? Have you included everything? Have you enclosed

the correct number of copies? Do you have all the signatures?

At some point, preferably four days before the deadline, sit down with the narrative and read it as though you've never seen it before. If you were the funder, would you fund it? How could you make it better? Could you frame the issues so that they are a little closer to the donor's heartstrings? Could you clarify or simplify or cut out three pages? Take some time to make revisions.

Look at the budget. Does it describe the proposal? If the funder looks only at the budget, can the funder make sense of the project you are proposing? Compare the narrative with the budget. Is everything described in one document confirmed in the other? For example, there should be no surprises hiding in the budget. Check your arithmetic; the budget gets worked with several times in the process of preparing a proposal, and it's not unusual for a mistake to occur.

Finally, let someone else look at it, someone you trust and respect. You're too close to it; you're just not objective.

A final point about funding proposals: it's my red flag theory. When I ask someone to review a proposal, I ask her or him to be on the lookout for red flags, those little nuisance buzzers that go off in your head when something isn't quite right. Maybe the project director's getting paid seventeen times what the artist is getting paid. Maybe it's not obvious why anyone would need forty-seven limousines to transport thirty school children down the street. Now, there's a reason for everything; I simply think the reviewer deserves an explanation. When a red flag is identified, try to justify or describe the apparent weirdness (or consider revising your plans). If a red flag goes up for you or a trusted colleague, it's fair to assume that it will go up for someone at the funding agency who is reviewing the proposal.

## THE 1990S AND BEYOND

It looks like the earth's resources are being stretched to the limit, and what's true globally is often the case locally. How is an artist to survive and flourish? Collaborate with others, share resources, make do with diminished resources, have fun. Artists are known for their creativity, and these times require it.

Set realistic goals; prioritize these goals, and retrench when necessary. Expansive times may come again, and then again, you may find you can reevaluate the project and get by on less. See whether you're meeting a perceived community need; even in difficult times, if the community feels your work is necessary, it will find a way to support the work.

Writing grants or engaging in other fund raising activities is time-consuming; it can be both rewarding and frustrating. Regardless of your funding success rate, however, the ability to articulate a project clearly and to prepare a budget are useful skills. Proposal writing is program planning; as you write a persuasive case and define the details of an undertaking, the enterprise becomes more real (if you can imagine and explain it, you can do it).

Finally, if you choose to pursue these avenues, give yourself credit for whatever you are able to do, and don't give up. Good luck. Perseverance furthers.

# WHEN TO HIRE A LAWYER

**GREGORY T. VICTOROFF, ESQ.**

*Gregory T. Victoroff is a partner in the Los Angeles law firm of Rohde & Victoroff and past president of the Beverly Hill Bar Association Barristers. He is the author of* Poetic Justice: Delivery of Legal Services to Artists and Authors, *published by the American Bar Association in conjunction with Mr. Victoroff's live and video ABA art law presentations in the U.S. and Canada. He is also a member of the ABA Executive Committee of the Los Angeles County Bar Association Intellectual Property and Entertainment Law section and is on the statewide Advisory Council for California Lawyers for the Arts.*

Due to the high cost of quality legal representation, lawyers should be hired only when their services are warranted. On the other hand, it is less expensive to consult a good attorney at the beginning of a legal relationship, or before you sign a contract, rather than after problems arise that could have been avoided by careful planning. A lawyer may be able to negotiate higher sales prices, advances or royalty rates, ownership, co-ownership or reversion of your copyrights, or a fair termination clause to get you out of a contract if problems arise.

Copyright infringements present serious questions regarding the economics of hiring lawyers. If the work was registered with the Copyright Office prior to the infringement, under current law, you have a chance of recovering the legal fees and costs (as high as $400,000 or more) involved in a copyright infringement trial. But if the work was unregistered, even if you win the trial, the court will not permit you to recover legal expenses; your recovery is limited to your "actual damages," not including legal fees, which damages, in most cases, do not amount to even half of the legal fees and costs of trial. Similarly, in breach of contract cases, if the contract provides for an award of attorneys' fees in the event of litigation, the possibility of recouping your legal fees and court costs if you win can make all the difference in your budgeting and cost-benefit analysis of how to deal with a breach of contract.

Do not expect lawyers to work for free; do not expect them to handle business disputes on a "contingency" (no recovery–no fee) basis, and do not get deeply into debt with your lawyer by commencing a lawsuit that you cannot afford. If appropriate to the type of business you do, develop and use a form contract with fill-in blanks you can customize to different situations. Do not run up a $1000 legal bill negotiating a contract that will only pay you $1200. Finally, do not confuse your relationship with your lawyer with your social relationships. Resist the temptation to call a lawyer just to

chat about your career or about minor business problems. Your lawyer has to charge $75–$250 per hour to pay for office rent, insurance, equipment, secretaries and law clerks. Respect the value of your lawyer's time and use this valuable resource sparingly and wisely.

## Ethics and Professional Responsibility

Although lawyers in every state are bound by rules of professional responsibility, ethical rules are sometimes violated. Here's a list of ethical rules that are often violated by lawyers representing artists and dealers.

♦ Failure to use proper written attorney fee agreements.

♦ Failure to maintain clients' money in a separate trust account.

♦ Failure to disclose, or obtain a client's written consent to, conflicts or potential conflicts of interest (such as where the lawyer or the lawyer's firm previously represented the artist or gallery you are currently negotiating with or suing).

♦ Abandonment of a client due to unpaid legal bills, or any other reason.

♦ Failure to communicate written offers of settlement.

♦ Direct solicitation of legal work.

♦ Failure to communicate with clients (i.e., returning phone calls).

♦ Failure to return all client's files and papers when the lawyer's services are terminated.

If you have questions or concerns about a lawyer's ethics or integrity, contact the State Bar to see if any complaints have been filed against that attorney. Ask for, and check out the lawyer's references. Be an informed consumer of legal services.

## Lawyer Referral Services

Many state and local bar associations have lawyer referral services. For a small fee, you can obtain the names of one or more lawyers with expertise in specified areas of law. In many cases, a free initial consultation is included in return for a referral fee of between $25–$40. In many states, Volunteer Lawyers for the Arts organizations, listed in the resource appendix, provide referrals to free or low cost lawyers for qualified artists.

## Types of Law Firms

Law firms come in many different sizes and styles, ranging from one to five hundred lawyers. As a general rule, larger law firms charge more than smaller firms. In

return for higher fees, clients sometimes get access to services not offered by smaller firms, higher quality lawyers, in-house translators, computerized online legal research capability, 24-hour word processing, in-house messengers, lavish conference rooms and complete libraries. Large firms may also offer expertise in diverse areas of law such as tax, immigration, criminal law, copyright or trademark law, which may not be available at a smaller firm. For ordinary employment contracts, sales contracts or usual business and collection matters, most individual clients can get their needs handled as well at a small firm as at a large one.

For matters involving specialized areas of the law, it is crucial to consult an attorney with training and experience in the particular area. When copyright, patent, tax, criminal or family law is involved, be sure the attorney you consult has taken the appropriate courses, including recent continuing legal education courses (required by law in many states) and has had recent firsthand experience handling matters similar to yours. Many state bar associations have created certified specialties. In California, only criminal law, workers' compensation, immigration, taxation, patent law, and family lawyers can truly call themselves certified specialists.

Art law is not a certified specialty in any state. Any attorney claiming to "specialize" in any aspect of art law is claiming credentials that don't exist. Matters involving patent law (protecting rights to inventions rather than art) can be handled only by attorneys who have passed a special patent law bar exam. Beware of novice attorneys or attorneys interested in "learning about" or expanding their practice into the area of art law. You may end up having your lawyer learn at your expense and getting inferior services in the bargain.

## LEGAL FEES

Lawyers are expensive, usually charging $75–$150 per hour for their services. Lawyers who "litigate," that is, bring and defend lawsuits in court, charge even more. That is particularly true of litigators practicing in the federal courts where all claims involving copyright must be brought. Lawyers with experience in the diverse areas involved in the representation of artists, galleries and art dealers, such as contract, business law and copyright, may cost even more, charging between $150–$350 per hour.

Do not be misled by the old fashioned notion that it is somehow undignified to investigate the expense of legal representation before hiring a lawyer. In the real world, idealistic fantasies of defending one's principals at a jury trial are luxuries that can be afforded only by a few wealthy individuals and companies. In many large metropolitan areas, it can take three to five years for a lawsuit filed in state court to come to trial; two to three years in federal court. That's three years of legal activity, averaging between $1,000–$5,000 per month. Lasting between three to five years, major lawsuits can easily cost $50,000–$500,000 in legal fees, plus up to $20,000 in costs. Costs can include long distance phone calls, photocopies, faxes, overnight mail service, postage, messengers, trademark and copyright search reports, copyright and trademark application and registration fees, expert witness fees, court reporter fees and more. In light of the inordinate expenses that occur during litigation, it is essential to allocate your financial resources wisely when planning legal action.

Legal fees are almost always negotiable and are rarely set by law. The number of different fee structures is limited only by the resourcefulness of the client and lawyer.

Examples of different fee arrangements include hourly rates, flat fees, share of money received or recovered, share of money saved, contingent on result, bonuses, or any combination of these. It has become increasingly common in hard economic times for lawyers and artists and dealers to barter artwork for legal services. Regardless of the terms of the fee arrangement, lawyers have an ethical obligation not to charge an "unreasonable" fee. What is reasonable, however, varies from case to case, depending on the difficulty and time involved, results obtained, the complexity of the matter, and other factors. The lawyer may not pay him or herself out of a client trust account if the fee is disputed. State and local bar associations have fee dispute mediation and arbitration services that can often help resolve fee disputes with a minimum of acrimony and expense.

## FINDING A LAWYER

There is little difference between hiring a lawyer and hiring an auto mechanic or plumber. If you want to hire a lawyer and have determined that the value of the dispute warrants incurring legal fees, and you can afford the fees, or have made other financial arrangements to pay for the legal services, you should begin your search for a competent attorney. Obtain personal recommendations from trustworthy individuals about more than one attorney if possible. Check around to see if the lawyer's fees are competitive, remembering that price is not always the best indication of the value or quality of an attorney's work product. Remember that you have the right to seek the advice of another lawyer regarding any terms in the retainer agreement. Do not be shy about discussing fees—hourly as well as long range.

Questions to ask regarding the work to be done by the attorney:

♦ How much will it cost?

♦ How long will it take?

♦ Is it guaranteed?

♦ What are the chances of winning?

♦ What are the risks of losing?

♦ Can I get it done any cheaper?

♦ What are my alternatives?

♦ How many of these types of matters have you handled lately?

♦ What were the results of those similar cases?

♦ Does the attorney carry malpractice insurance?

## RETAINER AGREEMENTS

In many states, attorneys, by law, must provide clients with some kind of written fee agreement. In California for example, when a fee is likely to exceed $1,000, lawyers must provide individual clients with a written fee agreement. In addition to explaining the lawyer's fee, the agreement must disclose whether the lawyer has malpractice insurance, that the fee is negotiable and not set by law, and other information required by the State Bar. Even if not required by law, a written fee agreement avoids misunderstandings, expresses the parties' expectations and may save you money and avoid headaches in the long run.

## TERMINATING LEGAL SERVICES

You have an absolute right to fire your lawyer at any time, but your attorney/client relationship should only be terminated after you have considered all of the consequences. Unless the attorney has been seriously negligent in handling your case, simply firing him or her will not relieve you of the obligation to pay reasonable legal fees and costs incurred during the representation. Written contingent fee agreements may give the attorney the right to receive a fair share of any recovery, even if they are fired and payment is obtained by another lawyer. This factor may affect a new lawyer's willingness to accept your case, and could diminish your net recovery by causing you to pay two lawyers. Usually a short, polite note is all that is required to terminate the services of your attorney. You should also provide instructions regarding any pending matters, requesting the attorney either to complete a certain matter, or immediately stop all work. You should also instruct the attorney where to send your files and papers; usually either to you or to your new attorney. Regardless of the circumstances of the termination, the attorney has an ethical and legal duty to return your files and papers to you without delay.

# COLLECTIONS: GET THE MONEY

**KENT C. LIU**

*Kent C. Liu is an attorney based in Los Angeles.
His practice is concentrated in the areas of copyright,
trademark, music, business law and business litigation.
He is a panel attorney and frequent volunteer with
California Lawyers for the Arts. Mr. Liu is a graduate
of UCLA and University of the Pacific,
McGeorge School of Law.*

One important step often overlooked by artists is the mercenary task of actually getting the cash in *your hands*.

Clearly, the best arrangement is to be paid in advance. However, this is not often customary and/or the situation does not lend itself to advance cash payment. Many times you will find yourself in the situation where you must wait for payment. A typical situation is working on a project for someone with payment to be made upon completion.

In the event that you encounter difficulty in being paid on time, or being paid at all, there are several alternatives available to you. If your dispute involves a large sum of money, you may wish to seek out the services of an attorney. However, if the sum owed you is not large, there are still methods available to protect your rights that do not necessitate the hiring of an attorney.

You can attempt to resolve the dispute informally or formally. One way to resolve a dispute informally is by negotiating a settlement with the person owing you the money without involving a third party to act as an intermediary. The other options available are more formal involving filing fees, legal procedures and documents, rules and one or more persons acting as an intermediary. The formal methods vary, ranging from the relatively informal methods known as "alternative dispute resolution" (ADR), to the filing of a lawsuit in court.

## INFORMAL RESOLUTION: DIRECT SETTLEMENTS

The simplest way of resolving your dispute, is by dealing directly with the other party. If you and the other party can settle the dispute, you both end up saving time and money.

Generally speaking, resolving a dispute via this method involves nothing more than opening discussions with the other party. The goal here is to reach a resolution that is acceptable to both parties—a compromise that everyone can live with. For example, you believe that you are owed $500. Upon confronting the other person, he

offers to split the difference with you and pay you $250. From there, the two of you negotiate and finally reach an amount that you can each live with and settle on $350.

Assuming that you and the other party have agreed on terms that will settle your dispute, do not be surprised if the other party (the one owing you the money) wishes to have a signed written agreement reflecting the agreement. This protects both parties in that it is a contract in settlement of your dispute. It is also evidence of the resolution if you have to sue to collect payment.

It is best to obtain the money before, or simultaneously with the signing of the agreement, but it is not essential. Even if the agreement is signed before the money changes hands, it will not be effective until the other party pays you, so long as you have not acknowledged receipt of the money in the signed agreement.

This document has certain additional benefits. If it was difficult to reach a settlement with the other party, you may wish to get the settlement in writing and consummated as quickly as possible, thereby committing the other party to the settlement and reducing the risk they may change their mind.

*Caution:* Before engaging in discussions with the other party, be aware of the "statute of limitations" applicable to your situation. A statute of limitations is a law that fixes the time within which you must sue or lose the right to bring a lawsuit. You must know how much time you have to work out your problem, because there is no guarantee that you and the other party will come to an agreement.

Before signing any settlement agreement, be sure that it accurately reflects the dispute that is being settled. Be certain that it is written as narrowly and specifically as possible, faithfully recounting the facts of your dispute. If the agreement is drafted broadly, describing facts and disputes beyond the dispute that you intend to settle, you may lose your right to bring a lawsuit for the other disputes.

## FORMAL RESOLUTION: ALTERNATIVE DISPUTE RESOLUTION

Alternative dispute resolution (ADR) are informal methods compared to filing a lawsuit in court. Usually, these methods utilize the services of a neutral third party, someone who does not have an interest in the dispute. This person will either decide who is right or wrong, or will find a way for the parties to settle their differences.

Both ADR and the small claims courts are similar in that they are fairly inexpensive and move quickly. However, the main difference between ADR and the small claims system is that ADR has no jurisdictional limit on the dollar amount of the dispute. If your claim is greater than $5,000 yet not great enough to justify the hiring of an attorney and the filing of a lawsuit in a higher court, ADR may be a viable and practical alternative.

Similar to working out a settlement directly with the other party, ADR methods are voluntary and private. Compared to the filing of a lawsuit in a court higher than the small claims court, ADR will save you time and money. Most courts are very busy and understaffed. Consequently, using the legal system is very time consuming and expensive. Whereas, resolving a dispute through ADR may take only a few hours, thereby reducing the costs. In addition, some organizations that provide ADR services charge low fees or none at all. Lastly, ADR can be less confrontational than a lawsuit, therefore you may be able to resolve your dispute without ruffling feathers.

## Mediation

Mediation is the most informal of the ADR methods. The mediator, who is a trained neutral third party, will discuss the dispute with you and the other party. Depending on the situation, he may speak with both of you together or separately.

Mediators do not give opinions or decide who is right or wrong, they merely attempt to facilitate a settlement. A good mediator will help you and the other party exchange information and ideas to settle your dispute.

It is quicker and cheaper than many other ADR methods. However, the mediator is not obligated to resolve your problem. Thus, the downside to mediation is similar to that of dealing directly with the other party. After going through the entire process you may not reach a final resolution.

A more detailed discussion about mediation is found in the chapter "Mediation for Visual Artists."

## Arbitration

Arbitration is more formal than mediation, although less formal than a lawsuit. In some ways, it is comparable to a lawsuit filed in small claims court, which will be discussed below.

As with all methods of ADR, arbitration is voluntary. However, if your dispute involves a contract it may include an arbitration clause and you may have no choice but to arbitrate your dispute. Thus, arbitration is voluntary in that you voluntarily signed the contract.

Most organizations providing arbitration services utilize rules similar to those of the American Arbitration Association, the largest nationwide organization providing arbitration services. These rules generally relate to procedural matters such as the filing of documents, the selection of an arbitrator and the scheduling of the hearing. As for the hearing itself, the arbitrator, a trained neutral third party has the authority to handle the proceedings as he sees fit. For instance, if attorneys are representing both parties, the arbitrator may choose to run the proceedings similar to a regular court trial. Or, if only one side is represented by counsel, he or she may choose to handle things more informally.

In any case, arbitration is the most formal of the ADR methods in that both sides are given the opportunity to present evidence, both written and oral to the arbitrator. In addition, the parties can call witnesses. The arbitrator then considers all the evidence presented and makes a decision.

Generally speaking, arbitration clauses are drafted such that if they are implicated, the arbitrator's decision will be "binding" (i.e., final). However, if an arbitration clause is not involved and you and the other party choose to utilize arbitration, the two of you can decide beforehand whether or not you wish the arbitrator's decision to be final. If it is agreed that the arbitrator's decision will be nonbinding, either party will have the ability to "vacate" or reject the arbitrator's decision and go to court.

## Finding an ADR Program

If you and the other party determine that ADR is appropriate for your dispute, the next step is to locate an ADR program. Your state bar, local bar association, volunteer lawyers for the arts programs, phone book and state department of consumer affairs can assist you in locating an ADR program. The American Arbitration Association has offices nationwide in most major cities.

# SMALL CLAIMS COURT

Although small claims court involves the court system, it is considered an informal procedure. There are no juries or attorneys, only a decision as to who is right or wrong.

Although the exact operation of small claims courts varies from state to state, they are generally similar. This chapter will go through the steps of filing a claim by guiding you through the California small claims system.

## Filing a Claim in Small Claims Court

As a preliminary matter, the person filing the claim is the "plaintiff." The party who is sued is the "defendant."

*Jurisdiction.* Small claims courts have a "jurisdictional" limit on the amount of money that can be claimed. If the amount exceeds this limit, the court will be unable to hear the dispute or you will have to forego claiming the amount that is over the limit.

In California the jurisdictional amount is $5,000. Thus, the court can hear any dispute that involves a claim that is $5,000 or less. If your claim is greater you may want to sue the defendant in a higher court. Or, you may reduce your claim to fit within the limit. If you are owed $5,500, you can give up $500 in order to bring your claim within the limit. However, you cannot sue the defendant twice separately, once for $5,000 and a second time for $500.

In addition, small claims courts generally limit the number of cases a person can file during a certain period. For instance, in some states, during a calendar year (between January 1 and December 31) you cannot file more than two small claims cases claiming more than $2,500 each.

*Attorneys and Assistance.* Attorneys are not allowed to argue for you in small claims court, however, you are allowed to consult with an attorney as often as you like before the trial. After a judgment is rendered in your case and if either party appeals the judge's decision, both parties may be represented by attorneys.

If you do not know an attorney, cannot afford an attorney or it is impractical to hire an attorney, you can often obtain assistance and information from a small claims advisor. In California, the law requires that each county provide a small claims advisor without charge.

*Statute of Limitations.* As discussed earlier, as soon as you think you may have a dispute you should find out the applicable statute of limitations. If the statute of limitations has already passed it is too late to file even a small claims lawsuit.

In California, a personal injury claim must be filed within one year of its occurrence, but claims involving property damage, contracts and other problems may be filed beyond one year, but rarely more than two to four years.

*Demand.* Before filing a claim, you must demand payment, if possible, from the defendant. If the situation allows, it is best to do this in writing. If the defendant refuses to pay you or ignores your demand, you can then proceed with your lawsuit.

*Venue—Where You File Your Lawsuit.*  You must sue the defendant in the proper court. If you file in the wrong court, your case could be dismissed. The following circumstances will determine which court you should file in: where the defendant lives or where the business is located; where the damage or accident occurred; where the contract was signed or performed; and if the defendant is a corporation, where the contract was broken.

*Defendant's Name.*  Although this may seem trivial and simple, it is very important that you sue the defendant using his, her or its *exact legal name.* If you do not use the correct name of the person or company you are suing, your case may be dismissed and you will have to start the process over. Or, if the incorrect name is used and it is not brought to the court's attention at the trial, it may cause problems when you try to collect your money judgment from the defendant, if you prevail in your case. Therefore, be sure to state the defendant's name correctly.

If you are suing a person, you will need their full name and address. If you can, obtain the defendant's middle name, if it is unavailable it is acceptable to sue without it. However, when filing your claim be sure to get the person's correct first name, not a nickname or middle name. Also you must use an actual street address, not a post office box.

If the defendant is an unincorporated business, you will sue it by the company name as well as the owners' names, because the owners will be liable for any judgment you may obtain against the company. If you only have the owners names and you cannot acquire the company name, this is not fatal to your suit. However, if you only have the business name, you will need to secure the owners' names because these are the people that you will actually be suing. To get the owners' names, you can contact your County Clerk's office and locate the names of the owners by giving them the "fictitious business name."

If the defendant is a corporation you will need the full name of the corporation, its address and the name and address of the person who is designated to accept service of lawsuits, called the "agent for service." Generally, you can obtain this information from your state's Secretary of State.

*Facts of Your Dispute.*  In order to fill out the required paperwork, you must calculate the exact amount of money you feel is owed you. You will have to state the reason(s) why you are claiming the money as well as the date and place that the dispute arose. Essentially, you will have to state what happened.

*Notifying the Defendant.*  A copy of your claim, called the "Complaint," must be delivered to the defendant by a person over 18 years of age who is not a party to the lawsuit. This is known as "serving" the defendant.

Generally, there are four ways to accomplish this: 1) You can serve the defendant by paying a fee and arranging for the sheriff's or marshal's office to serve the notice. 2) You may arrange for a "process server" to personally make the delivery. A process server is a

private party licensed by the state to serve parties to lawsuits. Generally, their fees are higher than the sheriff's or marshal's office. 3) A friend of yours can act as a process server, however, he must sign the "proof of service" form discussed below. 4) In some cases, the clerk of the court can also serve the defendant for you by *certified mail.*

The proof of service form must be signed by the process server or clerk of the court (if you use certified mail) stating when and how the defendant was served with notice of your lawsuit. This proof of service must be returned to the court clerk as soon as the defendant has been served. If the defendant does not appear at the trial, the court will inquire as to whether the defendant was ever informed of the lawsuit and trial. If you cannot prove that the defendant was served, the judge cannot rule in your favor even though the defendant did not appear. You may then have to obtain a new trial date and re-serve the defendant.

Properly serving your lawsuit is an important aspect of your small claims action. There are very detailed and specific rules that must be followed. Be sure to follow them exactly. Instructions can be found in the paperwork provided by the small claims court.

## Cross-complaint

The defendant in your case may believe that he has a claim against you. If this is the case, he may file a cross-complaint against you. This is also referred to as a "Claim of Defendant." There is no difference between the Claim of Plaintiff and the Claim of Defendant; you just happened to file your claim against the defendant before he or she filed a claim against you. Therefore, everything discussed above and below relating to your claim (the Claim of Plaintiff), applies, for the most part, with equal force to the Claim of Defendant.

## Preparing for Court

You will have an opportunity to present your evidence to the judge. Generally, there is not a set amount of time for the presentation of evidence, however, because the courts are so busy it will not allow the parties to get into issues that are extraneous to the dispute. Therefore, you should be organized and familiar with all aspects of your case in order to make efficient use of your time and effectively communicate your position to the court.

Be sure to add up the costs that you have incurred in filing your lawsuit. Bring the itemized list of these expenses to the trial and ask the judge to add this amount to the judgment, if you prevail.

## What to Bring to the Court Trial

If your claim involves any documents, be sure to bring originals of all the documents necessary to proving your case. In the event that there is a question as to the authenticity of any of the documents, the originals will assist in resolving that issue. It may help to bring photocopies of each document to court, including a copy with notes on it for your own use.

If your claim involves any objects or articles, for example, damage done to your artwork, bring it with you if possible. If the item is too large, or is immovable, bring photographs showing the damage that was done.

Lastly, if you have any witnesses, you will have to bring them to court. Small claims courts often consider only live testimony from witnesses. However, in the event that your particular judge will accept a signed statement in lieu of live testimony, you should get your witness to sign a declaration narrating his testimony, notarized if possible.

If a witness refuses to attend the trial or the other side refuses to provide important documents, the court has the power to issue a "subpoena." This is an order from the court directing the witness to attend the trial or bring the documents. If a subpoena is necessary, the court clerk can tell you how to do this. But, if you subpoena someone, be prepared to pay that person a small fee, usually set by law, for each day that he has to appear in court, plus mileage to and from the court. You may be able to recover these costs if you prevail.

### Failure to Appear at the Trial

If you, the plaintiff fail to appear at the trial, your case may be dismissed or decided in favor of the defendant. If the defendant is unable to attend the trial on the scheduled date, he or she can write to the court clerk before the trial date and ask to get the date changed. However, if the defendant was properly notified about the lawsuit and trial and did not show up, the judge is likely to order a "default judgment" against the defendant. Essentially, this means the court has decided the case against the defendant.

If either of the above situations occurs, the party may still be able to get a second chance. But, in order to get a second chance, they will need a very good reason for not attending the trial. If you think you have such a reason, you must file a motion to "vacate the judgment." This must be done within twenty days of the date that the court clerk mailed you notice of the court's decision. The papers for filing this motion can be obtained from the small claims court. Furthermore, you must file this motion, if you wish to appeal the decision with a higher court. Otherwise, you may lose your right to appeal.

### What Happens at the Trial

At the trial, when requested to by the judge, you make a brief statement summarizing the facts and your position. Listen carefully to any questions the judge asks and answer the question that is asked. Do not attempt to bring in evidence that is beyond the scope of your case. When the judge is finished questioning you and you feel that further issues need to be discussed or clarified, at that time ask if you may provide further evidence or testimony.

As you are presenting evidence to the court, be sure not to insult or argue with the defendant, no matter how upset you may become.

Upon the completion of the presentation of evidence by both parties, the court may announce its decision or may take the matter "under submission." If it is taken under submission, the judge will have an opportunity to review and research the law if necessary and will probably render a written decision in a few weeks.

### Judgment

If you are successful and the court orders the defendant to pay you the money that you claimed in your lawsuit, you are now the "judgment creditor." The defendant, the losing party and the one owing the money is known as the "judgment debtor." Although you have won your case, enforcement of this judgment is put off until the time period for the filing of an appeal has passed or until a decision has been rendered in the appeal. Thus, you cannot collect your money or take any further action until this time period has elapsed.

## Appeal

An appeal is a resort to a higher court for review of the small claims court's decision and the granting of a new trial. Only losing defendants can appeal the court's decision. If you are the plaintiff and you lose, you cannot file an appeal, unless the defendant filed a Claim of Defendant against you and you lost the case.

The time period available to the defendant to file an appeal is limited. In California, the timing is thirty days from the date the Notice of Entry of Judgment is mailed. If an appeal is filed, there will be a new trial on all the claims that were presented in the original small claims action. Accordingly, there will be a new trial and both parties will have to present their evidence all over again. The parties are allowed to be represented by attorneys in the appeals phase.

## Costs

The prevailing party is generally entitled to the costs expended in bringing the lawsuit. These costs include all court filing fees and any costs related to serving the defendant. In attempting to collect on your judgment, you may incur additional costs. You are generally entitled to recover these costs as well as interest on the judgment at the prevailing legal rate. In order to make these additional costs part of your original judgment, file, with the court, a form known in California as "Memorandum of Costs."

## Collecting the Judgment

If you won the case and the time for filing an appeal has passed or you won the appeal, you are now ready to collect your money or get possession of your property. Unfortunately, the court cannot collect the money for you, but the information on the forms and the small claims advisor can assist you and provide you with some techniques to collect your judgment on your own. Here is a list of the methods available to you.

***Voluntary Payment by Judgment Debtor.*** Clearly, your first step should be to request the judgment debtor to pay you, or to return the property if your claim involved the possession of property. Hopefully, he or she will comply with your request and your suit will be completely finished upon the filing of an "Acknowledgment of Satisfaction of Judgment" (this form will be discussed later). However, if he or she refuses to pay or return the property, you will have to resort to the means discussed below in order to collect your judgment, because the court will not do it for you.

***Statement of Assets.*** If the judgment debtor refuses to pay you the judgment amount, he is required by law to submit to you within thirty days from the date the court clerk mailed him the notice of entry of judgment a form known as "Judgment Debtor's Statement of Assets." This form contains questions regarding the nature and location of the judgment debtor's assets that may be available to satisfy your judgment. If he willfully refuses to provide you with this form completely filled out and in a timely manner, you may ask the court to apply sanctions (i.e., penalties) to your judgment for contempt of court.

***Order of Examination and Subpoena Duces Tecum.*** In addition to the Statement of

Assets, the "Order of Examination" and "Subpoena Duces Tecum" are further methods available to you to obtain financial information about the judgment debtor.

By filing an Order of Examination with the court you will be able to force the debtor to answer questions in court concerning his income and property. Furthermore, by having a Subpoena Duces Tecum issued, you will be able to obtain any documents under the judgment debtor's control that are relevant to collecting your judgment. Thus, via this method, you will be able to obtain his or her financial records. These forms can be obtained from the court clerk's office.

***Additional Ways to Locate the Judgment Debtor and His Assets.*** Although this is not a formal method addressed by the judgment enforcement laws, a review of all public records may reveal information about your judgment debtor and his assets. Accordingly, it may be worthwhile to check with the County Assessor, County Recorder, County Clerk, Secretary of State, Department of Motor Vehicles, State Board of Equalization, Contractor's Licensing Board and Professional Organizations (i.e., State Bar, State Medical Association, etc.). By using these public records, you may be able to determine whether he or she has multiple locations or more than one mailing address, which may lead to the location of more assets.

In addition, from your previous dealings with the judgment debtor you may have a social security number or know his bank account number(s) or branch where his bank account is located. For example, if you received a check from the judgment debtor in the past, if you have a photocopy of it you can easily locate the account. If you wrote him a check, the back of your canceled check may indicate where the check was deposited.

As a general rule, you should collect the above mentioned information during the course of any business relationship. This goes for any relationship you have with anyone who may one day be in the position of owing you money. This will make collecting on your judgment easier, in the event that you bring a lawsuit and prevail.

***Writ of Execution.*** After you have obtained and evaluated all the information concerning the judgment debtor's property and finances, you are ready to seek a "Writ of Execution" from the court. A Writ of Execution is a court order to enforce the judgment creditor's judgment. The Writ is like a hunting license of sorts, authorizing a sheriff or marshal to seize the property that has been described in the Writ to satisfy the judgment.

After the writ is issued by the court you must deliver it with instructions and the required fee to a "levying officer," usually the local sheriff or marshal. The officer then seizes the particular property identified in your instructions. Almost anything that the judgment debtor owns or is entitled to is fair game. Some examples of the types of property that the sheriff or marshal may seize on your behalf are the debtor's wages (wage garnishment), car, bank accounts, the income of an ongoing business (till tap), personal property, land and/or rental income. However, certain types of property may require the filing of additional forms.

***Abstract of Judgment.*** If the judgment debtor owns real property (i.e., land), you may wish to record a "lien" on that property. A lien is a claim or encumbrance upon the property of another as security for a debt owed by the owner of the land. If the land owner ever sells the land, the lien holder will be paid from the proceeds of the sale.

In order for the lien to be effective, you must fill out and file an Abstract of Judgment with the County Recorder's office in the county where the land is located.

If the land is sold, a properly recorded lien will almost guarantee you payment. However, the problem with a lien is that you have no control over when or if the property will be sold. If the property is never sold you should not expect to receive payment as a result of your lien.

*Credit Rating Agencies/Credit Bureaus.* Finally, if the judgment debtor is being uncooperative, you can report your outstanding judgment to a credit rating agency or credit bureau. Although this is not illegal, you will not find it in the judgment enforcement laws of your state. It is merely a practical solution to a stubborn problem. By reporting the unpaid judgment, you will put a black mark on the debtor's credit rating and it may impede him or her from obtaining a loan or some other form of credit. If this happens, the debtor will be forced to pay you in order to clear up his or her credit. If the judgment debtor really desires the credit or loan applied for, they will have considerable incentive to pay you.

### Satisfaction of Judgment

Immediately upon obtaining full payment from the judgment debtor, whether by voluntary payment or one of the methods illustrated above, you must file a "Satisfaction of Judgment" with the court. The Satisfaction of Judgment is an acknowledgment by you, the judgment creditor, that the judgment owed you by the judgment debtor has been paid and completely satisfied.

Unless you have sufficient justification, failure to file the Satisfaction of Judgment with the court clerk within fourteen days of receiving a request by the court or judgment debtor to do so may expose you to liability to the judgment debtor for any and all damages sustained by him by reason of your failure to file the Satisfaction of Judgment, as well as a $50 sanction.

## CONCLUSION

If you cannot hire an attorney or your situation does not necessitate the hiring of an attorney, do not be discouraged from pursuing your claim through ADR or the small claims system. The information discussed above may seem complicated, but in actuality, these systems are more user friendly than they may appear.

# MEDIATION FOR VISUAL ARTISTS

**MADELEINE E. SELTZER**
*Madeleine E. Seltzer is a former practicing attorney
and a partner in Seltzer–Fontaine, a legal search firm
based in Los Angeles. She is a volunteer mediator for
Arts Arbitration and Mediation Services, a program of
California Lawyers for the Arts and an advisory board
member for Sojourn Services for Battered Women
and Their Children.*

**W**hen the relationship between an artist
and his or her representative breaks down, or a dispute arises between the artist and
others, it is advisable to consider mediation as a means of resolving the problem.
Mediation is usually superior to the traditional manner of settling disputes in our soci-
ety—litigation in the courts—for a variety of reasons. It is particularly well-suited to
resolving disputes involving artists because of its unique characteristics and should be
considered before other options are pursued.

## GENERAL PRINCIPLES

Mediation is a form of alternative dispute resolution, a term that is used by attor-
neys to describe resolving disputes outside of the court system. Mediation, however, is
unique from other alternative dispute resolution methods, in that the parties them-
selves craft their own settlement of their particular dispute. The goal is to remove the
adversary structure of the conflict in which each party is essentially at war with the
other, and only one party comes out the winner. Theoretically, the parties do this in a
proactive, cooperative and mutual manner. Instead of a judge or arbitrator imposing a
decision, a neutral third party, the mediator, assists them in the process. Because the
parties deal directly with each other, set their own agenda, and work out their own
resolution, mediation allows them to explore their relationship, the difficulties that led
to the conflicts at hand, and come up with creative solutions.

In addition, mediation has other attractive features. First, it is low risk because it is
voluntary and nonbinding. If it does not result in a mutually agreeable settlement of
the dispute, the parties are free to pursue other courses of action, including litigation.
Second, it is flexible and adaptable. It is applicable to almost any kind of dispute; it can
be utilized at any stage of a conflict; and the parties can choose any available mediator.
Third, it is informal—there are few structural or substantive rules such as rules of evi-
dence or procedure or legal precedents that must be followed. Finally, it is cost-effective

in intangible as well as tangible ways. Legal fees are minimized, as with other alternative dispute resolution methods, and the parties, not their lawyers, run the mediation. Mediation takes much less time to conclude than other methods of dispute resolution. Also, the nonadversarial and cooperative nature of mediation helps the parties to avoid the costs associated with damage or destruction of their business relationship, thereby enabling them to continue in a mutually profitable arrangement. In addition, the emotional costs of antagonistic combat in litigation are avoided. Moreover, agreements arrived at through mediation are usually more durable than other forms of dispute resolution so that the costs associated with future disputes are avoided.

## HOW MEDIATION WORKS

The basic mediation process involves the parties, which may comprise two individuals, several individuals, or even groups on either side, and one mediator or two co-mediators. The fundamental purpose of the mediator(s) is to facilitate discussion among the parties; to create an environment that allows the parties to effectively communicate with each other, express their grievances and discover their own road to settlement of their conflict. The mediator may also help in articulating a potential agreement that the parties are close to reaching: that is, the mediator may help to draft an agreement that fairly, fully and specifically incorporates the parties' intentions.

The actual mediation process is quite simple, which is part of its beauty and attraction. It usually begins with each party giving his or her account of the situation that led to the mediation. Then, with the help of the mediator, the parties set an agenda as to how they want the mediation to proceed. Issues are narrowed and, with the use of various devices employed by the mediator, such as private meetings with the individual parties, called caucusing, the resolution process begins. The goal is to reach a written agreement as to some, if not all, of the matters in dispute. The parties should be aware that such agreements are usually enforceable as contracts in courts of law.

In order to encourage free and uninhibited dialogue among the parties, it is imperative that both oral and written information presented in a mediation be treated as confidential. Therefore, the parties are encouraged to enter into such an agreement

### ARTS ARBITRATION AND MEDIATION SERVICES: A MODEL PROGRAM

The California Lawyers for the Arts, a nonprofit organization that has served and promoted the interests of artists in California for many years, established Arts Arbitration and Mediation Services (AAMS) in 1980 to provide services to artists. Since then, more than 400 cases have been resolved. There is a volunteer panel of specially trained mediators and arbitrators whose backgrounds include the arts, law, and business. It was the first program to offer alternative dispute resolution services to artists in the country and has served as model for similar services in other areas, such as Texas, Washington, and Washington, D.C. According to the director of the Southern California office of CLA, many of the disputes that are handled in the program involve visual artists and include such issues as copyright, royalties, personality conflicts, negotiating collaborations, payment for work, general contracts and leases and employment problems. The rate of success in resolving these matters is about 75%.

before the commencement of the mediation to ensure that the information provided will not be used in a subsequent legal proceeding. Some states, such as California, Colorado and Virginia have enacted legislation ensuring confidentiality. For example, according to California Code: "…evidence of anything said or of any admission made in the course of the mediation is not admissible in evidence or subject to discovery, and disclosure of this evidence shall not be compelled, in any action or proceeding in which, pursuant to law, testimony can be compelled to be given." This rule also applies to documents. In addition, the statute pronounces that, "When persons agree to conduct or participate in mediation for the sole purpose of compromising, settling, or resolving a dispute,…all communications, negotiations, or settlement discussions by and between participants or mediators in the mediation shall remain confidential."

Because of all of the advantages of mediation described here, it is advisable that mediation clauses be included in standard agreements. By so doing, the parties will be required to employ mediation before other methods of dispute resolution are used. Mediation clauses can be found in the chapters that include contracts with analysis.

## MEDIATION: A PROCESS OF BEST RESORT

Mediation is particularly well-suited to conflicts that arise for visual artists. First, visual artists may have disputes with their dealer, representative, or a collaborator on a work. Since mediation tends to preserve rather then destroy relationships, it is preferable to other forms of dispute resolution. Second, there is often an emotional undercurrent with disputes involving visual artists, particularly when their work is at issue. These issues include the content of the artist's work; credit for work performed; and the factors contributing to the production of the work. Mediation allows for the airing of feelings and enables the intangible and even irrational elements of a situation to be given as much weight as the tangible and rational. Rules of law and other external standards such as market value of services or work produced need not control the result in a mediation. The parties create their own rules with which to fashion their own particular resolution. Third, the artist retains the power that he or she may have historically relinquished to others such as a representative or lawyer. This gives the artist dignity and a sense of control that he or she may not otherwise have. The artist is on equal footing with the other party in the mediation process. Moreover, the artist is on equal footing with the mediator who is there to facilitate the process, unlike a judge or arbitrator whose function it is to impose their will and decide the matter. Fourth, very often the parties have not entered into a written contract, which makes the enforcement of their rights and obligations more difficult using traditional means. Finally, the relatively inexpensive cost of mediation makes it an extremely attractive alternative to litigation for the parties.

# ARTISTS AND INSURANCE

**PETER H. KARLEN**

*Peter H. Karlen practices art, publishing, and intellectual
property law (including copyright, trademark, and moral
rights law) in La Jolla, California.*

In *Funk & Wagnall's Standard Dictionary*,
insurance is defined as: "An act, business, or system by which pecuniary indemnity is
guaranteed by one party (as a company) to another party in certain contingencies, as
of death, accident, damage, disaster, injury, loss, old age, risk, sickness, unemployment,
etc., upon specified terms."[1] In short, insurance is a financial arrangement whereby
one party, the insured, is guaranteed compensation by another party, the insurer, for a
specified loss. Typically, the insured party pays for this indemnification by remitting
premiums to the insurer. These premiums are usually small amounts of money payable
in periodic installments.

One can "insure" oneself by merely setting aside reserves of money to cover possible losses. One way of doing this is to put aside small sums on a periodic basis and
build up a reserve. However, for most individuals, including artists, self-insurance
makes little sense. Either one puts away a large sum to cover loss, or one saves small
sums and earns money on the invested savings in the hope that no loss will occur, at
least until the fund has been built up to considerable proportions.

It makes sense to pool one's contributions in an insurance fund along with contributions of others, to distribute the risks, liabilities, and financial responsibilities. Such a
system, if established among many individuals, or perhaps even by associated artists,
might be viable to insure against their losses. However, most people don't have the
time to run insurance programs—to fill out policies, pay out claims, and collect premiums. This is why we use insurance companies. In exchange for the above services,
the insurance company receives the moneys of numerous subscribers. It invests the
moneys for its own benefit, makes a profit from investments and premiums, and maintains a reserve to pay out on valid claims. The insurance company is a conduit for the
moneys of subscribers and claimants, and acts as the mediator in a system of allocating
risks and benefits.

For artists, insurance protects against many losses. They may procure life, disability, and medical insurance and they can insure their inventory just like other business
people. However, even ordinary insurance policies for artists present special considerations, and there are special kinds of artist insurance policies that are not common to
other occupational groups.

---

1 *Funk & Wagnall's Standard Dictionary of the English Language, International Edition*, Vol. 1, 1960.

Not every kind of loss, policy, risk, consideration, concern, or requirement is covered here, and the reader should consult with knowledgeable insurance agents and brokers, as well as insurance-coverage attorneys, to determine what coverages are needed, what policies to select, what the policies require of the artist, how to make claims on the policies, and what policy limits are needed. The principal goal is to familiarize the reader with some of the concerns and concepts with which he or she must be familiar before entering the insurance market.

## INSURING ONE'S WORK

Most artists don't command high prices for their work, and perhaps they don't want extra insurance policies and premium payments when they start their careers. Nevertheless, many artists are deeply attached to their works and are concerned with protecting those works against loss or damage.

There are several ways in which works may be lost or damaged. Loss may occur in the studio; in transit to or from a purchaser, dealer, museum, agent, publisher, advertising agency, licensee or printer (hereafter collectively referred to as "client" or "user"); or on the client's or user's premises.

### Studio Insurance

When the artist works at home, and uses the home office income tax deduction, studio insurance problems are not necessarily complex, especially if the artist does not have many visitors to the studio. Fire insurance, extended to cover other perils such as lightning and explosion, plus theft insurance, should protect the artist's works, equipment, supplies, and library. Even a package policy, such as a homeowner's or commercial policy, may sometimes be adequate. Of course, a shortcoming of the homeowner's policy is that it will not necessarily cover property held for sale or sold but not delivered; nor will it cover business property away from the premises. This means that the artist with a homeowner's policy who maintains a home studio is taking a chance when it comes time to claim a loss occurring in the studio. Moreover, the artist may not be able to gain protection from a floater policy, covering personal property subject to "floating" from one place to another, because the artist's works may be considered inventory not protected under many personal property floater policies. Nonetheless, the floater policy would probably cover works of other artists collected by the insured artist, who is considered a collector just like any other.

In any case, the insurance policy for the home studio should at least cover loss by fire, theft, and vandalism; flood and earthquake coverage should also be considered. In addition, some artists need valuable papers insurance, an all-risk policy for many perils. This type of insurance is recommended for photographers, graphic designers, and architects, whose plans, drawings, negatives or blueprints are particularly valuable. One drawback of valuable papers insurance is that it will often cover only reproduction costs of the papers in question, and may not provide reimbursement for the full value of the papers. When buying this type of insurance, ask what the valuable papers clause will cover relative to the type of papers you want insured.

No matter what policy the artist procures for works in the home studio, he or she should ascertain what kinds of damage give rise to proper claims under the policy. Many policies will not cover minor damage to the work such as scratches or chipping

unless the artist demands such coverage, in which case premiums will rise sharply. Also artists cannot expect coverage for all perils such as earthquakes (unless they have earthquake insurance), wars, insurrections, or certain "acts of God."

If the studio is not located at home but is in separate business premises, a commercial package policy may be required. The commercial policy, unlike the homeowner's package policy, can be structured to cover inventory and business property. It is possible, of course, to procure separate fire, theft, and vandalism policies, but the package policy will cover more perils and will be relatively cheaper and easier to administer than the separate policies. A comprehensive commercial package policy can cover the artist's works, library, equipment, and supplies.

When procuring studio insurance the artist should clearly inform the agent that his or her works are to be covered, in order to ensure that both parties know the extent of coverage desired. If the works reach a certain value, the insurer may request an inventory of protected works. Thus, the artist will have to provide at least a list of the titles, descriptions, and values of the works. Naturally, the artist should maintain photographs of the works, preferably transparencies, not only because they may be requested but also to prove claims, and for other purposes including preservation of moral rights and other intellectual property rights. The descriptions of the works should at least include dimensions, year of creation, medium, and colors, if any. The value of each work should be its selling price, or its fair market value, that is, what a willing buyer would pay for the work in an "arm's length transaction," an often used legal term that means a clean, neutral transaction. The artist should not underestimate value because, if valuation is negotiated when making a claim, the insurer may attempt to lower the valuation. Past sales proceeds for similar works are a good gauge for valuation. Evidence can include gallery records, sales slips, invoices, and contracts for sales or licensing. Whenever new works are placed in the studio they, too, should be included on supplements to the inventory, which should be kept updated at all times. Under appropriate circumstances, the inventory should be filed with the insurance company.

Carefully read your policy to ensure how the works are valued by the insurer. Sometimes a loss will be compensated at market value, but other times "replacement" value is the standard. This latter value is the cost at which the property can be replaced. Seldom will replacement value be greater than market value, though with art, this sometimes happens.

The standard by which property is evaluated after loss is especially important for unusual property. Many artists have their portfolios lost or stolen. Portfolios are often irreplaceable because they contain images of the artist's work going back to the beginning of their career. A portfolio may have little market value and may be impossible to replace, yet it may be the lifeblood for an artist. How is it to be fairly compensated?

## Works in Transit

Many times losses occur in transit from the studio to other locations. A work may be lost or damaged while being delivered to a client or user. The results may be calamitous and embarrassing, and the ordinary policy for home or office studio may not cover these losses. Sometimes the artist may seek compensation for these losses by making claims against the party at fault. For instance, the artist may sue the carrier who transported the work. Also the risk of loss often passes to the purchaser who buys a work in the artist's studio and leaves it there for later pickup or delivery, and the artist can sometimes keep the sale proceeds even though the work was later lost in

transit. However, this is not a good way to conduct business in the absence of insurance. The artist should either make the carrier, client or user liable for the loss by prior agreement or else insure works being delivered.

Before the advent of special policies to protect artists, the usual policy was "inland marine insurance," a species of floater policies used to cover merchandise in transit, including artworks to be placed on consignment. Other alternatives for artists who have infrequent shipments, and who don't need a policy in force continuously, are parcel post insurance, trip transit policies, registered mail and express shipment insurance, and other minor policies that cover only the shipment in question. The transaction costs and premiums per shipment are frequently higher, in the aggregate, for this limited insurance, and the broader transit insurance policy may be justified for artists who ship too many works to be bothered by constant paperwork.

With transit insurance, complete records must be kept that not only indicate at least the title, description, and value of the work but also its destination and mode of shipment. The insured must also be aware that the transit policy may only cover works shipped in a certain manner by specified channels, packaged in specified ways, to limited destinations (e.g., in the United States only).

Unlike the insurance that covers the studio, which may come under the rubric of a home or office package policy, the policies that cover art in transit may not be available from every insurance agent. In fact, if high valuations or unusual risks are involved, many agents may duck the policy or present policies with exorbitant premiums. It is often best to deal with those agents and companies that routinely insure works of art. Transit insurance is usually procurable from agents and brokers who deal heavily in commercial insurance.

The problem of loss during shipment is particularly acute when buyers are involved, especially when money has changed hands and the buyer is strongly interested in receiving a particular piece. Usually there is no diplomatic way to foist insurance costs on the buyer unless they are surreptitiously included in the purchase price. However, with museums, the situation may be remedied somewhat. When a museum wants to grace its interiors with the artist's work, the artist can insist that "wall-to-wall" insurance be carried by the museum. This insurance protects the work when it leaves the artist's studio until after exhibition and return to the studio. Preferably, the museum's policy should guarantee payment for the work's full value as stated by the artist. If the museum refuses to provide outside insurance, the artist should either refuse to lend the work *or* include a provision in a written lending agreement making the museum absolutely liable for loss and damage during exhibition and transit both ways. For original graphic artwork being shipped for reproduction, the artist should ask the advertising agency or other user to pay for insurance or be responsible for loss. After all, loss of a work not only deprives the artist of the full sales price for the work but also effectively destroys the copyright and, if applicable, the right to resale royalties.

Artists, however, may not be in the same position with respect to galleries and dealers. Most museums and large advertising agencies have broad and effective insurance policies. But gallery owners who wish to reduce overhead may not carry insurance, or may try to shift the burden of insurance to the artist. Again there are alternatives. Either the artist should bargain for an insurance clause in a written consignment agreement or insist on a clause making the dealer absolutely liable.

Sometimes the artist and dealer reach an agreement whereby they will split the costs of insurance to and from the gallery. That is, they will share the costs of

insurance payments for individual shipments, not the cost of a long-range policy, unless they plan a long-term relationship. Or the artist may insure the work on its way to the gallery while the gallery pays the premium for the return shipment, or vice versa. If the dealer won't pay for insurance he or she may be persuaded to accept responsibility for loss in transit, though this promise may be limited to return shipments for which he or she will determine the manner of shipping. Usually, the dealer will not voluntarily accept responsibility. Nevertheless, special statutes that regulate artist-dealer relationships and consignment sales, discussed below, may automatically place responsibility for loss or damage on the dealer.

### Works on Display or in Process of Reproduction

Once a work is actually on the premises of the client or user, the artist's problems may ease. In most cases, museums, dealers, and advertising agencies have insurance for property on their premises, though it is always wise to obtain a written promise that the insurance is in force *and* covers the artist's works adequately. Again, with a museum, the artist should not lend the work if there is neither insurance nor an agreement to accept absolute liability. If a valuable or irreplaceable work is to be reproduced, the artist should not let it remain on the premises of the advertising agency, printer or publisher without similar assurances. Though some dealers carry an art dealer's floater policy or an all-purpose floater policy, with an uninsured dealer the situation is different. Naturally, a dealer may not want to accept absolute liability in the absence of insurance, but he may have no choice under artist-dealer relations laws, many of which call for strict liability of the dealer. There are numerous such statutory schemes, for example, in Arizona, Arkansas, California, Colorado, Connecticut, Florida, Georgia, Illinois, Iowa, Kentucky, Maryland, Massachusetts, Michigan, Minnesota, Missouri, Montana, New Mexico, New York, North Carolina, Ohio, Oregon, Pennsylvania, Tennessee, Texas, Washington, and Wisconsin. Many of these statutes make the dealer liable for loss of, or damage to, consigned works. The Uniform Commercial Code, which deals with consignment sales in general, also shifts the responsibility to the consignee. Moreover, under the special artist-dealer relations statutes, artists often cannot be forced to waive their statutory rights, so any agreement that shifts responsibility for loss or damage may be unenforceable. Nevertheless, despite these statutory rules, when the dealer has no insurance, all the artist can do is demand compensation from the dealer. If the dealer refuses, the artist must go to court, and though the artist will usually win, litigation is an unpleasant prospect. Perhaps a comprehensive insurance policy that covers business property or inventory off premises would be a more appropriate choice for the artist.

## LIABILITY INSURANCE

Artists who run active studios with many visitors should consider policies that cover personal injuries to other persons. Personal injuries are covered under most home and office package policies, so the artist may not need a separate policy if they are already using a home or office policy to insure their works. However, as mentioned before, a homeowner's policy will usually not cover inventory or business property, and it may not cover injuries sustained on business premises.

If the artist is not protected by a package policy, a separate liability policy should

be secured especially for artists who work in hazardous areas or with materials that present dangers to visitors. For instance, artists who run small foundries on their premises or who produce large sculptures may want fairly high coverage for personal injuries. Even darkroom chemicals are potential hazards. Failure to get such insurance can result in exposure to enormous claims. A very large judgment against an artist can be a burden for life, and coverage is relatively inexpensive.

The problems of personal injury insurance are especially vexing for performance artists, particularly those not covered because they don't perform in traditional venues such as auditoriums and theaters whose proprietors carry insurance. Artists who perform dangerous performance art outdoors should either be judgment-proof, have accommodating relatives who live abroad, or somehow obtain insurance for their performances. Strange as it may seem, insurance to cover daring performance art may be available. There is always a species of public liability insurance available for performers or theater owners, if one is willing to pay for it.

Artists are not only liable for slip-and-fall accidents on their premises and for injuries caused by performances, but they can be held liable for injuries resulting from defects in their products. The sculpture that tips over, the mobile that falls from the ceiling, or the electric work that starts a fire may spark claims against the artist. These types of claims often cannot be referred to home, office or personal liability policies unless the incident occurs on the insured person's premises; the artist may need a products liability policy. However, artists who produce only oil paintings or small sculptures may not need a products liability policy to insure against such claims. These kinds of works usually don't cause injury, and the artist, after all, is not often responsible if someone else uses the work as a weapon or projectile. Nonetheless, if the artist's works are incorporated in useful articles such as furniture or kitchenware that are in physical contact with people, or if the works are large and made to hang from walls or ceilings, a products liability policy may be recommended. For the artist producing potentially dangerous works for use in many locations, it is imperative to procure such a policy.

The artist should remember that in products liability cases the court may impose "strict liability," so that the innocent artist can't avoid financial responsibility if the claimant can establish that a defect in the work contributed to his injuries. The best thing is for the artist to buy insurance, which in most situations is relatively inexpensive. The expense must be viewed as another cost of doing business. Artists should ensure that the policy covers all of their line of products for all intended uses. It won't help to have a policy that does not apply to a particular work used in a certain fashion. If there are any doubts about coverage, check with the insurance agent and, if necessary, broaden the scope of the policy with a rider. When artistic works are produced in large quantities, the cost per item is usually small.

Another type of coverage needed by some artists is "completed operations" liability insurance that is akin to products liability insurance. Unlike the products liability policy that covers injuries from defects in goods produced by the artist, the completed operations policy covers injuries arising from the use of goods. For instance, the artist whose large hanging mobile falls on someone should be covered by a completed operations policy.

## Off-premises Liability

An artist, working with or without assistants at a construction site or some other place away from the artist's studio or offices, can have liability problems not covered under a commercial package policy.

If a defect in the work or the way in which the work was installed causes the injury, perhaps the liability is covered under a products liability/completed operations policy. But what about injuries caused in the process of installing the work? The injured employee may be covered under a worker's compensation policy, but what about an injured bystander?

General liability coverage is therefore highly recommended for off-premises projects. In fact, some commissioning parties, including public agencies, may even require this coverage before they will let out a job to the artist.

The problem for the artist, however, is to get coverage at a decent rate. An artist is not treated like a construction company that can get such coverage at a much lower rate.

Artists must also consider coverage for nonphysical injuries, e.g., in the form of defamation, invasion of privacy, copyright infringement, trademark infringement, and unfair competition. Remember, artists who project themselves and their works into the public limelight say things about other people and are thus possible targets of defamation and invasion-of-privacy lawsuits. Artists are also high-risk targets of copyright infringement lawsuits, especially those brought by disgruntled competitors or crackpots.

The typical "personal injury" coverage in a package policy may cover defamation and invasion-of-privacy claims. Also, the "advertising injury" coverage in the package policy may provide some protection against trademark and unfair competition claims and possibly copyright infringement claims.

Note, "advertising injury" coverage is increasingly more difficult to get, so you may have to shop around if you want coverage for infringement and unfair competition lawsuits.

For artists who subcontract with others to work for them, independent contractors' liability policies may sometimes cover claims from operations by subcontractors on the artist's behalf.

Where artists run large businesses such as manufacturing enterprises, a comprehensive general liability policy, which will cover most of the liabilities faced by the business, may be recommended.

Another possibility for added protection is an "umbrella" policy. The principal purpose of an umbrella policy is to enhance the limits of all or virtually all the liability coverage that the insured already has. As an example, an umbrella policy that has $1,000,000 in coverage might extend that coverage to automobile accident liability, premises liability, personal injury, etc.; however, because that umbrella principally enhances only the coverage that already exists, it does not generally provide coverage in new areas. That is, if you don't have car insurance but you buy a $1,000,000 umbrella policy, it will probably not apply to your car.

## Indemnification

A rather less effective protection is contractual indemnification from a person other than an insurance company. For example, an artist might undertake a dangerous project on behalf of a patron with the patron's assurance that he will cover all risks, losses, and liabilities. Or the artist may take a copyright or trademark license from an intellectual property owner based on certain warranties that the copyright or trademark is free of claims, and with the further understanding that if the warranty proves untrue, the owner will indemnify the artist for all losses. There are a number of cautions about these promises of indemnification. First, in virtually all cases they must be substantiated in a written instrument signed by the party promising to indemnify because the statute of frauds in the applicable jurisdiction may require the promise to be in writing. Second, such promises are only as good as the credit of the indemnitor. That is, if the artist suffers a loss or liability, the indemnitor may not be solvent enough to fulfill the indemnification promise, or may just simply refuse to do so; thus, the artist is either out of luck or has to sue the indemnitor. It's usually better to have insurance coverage as a backup, because insurance coverage from a highly rated company means that the artist is dealing with an indemnitor able and ready to pay. Artists should secure promises of private indemnification whenever possible but should remember that proper insurance is almost always the better security.

## Worker's Compensation Insurance

Artists, like any other employers, are generally responsible for injuries sustained by employees within the scope of their employment. This is why we have the usual requirement of obtaining worker's compensation insurance.

Though it is beyond the scope of this chapter to cover worker's compensation insurance in detail, we note that one critical issue is determining who are the artist's covered employees. The problem is that persons who the artist may hire as independent contractors and pay in connection with IRS Form 1099 may still be regarded as employees. The careful artist should cover so-called independent contractors whenever there is any doubt as to their employment status.

In some states there may even be special legislation that determines employee status in relation to the contractor's work for an artist. For instance, in California, the Labor Code (Section 3351.5) has special provisions relating to work made for hire agreements. Thus, under California law, an artist who commissions an apprentice to help with the creation of a work and forces the apprentice to sign a work made for hire agreement could be regarded as the employer of the apprentice and therefore be required to cover the apprentice under a worker's compensation policy, even if the apprentice was hired as an independent contractor.

## DISABILITY, DISMEMBERMENT AND MEDICAL INSURANCE

Many professionals are solicited by insurance agents to buy disability and dismemberment insurance policies. This kind of coverage is often associated with well-to-do physicians, lawyers, and corporate executives. Artists, however, especially the chosen few who make their living exclusively from their art, should consider insurance to cover their own injuries. The fact that Betty Grable obtained insurance for her legs, which were considered income-producing assets, does not mean that all artists should

insure their hands. Nevertheless, certain artists who receive high returns from their work must view their hands as capital assets; and insurance for severe injury or dismemberment, which would compensate them for a catastrophic accident, should be considered. The problem with disability insurance, however, is the payout. Unless premiums are rather high, many benefit programs have payments that would leave the artist a pauper, unless they had savings.

No chapter on insurance would be adequate without at least a reminder concerning medical insurance. At the time of writing, it is not yet national law to require all employers to cover employees with medical insurance. But such may become the law very soon, and artists may have to provide medical insurance for their employees. Medical insurance is recommended for obvious and nonobvious reasons. Medical insurance covers the gaps in other insurance policies. As an example, if you are in an automobile accident with an uninsured driver and are seriously injured, even with uninsured motorist coverage and the small amount of medical benefits usually carried under an auto policy, you may still be in deep trouble. As an employer, you may have no coverage for your own work-related injuries that would be covered for your employees under a worker's compensation policy. You should ask, however, as there are special circumstances that allow employers to be covered under worker's compensation. It would be useful coverage to have, even though medical insurance also enables you to take care of medical conditions that can threaten your career.

There are a number of crucial variables in getting medical insurance, the most important being the coverage afforded. Some people just want coverage for catastrophic injuries and diseases and will accept large deductibles in order to lower premiums. But I think the better strategy is to have coverage that will encourage you to visit the doctor whenever you want to take care of something, even though this coverage may cost more.

## SELECTION OF INSURANCE

Artists may find good policies from insurance carriers they've been dealing with for years in connection with homeowner's or auto insurance. Their own local company agent may have suitable policies for simple coverage. But if more is desired, the artist frequently has to visit an insurance broker who procures policies from many different carriers; but sometimes even that isn't enough. Though a broker may point the artist to the right kind of policy, the careful artist will have the policy reviewed by an attorney familiar with insurance coverage. After all, it's the broker's business to sell policies, not to interpret them. More often than not, when the artist requests unusual kinds of coverage or very broad protection in the areas of personal and advertising injury, the policy selected by the broker doesn't do the full job; only a coverage attorney will know whether it does.

Please remember not to select the insurance policy with the lowest premium, unless it is the best policy from the best carrier. There are many companies charging low premiums whose policies give the least coverage and who resist paying out claims. For example, over the years, I always felt that I was paying a little more for the coverage I had from my carrier, but I found out that this company was there when I needed them, compared to lower-cost carriers who, as I have seen from my practice, fight customer claims. Paying low-cost carriers who have bad pay-out records is like throwing one's money away.

Remember that the insurance policy is only as good as the solvency of the insurer. An insurance company that is highly rated and licensed to do business in your home state is a better bet than a foreign, unrated or low-rated company.

Even when you get the right policy and the right company, you still must have proper limits of coverage. If you have a policy that covers copyright infringement claims but the limits are only $25,000, this is small solace, because copyright infringement suits are a lot more costly than $25,000. If in doubt, pick the higher limit. Remember, the coverage limit may include not only the amount of the judgment or pay-off to the claimant but also the cost of defending the claim, including all the attorneys' fees.

Organizations and companies that either directly provide insurance for artists or facilitate selection of insurance policies for artists are listed in the resource appendix.

## POLICY RESPONSIBILITIES

Just because you have insurance doesn't mean that it will pay off. You must comply with your responsibilities under the policy. As mentioned above, you must maintain proper records to substantiate losses. Check with your agent or broker and read the policy to see exactly what documentation must be retained and for how long.

You must also report claims promptly. The policy specifies the period of time following the claim during which you must report it. Failure to timely report may result in loss of coverage.

You also have to cooperate with the carrier in connection with any investigation, and in a litigated matter, you must be prepared to provide testimony.

In the event of a dispute between you and the carrier as to the value of lost or damaged property, you may be forced to arbitrate the dispute if you and the carrier can't agree on the compensation to be paid to you. Remember, insurance companies don't always pay you the full amount of the loss.

## CONCLUSION

Insurance is not a panacea for all your problems. If you pick the wrong company, the wrong policy, the wrong coverage, or the wrong policy limits because you did not get good advice from an attorney or broker, then your premiums may be a complete loss.

On the other hand, good insurance coverage can really let you sleep at night, especially if you worry about loss and liability. There is hardly a better sounding phrase than when an insurance agent says, *"You're covered,"* after you have filed a claim.

# Restrictions on Content

# Art, Sex and Protest: Censorship and Freedom of Artistic Expression

**STEPHEN F. ROHDE**

*Stephen F. Rohde is a partner of the Los Angeles
law firm of Rohde & Victoroff, which specializes in literary
property, entertainment and constitutional law. Mr. Rohde
writes and lectures frequently on the First Amendment.
He is author of "Art of the State: Congressional Censor-
ship of the National Endowment for the Arts"* (Hastings
Communications and Entertainment Law Journal,
*1991), and* Foundations of Freedom, *published by the
Constitutional Rights Foundation, on the occasion
of the bicentennial of the Bill of Rights.*

Every artist has a vital stake in the First Amendment. You don't have to be Andres Serrano or Robert Mapplethorpe to appreciate that the well-spring of your creative freedom is the First Amendment. Without robust protection for freedom of expression, artistic freedom is doomed.

You may try to assure yourself that your own art will never bear the brunt of censorship. You may try to distance yourself from the "controversial artists" who provoke outrage and question authority.

But don't kid yourself. Censors begin with Serrano and Mapplethorpe; but censorship is habit-forming. Somewhere, somehow *your* art may offend *someone,* and the precedents set in extreme cases will support an ever-widening net of repression that could ultimately ensnare your creations.

Furthermore, you are a citizen who appreciates the role of art in society. You understand that a nation that muzzles its artists will soon muzzle intellectuals, then scholars, teachers, librarians, students, businessmen, etc.

Visual artists who address sexuality, religion, politics, civil liberties and other controversial issues face renewed dangers of censorship from local, state and federal authorities. In recent years, the scope of censorship has expanded to include not only obscenity, but accusations of indecency, lewdness, flag desecration, incitement to violence, profanity, and even blasphemy. In addition to conventional criminal charges, an unholy alliance of right wing fundamentalists and politically correct feminists is promoting new civil remedies, such as the "Pornography Victims Compensation Act" (discussed below) to punish offensive art. The Federal Communication Commission has stepped up its indecency enforcement by levying exorbitant fines against radio stations that carry Howard Stern and other shock jocks. Conservative United States senators persist in trying to impose content restrictions on art funded by the National Endowment for the Arts and public

colleges and universities are using speech codes and sexual harassment rules to punish artistic expression in student newspapers and classroom lectures.

It is a dangerous time to be an artist. But artists have always been sacrificial lambs when powerful authorities try to stifle dissent and impose their orthodox views to maintain control over the people.

This chapter explores a wide variety of efforts to censor art, books, and music. It is intended to alert readers to the current threats of censorship and provoke further inquiry.

Judging by recent events, the United States appears to have commemorated the 200th anniversary of the Bill of Rights by stepping up the censorship of books, art and music. As usual, the suppression of obscenity and indecency is trotted out as the excuse. From Mapplethorpe in Cincinnati, to 2 Live Crew in Florida, to over two hundred forty attempts in thirty-nine states to ban books from classrooms and libraries, there is a concerted effort to use criminal prosecutions and administrative proceedings to punish controversial ideas. Win or lose, the very initiation and perpetuation of these cases creates its own irremediable punishment in huge legal fees, lost energy and—worst of all—self-censorship.

## OBSCENITY: MILLER V. CALIFORNIA

Since 1973, the United States Supreme Court has upheld obscenity laws that comply with a three-part test adopted in the case of *Miller v. California*. The prosecution must prove, beyond a reasonable doubt, that each of the following three tests has been met:

♦ Whether "the average person, applying contemporary community standards" would find that the work, taken as whole, appeals to the prurient interest.

♦ Whether the work depicts or describes, in a patently offensive way, sexual conduct specifically defined by the applicable state law.

♦ Whether the work, taken as a whole, lacks serious literary, artistic, political, or scientific value.

In this country, only sex speech is subjected to censorship under these vague, elastic and oppressive standards. When it comes to other subject matter, having nothing to do with sex, the First Amendment would not tolerate the punishment of speech that did not conform to "contemporary community standards" (whatever that means) or was "patently offensive" to any twelve jurors or failed to achieve a level of "serious literary, artistic, political or scientific value." If our elected officials, talk show hosts, romance novelists, stand-up comedians and other assorted opinion makers were judged by such standards, most of them would be in jail.

## ANTHONY COMSTOCK AND REV. DONALD WILDMON

But the fact that obscenity laws purport to censor only sex speech should not suggest that they were not intended or enforced to suppress a far wider range of

controversial ideas and to purposely accustom the public to governmental control of what we can see, read and do.

The father of modern American obscenity law was Anthony Comstock. Born in 1844, he served two years in the Union Army during the Civil War and kept a diary brimming with confessions of his struggle with temptation. In 1872 he founded the "New York Society for the Suppression of Vice" and led his first raid on a bookstore. From the outset, Comstock pursued twin goals—the eradication of obscenity and the banning of "abortifacients and contraceptives." Here we see the ominous link between restricting freedom of speech and restricting freedom of choice that persists to this day.

Between 1872 and 1874, Comstock seized 130,000 pounds of books and 60,300 "articles of rubber made for immoral purposes, and used by both sexes."

Comstock lobbied Congress to pass a new law prohibiting the use of the mails or advertising to sell obscene literature and items "for the prevention of conception." The law would serve as a model for similar "Comstock" statutes in twenty-two states.

As soon as President Ulysses S. Grant signed the bill, he appointed Comstock as a special postal inspector, a position he held until his death in 1915. In his first fifteen years, Comstock made twelve hundred arrests and seized a wide variety of books and artworks. In 1906 he raided the Art Students League in New York because they used nude models. Comstock also led the fight to prosecute Margaret Sanger, a founder of the birth control movement.

Today, Comstock's work is carried on by such groups as the American Family Association (AFA), with five hundred thirty-five chapters in all fifty states, headed by Rev. Donald Wildmon of Tupelo, Mississippi. Wildmon's brother Allen, a spokesmen for the AFA, is not shy about its real agenda. "Whose set of values is going to dominate in society?" he asks. The attack on art funded by the National Endowment for the Arts, Wildmon explains, "is just one spoke in the wheel as far as the overall picture—you've got rock music, you've got abortion. Somebody's values are going to dominate. Is it going to be a humanistic set of values, or a Biblical set of values?"

## MAPPLETHORPE IN "CENSORNATI"

For the first time in American history, on April 7, 1990, an art museum was indicted for obscenity. The Cincinnati Contemporary Arts Center had just opened an exhibit entitled "The Perfect Moment," consisting of one hundred seventy-five photographs by the late Robert Mapplethorpe, a renowned photographer whose works ranged from still lifes of calla lilies and orchids to sexually explicit homoerotic portraits. In 1984 the NEA had awarded Mapplethorpe a $15,000 fellowship and in 1988 had paid $30,000 to help defray the costs of mounting "The Perfect Moment" at the Institute of Contemporary Art at the University of Pennsylvania.

Cincinnati had long been a hotbed (cold bed?) of censorship. In 1957, Cincinnati businessman Charles Keating (yes, that Charles Keating) founded Citizens for Decent Literature (later renamed Citizens for Decency Through Law). Before moving to Phoenix (to build his ill-fated S & L fortune), Keating passed the antismut mantle to Rev. Jerry Kirk, who founded Citizens for Community Values (CCV) and the National Coalition Against Pornography, which actively pushed for the indictment of the Arts Center and its director Dennis Barrie.

The trial began on September 24, 1990. At stake were seven photographs that

were part of a special portion of the exhibit from which children had been excluded. Two were photographs of young children in various states of nudity with their genitals partially exposed. Five were graphic depictions of homoeroticism, including a self-portrait of Mapplethorpe with a bullwhip in his ass and one showed a man urinating into another man's mouth. Two were photographs of young children in various states of nudity with their genitals partially exposed.

Almost without exception, observers believed that Barrie and the Arts Center would be convicted and that the case would ultimately depend on the dispassionate review of an appellate court. The jury pool didn't give the defendants much hope. Most said they didn't read newspapers, could count their visits to any kind of museum on one hand, and lived in the conservative suburbs surrounding Cincinnati. When one prospective juror admitted she had worked for Rev. Kirk, had attended a convention of the National Coalition Against Pornography, had subscribed to the CCV newsletter, and after seeing the Mapplethorpe photographs, had formed the opinion that they should never be displayed any time, anywhere, for any reason, the trial judge still refused to exclude her "for cause" because she said she could be a fair and impartial juror. (The defense used one of its six peremptory challenges to get her off the jury.)

The prosecution's entire case in chief was to simply present the photographs to the jury. No expert testimony. Prosecutor Frank Prouty told the jury: "You have the chance to decide on your own—where do you draw the line? Are these the kinds of pictures that should be permitted in the museum?"

By contrast, the defense put on an elaborate series of expert witnesses who testified to the artistic merit of the Mapplethorpe exhibit. Defense lawyers Lou Sirkin and Marc Mezibov knew that to win the case they had to prevail on the third prong of the *Miller* test—that no matter how prurient or patently offensive, the Mapplethorpe photographs had serious artistic value. They called Janet Kardon, the curator of the show in Philadelphia; Jacqueline Baas, director of the University of California Art Museum; John Walsh, director of the J. Paul Getty Museum; and Robert Sobieszek, former curator at the International Museum of Photography at the George Eastman House. Each explained why these sometimes shocking photographs were works of art.

The defense also presented testimony from the mothers of the two children photographed by Mapplethorpe. Both were friends of the photographer, had willingly consented and encouraged the photographs of their children and were present when they were taken.

The defense experts had apparently made such an impact on Prouty that he decided they could not go unchallenged. He called Dr. Judith Reisman, a former research director for Wildmon's AFA who had written an article on Mapplethorpe for *The Washington Times* (the Moonie-owned daily, not to be confused with *The Washington Post*) called "Promoting Child Abuse As Art." (Her other qualification was that she had been a songwriter for Captain Kangaroo.)

Dr. Reisman testified that the photographs were not art. Ironically she conceded that the bullwhip photo "would be one of the only photos that might offer emotion, but the face is blank. It says 'I am here.'" By admitting that the photo said anything—that it communicated any message—Dr. Reisman may have netted the defense a slight advantage.

Sirkin, in his closing argument, called some of the photographs ugly and possibly offensive, but argued that art is not always pretty. Mezibov urged the jurors "to show the country that this is a community of tolerant and sensitive people."

Prouty appealed to a different sense of civic pride. He urged the jurors to let the world know that Cincinnati was different from other cities. He ridiculed expert Jacqueline Baas ("she's from California") and he argued that the art world thinks it's above the law ("They're saying they're better than us").

On October 5, 1990, the eight-person jury, after only three hours of deliberation, found Barrie and the Arts Center *not guilty on all charges*. "The prosecution basically decided to show us the pictures so that we'd say they weren't art when everybody else was telling us they were," said one juror. "The defendants were innocent until proven guilty, and they didn't prove them guilty."

Once the glow of the victory faded, it was apparent that the First Amendment had escaped by only the skin of its teeth. Had the prosecution called any of the scores of self-appointed experts on child pornography, obscenity or the resulting "disintegration of the American family," the jury might have had something to hang a guilty verdict on.

The acquittal did not come without its costs. Barrie and the Arts Center incurred $325,000 in expenses for expert witnesses, transcripts, court costs, and legal fees (even though a considerable amount of legal work was contributed pro bono). Add to that the hundreds of hours spent by Barrie and his staff—precious time stolen from the work of administering the Arts Center—and the intimidating message to others that they too could face a year in prison and $10,000 in fines for exhibiting art. The result is a devastating tax on the exercise of artistic expression.

## 2 LIVE CREW IN BROWARD COUNTY

Meanwhile, across the country in Fort Lauderdale, Florida, the First Amendment could only claim a split decision. In separate prosecutions, on October 2, 1990, Charles Freeman, a record store owner, was convicted of selling the notorious 2 Live Crew album *As Nasty As They Wanna Be,* while on October 20, 1990, the group itself was acquitted for performing several songs from the album at a nightclub.

It's difficult to tell whether Mapplethorpe's homoerotic photographs or 2 Live Crew's sexist rap lyrics are more alien to America's mainstream culture. Either way, these obscenity prosecutions attack minority life styles that deliberately challenge conventional values. Of course the protection of minority viewpoints from majority control is exactly what the First Amendment is all about. The majority doesn't need special constitutional protection for the expression of its ideas; its got the votes. It is minority viewpoints, from blacks, gays, radicals, extremists, atheists, etc., that need protection. But when the law, as in the case of obscenity, allows the prosecution to expose a jury to shocking material they may not otherwise have chosen to observe, it is remarkable for any juror to rise above his or her own personal objections and vote for acquittal.

2 Live Crew's misogynist lyrics are a perfect example. They portray a world of willing sex slaves and turgid males. "He'll tear the cunt open 'cause it's satisfaction" and "Grabbed one by the hair, threw her on the floor opened up her thighs and guess what I saw." The songs on *As Nasty As They Wanna Be* refer endlessly to male and female genitalia, human sexual excretion, oral-anal contact, fellatio, group sex, erections, masturbation, cunnilingus and sexual intercourse.

To blunt the threats of an obscenity indictment, 2 Live Crew's attorney Bruce Rogow, a law professor at Nova University, filed a declaratory relief action. The

strategy was to preempt the state prosecution by securing a Federal court determination that *As Nasty As They Wanna Be* was *not* obscene under the *Miller* test.

The plan backfired.

On June 6, 1990, U.S. District Judge Jose A. Gonzalez, Jr. declared the album obscene. Frankly, any legal opinion that begins by misquoting Justice Oliver Wendell Holmes can't be all good. He cited a 1919 U.S. Supreme Court case to show that "the First Amendment is not absolute and that it does not permit one to yell 'Fire' in a crowded theater." What Justice Holmes actually wrote was: "The most stringent protection of free speech would not protect a man in *falsely* shouting fire in a crowded theater *and causing a panic*." (Emphasis added).

It is not the mere utterance that criminalized the speech: it was that the speech was false and actually caused a panic. That one often hears Justice Holmes misquoted at cocktail parties is lamentable; that a Federal Judge should ground his legal opinion on such a mistake is irresponsible.

Not that that was Judge Gonzalez's only mistake. When it came time for him to decide whether *Nasty,* taken as a whole, lacked "serious literary, artistic, political, or scientific value," Judge Gonzalez exposed an extraordinary case of cultural myopia and artistic narrow-mindedness.

2 Live Crew had offered the testimony of Prof. Carlton Long, who was qualified as an expert on black American culture. He testified to the political message in the album, including its commentary on Abraham Lincoln in the song "Dirty Nursery Rhymes" and the repeated use of the device of "boasting" to stress one's manhood. Without explanation, Judge Gonzalez simply concluded that the album lacked "any serious political value."

Prof. Long also found genuine sociological value in the devices of "call and response" ("Tastes Great—Less Filling," parodying the beer commercial), "doing the dozens" (a word game that Judge Gonzalez himself recognized as "a series of insults escalating in their satirical content") and boasting (a device where persons "overstate their virtues such as sexual prowess"). Remarkably, Judge Gonzalez concluded that since these devices were "part of the universal human condition," not exclusive to the culture of black Americans, they could be ignored in judging the value of the album.

Judge Gonzalez did not disagree that the album revealed comedy and satire, he just didn't get the joke. Betraying total ignorance of the role of satire, he simply could not imagine reasonable people finding anything funny about the album's treatment of violence, perversion, sex and genitals. Of course the very fact that he had to address this issue was the best evidence of the album's artistic value. Having elsewhere conceded that "this court's role is not to serve as a censor or an art and music critic," Judge Gonzalez proceeded to act just like one.

Fortunately, Judge Gonzalez's decision came in a civil case, not in a criminal case. It was not binding on any Florida criminal court, but it had the demoralizing impact of letting the authorities claim that 2 Live Crew and other purveyors of the *Nasty* album were now "on notice" that they were circulating obscene material.

Two days after Judge Gonzalez's ruling, Charles Freeman was arrested at his store for selling a copy of the album to an adult undercover cop in Fort Lauderdale. And two days after that, three members of 2 Live Crew, including leader Luther Campbell, were arrested for performing their songs at an adults-only concert.

Freeman, who sold about one thousand copies of the album netting him about $3,000, was convicted, while Campbell and the others, who sold more than 2 million

copies, earning them approximately $6 million, were acquitted. It's hard to tell what made the difference. Constitutional lawyer Rogow handled the defense in both trials. Freeman was tried first, before an all white jury. Campbell's jury included one black. In Freeman's case, the *Nasty* album itself was on trial. In Campbell's case, the prosecution was burdened with a barely audible tape of the live performance. Regrettably, the unsuccessful trial may have served as a dress rehearsal for successful one, where Rogow, the experts and even the jurors appeared not to take the rap music so seriously and often punctuated the testimony with irrepressible laughter. This obviously helped Campbell, who maintained all along that his music was supposed to make people happy.

Campbell also had help from Henry Louis Gates, Jr., then professor of literature at Duke University, who called 2 Live Crew's music "astonishing and refreshing." Lacing his testimony with allusions to Shakespeare, Chaucer, Eddie Murphy, Ella Fitzgerald and James Brown, Gates said that the group had "taken stereotypes of black men—as oversexed, hypersexed in an unhealthy way—and blown them up. You have to bust out laughing."

The jury bought it. "We agreed with what he [Gates] said about this being like Archie Bunker making fun of racism," according to jury foreman David Garsow, a 24 year-old office clerk who sings at the Key Biscayne Presbyterian Church. Helena Bailie, a retired sociology professor from New York, said she admired what fellow juror, Beverly Resnick, 65, had said during the deliberations: "You take away one freedom, and pretty soon they're all gone."

## "THE CENSORSHIP MOVEMENT IN AMERICA IS FLOURISHING"

With those words, Arthur Kropp, President of People for the American Way, released the tenth annual survey on book censorship in America's schools. Covering the 1991–92 school year, three hundred ninety-five incidents were reported in forty-four states. In fully 41%, the challenged materials were removed or restricted.

Over the past few years, a chilling roster of titles has come under attack:

*The Hobbit,* by J.R.R. Tolkien, which was accused of promoting Satanism; *The Red Pony* and *Of Mice and Men,* by John Steinbeck, for offensive language; *Where the Sidewalk Ends* and *A Light in the Attic,* by Shel Silverstein, for promoting disruptive behavior and for sexual innuendoes and demonic overtones; *Catcher in the Rye,* by J.D. Salinger, for offensive language; *Cujo,* by Stephen King, for profanity and sexually explicit content; *The Color Purple,* by Alice Walker, for undermining family values; *Little Red Riding Hood,* for its depiction of a grandmother drinking wine; *Blubber,* by Judy Blume, for offensive language; *Night,* by Elie Wiesel, because it is "depressing" and inappropriate since the past should be forgotten; and *Das Kapital,* by Karl Marx, for being politically subversive.

In addition to these authors, People For The American Way reports that works by other great American and international authors were challenged, including Langston Hughes, James Thurber, Mark Twain, Maya Angelou, Rudyard Kipling, Nathaniel Hawthorne, Laura Ingalls Wilder, Margaret Atwood, Pat Conroy, Toni Morrison, Erich Maria Remarque, and Ray Bradbury.

Meanwhile, re-elected for six more years, Helms set the agenda for the 90's: "I say to all the arts community and to all homosexuals: You ain't seen nothing yet!"

# PORNOGRAPHY VICTIMS COMPENSATION ACT

Having demonstrated such heart-felt sensitivity to sexual harassment against women during the Clarence Thomas–Anita Hill hearings in 1992, Senator Strom Thurmond (SC), and his Republican colleagues Mitch McConnell (KY) and Charles Grassley (IA), have recently proposed the Pornography Victims Compensation Act (S.1521).

S.1521 would create a brand new federal civil damage claim against producers and distributors of sexually explicit books, movies, magazines, videos and other materials on the grounds that their words or images substantially contributed to a sexual crime against the complaining party, even if the assailant was never charged or convicted of such a crime. The obscenity of a work would be judged by local standards, after the fact, under the easier civil (rather than criminal) burden of proof.

This legislation creates a minefield of legal and constitutional problems that would intimidate even the most courageous writer, distributor or producer. It perpetuates the "porn made me do it" excuse for serious sexual assaults. It saps time and precious resources that should be devoted to finding real solutions for sexual dysfunction. And it feeds a rising tide of intolerance and a habit of censorship that threaten even those in the creative community whose works are far removed from anything remotely pornographic.

The bill was inspired by similar legislation promoted by antipornography feminists Catharine MacKinnon and Andrea Dworkin, and it is opposed by a wide spectrum of organizations, including the American Booksellers Association, the American Library Association, the Association of American Publishers, National Organization of Women chapters in New York, California and Vermont, and by Feminists for Free Expression, an ad hoc committee of over two hundred women who argue that it is "no goal of feminism to restrict individual choices or stamp out sexual image."

S.1521 stems from an enticing but wholly unsubstantiated theory that attempts to link exposure to sexually explicit words and pictures with the commission of sexual crimes. The two year $2 million President's Commission on Obscenity and Pornography (1970) concluded that there was "no reliable evidence… that exposure to explicit sexual material plays a significant role in the causation of delinquent or criminal sexual behavior." Not to be confused with the facts, Attorney General Edwin Meese in 1986 appointed a new Commission on Pornography, which claimed to find the missing link between pornography and sex crimes. But several studies were misquoted, and when one researcher, who was commissioned to review the existing data, found no causal relationship, her report was simply ignored.

Again, in 1986, Surgeon General C. Everett Koop's Workshop on Pornography and Public Health studied the issue and concluded that "[a]n increase in aggressive behavior toward women has been proposed often as one likely effect of exposure of pornography, but there does not seem to be sufficient scientific support for a generalized statement regarding the presence of this effect."

All of these research findings are consistent with the history of human experience. As novelist John Irving wrote in the *New York Times Book Review,* opposing S.1521, "At the risk of sounding old-fashioned, I'm still pretty sure that rape and child molestation predate erotic books and pornographic magazines and X-rated video cassettes." Feminists for Free Expression echoed this point in a letter to the Senate Judiciary Committee: "Violence against women and children flourished for thousands of years before the printing press and motion picture, and continues today in

countries like Saudi Arabia and Iran, where no commercial sexual material is available."

Who can tell what may stimulate one to commit a crime? It is reported that Heinrich Pommerenke, a German rapist and mass slayer of women, carried out his ghastly deeds after seeing Cecil B. DeMille's *The Ten Commandments.* During a scene in which women dance around a golden calf, his suspicions about the opposite sex were confirmed; women, he decided, were indeed the source of the world's troubles, and it was his mission to execute them. After leaving the theater, he slew his first victim in a nearby park.

Similarly, John George Haigh, the British vampire who sucked his victims' blood through soda straws, claimed that he first experienced a thirst for blood by watching a "voluptuous" procedure—the drinking of the "Blood" of Christ—in an Anglican communion service. Then there was the case of the Frenchman who confessed that he had killed his uncle by poisoning a bottle of wine, using a recipe from an Agatha Christie murder mystery.

What is particularly pernicious about the Pornography Victims Compensation Act and its little sister introduced in 1993 in the Massachusetts legislature (that reaches far beyond obscenity and punishes any graphic, sexually explicit material that "subordinates" women and others) is that these proposals are promoted by certain feminists as a means of combating sexism. These bills appeal to the apparently progressive agenda of opposing sexual harassment and preventing sexual assaults. As such, they test the true meaning of the First Amendment, which was intended to protect not merely ideas we like, but ideas we hate. Surely all decent Americans object to the subordination of women, but that does not mean that censorship can be used to obliterate the portrayal of such subordination from all books, magazines, movies and art.

"If there is a bedrock principle underlying the First Amendment," retired Justice William J. Brennan, Jr., wrote in a decision upholding constitutional protection for burning the American flag, "it is that the Government may not prohibit the expression of an idea simply because society finds the idea offensive or disagreeable."

Fortunately, previous attempts to enforce legislation similar to S.1521 have been defeated on constitutional grounds. In 1984, MacKinnon and Dworkin sponsored an ordinance in Indianapolis that defined pornography as a form of discrimination against women, giving rise to a panoply of civil and administrative remedies against publishers and movie producers. Many of the same groups who now oppose S.1521, successfully enjoined the ordinance. They pointed out that films like *Dressed to Kill, Ten, Star 80, Body Heat, Swept Away* and books like the *Witches of Eastwick, The Delta of Venus, and The Carpet Baggers* could all run afoul of the new law. The appellate court invalidated the ordinance on the ground that its prohibition of expression was sweepingly overboard. "Much speech is dangerous. Chemists whose work might help someone build a bomb, political theorists whose papers might start political movements that lead to riots, speakers whose ideas attract violent protesters, all those and more leave loss in their wake." The court warned that punishing the press by means of this new remedy "could be more dangerous to speech than all the libel judgments in history."

Our society is not without means to protect women from rape and sexual assault. No woman is safer because a book or movie is censored. Feminists for Free Expression, led by Betty Friedan, Judy Blume, Nora Ephron, Erica Jong and Susan Isaacs, point out that S.1521 diverts attention from the substantive triggers to violence. "Violence is caused by deeply-rooted, economic, family, psychological and political factors, and it is

these that need addressing." They also remind us that historically "information about sex, sexual orientation, reproduction and birth control has been banned under the guise of 'morality' and the 'protection' of women," leading to "the suppression of important works, from *Our Bodies Ourselves* to novels such as *Ulysses, The Well of Loneliness* and *Lady Chatterly's Lover,* to the feminist plays of Karen Finley and Holly Hughes."

The creative community must actively exercise its freedom of expression by opposing S.1521 and its counterpart in Massachusetts. Lasting solutions to society's serious problems have never been achieved through censorship.

## CENSORSHIP OF FLAG ART

Powerful artistic symbols provoke powerful reactions. That is their purpose. Artists cannot complain when they take cherished icons such as the American flag in vain, and then they suffer withering criticism from those who hold the flag as sacred. Artists can, and should, object, however, when local, state and federal authorities seek legal suppression.

Because it is such a prominent symbol of our nation, the American flag has been used by patriot and protester alike to represent the best or the worst in us at any given historic moment. Since the founding of our country, editorial cartoonists have freely used the flag as a potent image to evoke the entire spectrum of opinion about the strengths and weaknesses of America.

In modern times, no event polarized our nation more than the Vietnam War, and the American flag was often at the center of the debate. In the early 1960's, the owner of a New York City art gallery was criminally charged and convicted under New York's flag desecration law for mounting an antiwar exhibition that included a phallic symbol wrapped in the American flag and another flag in the shape of a human body hanging from a noose. Fortunately, the conviction was invalidated by a federal court that found that the sculptures were protected by the First Amendment.

In Atlanta, Georgia, authorities refused to allow the musical *Hair* to be presented at the city's civic center, in part because they claimed a scene with an actor wrapped in an American flag would violate Georgia's flag desecration law. Again, a federal court disagreed and cleared the way for the play to open.

A controversial work called "What is the Proper Way To Display a U.S. Flag?," which encouraged viewers to walk on the flag, was condemned in both Chicago and Anchorage. In 1989, Chicago responded by passing the "Desecration of Flags" law, prohibiting virtually any use of the flag as an artistic symbol. A group of artists successfully challenged the law in state court. In 1992, in Alaska, the same work was displayed at the Visual Art Center. Taking the law into their own hands, a local veterans group not only stole the original flag but each replacement, until they realized that the art center had an inexhaustible supply.

Every battle over the censorship of flag art does not end so well. In 1992, responding to the objections of veterans and other, an Oklahoma art gallery consigned artist Rick Freeman's work "Home of the Homeless, Amen" to a broom closet. The sculpture, containing a shopping cart with a pair of praying hands, on top of an American flag, had won a prize at an annual art exhibition. Nevertheless, the gallery caved in to criticism, citing a federal law mandating respect for the flag.

## CENSORSHIP OF THE NATIONAL ENDOWMENT FOR THE ARTS

In recent years, a new threat to artistic freedom has been posed by efforts to impose content restrictions on the art funded by the National Endowment for the Arts (NEA). It is important to look at the origins of the NEA and examine the nature of the threat to its artistic independence.

### The Creation of the NEA

In 1965, the NEA and the National Endowment for the Humanities (NEH), were created by the same act of Congress. Congress found that "the encouragement and support of national progress and scholarship in the humanities and the arts, while primarily a matter for private local initiative, is also an appropriate matter of concern to the Federal Government."

Because "the practice of art and the study of the humanities requires constant dedication and devotion," Congress declared that "it is necessary and appropriate for the Federal Government to help create and sustain not only a climate encouraging freedom of thought, imagination, and inquiry, but also the material conditions facilitating the release of this creative talent."

These were grand and laudable purposes, and the NEA and NEH were launched with a sense of civic pride and a belief that government could be a force for creative freedom, in contrast to totalitarian regimes that control the arts for ideological purposes. Congress rejected the notion that NEA or NEH should promote any given orthodoxy or majority viewpoint. "[O]ne of the artist's and the humanist's great values to society is the mirror of self-examination which they raise so that society can become aware of its shortcomings as well as its strengths." Indeed, Congress emphasized that the endowments were intended to encourage "free inquiry and expression," that "conformity for its own sake is not to be encouraged," and that "no undue preference should be given to any particular style or school of thought or expression." In the end, the standard "should be artistic and humanistic excellence."

The scope of NEA grants reaches all art forms, styles and media including painting, photography, sculpture, crafts, poetry, fiction, music, dance, theater, film and animation.

### The Furor Over Serrano's Piss Christ

On May 18, 1989, Senator Alfonse D'Amato (R–NY) took the Senate floor and denounced the NEA for helping to fund a $15,000 fellowship for artist Andres Serrano. In particular, D'Amato characterized Serrano's photograph *Piss Christ* as "garbage" and a "deplorable, despicable display of vulgarity." D'Amato and twenty-six other senators signed a letter to the NEA demanding changes in its procedures to prevent federal funding of "sacrilegious art." Meanwhile Senator Jesse Helms (R–NC) issued his own denunciation of Serrano, saying, "He is not an artist. He is a jerk. And he is taunting the American people, just as others are, in terms of Christianity."

Serrano, a highly acclaimed Hispanic–American artist, had exhibited his work nationally and internationally for more than fifteen years. *Piss Christ* had been included in a ten-city touring exhibit organized by the Southeastern Center for Contemporary Art (SECCA), based in Winston–Salem, North Carolina (not so coincidentally, Helms' home state). SECCA had received $75,000 from the NEA, or about one

quarter of the cost of the show. Each of the ten artists exhibited, including Serrano, received an award of $15,000. The show was exhibited, without incident, at the Los Angeles County Art Museum, at the Carnegie–Mellon University Art Gallery in Pittsburgh and at the Virginia Museum of Fine arts.

*Piss Christ* is a 60x40–inch Cibachrome showing a plastic crucifix submerged in a brown liquid. 1987, Serrano began experimenting with the use of bodily fluids in his work—first blood, then urine and, more recently, semen. "I use bodily fluids because they are life's vital fluids," he said. "They appeal to me visually and they're symbolically charged with meaning." Serrano denied that *Piss Christ* was sacrilegious. "My work reflects ambivalent feelings about religion and Christianity… of being drawn to Christ but resisting organized Christianity."

According to Donald Kuspit, professor of art history and philosophy at the State University of New York at Stony Brook and author of an essay in the show's catalog, works like *Piss Christ* are aimed "against American superficiality, which denies the 'life blood' of things."

In the House of Representatives, Congressman Richard Armey (R–TX), a long-time foe of the NEA, seized the opportunity to renew his attacks on federal funding of "offensive" art. "The NEA is acting like they should have every privilege of a rich child. They want freedom without responsibility." In a revealing analogy, Armey compares the relationship between Congress and the NEA to that of a parent and child. "In a way I'm asking the NEA to live by the same standards that I set for my daughter. He who pays the bill sets the standards. My daughter wanted to go to college. I told her, you'll go to a school I approve of and major in an area I approve of. I didn't want her to major in art or history or literature or anything else that would leave her unemployed."

## The Senate Adopts the Helms Amendment

On July 26, 1989, the Senate passed legislation, including an amendment proposed by Senator Helms, that would have prohibited the use of federal arts funds to "promote, disseminate or produce—obscene or indecent materials, including but not limited to depictions of sadomasochism, homoeroticism, the exploitation of children, or individuals engaged in sex acts; or, material which denigrates the objects or beliefs of the adherents of a particular religion or nonreligion." The measure would have also barred grants for artwork that "denigrates, debases or reviles a person, group, or class of citizens on the basis of race, creed, sex, handicap, age or national origin."

If enacted, the Helms Amendment's vague language was sure to confuse and intimidate even the boldest of artists. After all, is there any national consensus on the definition of "indecent materials"? What constitutes "homoeroticism"? How does one decide if something "denigrates the objects… of a particular religion"? What does "nonreligion" mean? Could one run afoul of the law by "denigrating" atheism?

While the Helms Amendment was pending, The New York Times asked the directors of six major arts organizations that were currently receiving NEA funding to identify established works of art that would have been prohibited from receiving NEA funds under the Helms Amendment. Over fifty well-known works from the fields of dance, theater, film, photography, opera, and painting were listed. They included Aristophanes's *The Clouds* (denigrates religion); all the plays written by Sean O'Casey (denigrates Catholics and Catholicism); D.W. Griffith's, *The Birth of a Nation* (denigrates ethnic groups); Ingmar Bergman's *The Virgin Spring* (depicts sex with children); Verdi's *Rigoletto* (denigrates a hunchback); and Thomas Mann's *Death in Venice* (depicts

homoeroticism involving children). According to Joanne Koch, executive director of the Film Society of Lincoln Center, "since the Society is devoted to presenting the best in cinema from an artistic perspective—rather than a political bias—there is virtually no way that our many programs could continue within the confines of Senator Helms' bill."

On September 29, 1989, the Helms Amendment was submitted to the full Senate, which *rejected* it, sixty-two to thirty-five. Helms countered by offering to limit his restrictions to a ban on "obscene or indecent" art, but instead, on a motion by Senator Wyche Fowler (D–GA), the word "indecent" was eliminated, and the full Senate, on a vote of sixty-five to thirty-one, approved the revised amendment. On the same day, the conference committee adopted the new version.

Since the Helms Amendment had originally contained six repressive measures, the arts community felt lucky to survive with so few of them intact. As it turns out, that's exactly how Helms planned it all along. As soon as the Conference Report was issued, Helms declared victory. "The NEA has gotten the message. I don't believe you're going to see any more of this garbage being funded by the taxpayers."

### The New NEA Restrictions Unconstitutionally Deny a Government Benefit on the Basis of the Content of Protected Speech

No argument during the debates over restricting NEA funding attracted more support for the Helms Amendment, even among moderate members of Congress, than the contention that the proposed restrictions had nothing to do with censorship but were only a responsible effort by elected officials to protect the taxpayers. After all, every artist is entirely free to create any art he or she wants, no matter how sexually explicit or outrageously offensive, so long as the taxpayers do not have to pay for it.

This Faustian argument reflects the notion that artists who accept money from the government must give up part of their soul. If they want to insist on total independence, then they must remain totally independent. There is not a little of the philosophy of in loco parentis in this argument. The artist is seen as the child, the government as the parent. The child is financially dependent on the parent; the parent, therefore, dictates what the child does. If the child wishes to be free of the parent's control, the child must give up his allowance.

Whether these notions hold true in personal, private, and family matters, in the relationship between artists and their government there is one additional factor: *the First Amendment.* The Supreme Court has long held that once Congress decides to grant subsidies, distribute public funds or authorize exemptions, it must do so without penalizing individuals for their beliefs, no matter how unorthodox, and without abridging their free speech, no matter how controversial. Justice William Brennan has written:

> *It cannot be gainsaid that a discriminatory denial of a tax exemption for engaging in speech is a limitation on free speech.... To deny an exemption to claimants who engage in certain forms of speech is in effect to penalize them for such speech. Its deterrent effect is the same as if the State were to fine them for this speech. The appellees are plainly mistaken in their argument that, because a tax exemption is a "privilege" or "bounty," its denial may not infringe speech.*

On reflection, this constitutional doctrine makes perfect sense. No one would seriously argue that Congress could constitutionally pass a law specifying that Social Security benefits could only be paid to Democrats or that religious tax exemptions could only be claimed by Episcopalians. Such overt acts of discrimination could not

be justified by the claim that Congress was simply conserving taxpayers' money.

Even though a person has no "right" to a valuable governmental benefit and even though the government may deny him the benefit for any number of reasons, there are certain reasons on which the government may not rely. It may not deny a benefit to a person because of his constitutionally protected speech or associations. Otherwise, his exercise of those freedoms would be penalized and inhibited. This would allow the government to "produce a result which [it] could not command directly."

Unquestionably, the NEA restrictions singled out disfavored content and denied government benefits solely on that ground. In so doing they encouraged self-censorship and endangered First Amendment rights.

### The New NEA Restrictions are Unconstitutionally Vague

Any "statute which either forbids or requires the doing of an act in terms so vague that men of common intelligence must necessarily guess at its meaning and differ as to its application, violates the first essential of due process of law."

In matters touching on vital First Amendment freedoms, this principle requires heightened scrutiny. Our zealous solicitude toward freedom of expression requires that "precision of regulation must be the touchstone" for laws which purport to burden or regulate speech. Such exacting precision is necessary when it comes to First Amendment rights because the "[t]hreat of sanctions may deter... almost as potently as the actual application of sanctions."

The Supreme Court has long held that "sex and obscenity are not synonymous." This explains why current constitutional law protects works of literature, once banned or sought to be banned, such as Dreiser's *An American Tragedy*, Lawrence's *Lady Chatterly's Lover*, Miller's *Tropic of Cancer* and *Tropic of Capricorn*, and Joyce's *Ulysses*.

Obviously, depictions of "sadomasochism," "homoeroticism" or "individuals engaged in sex acts" could easily fall on the protected side of the sex/obscenity dichotomy. Frankly, so could some depictions of "the sexual exploitation of children," particularly where the purpose of those depictions is to condemn such exploitation or to educate the public to the horrors of such exploitation. By penalizing protected works of art, the new legislation clearly violates the First Amendment.

If there is any doubt that the term "obscene" as used in the new NEA restrictions was unconstitutionally vague, the additional terms rendered the new law hopelessly ambiguous. In addition to obscene works, the new restrictions disqualify from NEA funding "depictions of sadomasochism, homoeroticism, the sexual exploitation of children, or individuals engaged in sex acts." No definition of these terms could be found in the new legislation. It is unclear whether each of these four additional areas must also be obscene or whether art which falls into these categories is disqualified even if it is not itself obscene under the *Miller* test.

As separate categories of condemned art, these four classifications defy any clear and objective definition. Sadomasochism could include a wide variety of artistic depictions in which men or women are portrayed as submissive or subservient. Homoeroticism could include photographs of homosexuals kissing, embracing or simply holding hands. More graphically, it could include paintings, drawings or photographs of nude homosexuals touching or caressing each other in ways that would not be obscene under the *Miller* test, but which would be considered shocking or offensive to many members of Congress.

"The sexual exploitation of children" is not a self-defining phrase. Many might

consider the publication of a photograph of a nude child, without more, to fall within that category. Many more might consider the publication of a photograph of two nude children to fall within that category. Nevertheless, such photographs are constitutionally protected. Indeed, a wide body of opinion believes that taboos against childhood nudity contribute to repressed sexual attitudes and antisocial behavior. Would a play in which a character verbally describes child molestation constitute the "depiction of... the sexual exploitation of children"? Would photographs portraying children in coy or sexually suggestive poses come within this category?

On April 18, 1990, the U.S. Supreme Court, in a six to three decision, reversed the conviction of Clyde Osborne, who had been charged with violating an Ohio child pornography law for privately possessing four photographs of a nude fourteen year old boy. The statute purported to make it a crime to possess material "that shows a minor who is not the person's child or ward in a state of nudity...." Recognizing that "depictions of nudity, without more, constitute protected expression," the court ordered a new trial to determine whether "such nudity constitutes a lewd exhibition or involves a graphic focus on the genitals."

The remaining phrase in the NEA legislation, the "depiction of... individuals engaged in sex acts" was also hopelessly vague. Presumably this meant something different than obscene because legislators are presumed not to include redundant verbiage in their legislation. But if "sex acts" are not confined to "obscene sex acts," they could well include depictions that are outside the *Miller* standard and therefore protected by the First Amendment. The words sex acts are far from self-defining, and particularly when applied to books, poems, plays, paintings, photographs, sculptures, dances and other art forms, the words simply defy any definition sufficient for First Amendment purposes.

The new restrictions used terms that were reminiscent of the 1984 Indianapolis ordinance, discussed earlier and later struck down in court. A coalition of groups led by the American Booksellers Association, the Association for American Publishers, Inc., and the Freedom to Read Foundation successfully enjoined the ordinance and obtained a declaration that it was unconstitutional. The court observed that it was "struck by the vagueness problems inherent in the definition of pornography itself, more specifically, the term, 'subordination of women.'" The court pointed out that the term is not specifically defined in the ordinance, and "it is almost impossible to settle in ones [sic] own mind or experience upon a single meaning or understanding of that term."

The court found that the "enumerated categories of pornography set out in the Ordinance are also plagued with these same constitutional deficiencies relating to vagueness." Terms such as "degradation," "abasement," and "inferior," found in the ordinance, are "subjective terms, reflective of the observer's state of mind" and "arguably have several different meanings."

Given the broad sweep of the ordinance, the court held that it was unconstitutionally vague in that persons subjected to the ordinance "cannot reasonably steer between lawful and unlawful conduct, with confidence that they know what its terms prohibit."

It can be said, with equal force, that the new restrictions imposed on the NEA were mystifying. They were purely subjective and reflective of the observer's state of mind. An artist of reasonable intelligence simply could not tell if his or her work may, in the opinion of his or her peers, let alone the chairperson of the NEA or any particular member of Congress, run afoul of these elastic standards.

Clearly, in writing the new regulations, Congress did not use the touchstone of precision or objective measurement. The new regulations were hopelessly vague and therefore abridged cherished First Amendment rights.

Fortunately, the Helms restrictions were struck down by a federal court. And when Congress tried again—this time trying to enforce vague "standards of decency"—the restrictions were again found unconstitutional.

## CONCLUSION

The next decade poses an ominous question: Will freedom of expression and artistic creativity flourish abroad and dwindle at home? As totalitarian regimes lose control in other corners of the globe, will our own government expand its grip over what Americans can see and read?

Or, will the arts fulfill their time-honored role of challenging authority, deflating pompous bureaucrats, inspiring self-realization and encouraging tolerance and diversity? It is the duty and the challenge of all who value the arts and the humanities—the constituents of the First Amendment—to make it so.

# Ten Commandments for the Fight Against Censorship

**DAVE MARSH**
*Dave Marsh has been writing and lecturing about
censorship since the early 1980s. He is the author of more
than a dozen books about popular music, including two
best-sellers about Bruce Springsteen,* Born to Run *and*
Glory Days. *He is also a founder of* Creem, *former
associate editor of* Rolling Stone, *and a current
music critic for* Playboy.

## 1. Emphasize the Positive

The censors do *not* have the right to define the agenda and pick the battleground.
Aggressively expose the history of what censorship has done to ruin democracy in
countries all over the world. Insist that the greatest peril to our children's education
and morals is ignorance and the denial of reality. Remind everyone that unpleasant
social realities can't be solved until we all have the right to say openly what's on our
minds. Never forget that free speech advocates are parents, good citizens, and (often)
good Christians too.

## 2. You Don't Have to Live Like a Refugee

The majority of Americans *are* moral; they're also in favor of free speech. A July
1990 *Newsweek* poll showed that 75% of Americans felt that the right of adults to
"determine what they may see and hear" was "more important" than society having
"laws to prohibit material that may be offensive to some segments of the community."
So, don't shut up—you don't just have the *privilege* of free speech, you have the *right* to
speak, and when that right is threatened, speaking out becomes an *obligation*.

## 3. On the Other Hand, Remember This

The First Amendment exists to protect speech and activities that are *un*popular. If it
only served to protect that which everybody (or "the majority") agreed with, it wouldn't
need to be there at all. Limiting free speech is what's *un–American*—without it all our
other rights and liberties quickly disintegrate. That's why it's the *First* Amendment.

That also means that it's imperative to support independent sources of culture in all the arts, especially given the growing concentration of the publishing, music, and film industries in the hands of a small number of corporate interests. The artists, retailers, and others fighting hardest for free expression tend to be those outside the mainstream of the system. For some art forms—avant garde poetry, the blues, and documentaries, for instance—the independent publishers, record labels, and film distributors provide virtually the only means of existence. So where you have a choice, shop and browse on that basis.

## 4. Don't Believe the Hype

Don't let censors claim they aren't censoring; if it restricts freedom of expression, it's against the First Amendment. One of the most important lessons that censors have learned over the years is never to use the word "censorship." But, as Ali Mazrui wrote in *The Black Scholar,* "Censorship in the U.S. is basically privatized… freelance censors abound."

Censorship isn't about intentions; it's about consequences. Whether they're presented as "consumer information" or "child protection" or "public safety" (as in the refusal of civic facilities to allow certain kinds of performances to take place), regulations and activities that deny the right to speak *are* forms of censorship, no matter what name their sponsors give them.

## 5. Freedom Isn't Free

The majority of censorship is *economic,* which forces artists to work day jobs to stay alive, and prevents them from creating freely, let alone acquiring the equipment to work with and the space to work in.

Turn some of the ideas in this book into fund-raisers. Use the money you receive to publish and distribute free speech information, to take out anticensorship ads, to develop and produce free speech public service announcements, and for the legal expenses of those who are censored.

## 6. Keep Your Sense of Humor

This will immediately distinguish you from the censors, who don't have any. Censorship fanatics *never* tell jokes about the issue; they never let the air out of their own bags of wind. Don't be afraid to help them out—or to deflate your own gasbag once in a while.

## 7. Remember the Commandment the Censors Forgot

"Thou shalt not bear false witness against thy neighbors." That doesn't just mean don't lie; it means get the facts straight. So go after those half-truths and expose the lies the censors promote. Make yourself so well-informed that you'll *know* when

censors are fabricating facts or distorting "scientific studies," or when they're refusing to acknowledge common sense. If you doubt what they're saying, make 'em *prove* what they're saying is so, and don't let them bluster and bully with anecdotes that never involve names, dates, or places.

## 8. DON'T MOURN

Organize seminars and study groups to look at censorship in context; accept no easy answers. Find out where attacks on free speech are coming from—even if it means going back one hundred or even five hundred years. It's important to see both censored and uncensored art. Teach yourself the history of free music, free art, free cinema, etc., so that the lies of the censors won't trick you.

## 9. TAKE ADVANTAGE OF RESOURCES

Use telephones, fax machines, photocopiers—wherever you can find them. It doesn't take an army to make a big difference. Jack Thompson, the Florida censor who launched a campaign that helped get 2 Live Crew indicted, did it all out of his house with a phone and a fax setup. You can fight back effectively using the same kind of tools.

## 10. NETWORK

Contact other groups in your area that should have an interest in free speech—not just art councils, but unions, civil rights organizations, churches, journalists, broadcasters, feminists. Make sure they understand the issue. Ask for their support—and support their causes whenever you can.

*From Dave Marsh's book,* Fifty Ways to Fight Censorship: and Important Facts to Know about the Censors, *© 1991 by Duke and Duchess Ventures, Inc., modified and reprinted with permission of the publisher, Thunder's Mouth Press.*

# The Visual Artist and the Law of Privacy

**ROBERT C. LIND**

*Robert C. Lind is a professor of law at Southwestern University School of Law in Los Angeles. He received his Bachelor of Elected Studies degree, summa cum laude, from the University of Minnesota in 1976, his J.D. degree from George Washington University in 1979 and his Master of Laws degree, with highest honors, from George Washington University in 1983. Professor Lind teaches courses in copyright, trademark, entertainment, defamation, privacy, museum and art law. He is a member of the District of Columbia and California bars.*

The law of privacy is an area of law that arises in many different contexts ranging from protection against police invasion of your home to businesses snooping into your records to the media exploiting your personal life to advertisers using your name to sell products. For visual artists, the law of privacy often arises when the likeness of an actual living or dead person is incorporated into an artwork. The sources of privacy protection vary greatly. Federal and state constitutions, federal and state statutes and numerous judicial decisions provide privacy protections.

## PRIVACY PROTECTION

The United States Constitution implicitly provides for protection of selected "zones of privacy." In the area of criminal law, it protects against unreasonable searches and seizures by law enforcement agencies. In the civil context, the federal constitution provides limited privacy protection of "fundamental rights." This protection extends to matters relating to marriage, procreation, contraception, family relationships, child rearing and education. However, it has been generally held that there is no federal constitutional protection against the disclosure of private facts.

State constitutions also provide similar implicit privacy protections, with some state constitutions explicitly providing for the protection of privacy. As a general rule, state constitutions provide greater protection for privacy in a greater number of areas than that provided by the federal constitution. For example, the Alaska Constitution permits, as a privacy right, an adult's possession of marijuana in their home for personal use. In California, the state constitutional privacy amendment has been interpreted as protecting against the compiling of personal information by government and business.

Statutory privacy protections are numerous and varied. However, common law privacy, the protection of privacy created by the courts, is most important to the visual artist. This protection provides for four separate causes of action, each of which protects a different interest. These include types of legal actions called the "public disclosure of private facts," "false light," "intrusion" and "appropriation" or "right of publicity."

## PUBLIC DISCLOSURE OF PRIVATE FACTS

This cause of action most strongly protects the "right to be let alone." It protects against the disclosure to the public of a private fact concerning the plaintiff, the disclosure of which is highly offensive to a reasonable person and in which the public has no legitimate interest. Although it is possible that a work of art could disclose such a fact in an actionable manner, it is more likely that a visual artist would be a plaintiff in such an action.

### Public Disclosure

The communication by the defendant must be to the public at large or it must be substantially certain to become public knowledge. Note that this is a more demanding requirement than the publication requirement of defamation actions. Inclusion of a statement in any organ of the mass media, such as a newspaper, magazine or television broadcast, would constitute a public disclosure. In addition, general distribution of a handbill, placing a sign in the window of a store on a heavily traveled road or making the statement to a large number of persons would also be deemed a public disclosure. Showing a work of art in a gallery or in a show would undoubtedly meet this requirement.

### Disclosure of Private Facts Concerning the Plaintiff

This action protects against statements that are true. If the statement at issue is false the defendant would be sued for defamation or false light invasion of privacy. Not only must the statement be true, but it must deal with a "private" fact. A work of art that portrays a person with AIDS in a private hospital bed may be actionable. Public facts, however, are not actionable. If the information published can be found in a public document, or if many people have been privy to the information, or the situation at issue occurred in a public place, it will be deemed public information and not actionable. Therefore, an artist's depictions of individuals present in street scenes or other public places or events are protected.

### The Statement Must be Highly Offensive to a Reasonable Person

Not all statements that disclose private facts about a plaintiff are actionable. It must be found that the disclosure of the statement is highly offensive to a reasonable person. This is an objective test. It is not enough that the plaintiff is upset by the disclosure. Mere bad manners are not actionable. It must be shown that the matter disclosed is so offensive as to "shock the ordinary sense of decency or propriety," relative to the "customs of the time and place, to the occupation of the plaintiff and to the habits of his neighbors and fellow citizens." The types of disclosure that meet this test include pictures of individuals in the nude or with deformed human anatomy, confidential medical, psychiatric or sexual information or information regarding debts or credit

difficulties used to harass the plaintiff. Statements that are laudatory in nature would not bring shame or humiliation to a person of ordinary sensibilities and are not actionable under this cause of action.

## The Statement Must Not be of Legitimate Concern to the Public

The plaintiff must prove that the information disclosed by the defendant is not of legitimate concern to the public. Rather than the public figure status approach that has been adopted by the courts in defamation cases, First Amendment protections focus on the subject matter of the statement at issue. If the statement is found to be newsworthy, it is found to be of legitimate concern to the public and the defendant is cleared of all liability, regardless of how much injury the plaintiff has suffered.

> In determining what is a matter of legitimate public interest, account must be taken of the customs and conventions of the community; and in the last analysis what is proper becomes a matter of community mores. The line is to be drawn when the publicity ceases to be the giving of information to which the public is entitled, and becomes a morbid and sensational prying into private lives for its own sake, with which a reasonable member of the public, with decent standards, would say that he or she had no concern.[1]

There is no national test of newsworthiness. The general concept of newsworthiness has been broadly defined by the courts.

California and New York courts have had a tremendous impact on the definition of newsworthiness, due to the large number of public disclosure cases that have been decided there. California courts employ a three part test of newsworthiness that analyzes: 1) the social value of the published facts; 2) the depth of the intrusion into ostensibly private matters; and 3) the extent to which the plaintiff voluntarily assumed a position of public notoriety.

When the former husband of actress Janet Leigh unsuccessfully brought a disclosure privacy claim against a movie magazine, the court stated:

> [T]here is a public interest which attaches to people who by their accomplishments, mode of living, professional standing or calling, create a legitimate and wide-spread attention to their activities. Certainly, the accomplishments and way of life of those who have achieved a marked reputation or notoriety by appearing before the public (for instance actors and actresses, professional athletes, public officers, noted inventors, explorers, war heroes), may legitimately be mentioned and discussed in print or on radio or television. Such public figures have to some extent lost the right of privacy, and it is proper to go further in dealing with their lives and public activities than with those of entirely private persons.[2]

In New York there is no recognition of the common-law right of privacy. The only available remedy is that statutorily created by Civil Rights Law sections 50 and 51. These statutes permit recovery where a defendant has used an individual's name, portrait or picture, primarily for trade or advertising purposes, without written consent. It has been held, however, that these statutes do not apply to the publication of newsworthy matters or events. Where the statement is not connected with a matter of public interest, or the public interest is merely incidental to the commercial purpose of the publication, or the use is an advertisement in disguise, the statute applies and the use becomes actionable.

---

1  Restatement (Second) of Torts §652D cmt. f (1977).
2  *Carlisle v. Fawcett Publications, Inc.,* 201 Cal. App. 2d 733, 20 Cal. Rptr. 405 (1962).

New York has not adopted a clearly delineated test of newsworthiness. The scope of what is newsworthy or of public interest is defined by the courts. Further, public interest is not strictly limited to news or nonfictional material. As one New York court has stated: "The newsworthiness exception applies not only to reports of political happenings and social trends, but also to news stories and articles of consumer interest including developments in the fashion world."[3]

The courts of all jurisdictions tend to favor defendants, particularly media defendants, in the determination of what is newsworthy. The following topics have been found to be newsworthy and, therefore, not actionable: criminal activities; marriages and their dissolution; legal disputes between family members; civil litigation; a mother's abandonment of her newborn child; sexual orientation; drug abuse; sexual matters; and hospitalization. Although the concept of newsworthiness has limits, court decisions that have found a statement to be not newsworthy, as a matter of law, are limited in number.

### Consent or Waiver

Where a work of art represents recognizable persons or contains their names, a release should be obtained from those persons, particularly if they are private individuals. Such a release, which grants the artist the right to use the name or likeness of the individual in connection with the incident depicted, would constitute a consent or waiver and act as an absolute defense to an action for disclosure of private fact.

### Damages

A plaintiff is permitted to recover damages for injuries that normally result from such an invasion of privacy. These have been found to include injury to feelings or sensibilities, past and future humiliation, embarrassment, depression and withdrawal from society. The cost of medical or psychiatric treatment may be recovered. The showing of special damages, such as those necessary for some defamation actions, is not required. Punitive damages may be awarded where the defendant acted with hatred, ill will or spite.

## FALSE LIGHT INVASION OF PRIVACY

The false light action makes actionable the public dissemination of false information that places the plaintiff "in a false light in the public eye," which would be highly offensive to a reasonable person. This action is similar to an action for defamation and is often alleged at the same time a defamation action is brought. For example, when artist Paul Georges was sued for his painting *The Mugging of the Muse*, he was sued not only for libel, but also for casting the plaintiffs in a derogatory and socially unacceptable light. The painting depicted the plaintiffs, two fellow artists, armed with knives, attempting to assassinate a woman on a city street. However, for the false light action, the false statement need not be defamatory to be actionable. A laudatory statement may make the plaintiff appear more ridiculous than a factual treatment, at least to those who know the truth, and may be actionable under this form of privacy.

Baseball pitching star Warren Spahn successfully sued the publisher of a book that

---

3 *Stephano v. News Group Publications, Inc.*, 64 N.Y.2d 174, 485 N.Y.S.2d 220, 474 N.E.2d 580 (1984).

contained imaginary incidents, manufactured dialogue and a manipulated chronology. The distorted biography falsely portrayed his childhood, his relationships with his father and his wife as well as his military experience. Although these portrayals were not defamatory, the court found that the defendants knowingly placed Spahn in a false light.[4]

One scenario that may lead to a false light lawsuit occurs when a stock photograph or film footage of the plaintiff is used to illustrate a story with which the plaintiff has no connection, but which places the plaintiff in an offensive light. Thus, while the original photograph may not have been actionable, e.g. because it was taken in a public place, its use in connection with a derogatory article may place the photograph's subjects in a false light and cause them injury.

A Washington, D.C. cab driver successfully sued the *Saturday Evening Post* for inserting a photograph of her in an article describing dishonest cab drivers.[5] There is First Amendment protection of statements that are actionable under false light invasion of privacy. The courts, however, are not in agreement as to the form this protection should take. Some courts focus on the subject matter of the statement by taking the position that a defendant has a conditional privilege if the statement was newsworthy, that is, if it dealt with a matter of public interest. That conditional privilege can be overcome with proof of constitutional malice, i.e., that the defendant, at the time the statement was disclosed, knew that it was false or acted with reckless disregard as to its truth or falsity. Other courts focus on the status of the plaintiff, similarly to the approach taken in defamation cases. Where the plaintiff is a public person, proof of constitutional malice is required. Where the plaintiff is a private person, mere negligence is sufficient.

Other defenses that are available to a defendant in a defamation action are also generally available in a false light action. In addition, the damages available to a defamation plaintiff are also available in a false light action, for which the plaintiff may recover for the indignity and mental distress caused by the offending disclosure.

# INTRUSION

The tort of intrusion makes actionable the intentional intrusion into the plaintiff's solitude or seclusion, either as to their person or to their private affairs or concerns, which would be highly offensive to a reasonable person. This action may prohibit not only physical intrusion, but intrusion by means of electronic, photographic or optical devices as well.

It would appear that only when an artist is overzealous in their attempt to obtain information or images do they run a risk of liability for intrusion. The unauthorized tape recording of private conversations or electronic communications can present legal problems. In addition, with the advent of high powered still and video cameras, care must be taken as to the circumstances under which film or video is shot. While most shots taken of people on the street would not be actionable as an intrusion, film or video taken through someone's bedroom window could be a high risk venture. It is not necessary that the information or image gained through the intrusion be publicized to be actionable. The act of the intrusion itself is enough.

4  *Spahn v. Julian Messner, Inc.,* 18 N.Y.2d 324, 274 N.Y.S.2d 877, 221 N.E.2d 543 (1966), vacated and remanded, 387 U.S. 239, aff'd, 21 N.Y.2d 124, 286 N.Y.S.2d 832, 233 N.E.2d 840 (1967), appeal dism'd, 393 U.S. 1046 (1969).
5  *Peay v. Curtis Pub. Co.,* 78 F. Supp. 305 (D.D.C. 1948).

Subsequent use of the information or image may affect the amount of damages the plaintiff may receive. Not all courts agree as to whether injuries suffered as a result of the publication of the material obtained via the intrusion is recoverable. While some jurisdictions permit the inclusion of harm from the public dissemination of the improperly obtained information, other jurisdictions limit recovery to the injury caused directly from the intrusion and exclude injuries caused by the publication.

Jackie Kennedy Onassis was successful in obtaining a court order prohibiting paparazzo Ron Galella from coming within twenty-five feet of her or thirty feet of her children even on public property. Galella had made a career of taking photographs of Mrs. Onassis and her children. He went so far as to frighten her by jumping out of bushes to obtain that "special" shot. The court held that although Mrs. Onassis was a public figure, she could claim a zone of physical privacy while walking on public side-walks. Galella eventually violated the court's order, received a suspended fine of $120,000 and agreed to never again photograph Mrs. Onassis.[6]

Constitutional protection for individuals engaged in intrusive activity is limited. Because intrusive action involves information gathering rather than information dissemination, it is considered to be less deserving of First Amendment protection.

## APPROPRIATION/RIGHT OF PUBLICITY

This area of privacy law has two branches. The appropriation cause of action protects an individual's dignity in the use of their name or likeness. The right of publicity protects the individual's commercial interests in the use of their name, likeness or other forms of identity. States differ in the source of protection for these branches of privacy law. Some states, such as New York, rely solely on statutory protection. California offers both statutory and common-law protection, while other states provide only common-law protection or no protection at all.

### Appropriation

The appropriation cause of action makes actionable the appropriation, for the defendant's advantage, of the plaintiff's name or likeness. The appropriation of the plaintiff's name or likeness need not be commercial or pecuniary in nature. It is sufficient that the appropriation be for the defendant's benefit and that it injured plaintiff's feelings and disrupted their peace of mind. This action does not require publicity. It is sufficient that the defendant intended to use the plaintiff's name or likeness for a personal benefit. For example, the unauthorized use of a name on a petition has been held actionable. The gist of this action is that the plaintiff's dignity has been injured by their name or likeness being associated with the defendant or the defendant's actions, products or causes. The injury is personal in nature, not commercial.

Cheryl Ladd successfully sued the producers of a pornographic motion picture titled *Taxi Girls*. Advertisements for the motion picture stated that the star was a "Cheryl Ladd look-alike." Instead of showing a photo of the actual star of the motion picture, the advertisement included a publicity shot of Ms. Ladd. Her complaint had two counts. The first count was for appropriation and argued that Ms. Ladd was personally affronted by her name and likeness being associated with the motion picture.

---

6 *Galella v. Onassis*, 353 F. Supp. 196 (S.D.N.Y.), modified, 487 F.2d 986 (2d Cir. 1973).

The second count was for violation of her right of publicity and argued that Ms. Ladd had not been paid for the commercial use of her name and likeness.

## Right of Publicity

Unlike the appropriation cause of action that protects the dignity of the individual, this cause of action protects the commercial value of a person's name or likeness. The law in this area continues to evolve. There exist many jurisdictional differences regarding such issues as, whether a noncelebrity has a right of publicity, whether a deceased person has an enforceable right of publicity, the scope of a person's right of publicity and the parameters of the newsworthiness defense. There are two sources of protection for the right of publicity: the common-law protection developed by the courts and the statutory protection created by state legislatures. Although the primary purpose of each is the same, some of the differences that do exist are discussed below.

One of the major jurisdictional differences concerns whether the right of publicity is descendible. The issue of post mortem rights, whether a person's right of publicity survives their death, may be of great commercial importance. A prime example is Elvis Presley. The Presley estate has made more money licensing Elvis' name and likeness since his death than Elvis made during his lifetime. In jurisdictions where the protection of an individual's name and likeness is primarily viewed as a privacy interest, the rights of the individual are said to die with the person and are not descendible. Where the name and likeness of an individual is primarily viewed as a commercial property interest, their use is protected by the right of publicity, which is deemed to be descendible, after the person's death. The majority of states have found the right of publicity is descendible, although the two major media and art jurisdictions differ on this issue. While California has a statute (Civil Code 990) specifically granting a right of publicity for fifty years after the death of the deceased personality, there is no post mortem right of publicity under New York law.

***Common Law Protection of the Right of Publicity.*** Many states have recognized a common law right of publicity. In general, the elements of such an action are: (1) the defendant's use of the plaintiff's identity, (2) the appropriation of plaintiff's name or likeness to defendant's advantage, (3) lack of consent, and (4) resulting injury.

There are disagreements among various state laws concerning the breadth of the interest protected by this cause of action. While there is a consensus that a celebrity's name and likeness will be protected, a minority of states find that a noncelebrity has no right of publicity. An additional issue concerns the scope of a person's right of publicity. Most courts will grant protection to reasonable variations of a person's name such as stage names, famous first names and nicknames. Some courts, however, have protected only full names or have refused to protect pen names or stage names.

The courts agree that use of a picture of a person, without reference to their name, can be an invasion of the right of publicity. This may be true even when the person's facial features are not used, as long as they are identifiable in the picture. The broadest scope of protection, determined by courts interpreting California law, has held that use of the plaintiff's name or the use of an actual photograph or drawing of the plaintiff is not required, only the use of identifying indicia. For example, these courts have concluded that a person's "identity" was appropriated by use of the plaintiff's race car in a television commercial and by imitation of a singer's voice.

For example, the use of the term "Here's Johnny" in the marketing of portable

toilets was found to violate Johnny Carson's right of publicity.[7] Recently, Vanna White succeeded in arguing that an advertisement that depicted a robot, dressed in a wig, gown and jewelry, posing on the "Wheel of Fortune" game show set, violated her common law right of publicity.[8] She was ultimately awarded $403,000 at trial. These cases have been criticized by some attorneys and judges as going "too far" in enforcing the right of publicity.

***Statutory Protection of the Right of Publicity.*** Several states have enacted statutes that protect the right of publicity. Some of these states have made the statute the exclusive remedy. Although six states have modeled their statutes after New York's, each state's statute is different and has its own peculiarities. Most litigation has involved the California and New York statutes.

Under California's statute (Civil Code 3344) a plaintiff is required to prove: the defendant "knowingly" used the plaintiff's name, voice, signature, photograph, or likeness, on or in products, merchandise or goods, for purposes of advertising, selling or soliciting purchases, without the plaintiff's consent.

The scope of a person's right of publicity has been more narrowly construed under the statute than is the case with the common-law action. It has been determined that the broad notion of "identity" is not protected by the statute. Under the statute, only the actual physical voice of the person is protected, voice imitation does not violate the statute. The term "photograph" includes a motion picture or live television transmission in which the person is readily identifiable.

A successful plaintiff is able to elect between receiving the statutory damages minimum of $750 or the combined amount of plaintiff's actual damages and defendant's profits attributable to the unauthorized use. Punitive damages are available and the prevailing party is entitled to attorneys' fees and costs.

The California statute provides for a complete defense when the name, voice, signature, photograph or likeness is used in connection with "any news, public affairs, or sports broadcast or account, or any political campaign...." Recent cases have interpreted this section as providing the media with even greater protection than that required by the First Amendment. While the "news" exemption has been equated with the traditional protection given to matters in the public interest, the "public affairs" exemption is viewed as including matters that would not necessarily be considered news. This statute does not include a specific defense for use of a person's name, voice, signature, photograph, or likeness in works of art.

California's "post mortem" statute protects the right of publicity of a deceased person. The statute sets forth the ownership of the right after the death of the individual and a registration requirement whereby the person's name must be registered with the Secretary of State. This statute has a more specific rendering of statutory defenses. Under these defenses the statute does not apply to "Material that is of political or newsworthy value" or to "Single and original works of fine art." It is not clear whether this latter statutory defense would protect fine artworks in multiples. The statutory protection of an artist who produces an edition of cast busts or a lithographic series is less certain than the protection granted to an artist who produces an individual portrait.[9] The owners of John Wayne's publicity rights unsuccessfully sued Andy

---

7  *Carson v. Here's Johnny Portable Toilets, Inc.,* 698 F.2d 831 (6th Cir. 1983).
8  *White v. Samsung Elecs. Am., Inc.,* 971 F.2d 1395 (9th Cir. 1992).
9  Ralph E. Lerner & Judith Bresler, *Art Law: The Guide for Collectors, Investors, Dealers, and Artists* 344-45 (1989).

Warhol for the unauthorized use of Wayne's likeness in a print. In dismissing the suit, the trial court held that the use of Wayne's likeness in a work of art produced in multiple form was protected by the First Amendment.[10]

Under New York law, the right of publicity is exclusively statutory. New York's statute is the oldest and least specific statute protecting the right of publicity. Enacted in 1903, the New York and federal courts have had time to add quite a bit of judicial gloss to the statute.

The statutory basis for a right of publicity action in New York is the same statute that allows for recovery for the public disclosure of a private fact analyzed above. The action arises whenever a defendant uses a living person's name, portrait or picture, for advertising or trade purposes, without obtaining the person's written consent to do so. The distinction here is that the plaintiff is seeking commercial damages, rather than damages for personal injuries. A successful plaintiff is able to obtain an injunction, recover damages and may be awarded punitive damages if the defendant knowingly used the plaintiff's identity.

The consent of the person depicted constitutes a defense to a right of publicity action. Unlike California, however, in New York the consent must be in writing. The New York statutes specifically exempts certain uses of a person's name, portrait or picture. Under this exemption, a professional photographer is permitted to exhibit in their studio photographs taken of individuals unless the individual objects in writing. In addition, anyone is permitted to use the name of an artist to correctly and truthfully identify a work created by the artist. New York also recognizes an "incidental use" exception to a right of publicity action. Under this exception an incidental or fleeting mention of a person or appearance in a film is not actionable. Although there is no explicit newsworthiness defense set forth in the statute, New York courts have created such a defense.

A woman who appeared in the opening minutes of the motion picture *Sea of Love* unsuccessfully sued the producer of the motion picture for violating her statutory right of publicity. The self-proclaimed prostitute had been filmed while soliciting on a New York City street. She appeared for nine seconds during the opening title scenes of the motion picture. The trial court invoked New York's incidental use doctrine. "Liability under section 51 is limited, however, by the doctrine of incidental use, under which merely incidental or isolated uses of a name, picture or portrait are not actionable." In finding for the movie's producer, the court stated, "The statute requires a more direct and substantial connection between the appearance of the plaintiff's name or likeness and the main purpose and subject of the work."[11]

## The Newsworthiness Defense

As a general rule, the courts of every jurisdiction determine First Amendment protection in this area by analyzing the type of use made of the plaintiff's identity. Uses that are more informative in nature tend to be deemed newsworthy and are protected by the First Amendment. Uses that are more commercial in nature, such as merchandising, tend to be not protected.

Commercial exploitation of a person's name or likeness on calendars, games, posters, clothing, postcards, plates, trading cards and other merchandise, or in connection with

---

10  Franklin Feldman & Stephen E. Weil, *Art Law: Rights and Liabilities of Creators and Collectors* 1.2.7 (1993 Supp.).
11  *Preston v. Martin Bregman Productions, Inc.,* 765 F. Supp. 116 (S.D.N.Y. 1991).

services, are generally not protected by the newsworthiness privilege. In addition, the unauthorized use of a person's identity in the advertising of commercial goods and services is actionable. It is advised that the artist obtain a broadly stated written consent from the subject of an artwork or photograph even though the artist may only intend to use the subject's image in a single work. The artist may decide later to reproduce the work in poster form, or in a calendar or postcard. If the artist does not have a written consent that permits such a use of the subject's likeness, a successful right of publicity action could result.

The producer of a poster, sold in commercial quantities, which consisted of a photograph of Elvis Presley and the words "In Memory, 1935–1977" was held liable for infringing Elvis' right of publicity. Although the producer argued that the poster was commemorating a newsworthy event, the court found the poster to be a commercial product that was not protected by the First Amendment.[12]

Newsworthy uses of a person's identity are not actionable. Although at least one recent decision has stated that the newsworthiness analysis of the public disclosure of private facts action is not applicable in right of publicity cases, many decisions use such an analysis based on the same policy considerations. As one court has stated: "The privilege of enlightening the public is by no means limited to the dissemination of news in the sense of current events but extends far beyond to include all types of factual, educational and historical data, or even entertainment and amusement, concerning interesting phases of human activity in general."[13]

The use of a person's name or likeness by artists and the media is generally permitted. The First Amendment protects the dissemination of information and points of view to the public. Therefore, the use of a person's name or likeness in newspaper or magazine articles, on covers of magazines containing stories relating to that person, in motion pictures and television programs, in musical compositions and in books is protected. This protection is either expressly based on a newsworthiness exception or is implicitly applied when interpreting state right of publicity statutes. In New York, activities involving the dissemination of news or information concerning matters of public interest are privileged and do not fall within the "purposes of trade" requirement of the New York privacy statutes. Such media uses have also been consistently deemed not to be "for purposes of advertising or selling" in California. The scope of newsworthy subject matter has been liberally construed by the California courts: "The privilege of printing an account of happenings and of enlightening the public as to matters of interest is not restricted to current events; magazines and books, radio and television may legitimately inform and entertain the public with the reproduction of past events, travelogues and biographies."[14]

This view also protects original works of art. Painting a portrait of an individual or using the likeness of an individual in an artwork will be protected. The difficulty, of course, arises with the definition of "art." While original works are clearly protected, once multiple images are produced the courts become wary. The closer these multiple images are to merchandise, such as posters, the less likely the First Amendment will protect such use. The newsworthy privilege does not extend to commercialization of an individual's personality in a manner that is distinct from the dissemination of news or information.

12  *Factors Etc, Inc. v. Pro Arts, Inc.,* 496 F. Supp. 1090 (S.D.N.Y. 1980).
13  *De Gregorio v. CBS, Inc.,* 123 Misc. 2d 491, 473 N.Y.S.2d 922 (1984).
14  *Carlisle v. Fawcett Publications, Inc.,* 201 Cal. App. 2d 733, 20 Cal. Rptr. 405 (1962).

The individual claiming to be the "kissing sailor" in the famous photograph taken by Alfred Eisenstadt in Times Square on V-J Day sued Time Incorporated for the violation of his right of publicity. His suit was brought after *Life Magazine* offered to sell copies of the photograph for $1,600 each. The court found that while the use of the photograph in magazines and history books was protected, the sale of the photograph in a limited edition "clearly had a commercial purpose apart from the dissemination of news." The court decided, however, a full trial was needed to determine whether the primary function of the limited edition sales was a commercial exploitation or served some other protected public interest.[15]

The identity of a person may be used in connection with a matter of public interest so long as there is a real relationship between the person and the newsworthy information, the use is not an advertisement in disguise and does not constitute an unauthorized endorsement. Artistic uses of a person's identity in artwork or in a fictionalized account of an event in the life of a public figure in a novel or movie is protected if it is evident that the events are fictitious.

*Forum* magazine was successfully sued by Cher for statements it published in subscription advertisements next to her picture. One advertisement included the sentence: "So take a tip from Cher and hundreds of thousands of other adventurous people and subscribe to *Forum*." The court held that advertising to promote a news medium is not actionable under an appropriation of publicity theory as long as the advertising does not falsely claim that the person endorses the medium. While *Forum* had the right to use a photograph of Cher on its cover to announce that her interview was contained in that issue, and *Forum* had the right to use that cover in its subscription advertising, *Forum*'s statements constituted an implied endorsement of *Forum* by Cher and was therefore actionable.[16]

---

15  *Mendonsa v. Time, Inc.*, 678 F. Supp. 967 (D.R.I. 1988).
16  *Cher v. Forum International, Ltd.*, 692 F.2d 634 (9th Cir. 1982), cert. denied, 462 U.S. 1120 (1983).

# APPENDICES

## Artists' Resource Appendix

*(Listed by subject matter)*

### ART PACKERS AND SHIPPERS

Atlantic Van Lines
1001 Wilso Drive
Baltimore, MD 21223
(410) 368-4008

Atthowe Fine Arts
926 32nd Street
Oakland, CA 94608
(510) 654-6816

Cooke's Crating and Fine Arts
Transportation, Inc.
3124 East 11th Street
Los Angeles, CA 90023
(213) 268-5101

Eagle Transfer
40 Laight Street, 2nd Floor
New York, NY 10013
(212) 966-4100

Fine Arts Express
251 Heath Street
Boston, MA 02130
(800) 370-2302 or
(617) 566-1155

### ARTS ORGANIZATIONS

*Following is an alphabetical list of organizations that provide arts information. Included are reference sources, educational opportunities, information clearinghouses and community arts centers.*

American Association of Museums
1225 Eye Street NW, Suite 200
NW Washington, DC 20005
(202) 289-1818

American Council for the Arts
1 East 53rd Street, 7th Floor
New York, NY 10022
(212) 223-2787

American Craft Council
72 Spring Street
New York, NY 10012
(212) 274-0630

The American Federation of Arts (AFA)
41 East 65th Street
New York, NY 10021
(212) 988-7700

American Society of Appraisers
P.O. Box 17265
Washington, DC 20041
(800) 272-8258

Artists' Rights Society
65 Bleeker Street, 9th Floor
New York, NY 10012
(212) 420-9160

Artists' Space/Committee
for the Visual Arts, Inc.
38 Green Street, 3rd Floor
New York, NY 10013
(212) 226-3970

Art PAC
Bob Bedard
408 3rd Street SE
Washington, DC 20003
(202) 546-1804

ARTS, Inc.
315 West 9th Street, Suite 201
Los Angeles, CA 90015
(213) 627-9276

Association of Hispanic Arts, Inc.
173 East 116th Street, 2nd Floor
New York, NY 10029
(212) 860-5445

Business Committee for the Arts, Inc.
1775 Broadway, Suite 510
New York, NY 10019
(212) 664-0600

Center for Safety in the Arts
5 Beekman Street, Suite 820
New York, NY 10038
(212) 227-6220

Center for the Arts/YMCA
5 West 63rd Street
New York, NY 10023
(212) 787-6557

College Art Association
275 Seventh Avenue, 5th Floor
New York, NY 10001
(212) 691-1051

International Foundation for
Art Research (IFAR)
46 East 70th Street
New York, NY 10021
(212) 879-1780

International Sculpture Center
1050 17th Street NW, Suite 250
Washington, DC 20036
(202) 785-1144

LACE (Los Angeles Contemporary
Exhibitions)
6522 Hollywood Boulevard
Los Angeles, CA 90028
(213) 957-1777

Lillian Paley's Center for the Visual Arts
713 Washington Street
Oakland, CA 94607
(510) 451-6300

Los Angeles Center for Photographic
Studies
P. O. Box 74381
Los Angeles, CA 90004
(213) 466-6232

Los Angeles Public Library
Art and Recreation Department
630 West Fifth Street
Los Angeles, CA 90071
(213) 228-7225

Museum of Modern Art
11 West 53rd Street
New York, NY 10019
(212) 708-9400

National Artists Equity Association
1325 G Street NW
Washington, DC 20006
(202) 628-9633

National Assembly of State
Arts Agencies
1010 Vermont Avenue NW, Suite 920
Washington, DC 20005
(202) 347-6352

New York Artists Equity Association
498 Broome Street
New York, NY 10013
(212) 941-0130

New York City Department of
Cultural Affairs
2 Columbus Circle
New York, NY 10019
(212) 841-4100

New York Foundation for the Arts
155 Avenue of the Americas, 14th Floor
New York, NY 10013
(212) 366-6900

New York Graphic Society, Ltd.
33 River Road
Cos Cob, CT 06807
(203) 661-2400

New York Public Libraries, Galleries:
Main Library
42nd Street & Fifth Avenue
New York, NY 10018
212-340-0849

Donnell Branch
20 West 53rd Street
New York, NY 10019
212-621-0618

Performing Arts Library
40 Lincoln Center Plaza
New York, NY 10023
212-870-1630

Schomburg Center for Research
in Black Culture
515 Lenox Avenue
New York, NY 10031
212-491-2200
General Information:
(212) 930-0830

Otis Art Institute / Parsons
School of Design
2401 Wilshire Boulevard
Los Angeles, CA 90057
(213) 251-0500

Packing and Crating Information
Network (PACIN)
Registrar's Committee of the American
Association of Museums
Brent Powell, Chairman
c/o The Nelson Atkins Museum
of Art
4525 Oak
Kansas City, MO 64111
(816) 751-1294

Pasadena Arts Council
116 Plaza Pasadena
Pasadena, CA 91101
(818) 795-0825

Patent and Trademark Office
U.S. Department of Commerce
Washington, DC 20231
(703) 308-4357
(General Information.)

Pro Arts
461 9th Street
Oakland, CA 94607
(510) 763-4361

United States Copyright Office
Library of Congress
Washington, DC 20559
(202) 707-3000

Visual Artists and Galleries Association,
Inc. (VAGA)
521 Fifth Avenue, Suite 800
New York, NY 10017
(212) 808-0616

Washington Project for the Arts
400 7th Street NW
Washington, DC 20004
(202) 347-8304

## GRANTS, SCHOLARSHIPS, DIRECT ECONOMIC AID

*These organizations render direct finan-cial assistance through grants and funding, grants information, loans, scholarships, and competitions. Amounts available vary according to need and the specific project being funded. Contact organizations directly concerning application deadlines and specific requirements.*

The Artists' Foundation, Inc.
8 Park Plaza
Boston, MA 02116
(617) 227-2787

ARTS, Inc.
315 West 9th Street, Suite 201
Los Angeles, CA 90015
(213) 627-9276

Change, Inc.
P.O. Box 705, Cooper Station
New York, NY 10276
(212) 473-3742

Citizens' Stamp Advisory Committee
c/o Postmaster General
475 L'Enfant Plaza SW, Room 5700
Washington, DC 20260
*(Commission for stamp designs.)*

Foundation Center
79 Fifth Avenue
New York, NY 10003
(212) 620-4230

Foundation for Contemporary
Performance Arts, Inc.
151 East 63rd Street
New York, NY 10021
(212) 308-6032

Grantsmanship Center
1125 West 6th Street, 5th Floor
Los Angeles, CA 90017
(213) 482-9860

Materials for the Arts
New York City Department of
Cultural Affairs
2 Columbus Circle
New York, NY 10019
(212) 841-4100

National Artists Equity
Association, Inc.
1325 G Street NW
Washington, DC 20006
(202) 628-9633

National Endowment for the Arts
1100 Pennsylvania Avenue NW
Washington, DC 20506
(202) 682-5400

## HOUSING

Allied Arts of Seattle
105 South Main, Room 201
Seattle, WA 98104
(206) 624-0432

American Council for the Arts
1 East 53rd Street, 7th Floor
New York, NY 10022
Marie Walsh Sharpe Foundation Artist
Hotline: (800) 285-2789

ArtHouse
Fort Mason Center
Building C, Room 255
San Francisco, CA 94123
(415) 885-1194

Artspace Development Network
Artspace Projects, Inc.
400 First Avenue North, Suite 518
Minneapolis, MN 55401
(612) 339-4372

Artspace, Inc.
325 West Pierpont
Salt Lake City, UT 84101
(801) 531-9378

California Lawyers for the Arts
　San Francisco Office:
　Fort Mason Center
　Building C, Room 255
　San Francisco, CA 94123
　(415) 775-7200

　Los Angeles Office:
　1549 11th Street, Suite 200
　Santa Monica, CA 90401
　(310) 395-8893

Fort Point Arts Community, Inc.
of South Boston
249 A Street
Boston, MA 02210
(617) 423-1573

Lawyers for the Creative Arts
213 West Institute Place, Suite 411
Chicago, IL 60610
(312) 944-2787

National Artists Equity Association
1325 G Street NW
Washington, DC 20006
(202) 628-9633

New York City Department of
Cultural Affairs
Real Estate Office
2 Columbus Circle
New York, NY 10019
(212) 841-4100

Philadelphia Volunteer Lawyers
for the Arts
251 South 18th Street
Philadelphia, PA 19103
(215) 545-3385

Volunteer Lawyers for the Arts
1 East 53rd Street, 6th Floor
New York, NY 10022
(212) 319-2787

## INSURANCE

*The following organizations provide
various types of insurance for visual
artists.*

American Craft Council
72 Spring Street
New York, NY 10012
(212) 274-0630
Through:
　Association and Society Insurance

11400 Rockville Pike, Suite 700
Rockville, MD 20852
(301) 816-0045
*(Medical, hospital, indemnity, life insur-
ance and studio policies.)*

Chicago Artists' Coalition with
Washington National Health Insurance
Program
　Russell W. Holmquist Agency
　5153 North Clark, Suite 310
　Chicago, IL 60640
　(312) 334-1215
*(Group health insurance plan.)*

Fine Arts Express
251 Heath Street
Boston, MA 02130
(800) 370-2302 or
(617) 566-1155
*(Insurance for art in transit.)*

Graphic Artists' Guild
11 West 20th Street, 8th Floor
New York, NY 10011
(212) 463-7730
*(Life, health and disability.)*

Huntington T. Block Insurance
Agency, Inc.
1120 20th Street NW, 6th Floor
Washington, DC 20036
(202) 223-0673
*(Fine arts insurance.)*

International Sculpture Center
1050 17th Street NW, Suite 250
Washington, DC 20036
(202) 785-1144
*(Fine arts insurance for sculptors.)*

Marin Arts Council
251 North San Pedro Road
San Rafael, CA 94903
(415) 499-8350
*(Medical and dental insurance.)*

National Artists Equity Association
1325 G Street NW
Washington, DC 20006
(202) 628-9633
*(All-risk, fine arts coverage, major
medical and life.)*

Society of Illustrators
128 East Street
New York, NY 10021
(212) 838-2560
*(Life and health insurance.)*

## LEGAL INFORMATION,
## REFERRALS

*These organizations comprise a nation-
wide network of legal assistance
services. Most provide information
important to artists and referrals to
lawyers who practice in art-related areas.
Most offer legal aid on a reduced-fee,
"ability to pay" or pro bono (free) basis.
Some provide group services for artists'
membership organizations and conduct
seminars and symposia on legal issues
confronting visual artists. In addition,
many state bar associations have com-
mittees and sections devoted to the arts.*

American Arbitration Association
140 West 51st Street, 9th Floor
New York, NY 10020
(212) 484-4000

Arts Arbitration and Mediation Services
(AAMS) *(See California Lawyers for
the Arts.)*

Business Volunteers for the Arts
200 South Biscayne Boulevard
Suite 4600
Miami, FL 33131
(305) 376-8674

California Lawyers for the Arts
Fort Mason Center
Building C, Room 255
San Francisco, CA 94123
(415) 775-7200

Colorado Lawyers for the Arts
200 Grant Street, Suite 303E
Denver, CO 80203
(303) 722-7994

Connecticut Volunteer Lawyers
for the Arts
Connecticut Commission on the Arts
227 Lawrence Street
Hartford, CT 06106
(203) 566-4770

Fund for the Arts
623 West Main Street, 2nd Floor
Louisville, KY 40202
(502) 582-0100

Georgia Volunteer Lawyers for the Arts
141 Pryor Street, Suite 2030
Atlanta, GA 30303
(404) 525-6046

Huntington Arts Council
213 Main Street
Huntington, NY 11743
(516) 271-8423

Lawyers for the Creative Arts
213 West Institute Place, Suite 411
Chicago, IL 60610
(312) 944-2787

Louisiana Volunteer Lawyers for the Arts
c/o Arts Council of New Orleans
821 Gravier Street, Suite 600
New Orleans, LA 70112
(504) 523-1465

Maryland Lawyers for the Arts
Maryland Art Place
Baltimore, MD 21202
(410) 752-1633

North Carolina Volunteer Lawyers
for the Arts
City of Raleigh Arts Commission
P.O. Box 590
Raleigh, NC 27602
(919) 831-6234

Philadelphia Volunteer Lawyers
for the Arts
251 South 18th Street
Philadelphia, PA 19103
(215) 545-3385

San Diego Lawyers for the Arts
c/o Law Offices of Peter Karlen
1205 Prospect Street, Suite 400
La Jolla, CA 92037
(619) 454-9696

St. Louis Volunteer Lawyers and
Accountants for the Arts
3540 Washington, 2nd Floor
St. Louis, MO 63103
(314) 652-2410

Texas Accountants and Lawyers
for the Arts
2917 Swiss Avenue
Dallas, TX 75204
(214) 821-1818

Texas Accountants and Lawyers
for the Arts
1540 Sul Ross
Houston, TX 77006
(713) 526-4876

Visual Artists and Galleries Association,
Inc. (VAGA)
521 Fifth Avenue, Suite 800
New York, NY 10017
(212) 808-0616

Volunteer Lawyers for the Arts
1 East 53rd Street, 6th Floor
New York, NY 10022
(212) 319-2787

Volunteer Lawyers for the Arts, D.C.
918 16th Street NW, Suite 503
Washington, DC 20006
(202) 429-0229

Volunteer Lawyers for the Arts Program
Albany–Schenectady League of
Arts, Inc.
19 Clinton Avenue
Albany, NY 12207
(518) 449-5380

Washington Area Lawyers for the Arts
1325 G Street, Lower Level
Washington, DC 20005
(202) 393-2826

## UNIONS, GUILDS, CLUBS

*These organizations invite artists to
receive the benefits of membership.
They include unions, guilds and clubs
that provide opportunities for artists to
participate in group projects and to
interact with other artists, as well as
providing informational assistance to
their members.*

American Institute of Graphic Arts
164 Fifth Avenue
New York, NY 10010
(212) 807-1990

American Society of Artists, Inc.
P.O. Box 1326
Palatine, IL 60078
(312) 751-2500

American Society of Media
Photographers (ASMP)
14 Washington Road, Suite 502
Princeton Junction, NJ 08550
(609) 799-8300
(Call for local chapters.)

The Artists' Foundation, Inc.
8 Park Plaza
Boston, MA 02116
(617) 227-2787

Boston Visual Artists Union, Inc.
P.O. Box 399
Newtonville, MA 02160
(617) 695-1266

The Comic Book Professionals
Association (CBPA)
Noel Wolfman, Executive Director
P.O. Box 570850
Tarzana, CA 91357

Cultural Alliance of Greater Washington
410 8th Street NW, Suite 600
Washington, DC 20004
(202) 638-2406

Graphic Artists Guild
11 West 20th Street, 8th Floor
New York, NY 10011
(212) 463-7730

Motion Picture Screen Cartoonists Union
Steve Hulett, Business Representative
Local 839 IATSE
4729 Lankershim Boulevard
North Hollywood, CA 91602
(818) 766-7151

National Artists Equity Association
1325 G Street NW
Washington, DC 20006
(202) 628-9633

National Association of Artists
Organizations
918 F Street NW
Washington, DC 20004
(202) 347-6350

Society of Illustrators
128 East 63rd Street
New York, NY 10021
(212) 838-2560

Visual Artists and Galleries Association,
Inc. (VAGA)
521 Fifth Avenue, Suite 800
New York, NY 10017
(212) 808-0616

## Selected Bibliography *(Listed by subject matter)*

### BUSINESS AND MARKETING

*All-In-One Directory.* New Platz, NY: Gebbie Press, updated annually.

*The Art Calendar Guide to Making a Living As an Artist.* Upper Fairmount, MD: Art Calendar, 1993.

*Artist's Market.* Cincinnati, OH: Writer's Digest Books, updated annually.

Caplin, Lee Evan, ed. *The Business of Art.* Englewood Cliffs, NJ: Prentice-Hall, Inc., 1983.

Chamberlain, Betty. *The Artist's Guide to His Market.* Rev. ed. New York, NY: Watson-Guptill Publications, 1970, 1979, 1983.

Cochrane, Diane. *This Business of Art.* New York, NY: Watson-Guptill Publications, 1988.

Davis, Sally Prince. *The Fine Artist's Guide to Showing and Selling Your Work.* Cincinnati, OH: North Light Books, 1989.

Davis, Sally Prince. *The Graphic Artist's Guide to Marketing and Self-promotion.* Cincinnati, OH: North Light Books, 1991.

Dreeszen, Craig. *The Artist in Business: Basic Business Practices.* Amherst, MA: Arts Extension Service, Division of Continuing Education, University of Massachusetts at Amherst, 1991.

Engh, Rohn. *Sell & Re-sell Your Photos.* 3d ed. Cincinnati, OH: Writer's Digest Books, 1991.

Franklin-Smith, Constance, ed. *Art Marketing Sourcebook for the Fine Artist: Where to Sell Your Artwork: Over 2000 Listings of Artworld Professionals.* Renaissance, CA: ArtNetwork Press, 1992.

Gold, Ed. *The Business of Graphic Design: A Sensible Approach to Marketing and Managing a Graphic Design Firm.* New York, NY: Watson-Guptill Publications, 1985.

Gordon, Elliott and Barbara Gordon. *How to Sell Your Photographs and Illustrations.* New York, NY: Allworth Press, 1990.

*Graphic Artists' Guild Handbook of Pricing and Ethical Guidelines.* 8th ed., Cincinnati, OH: North Light Books, 1994.

Grant, Daniel. *The Business of Being an Artist.* New York, NY: Allworth Press, 1991.

*Guide to Newspaper Syndication, 1992-1993.* Available by mail order from Newspaper Syndication Specialists, Ste. 326, PO Box 19654, Irvine, CA 92720.

Katchen, Carole. *Promoting and Selling Your Art.* New York, NY: Watson–Guptill Publications, 1978.

Luther, Judith. *For the Working Artist: A Survival Guide for Artists.* Valencia, CA: Developed for the Office of Placement and Career Development, California Institute of the Arts, 1986.

McKenzie, Alan. *How to Draw and Sell Comic Strips.* Cincinnati, OH: North Light Books, 1987.

Messman, Carla. *The Artist's Tax Guide & Financial Planner.* Rev. ed. of *The Artist's Tax Workbook for 1990.* New York, NY: Lyons & Burford, Publishers, 1992.

Metzdorf, Martha. *The Ultimate Portfolio.* Cincinnati, OH: North Light Books, 1991.

Michels, Caroll. *How to Survive and Prosper as an Artist: A Complete Guide to Career Management.* New York, NY: H. Holt, 1988.

Morris, Gerri and Hope London Morris. *Marketing for Artists and Crafts People.* Manchester, England: North West Arts Board, 1994.

*Official Museum Directory.* New Providence, NJ: Reed Publishing, updated annually.

*Photographer's Market.* Cincinnati, OH: Writer's Digest Books, updated annually.

Ritchie, Bill Jr. *The Art of Selling Art: Between Productivity and Livelihood.* Seattle, WA: Perfect, 1989.

Russell, John J., mng. ed. *National Trade and Professional Associations of the United States.* 28th ed. Washington, DC: Columbia Books, Inc., 1993.

Scott, Michael. *The Crafts Business Encyclopedia: The Modern Craftsperson's Guide to Marketing, Management, and Money.* As revised by Leonard D. Duboff. Rev. ed. San Diego, CA: Harcourt Brace & Co., 1993.

Staake, Bob. *1993 Humor and Cartoon Market.* Cincinnati, OH: Writer's Digest Books, 1993.

Thompson, Ross and Bill Hewison. *How to Draw and Sell Cartoons.* Cincinnati, OH: North Light Books, 1985.

### COPYRIGHT

Conner, Floyd, et al. *The Artist's Friendly Legal Guide.* Rev. ed. Series title: Artist's Market Business Series. Cincinnati, OH: North Light Books, 1991.

Jensen, Timothy S. *VLA Guide to Copyright for Visual Artists.* New York, NY: Volunteer Lawyers for the Arts, 1987.

Leland, Caryn R. *Licensing Art & Design.* New York, NY: Allworth Press; Distributor: Cincinnati, OH: North Light Books, 1990.

Nimmer, Melville. *Nimmer on Copyright.* 5 vols. New York, NY: Matthew Bender & Co., Inc., 1978; updates, write for info.

Wilson, Lee. *Make it Legal.* New York, NY: Allworth Press, 1990.

## GRANTS AND FUND RAISING

*Arts Funding: A Report on Foundation and Corporate Grant-making Trends.* New York, NY: The Foundation Center, 1993.

Coe, Linda, Rebecca Denny and Anne Rogers. *Cultural Directory II: Federal Funds and Services for the Arts and Humanities.* 2d ed. Federal Council on the Arts and the Humanities. Washington, DC: Smithsonian Institution Press, 1980.

*The Foundation Directory.* New York, NY: The Foundation Center, updated annually.

*Foundation One Thousand: In Depth Profiles of the 1000 Largest U.S. Foundations.* (Previously published as *Source Book Profiles.)* New York, NY: The Foundation Center, updated annually.

*Fund Raising Ideas Catalog.* The Center for Nonprofits, 155 W. 72, New York, NY 10023. Free. (Send SASE.)

*Grant Guides 1993/1994 Editions:*
*Arts, Culture and the Humanities* and *Film, Media & Communications.* New York, NY: The Foundation Center, 1993.

Hall, Mary Stewart. *Getting Funded: A Complete Guide to Proposal Writing.* 3d ed. Portland, OR: Continuing Education Publications, Portland State University, 1988.

Margolin, Judith. *The Individual's Guide to Grants.* New York, NY: Plenum Press, 1983.

*National Guide to Funding in Arts and Culture.* 3d ed. New York, NY: The Foundation Center, 1994.

Porter, Robert, ed. *Guide to Corporate Giving in the Arts.* New York, NY: ACA Books, 1987.

Roosevelt, Rita K., Anita M. Granoff and Karen P.K. Kennedy. *Money Business: Grants and Awards for Creative Artists.* Rev. ed. Boston, MA: Artist Foundation, 1982.

Shanahan, James L. *United Arts Fundraising in the 1990s: Serving the Community Arts System in an Era of Change.* New York, NY: American Council for the Arts, 1993.

*Source Book Profiles.* See *Foundation One Thousand: In Depth Profiles of the 1000 Largest U.S. Foundations.*

*Taft Corporate Giving Directory,* Washington, DC: The Taft Group, updated annually.

## HEALTH HAZARDS, WORKER COMPENSATION AND PRODUCTS LIABILITY

Babin, A., P.A. Peltz and M. Rossol, *Children's Art Supplies Can Be Toxic.* New York, NY: Center for Safety in the Arts, 1989.

McCann, M. *Art Safety Procedures for Art Schools & Art Departments.* New York, NY: Center for Safety in the Arts, 1992.

McCann, M. *Artist Beware.* 2d ed. New York, NY: Lyons and Burford Books, 1982.

McCann, M. *Health Hazards Manual for Artists.* 4th ed. New York, NY: Lyons and Burford Books, 1994.

McCann, M. *Teaching Art Safely to the Disabled.* New York, NY: Center for Safety in the Arts, 1987.

Rossol, Mona. *The Artist's Complete Health and Safety Guide.* New York, NY: Allworth Press, Cincinnati, OH: North Light Books, 1990.

*The Safer Arts: The Health Hazards of Arts and Crafts Materials.* Ottawa: Health and Welfare Canada, 1988.

Seeger, Nancy. *A Painter's Guide to the Safe Use of Materials.* Series title: Alternatives for the Artist. Chicago, IL: School of the Art Institute of Chicago, Health Hazards in the Arts Program, 1984.

Spandorfer, Merle and Deborah Curtiss. *Making Art Safely: Alternative Methods and Materials in Drawing, Painting, Printmaking, Graphic Design, and Photography.* New York, NY: Van Nostrand Reinhold, 1993.

## HOUSING, LIVE/WORK SPACE, THE STUDIO LEASE

Bee, Carmi. *Artists' Housing: A Survey of Live/Work Space.* Washington, DC, 1983.

Biberman, Nancy and Roger K. Evans. *Artists' Housing Manual: A Guide to Living in New York City.* New York, NY: Volunteer Lawyers for the Arts, 1987.

Brown, Catherine R., William B. Fleissig and William R. Morrish. *Building for the Arts: A Guidebook for the Planning and Design of Cultural Facilities.* Santa Fe, NM: Western States Arts Foundation, 1984.

Green, Kevin W., ed. *The City as a Stage: Strategies for the Arts in Urban Economics.* Washington, DC: Partners for Liveable Places, 1983.

Kahn, Vivian and Larry J. Mortimer. *Seattle Artists' Housing Handbook.* Seattle, WA: City of Seattle Department of Community Development and Arts Commission, 1980.

Kartes, Cheryl. *Creating Space: A Guide to Real Estate Development for Artists.* New York, NY: Artspace Projects, Inc., the Bay Area Partnership and the American Council for the Arts, Allworth Press, 1993.

Kibbe, Barbara. *Live/Work: The San Francisco Experience.* San Francisco, CA: San Francisco Art Commission, 1985.

Lipske, Mike. *Artists' Housing: Creating Live/Work Space That Lasts.* New York, NY: Publishing Center for Cultural Resources, 1988.

*Live/Work: Form & Function.* San Francisco, CA: ArtHouse, a program of California Lawyers for the Arts and the San Francisco Art Commission, 1993.

*Live/Work: L.A.* Los Angeles, CA: California Lawyers for the Arts, 1990.

Macris, Natalie B. *Artists' Live/Work Space in San Francisco: Strategies for Preservation and Development.* San Francisco, CA: San Francisco Art Commission, 1985.

Mayer, R., ed. *Live/Work Space: Changing Public Policy.* San Francisco, CA: Artists Equity Association, Northern California Chapter, 1980.

Nesson, Jero. *Artists in Space: A Handbook for Developing Artists' Studio Space.* Boston, MA: Fort Point Arts Community, Inc., 1987.

Porter, Robert, ed. *The Arts and City Planning.* New York, NY: American Council for the Arts, 1980.

Reineccius, Richard. *The Inspector Cometh: A Guidebook to Assist in Finding or Creating Performing Space and Meeting the Codes.* San Francisco, CA: ArtHouse, a program of California Lawyers for the Arts and the San Francisco Art Commission, 1993.

Rieser, Enid. *The Chicago ArtSpace Study.* Chicago, IL: Chicago Department of Cultural Affairs, 1986.

Snedcof, Harold. *Cultural Facilities in Mixed-Use Development.* Washington, DC: The Urban Land Institute, 1985.

Stratton, Jim. *Pioneering in the Urban Wilderness.* New York, NY: Urizen Books, 1977.

## LAW, CONTRACTS, ARTIST/DEALER/REPRESENTATIVE RELATIONSHIPS

Allen, Julius W. *Resale Royalties for Visual Artists Background Information and Analysis.* Washington, DC: Congressional Research Service, Library of Congress, 1988.

Conner, Floyd, et al. T*he Artist's Friendly Legal Guide.* Rev. ed. Series title: Artist's Market Business Series. Cincinnati, OH: North Light Books, 1991.

Crawford, Tad. *Business and Legal Forms for Fine Artists.* New York, NY: Allworth Press; Cincinnati, OH: North Light Books, 1990.

Crawford, Tad and Eva Doman Bruck. *Business and Legal Forms for Graphic Designers.* New York, NY: Allworth Press, 1990.

Crawford, Tad. *Business and Legal Forms for Illustrators.* New York, NY: Allworth Press; Cincinnati, OH: North Light Books, 1990.

Crawford, Tad. *Legal Guide for the Visual Artist.* New York, NY: Allworth Press; Cincinnati, OH: North Light Books, 1990.

DuBoff, Leonard D. *Art Law in a Nutshell.* 2d ed. St. Paul, MN: West Pub. Co., 1993.

Duboff, Leonard D. *The Deskbook of Art Law.* New York, NY: Federal Publications, Inc., 1978.

DuBoff, Leonard D. *The Deskbook of Art Law: 1984 Supplement.* Washington, DC: Federal Publications, 1984.

Feldman, Franklin and Stephen E. Weil. *Art Law: Rights and Liabilities of Creators and Collectors.* Boston, MA: Little, Brown, 1986.

Feldman, Franklin and Stephen E. Weil. *Art Law: Rights and Liabilities of Creators and Collectors.* 1988 Supplement. Boston, MA: Little, Brown, 1988.

Goodwin, John R. *Legal Primer for Artists and Craftspersons.* Columbus, OH: Publishing Horizons, Inc., 1986.

*Graphic Artists' Guild Directory.* Vol. 7. California: Serbin Communications, 1990.

Hodes, Scott. *Legal Rights in the Art and Collectors' World.* Series title: Legal Almanac Series; No. 56. Dobbs Ferry, NY: Oceana Publications, 1986.

Leland, Caryn R. *Licensing Art & Design: A Professional's Guide for Understanding and Negotiating Licenses and Royalty Agreements.* New York, NY: Allworth Press; Cincinnati, OH: North Light Books, 1990.

Lerner, Ralph E., Chairman. *Art Law.* Series title: Patent, Copyright, Trademark, and Literary Property Course Handbook Series; No. 254. New York, NY: Practising Law Institute, 1988.

Lerner, Ralph E. and Judith Bresler. *Art Law: The Guide for Collectors, Investors, Dealers, and Artists.* New York, NY: Practising Law Institute, 1992.

Lerner, Ralph E., Chairman. *The Law and Business of Art.* Series title: Patent, Copyright, Trademark, and Literary Property Course Handbook Series. New York, NY: Practising Law Institute, 1990.

Lerner, Ralph E., Chairman. *Representing Artists, Collectors, and Dealers.* New York, NY: Practising Law Institute, 1985.

Marsh, Dave. *Fifty Ways to Fight Censorship: And Important Facts to Know About the Censors.* New York, NY: Thunder's Mouth Press, 1991.

Merryman, John Henry. *Law, Ethics, and the Visual Arts.* 2d ed. Philadelphia, PA: University of Pennsylvania Press, 1987.

Norwick, Kenneth P. and Jerry Simon Chasen. *The Rights of Authors, Artists, and Other Creative People: The Basic ACLU Guide to Author and Artist Rights.* 2d ed. Carbondale, IL: Southern Illinois University Press, 1992.

Pinkerton, Linda F. and John T. Guardalabene. *The Art Law Primer: A Manual for Visual Artists.* New York, NY: N. Lyons Books, 1988.

Victoroff, Gregory T. *Poetic Justice: Delivery of Legal Services to Authors and Artists.* Chicago, IL: American Bar Association, Young Lawyers Division, 1989.

## PACKING AND SHIPPING ARTWORK

*Art In Transit: Studies in the Transport of Art.* Washington, DC: The National Gallery of Art, 1991.

*Art In Transit Handbook.* Washington, DC: The National Gallery of Art, 1991.

Horne, Stephen A. *Way to Go: Crating Artwork for Travel.* Hamilton, NY: Gallery Association of New York State, 1985.

MacLeish, A. Bruce. *Care of Antiques and Historical Collections.* Nashville, TN: American Association for State and Local History, 1985.

Mills, John FitzMaurice. *Look After Your Antiques.* Secaucus, NJ: Castle Books, 1981.

Powell, Brent. *Soft Packing: Methods and Methodology for the Transporting of Art and Artifacts.* Registrars Committee of the American Association of Museums, PACIN Task Force, 1993. Available from the Nelson Atkins Museum of Art, Attn: Brent Powell, 4525 Oak, Kansas City, Missouri 64111.

Powell, Brent. *Technical Drawing Handbook of Packing & Crating Methods.* Registrars Committee of the American Association of Museums, PACIN Task Force, 1993. Available from the Nelson Atkins Museum of Art, Attn: Brent Powell, 4525 Oak, Kansas City, Missouri 64111.

Sacharow, Stanley. *Handbook of Package Materials.* Westport, CT: AVI Publishing Co., 1976.

## CONTRIBUTORS

### Ronald G. Bakal

Ronald G. Bakal, Attorney, has been practicing for over 20 years in the field of copyright and contracts. He has also taught courses in law and copyright at UCLA, USC, Pepperdine and Otis Parsons.

### Karen D. Buttwinick

Karen D. Buttwinick is a Los Angeles based attorney and artist. She is co-owner of the Brentwood Art Center, a private school of fine art located in Los Angeles. Ms. Buttwinick received her J.D. degree from Hastings College of the Law in 1989. She graduated in 1985 from Pitzer College in Claremont, California with a B.A. degree in English.

### Nat Dean

Ms. Nat Dean is a visual artist whose work has been shown worldwide in more than 400 group and solo exhibitions. Since 1978 she has taught workshops, lectured, and provided individual and group counseling. Ms. Dean has developed academic programming on the subjects of "survival and career development skills for artists" and "the business of art" at over 450 sites, including most major art schools and numerous arts organizations.

### Debra Fink

Debra L. Fink, Esq. is an attorney in Los Angeles. She received her A.B. degree, magna cum laude, in Communications from the University of Miami and her J.D. degree from Loyola Law School.

### Susan A. Grode

Susan A. Grode, Esq. is a partner in the law firm of Kaye, Scholer, Fierman, Hays and Handler and specializes in matters relating to creators and their creations in the fields of entertainment, publishing and the visual arts. Ms. Grode is counsel to many artists' groups and foundations and has lectured to members of the bar as well as artists at UCLA and USC. She is a graduate of Cornell University and the University of Southern California Law School.

### Peter H. Karlen

Peter H. Karlen practices art, publishing, and intellectual property law (including copyright, trademark, and moral rights law) in La Jolla, California. He is a contributing editor and writer to art and literary publications and the author of numerous trade and academic articles on art, publishing, entertainment and intellectual property law. For many years, Mr. Karlen has taught at law schools in the United States and Britain. Mr. Karlen has been listed in *Who's Who in American Law, Who's Who in American Art,* and *Who's Who in the World.*

### Robert C. Lind

Robert C. Lind is a professor of law at Southwestern University School of Law in Los Angeles. He received his Bachelor of Elected Studies degree, summa cum laude, from the University of Minnesota in 1976, his J.D. degree from George Washington University in 1979 and his Master of Laws degree, with highest honors, from George Washington University in 1983. Professor Lind teaches courses in copyright, trademark, entertainment, defamation, privacy, museum and art law. He is a member of the District of Columbia and California bars.

### Kent C. Liu

Kent C. Liu is an attorney based in Los Angeles. His practice is concentrated in the areas of copyright, trademark, music, business law and business litigation. He is a panel attorney and frequent volunteer with California Lawyers for the Arts (CLA). Mr. Liu is a graduate of UCLA and University of the Pacific, McGeorge School of Law.

### Dave Marsh

Dave Marsh has been writing and lecturing about censorship since the early 1980s. He is the author of more than a dozen books about popular music, including two best-sellers about Bruce Springsteen, *Born to Run* and *Glory Days.* He edited the first two editions of *The Rolling Stone Record Guide* as well as *Pastures of Plenty,* from the papers of folksinger Woody Guthrie. A founder of *Creem,* former associate editor of *Rolling Stone* and a current music critic for *Playboy,* Marsh also edits *Rock & Roll Confidential,* a newsletter about music and politics, with a special emphasis on censorship.

He serves on the board of the Rhythm and Blues Foundation and the advisory board of National Writers' Union. Marsh lives in New York City and Connecticut with his wife and two daughters.

### Andrea Miller-Keller

Andrea Miller–Keller, Emily Hall Tremaine Curator of Contemporary Art, has been on the curatorial staff at the Wadsworth Atheneum in Hartford, Connecticut since 1969. Founded in 1842, the Atheneum is the oldest public art museum in the United States. Miller–Keller has organized over 125 one-person museum shows in the Atheneum's MATRIX program, including the first one-person U.S. museum exhibitions of Richard Tuttle, Daniel Buren, Komar and Melamid, Keith Haring, Louise Lawler, Barbara Kruger, Lorna Simpson, Glenn Ligon and dozens of others. In 1992, she was awarded a National Endowment for the Arts Fellowship to study "Paradox or Prisoners Dilemma? Contemporary Art in the Context of the Traditional American Art Museum." She is co-author of a recent publication, *Sol LeWitt Wall Drawings: 1968-1993.*

### Amy L. Neiman

Amy L. Neiman is a Los Angeles based art law attorney. Ms. Neiman received her J.D. degree from UC Berkeley in 1985. She graduated from San Francisco State University in 1980 with a B.A. degree in Graphic Communications and worked as a graphic artist. Ms. Neiman is on the board of directors of California Lawyers for the Arts and has represented muralists in both contract negotiations and mural destruction cases.

### Louise Nemschoff

Louise Nemschoff, Esq. practices law in Beverly Hills, with an emphasis on copyright, trademark, intellectual property and entertainment law. She is a graduate of Harvard College and Yale Law School.

### Robert Panzer

Robert Panzer has been executive director of VAGA since 1989. His experience includes administrative and marketing positions in graphic design, architecture/engineering and publishing. He is a 1981 graduate of Cornell University.

### Robert Projansky

Robert Projansky is an attorney practicing in New York City.

### Stephen F. Rohde

Stephen F. Rohde is a partner of the Los Angeles law firm of Rohde & Victoroff, which specializes in constitutional, copyright, entertainment, literary property and trademark law. Mr. Rohde writes and lectures frequently in these areas. He is author of "Art of the State: Congressional Censorship of the National Endowment for the Arts" (*Hastings Communications and Entertainment Law Journal,* 1991) and *Foundations of Freedom,* published by the Constitutional Rights Foundation, on the occasion of the bicentennial of the Bill of Rights. Mr. Rohde represents writers, artists, film and television producers and book publishers. He is a graduate of Northwestern University and Columbia Law School.

### Eileen L. Selsky

Eileen L. Selsky is the editor of the *Entertainment Law Reporter.*

### Madeleine E. Seltzer

Madeleine E. Seltzer is a former practicing attorney and a partner in Seltzer–Fontaine, a legal search firm based in Los Angeles. She is a volunteer mediator for Arts Arbitration and Mediation Services, a program of California Lawyers for the Arts and an advisory board member for Sojourn Services for Battered Women and Their Children.

### Steven Shonack

Steven Shonack received his A.B. in 1990 from the University of California, Berkeley and his J.D., in 1994 from Loyola Law School, Los Angeles.

### Paul D. Supnik

Paul D. Supnik graduated from UC Hastings College of Law in San Francisco in 1971 and received a B.S. degree from UCLA in 1968. He is a past chair of the Intellectual Property and Entertainment Law Section of the Los Angeles County Bar Association, a co-editor of the 1980 edition of Committee for the Arts' publication, *The Actors Manual,* co-editor of the publication *Enforcement of Copyright and Related Rights Affecting the Music Industry,* and author of the chapter "Copyright" in *Proof in Competitive Business Litigation* published by California Continuing Education of the Bar. He practices entertainment, copyright and trademark law in Beverly Hills.

### Katherine M. Thompson

Katherine M. Thompson has her law practice in West Los Angeles, California and specializes in areas of art and copyright. She is a graduate of Pepperdine University, 1991.

### William Turner

William Turner is the owner of William Turner Gallery in Venice, California. Mr. Turner is also an attorney with a J.D. degree from the University of San Francisco. He has a B.A. degree from Colorado College where he majored in philosophy and fine art. Mr. Turner is on the board of California Lawyers for the Arts, is president of the Santa Monica/Venice Art Dealers Association and is the art editor for *Venice Magazine.*

### M. Christine Valada

M. Christine Valada is a lawyer and professional photographer who has written and lectured on copyright and other issues affecting creators. She is a former member of the national board of directors of the American Society of Media Photographers, serving as Rights Committee Chair and directing lobbying activities on copyright in Washington, D.C. from 1986–1988. She recently assisted with the formation of the Comic Book Professionals Association. She currently practices law in Los Angeles.

**Gregory T. Victoroff**

Gregory T. Victoroff is a partner in the Los Angeles law firm of Rohde & Victoroff. Since 1979, his law practice has involved negotiating book publishing, movie, recording and fine arts contracts and handling trials and appeals in state and federal courts.

Mr. Victoroff received a B.A. in theater and a teaching credential from Beloit College in 1976 and received his J.D. degree from Cleveland–Marshall College of Law in 1979. In 1978, he transferred to the UCLA School of Law to study copyright and entertainment law with the late Melville Nimmer and art law with Monroe Price. He is the author of *Poetic Justice: Delivery of Legal Services to Artists and Authors,* published by the American Bar Association in conjunction with his live and video ABA art law presentations in the U.S. and Canada. Mr. Victoroff's entertainment law articles have been published in the *Hastings Communications and Entertainment Law Journal; 1990 Entertainment, Publishing and the Arts Handbook; The Musician's Business and Legal Guide; The Visual Artist's Manual;* and *The Writer's Manual.* His entertainment law interviews have appeared in *USA Today, Los Angeles Times, LA Daily Journal, Art and Business News, Long Beach Press-Telegram, People, Los Angeles Lawyer* and *Keyboard Player* magazines. He is the past president of the Beverly Hills Bar Association Barristers and is co-chairman of its Committee for the Arts. He serves on the board of directors of Through Children's Eyes, a gifted children's photography program and on the statewide advisory board of California Lawyers for the Arts. He has lectured on copyright, photography, art law, censorship and publishing contracts for the American Bar Association, The American Law Institute, UCLA Extension, California Institute of the Arts, Otis/Parsons, California State Northridge, Art Center College of Design, Ringling School of Art and Design, Chaffee College, College of the Desert and the Los Angeles International Contemporary Art Fair. Mr. Victoroff has served as a legal consultant to documentary films including *Bombing LA,* about Los Angeles graffiti, and *Kamikaze Hearts,* about the San Francisco and Los Angeles adult movie business, and NBC's *Midnight Caller.* He is an arts arbitrator and mediator with California Lawyers for the Arts. For his pro bono volunteer legal services, Mr. Victoroff has received awards from the American Bar Association, the Beverly Hills Bar Association, the Boy Scouts of America, the Urban League and former Los Angeles Mayor Tom Bradley.

**Marlene Weed**

Marlene Weed, motion picture screenwriter and attorney, represents a wide variety of artists and writers in America and Europe. She is the author of *A Consumer's Guide to Insurance Policies.* As a member of the Writers Guild of America, West, Plagiarism Committee, she led the search for lawyers willing to represent artists and writers on a contingent fee and co-authored the Guild publication, *Plagiarism & Copyright Infringement.* Telephone (208) 324-3246.

**Elaine Wintman**

Elaine Wintman, consultant, has been Director of Development at Pacific Asia Museum in Pasadena, California; Manager of Corporate, Foundation and Government Relations at the California Institute of the Arts (CalArts); Associate Director of SPACES (Saving and Preserving Arts and Cultural Environments); and Gallery Director and Program Director of the Woman's Building in Los Angeles. She has served on the board of directors of the Gay and Lesbian Media Coalition and as vice president of the board of directors of About Productions. She has been instrumental in raising several million dollars in support for the arts and has led workshops throughout the U.S. on fund raising and arts management. She likes words and pictures and numbers, and she likes to encourage artists and other people to empower themselves and to follow their dreams. She likes to think that everything turns out for the best.

                                    End of Index

## About Jerome Headlands Press

Jerome Headlands Press, based in Jerome, Arizona, designs and produces business books for musicians, visual artists and professionals working in entertainment and the arts.

*"I feel strongly that artists should have access to business information and training to help them make a living and avoid costly mistakes. Until artists learn to treat their art as a business, they will sign bad contracts and be prey to people who will exploit their talents without fair compensation."*

Diane Rapaport, President and founder, is a pioneer in the field of music business education.

*The Musician's Business and Legal Guide,* edited by Mark E. Halloran, Esq., is the first book produced by Jerome Headlands Press for Prentice Hall. It was published in the fall of 1991. The book provides information on key legal and business issues by twenty-three prominent lawyers and business experts. The book went into its third printing in the spring of 1994.

*"For me, it's a correspondence prep school that should be read by all aspiring musicians and music business professionals. It gets to the heart of the matter without skimping on the specifics or glossing over the pitfalls. It's easy to find the particular information you need quickly, so you have time to get on with the music. It provides the facts you need to master the complex nature of today's competitive marketplace. I find it to be an invaluable aid to anyone interested in music as a career."*

Bill Graham, Bill Graham Presents, San Francisco, California.

*How to Make and Sell Your Own Recording,* by Diane Sward Rapaport, is the second book produced by Jerome Headlands Press for Prentice Hall. It was published in the fall of 1992. The book has been a friend and guide to more than 100,000 musicians, producers, engineers and owners of small recording labels. It has helped revolutionize the recording industry by providing information about setting up new recording labels independent of major label networks.

*"This is the bible for musicians… anyone about to embark on a first release can profit from the information, even if they already have a major label contract."*

Jon Sievert, *Guitar Player.*

*Performing and Recording Unplugged,* by Mike Sokol, a fourth book scheduled for publication by Prentice Hall in 1995, will help acoustic musicians set up appropriate sound reinforcement systems at their performances and make live recordings.

Jerome Headlands Press books are designed by Julie Sullivan, Sullivan Scully Design Group, in Flagstaff, Arizona.

The cover and illustrations for *The Visual Artist's Business and Legal Guide* were provided by Paul Nonnast. Paul is a sculptor, artist and architect. As president and founder of Aeon, he designs and builds titanium road racing bicycles.

Jerome Headlands Press is seeking manuscripts that help artists make successful careers. Please contact us with a letter describing your project, a working table of contents and sample chapter.

Jerome Headlands Press
PO Box N
Jerome, Arizona 86331